100 STORIES FROM THE AUSTRALIAN NATIONAL MARITIME MUSEUM

100 STORIES FROM THE AUSTRALIAN NATIONAL MARITIME MUSEUM

NEWSOUTH

AUSTRALIAN
NATIONAL MARITIME
MUSEUM

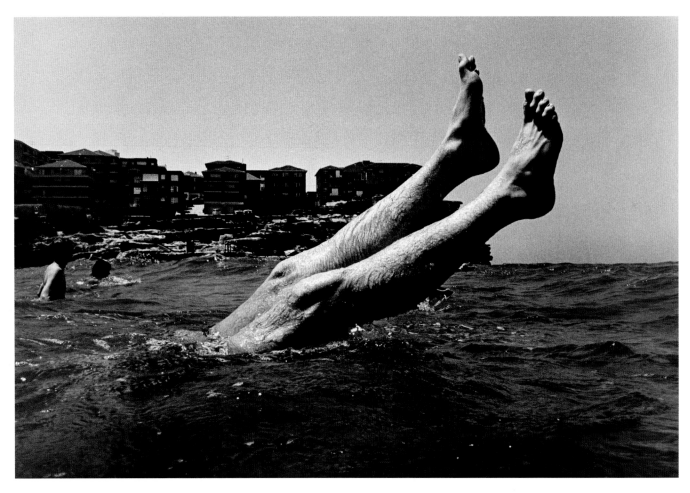

A NewSouth book

Published by
NewSouth Publishing
University of New South Wales Press Ltd
University of New South Wales
Sydney NSW 2052
AUSTRALIA
newsouthpublishing.com

© The Australian National Maritime Museum, 2012
2 Murray Street, Sydney NSW 2000
anmm.gov.au
Published on the occasion of the Australian National Maritime Museum's
20th anniversary year
First published 2012

10 9 8 7 6 5 4 3 2 1

National Library of Australia Cataloguing-in-Publication entry
Author: Australian National Maritime Museum.
Title: 100 stories from the Australian National Maritime Museum/Australian National
Maritime Museum.
ISBN: 978 174223 320 8 (pbk.)
ISBN: 978 174224 158 6 (ebook: epub)
Notes: Includes index.
Subjects: Australian National Maritime Museum.
 Museum exhibits – Australia – Anecdotes.
 Discoveries in geography – Australian – Anecdotes.
 Navigation – History – Anecdotes.
 Maritime museums – Australia – Anecdotes.
 Dewey Number: 387.50994

Members of Aboriginal and Torres Strait Islander communities are respectfully advised
that some of the people mentioned in writing or depicted in photographs in the following
pages have passed away.

All items are held in the collection of the Australian National Maritime Museum, unless
otherwise indicated.

Unless otherwise stated, all photography is by Andrew Frolows, Manager Photographic
Services, Australian National Maritime Museum, and is © The Australian National
Maritime Museum.

Editor/project manager Theresa Willsteed
Designer Di Quick
Copy editor Janine Flew
Indexer Mary Coe
Printer Everbest, China

Titles of works appear in italics; where the title has been ascribed, it is not italicised. If not
otherwise stated measurements are given in centimetres (cm), height x width x depth.

Every reasonable effort has been made to contact relevant copyright holders. Where this
has not proved possible, copyright holders are invited to contact the museum.

All information in this publication was correct at the time of printing.

This book is printed on paper using fibre supplied from plantation or sustainably managed
forests.

Above **Roger Scott (b 1944)** *Legs in the Air,* 1976 Paper, ink, 57 x 60.6 cm
© Roger Scott, courtesy Josef Lebovic Gallery Sydney

CONTENTS

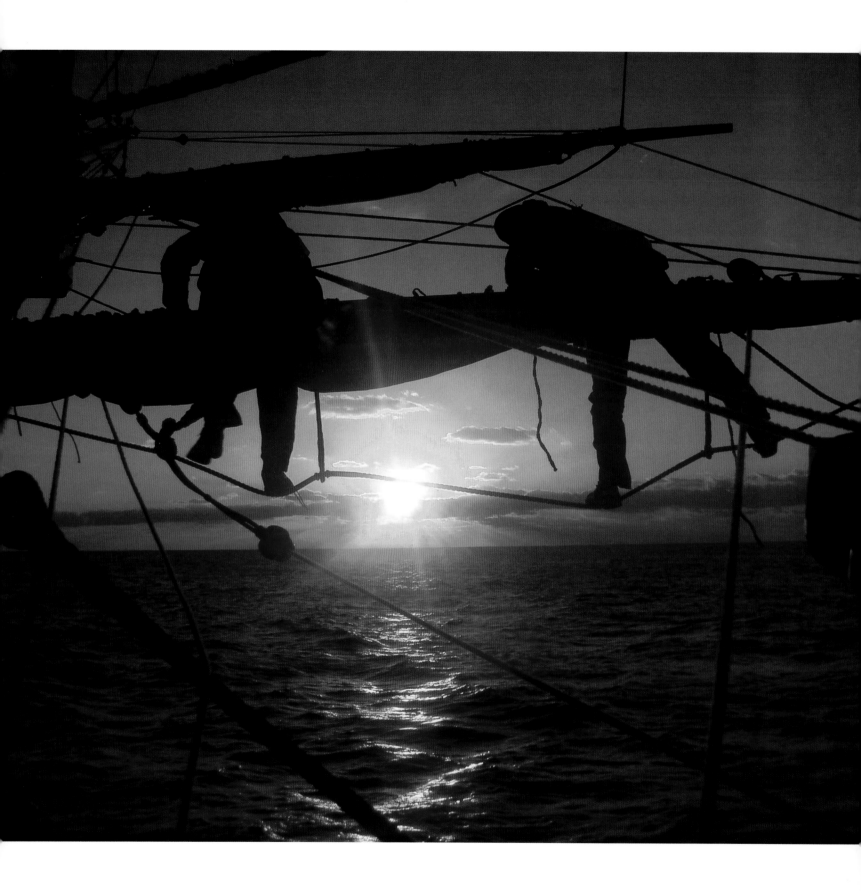

FOREWORD

The Australian National Maritime Museum is our nation's leading resource in the field of maritime heritage and history. Funded by the Australian Government and by the museum's own commercial activities, supported by private and corporate sponsors and the wider community, which includes our Members and many volunteers, this museum has a responsibility to collect, preserve and then to make accessible the material heritage of our nation's maritime history.

The range of this material is quite extraordinarily diverse, as you will see from the moment you begin to turn these pages. In scale this collection ranges from buttons and needles to full-sized ships – traditionally the most complex and largest-scale movable artefacts that any society produces, and thus – unsurprisingly – the largest museum objects that you will find anywhere in Australia.

This book reveals the great wealth of treasures that the Australian National Maritime Museum holds in its collections and archives. It was produced at the time that the museum was marking the milestone of 20 years since it opened to the public, and a slightly longer period – a quarter of a century – since this collection began to be assembled by the first curators appointed to create a National Maritime Collection for Australia.

One of those early curators was Mary-Louise Williams, who became the museum's director from 1999 to 2012 and who commissioned this book and guided its shape and

content prior to her retirement. In a real sense the book is a tribute to Mary-Louise's passion for, and her leading contribution to the assembling of, the National Maritime Collection.

Of necessity a book like this can only offer a very small sample of such a collection. Indeed, the objects included here represent something less than one thousandth part of it! But as the title of this work suggests, there is something much more important than the actual objects of timber or mineral or metal, textile or pigment. It's the human stories that they represent, stories that are researched and recorded and communicated by our dedicated staff.

The museum's new director at the time of publication, Kevin Sumption, has been a part of that process himself. Working with us at an earlier period of his career, shortly after the museum opened, Kevin has made his own contribution to some of the stories that we present here.

The Australian National Maritime Museum has a longstanding commitment to reaching out beyond its location on Sydney Harbour to the entire nation whose history it represents. It achieves this in many ways – from travelling exhibitions and a heritage grants program, to interstate voyages of our historic replica of Cook's *Endeavour*. For supporting these programs we extend our gratitude to the Minister for the Arts, the Hon Simon Crean MP, and to all of the Ministers preceding him during these 20 years of service to our public.

This book joins those other outreach programs, as a way of taking an inspired sample of a superb national collection, and the stories these objects embody, out to a wider audience around the country and beyond.

Peter Dexter AM FAICD
Chairman of the ANMM Council

Paying voyage crew on the *Endeavour* replica learn the skills of furling sail to the yard, supported by foot-ropes high above the sea, 2012. Photo: ANMM

INTRODUCTION

Every object has a story to tell and some of the tales, naturally, are more far-reaching than others. Take, for, example the small silver disk, 7.4 cm in diameter, known to history as *The* Charlotte *Medal*. This is a one-off. It has come down to us through the generations from a pivotal event in Australian history, the arrival of Britain's First Fleet of convicts and their gaolers in January 1788. On one side it displays a fine engraving of the three-masted convict ship *Charlotte* at anchor in Botany Bay; on the reverse, a brief inscribed account of *Charlotte*'s arduous voyage from Britain to the Antipodes.

The beautiful design comes from the hand of thief, forger and mutineer Thomas Barrett. It's believed he engraved the medal on board *Charlotte* in Botany Bay. He made it for John White, the Fleet's Surgeon-General, to celebrate the successful ocean passage halfway around the world. Today the medal is one of very few objects surviving from the First Fleet. It has a wealth of stories to tell us (see p. 46).

In this book celebrating the first 20 years of the Australian National Maritime Museum, curators present 100 stories about some of the museum's most interesting objects – items they have researched, acquired for the museum, documented and in most cases placed on display.

HMAS *Vampire* in dry dock, at the Captain Cook Graving Dock on Garden Island, Sydney. After a hull and structure survey, and cleaning, painting and repair work, fleet staff and volunteers celebrate a job well done. Photo: Cristiano Cicuta

Thomas Barrett (d 1788) *The* Charlotte *Medal*, 1788 (front) Silver, 7.4 cm (diam.) *Purchased with the assistance of the Australian Government through the National Cultural Heritage Account*

An Australian Government initiative, the museum is still relatively youthful. It recruited its first staff in the mid-1980s and opened its doors to the public on 30 November 1991. At the opening ceremony (then) Prime Minister Bob Hawke said that Australians sometimes forget just how vital the sea has been to the country's economic, political, social and cultural development. This new national museum, he declared, had been established to spotlight the country's maritime history and heritage.

The museum's mission is to explore and describe all the various ways in which the open seas and enclosed waterways have influenced human communities, past and

represents centuries of social and technical change on a broad scale across Australia and out over its bounding oceans and seas.

The stories in this book have been collected into nine chapters that broadly represent the museum's diverse collecting areas: 'First mariners' (Indigenous culture); 'Explorers and settlers' (European exploration and the young colony); 'Migrants and refugees' (people making new lives here); 'Sail and steam' (shipping and trade); 'Serving Australia' (colonial navies and the Royal Australian Navy); 'Linked by the sea' (Australian–American maritime relations); 'Industry and environment' (maritime industries); 'Sport and play' (aquatic recreation, competition and leisure); and 'Adventurers' (memorable achievers).

present, on this vast island. It's an absorbing study. We Australians look to the water for much of our livelihood (by way of trade, mining, fishing and tourism), our defence, sport and recreation. The ties binding us to the sea are strong. By examining those links, everyone comes to a better understanding of who Australians are.

In just 20 years, Australian National Maritime Museum curators have developed an outstanding collection of more than 130,000 objects. These range in size from coat buttons to HMAS *Vampire*, a 119-metre-long former Royal Australian Navy destroyer. They include such diverse items as Indigenous bark paintings, a 19th-century ship's surgeon's kit, a beer-can boat, swimsuits and surfboards, all of which feature in the following pages. The collection

Many of the objects that appear in these pages are included in the museum's galleries and we invite you to come along to see them for yourself, absorb their stories and contemplate their place in the wider picture of Australian social history.

This is Australia's, and indeed one of the world's, biggest and most progressive maritime museums. It occupies a remarkable 4.4-hectare site (2.2 hectares on land, 2.2 of waterway) on the western shore of Darling Harbour, with views across to Sydney's towering city skyline. The museum is part of Darling Harbour's lively tourist and recreation precinct, and yet it's still little more than two kilometres from the historic site where those convicts struck the first British settlement on Australian soil in January 1788.

The museum is a truly indoor/outdoor experience. Its wharves accommodate a fleet of 13 vessels of its own – together with the Sydney Heritage Fleet collection, it is one of the biggest museum fleets anywhere in the world. The three biggest vessels are open for inspection: the former RAN destroyer HMAS *Vampire*, former RAN submarine HMAS *Onslow*, and the superbly crafted replica of James Cook's 18th-century ship HM Bark *Endeavour*. You'll find the *Vampire* and *Onslow* stories in our chapter on the Navy (p. 122).

Still outdoors, visitors will also see:

- the unexpected sight of a 21-metre tall lighthouse in the centre of Sydney. It was transported panel by panel from Cape Bowling Green, North Queensland, where it was assembled in 1874 to lead ships through threatening reefs (see p. 114 for stories about the museum's guiding lights, lighthouse and lightship);
- the 21-metre wooden signal mast originally erected in 1912 at the Royal Australian Navy's Garden Island Dockyard, Sydney;
- a pair of massive 19th-century anchors now mounted on a wooden base and serving as a memorial to sailors lost at sea.

A very popular open-air feature is the Welcome Wall, where everyone is invited to record the names of forebears and friends who journeyed from countries across the globe to make a new home in Australia, this nation of migrants. More than 20,000 names have already been inscribed on the bronze panels, and thousands more are added each year. Subscribers can contribute information about those migrants to an online database. These thousands of stories together comprise an informal folk history of Australia which is available for the whole world to view on the museum's website at www.anmm.gov.au.

Inside the main exhibition building, visitors are often startled by the first object they see: the fastest boat in the world! Ken Warby's jet-propelled hydroplane *Spirit of Australia* is located above the ramp as you're proceeding from the foyer into the main galleries. This amazing, backyard-built craft set a world water speed record of 511.11 km/h that has stood unbeaten for more than 30 years. You can read about *Spirit of Australia* and Warby's ingenuity and courage on p. 244.

Further inside, the great sculpted glass lens from south-east Tasmania's former Tasman Island lighthouse rotates slowly on its vertical axis; a former Royal Australian Navy Westland Wessex helicopter hovers overhead (see p. 136); and welcoming galleries focus on different aspects of Australia's maritime history.

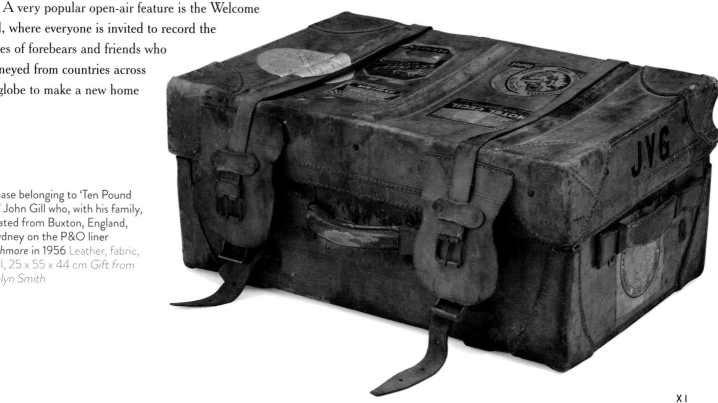

Suitcase belonging to 'Ten Pound Pom' John Gill who, with his family, migrated from Buxton, England, to Sydney on the P&O liner *Strathmore* in 1956 Leather, fabric, metal, 25 x 55 x 44 cm *Gift from Carolyn Smith*

These galleries display a fascinating variety of almost 2,000 objects, every one with its own stories to tell. At any time you may see Indigenous watercraft (pp. 4–7), navigational charts and instruments that helped 18th-century European mariners explore the Pacific (p. 44), personal possessions that migrant families brought with them on the great sea voyage to their new homeland (pp. 58–89) and the belongings of Oskar Speck, a young German who amazingly paddled a kayak from his homeland to Australia in the 1930s (p. 236). Then there's Lord Nelson carved in wood as a ship's figurehead (p. 125), and swimsuits and surf-lifesaving gear as evidence of Australia's well-known beach culture (pp. 212 and 220).

After enjoying the main exhibition building, visitors can take a tour through the Wharf 7 Maritime Heritage Centre, an adjacent building that houses our offices and collection storage, conservation laboratories and workshops, design and photographic studios and the museum's 30,000-title research facility, the Vaughan Evans Library. It's also home to an allied organisation, Sydney Heritage Fleet, which we sponsor with accommodation and a berth for their beautifully restored 1874 barque *James Craig*, open for inspection at Wharf 7.

The museum's activities and influence extend way beyond this busy Darling Harbour site through its many outreach programs. We have developed a range of programs to service museums and community associations that collect

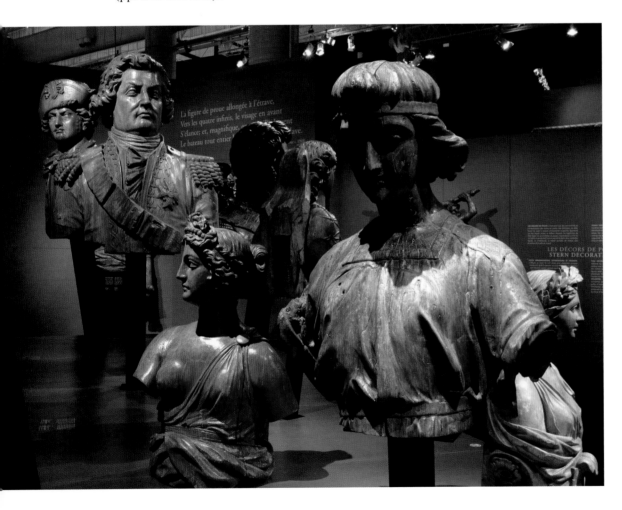

Les Génies de la Mer Masterpieces of French Naval Sculpture visited the museum from April to October 2005. For this exhibition, the Musée national de la Marine, Paris, shipped to Sydney a selection of exquisite sculptures that had adorned French ships from the 17th to 19th centuries.

and care for maritime heritage. These include a heritage grants program, internships for volunteer museum workers, advisory services, and a variety of means of displaying our maritime heritage around the country.

One fine example is provided by the *Endeavour* replica (see p. 32). In port, this meticulously researched and beautifully built ship is a floating museum, displaying faithfully the conditions on board Cook's famous ship of exploration. At the same time, however, the replica is fully seaworthy and the museum regularly sends it on sea voyages to share the ship's educational features with residents in other parts of Australia, and to teach 18th-century seamanship to voyage crew who sign up for passages between ports. To celebrate the museum's 20th birthday, *Endeavour* undertook an epic circumnavigation of the continent.

In another outreach program, the museum draws upon its collection to assemble travelling exhibitions for museums and other venues across Australia. One of these, for example, features *Banks' Florilegium* – a set of botanical prints commissioned by Joseph Banks following his 1768–71 voyage with Cook on *Endeavour* (p. 38). Another, titled *Exposed! The story of swimwear*, featured swimsuits from the museum's collection.

Our Welcome Wall's online database of stories is another form of outreach. So too is the museum's Australian Register of Historic Vessels (ARHV), a constantly expanding online database of significant craft in private ownership across the continent. Among them, naturally, are vessels in the museum's collection, including solo sailor Kay Cottee's yacht *Blackmores First Lady* (p. 246), the historic 18-foot skiff *Britannia* (p. 216), the former Royal Australian Navy patrol boat HMAS *Advance* (p. 122), the Vietnamese refugee boat *Tu Do* (p. 84) and Bass Strait 'couta fishing boat *Thistle* (p. 192). The ARHV links associations, individuals, clubs and museums all over the country.

The Australian National Maritime Museum is always looking for stories that help today's community to better understand what happened in our history, and why. Some of the evidence comes from conversations with living people; some comes from texts, images and other explicit forms of communication; and much comes from objects that have simply survived from times past, and now bear witness to the conditions and influences that existed then. Think of *The* Charlotte *Medal* and its vivid stories.

A museum's role in contemporary society is to sift through the material generated by past and present generations to identify what should be conserved for the community's lasting benefit. Here in the pages of this book are objects in the National Maritime Collection that tell 100 vivid stories about people – grand, humble and culturally diverse – who have contributed to the development of Australian society. They link us to them.

Mary-Louise Williams, Director, 1999–2012

Kevin Sumption, Director, 2012 onwards

The Australian National Maritime
Museum, as viewed from Pyrmont
Bridge, Sydney, 2012

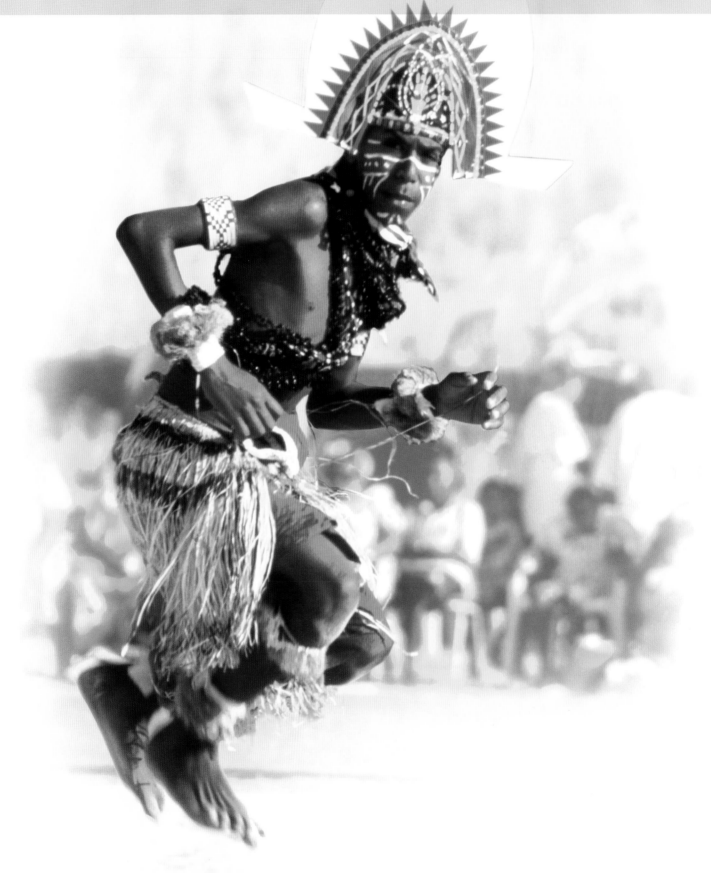

The cultures of Australia's Indigenous communities are among the oldest living traditions in the world, going back at least 50,000 years.

Within these cultures, people are at one with their physical environment – each sustains the other. In the Dreaming (sometimes called Dreamtime), Ancestral Beings moved across the land creating life and significant geographic features. Through the millennia, successive generations have conveyed Dreaming stories to their children in ceremony, song, dance, painting and storytelling, passing on important knowledge, cultural values and beliefs. These are living traditions, for today's Indigenous people continue to practise their traditional art forms to communicate their cultural heritage.

The Australian National Maritime Museum's Saltwater Collection – 77 bark paintings by Yolngu community artists in north-east Arnhem Land – is highly significant. The paintings were commissioned by Yolngu elders wanting to make a clear and powerful statement to the world about the community's traditional relationship with its Saltwater Country and the sea. Superb works of art, the paintings identify Ancestral Beings associated with the coastal region, geographical features and local flora and fauna. Several also served a wider purpose when they were subsequently accepted as documentary evidence in a successful Yolngu sea rights native-title case before the High Court of Australia.

As Australia's first mariners, Indigenous people created a vast range of rafts and canoes for use in different parts of the country and the Torres Strait. Each type has been influenced by its environment, the materials available and intended use. The museum's collection includes a raft made from mangrove wood trunks from the Kimberley coast in northern Western Australia and three very different types of bark canoe from the lower Murray River (South Australia) and the north-east and central-northern coastal areas of Arnhem Land (Northern Territory).

Among many smaller-scale objects in the museum collection is Arthur Koo'ekka Pambegan Jr's *Fish on Poles*, representing an ample catch of bonefish. The work is a contemporary reference to a Dreaming story that explains why these fish are abundant in North Queensland's Archer River.

John Bulun Bulun, an acclaimed artist of the Ganalbingu people of north-central Arnhem Land, is represented by several paintings portraying the arrival of Macassan trepang (sea cucumber) fishermen from Indonesia on our northern shores centuries ago and the ceremonies celebrating the friendships that developed.

Our Pacific neighbours and their maritime heritage are to be found in the work of Michel Tuffery, who comments on current issues that affect the whole Pacific region.

Bill Richards

The tenth Torres Strait Cultural Festival was held on Thursday Island in September 1998. This dancer from Saibai Island wears a traditional headdress and the dance mimicked a pearl shell thrown into the water. ANMM photographer Andrew Frolows completed a photographic essay of life in the Torres Strait in 1998.

Yolngu country, eastern Arnhem Land, and the wet season is slowly seeping into the land. Three men haul a dampened sheet of stringybark from a smouldering fire that carries the scent of the bush. Carefully, they push one end of the heated bark through a narrow gap between two sturdy branches driven almost parallel into the ground. Like wet, pliable leather, the warm and supple end folds upwards, and the sides come together dripping moisture at the base. The men then bind the top of the branches together tightly and, using a sharp blade, make a long angled cut, forward and down to the bottom tip of the folded end of the bark. They pierce holes along the raw edge then deftly thread fine, damp bark strips to sew the sides together. The prominent bow of a derrka has been created, and a canoe unique to Australia has begun to form, built with knowledge and skills that are thousands of years old.

Australia's first watercraft

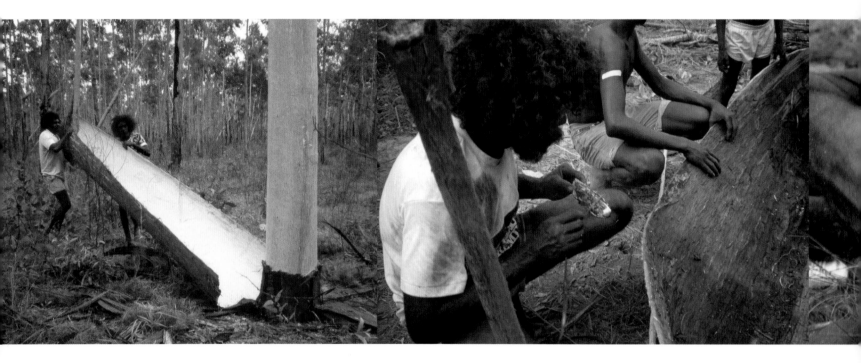

The museum's collection of Aboriginal and Torres Strait Islander watercraft highlights their diverse range, born from the Australian environment and shaped by the first people to live here. These craft are all recent commissions – in them, the makers and their communities are keeping alive the knowledge, traditions and culture handed down for countless generations. In early European reports, the watercraft were described as crude or simple, but they are now appreciated for their striking and bold shapes and a construction that reflects their builders' strong culture and deep understanding of the environment and the materials available.

The museum's gumung derrka was made by John Bulun Bulun (1946–2010), who was a senior member of the Ganalbingu people of north-central Arnhem Land. A pole is used to push the canoe along, while the fine reverse

bow easily parts the tall swamp grasses. Moving as a group, Yolngu people hunted from these canoes for magpie geese and their eggs in the wet season's flooded Arafura swamplands.

Na-Likajarrayindamara is a na-riyarrku sewn-bark canoe from Borroloola in the north-east of the Northern Territory. It was used for fishing on the coastline of the Gulf of Carpentaria. One person would paddle, while one or two others seated aboard searched for fish, four-pronged spears at the ready. Don Miller, Jemima Miller, David Isaacs and Arthur King from the Yanyuwa community

and cured the bark over one month to help form the elegantly simple shell, supported with just three eucalyptus branch beams. Standing to pole it along, the hunter and canoe would be cloaked with the river's mist and smoke from a fire on a mud hearth toward the rear, cooking a freshly speared fish.

The kalwa double raft's two sections are lapped one atop the other. This seemingly casual assembly makes for a capable vessel that was used along the Kimberley coast, home to treacherous tides and whirlpools. Roy Wiggan from the Bardi people near Broome in Western Australia made this fascinating craft, sharpening mangrove-wood trunks at

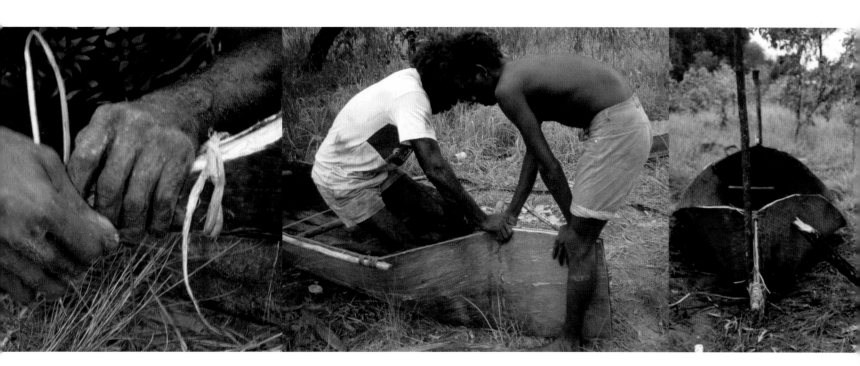

built this seagoing canoe. It is made from three sections of stringybark, carefully sewn together and supported by a clever framework of branches bracing the sides.

Paul Kropinyeri from the Ngarrindjeri community in South Australia made the museum's yuki, a bark canoe from the Murray River. A long section of bark from a river red gum is prised off the trunk, where a gentle bend contains the elements of a curved canoe profile. Kropinyeri weighted

FROM LEFT John Bulun Bulun (right), assisted by Charles Godjuwa, gathers bark; John Bulun Bulun (front) assisted by Paul (Paulie) Pascoe works on the canoe; tying the bow of the canoe; John Bulun Bulun and Paul Pascoe bind one end of the canoe together tightly; the derrka takes shape.
Photos: Diane Moon, ANMM

their base, then pinning them together with hardwood pegs, the raft's tapered fingers forming an elongated fan shape. Seated midway along and using a long-handled paddle, with a harpoon at hand, the Bardi fisher would search ahead for signs of dugong or turtle.

The walpo raft from Mornington Island in the Gulf of Carpentaria has a paddle made from the naturally shaped mangrove tree's buttressed root. The tiny vessel was used to venture across a river or close to shore, to fish on reefs and even hunt for dugong with a net. A carpet of flaking hibiscus bark sheets lies over a seemingly random tangle of white mangrove branches, whose intermingled twists and turns camouflage the considered layering, binding and shaping that underpin the structure. Ngarrawurn Murdumurdunathi from the Kaiadilt people made this walpo. It has a finer end at the bow, where he has carved the branch ends smooth and sharp, knitting it tightly together with strong handmade hibiscus rope.

Rra-Kalwanyimara is the museum's biggest canoe and was hewn from a tree trunk. The strength speaks for itself, and the axe and adze marks over the hull reveal the effort put into shaping the log. Fitted with thwarts, a sail, harpoon and float, these canoes were used to hunt dugong in the Gulf of Carpentaria. Macassan traders introduced the dugout to the people of Australia's northern coastline from the 1600s. The museum's dugout canoe is also from Borroloola, and was made by Annie Karrakayn, Ida Ninganga and Isaac Walayungkuma from the Yanyuwa and Garrawa peoples.

Canoes, rafts and dugouts such as these have been plying Australia's waterways for thousands of years. From Freshwater people inland to Saltwater people on the coast, the watercraft of Australia's first mariners are of great significance to Indigenous Australians.

David Payne

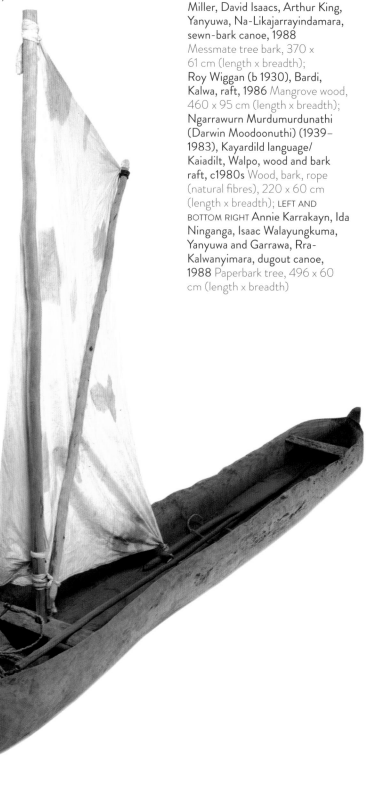

> FROM TOP Don Miller, Jemima Miller, David Isaacs, Arthur King, Yanyuwa, Na-Likajarrayindamara, sewn-bark canoe, 1988 Messmate tree bark, 370 x 61 cm (length x breadth); Roy Wiggan (b 1930), Bardi, Kalwa, raft, 1986 Mangrove wood, 460 x 95 cm (length x breadth); Ngarrawurn Murdumurdunathi (Darwin Moodoonuthi) (1939– 1983), Kayardild language/ Kaiadilt, Walpo, wood and bark raft, c1980s Wood, bark, rope (natural fibres), 220 x 60 cm (length x breadth); LEFT AND BOTTOM RIGHT Annie Karrakayn, Ida Ninganga, Isaac Walayungkuma, Yanyuwa and Garrawa, Rra-Kalwanyimara, dugout canoe, 1988 Paperbark tree, 496 x 60 cm (length x breadth)

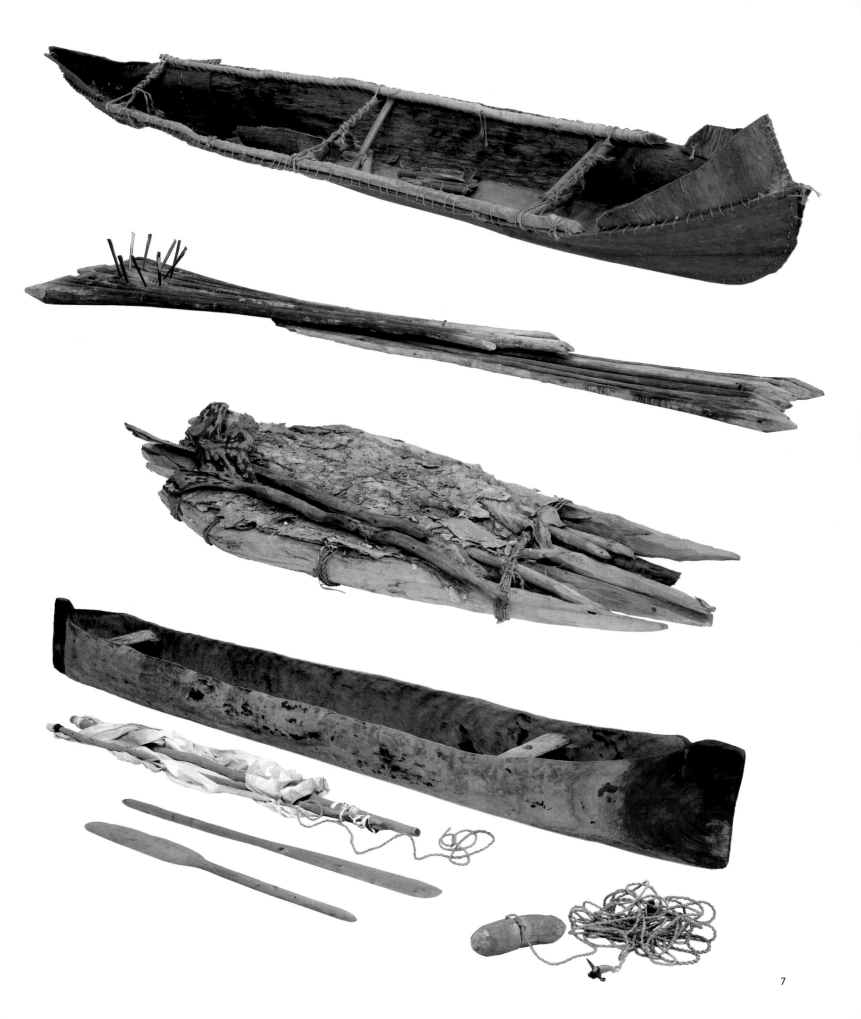

Yirrkala paintings of the Saltwater Collection

The Yolngu people of north-east Arnhem Land are intrinsically linked to the land and the saltwater coastline and, through many years of the last century, fought all the way to the High Court of Australia to have their native sea title finally recognised in 2008. These Saltwater Collection bark paintings form a comprehensive map and set out the Yolngu's legal claim over their Saltwater Country.

The Yolngu inhabit a landscape formed by the actions of Ancestral Beings. In 1963 a Swiss mining company began plans to mine bauxite on sacred Yolngu lands. The Aboriginal community organised a petition on bark to oppose this, and sent it to the Federal Parliament. They argued that the secret knowledge of elders expressed in art could constitute laws relating to land and sea that predated European law. Although their claims of land ownership were not accepted, this historic event highlighted the issue of Aboriginal land rights in Australia. In 1976 the *Aboriginal Land Rights (Northern Territory) Act* was passed by the Fraser government. The legislation is now seen as a benchmark in the recognition of Indigenous land rights. The Yolngu were decreed to be the legal owners of north-east Arnhem Land, but their ownership only covered rights on land and did not extend into the saltwater coastline. For the Yolngu, the sea and the land are inseparable.

In 1996 an illegal barramundi fishing camp was discovered at Garrangali, an area sacred to Aboriginal people in eastern Arnhem Land. Garrangali is the home of Bäru the sacred crocodile, and the local people discovered the severed head of a saltwater crocodile in a rubbish-strewn poachers' camp. This sacrilege motivated the elders at Yirrkala to co-ordinate the painting of a series of barks that demonstrated the rules, philosophies and stories of their region, to educate strangers about Yolngu law. The result was 80 bark paintings portraying the region between the coastal waters of Blue Mud Bay in the south to Arnhem Bay in the north – the Saltwater Country of eastern Arnhem Land. Each artist has inherited the right to paint their area of Sea Country, and each painting names and shows ceremonies. They document Yolngu culture, knowledge systems, Indigenous rights, non-European contact, animals, fishing, oceanography and climate. They explain family history and the creation of the seas and animals.

Nuwandjali Marawili's bark painting, *Bäru at Yathikpa*, portrays Bäru, the ancestral crocodile, in the saltwater of Yathikpa in East Arnhem Land. Bäru brought fire to the Saltwater people during the Creation Time. This fire is represented in the diamond-shaped miny'tji (sacred clan design). Accompanying Bäru are four depictions of another ancestor being, Balin the barramundi, which is admired by the Yolngu for its ability to live in salt and fresh water.

Living by the Sea by Marrnyula Munungurr depicts the Yolngu people of East Arnhem Land living and interacting with the sea. It shows the Yolngu camps and their traditional ways of hunting. People prepare harpoons to catch turtles and dugong, while others collect crabs for bait. The sea is shown busy and full of marine life. 'We are all connected to the sea through stories and hunting for food.'[1] The barks also have political and legal significance beyond their spiritual meaning – they underpin the community's native sea title claim. The museum's collection comprises 77 of these bark paintings by 47 Yolngu artists from 15 different sea-owning clans.

The Blue Mud Bay decision was finally handed down in in July 2008. The High Court of Australia gave the Saltwater people's rights and use of the Arnhem Land coast precedence over commercial interests and fishing, and recognised Aboriginal freehold title down to the low-water mark. The judges of the High Court ruled that anyone holding a licence under the *Fisheries Act* also required permission from the Northern Land Council before entering and fishing in tidal areas covered by the Aboriginal freehold grants.

Lindsey Shaw

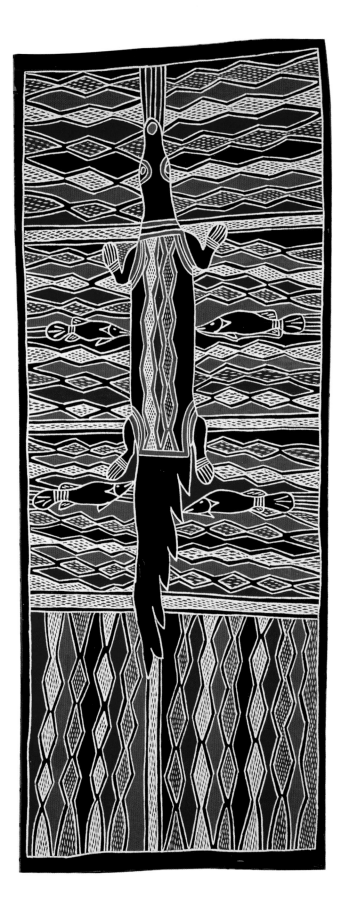

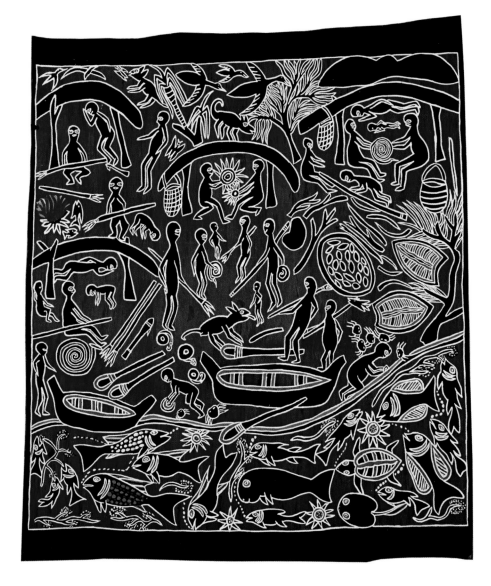

Nuwandjali Marawili (b 1956), Yirritja moiety, Madarrpa clan, Baniyala homeland *Bäru at Yathikpa*, 1998 Natural pigments on bark, 117 x 45 cm © Nuwandjali Marawili, reproduced courtesy of the artist *Purchased with the assistance of Stephen Grant of the GrantPirrie Gallery*

Marrnyula Munungurr (b 1964), Dhuwa moiety, Djapu clan, Wandawuy homeland *Living by the Sea*, 1998 Natural pigments on bark, 110.5 x 94 cm © Marrnyula Munungurr, reproduced courtesy of the artist *Purchased with the assistance of Stephen Grant of the GrantPirrie Gallery*

'When [Purrukapali and his wife Bima] returned to the camp they found that their baby Jinani had died. Purrukapali asked his wife, "Where have you been?" "I was out hunting with your brother [Japarra]," she replied. "Our son has died because you left him too long in the sun." Purrukapali was very angry. He started to fight with Japarra. Japarra said, "I do not want to fight, give me the baby and I shall bring him back to life." But Purrukapali answered, "No, he shall remain dead and because my son has died, everyone must die in the future." Japarra started singing and went up into the sky and became the moon. He dies only for a short time and always comes back to life again.' *John Wilson Wuribudiwi, Tiwi artist* [2]

Tiwi Pukumani burial poles

For the Tiwi people of Bathurst and Melville islands (off the coast of the Northern Territory, near Darwin), the origin of the Pukumani funerary ceremony lies in the story of Purrukapali and his wife Bima. In the last stage of a series of ceremonies, people place elaborately carved and painted timber burial poles (tutini) around the grave of a Tiwi person. They are impressive gifts to the spirit of the departed.

When a person passes away, his or her family selects artists to make the poles based on kinship and skills. They give the artists axes to cut the timber and ochre for painting. When the artists finish their work, close relatives of the deceased judge the poles to see if the artists have 'done a proper job'. Six burial poles were acquired by the museum to represent the burial practices, traditional culture and artistic works of these sea peoples of Bathurst and Melville islands. They were made by Tiwi artists John Martin Tipungwuti, Leon Puruntatameri, John Wilson Wuribudiwi, Pedro Wonaeamirri and Patrick Freddy Puruntatameri.

'The lines of the brush represent the miyinga (scars on the body) and the dots from the pwoja (painting comb) represent yirrinkiripwoja (body painting) and it all comes together to disguise me from the mapurtiti (bad spirits of the dead).' [3]

Pukumani poles are not the only way to mark the passing of a loved one – all Tiwi are expected to be able to compose a song and lead a ceremonial dance, and everyone has a chance to perform in the Pukumani ceremony. Great prestige comes from being a good composer and dancer. Today, performers dance in specially printed clothing – in the past, they wore elaborate armbands, chest ornaments and feathered headbands, so the spirits would not recognise them and because Purrukapali directed them.

When all the dances are completed and the participants have finished singing the wayward spirits back to their own country, and when the last wailing notes of the amburu (death song) have died away, the grave is abandoned and the burial poles are allowed to decay. The Pukumani ceremony is part of an ongoing social

process – it brings people together to share grief, confirm family ties and reaffirm the values of mutual support.

In 1911, the Mission of the Sacred Heart was established on Bathurst Island and many changes followed, including the banning of the Pukumani ceremony. But with the formation of the Tiwi Land Council in 1976, this policy changed, and traditional ceremonies are no longer suppressed. As most Tiwi are Christians there are efforts to combine Tiwi and Catholic ceremonies, with the Pukumani ceremony usually followed by a service conducted by a priest.

Lindsey Shaw and Leonie Oakes

< John Wilson Wuribudiwi (b 1955) Tiwi *Bima* (left) and *Purrukapali*, both c1995 Both paint on carved ironwood, **Bima**: 113 x 17.5 x 17.5 cm; *Purrukapali*: 124.5 x 24.7 x 21 cm; both © John Wilson Wuribudiwi

> Pukumani poles (Tutini), 1995 All: ochres on carved ironwood FROM LEFT John Martin Tipungwuti (b 1969) Tiwi 270 x 26 cm (diam.) © John Martin Tipungwuti; Leon Puruntatameri (b 1949) Tiwi 330 x 23 cm © Leon Puruntatameri; Pedro Wonaeamirri (b 1974) Tiwi 335 x 23 cm © Pedro Wonaeamirri; John Martin Tipungwuti (b 1969) Tiwi 321 x 26 cm © John Martin Tipungwuti; Patrick Freddy Puruntatameri (b 1973) Tiwi 334 x 29 cm © Patrick Freddy Puruntatameri; John Wilson Wuribudiwi (b 1955) Tiwi 335 x 25 cm © John Wilson Wuribudiwi. All artists licensed by Viscopy

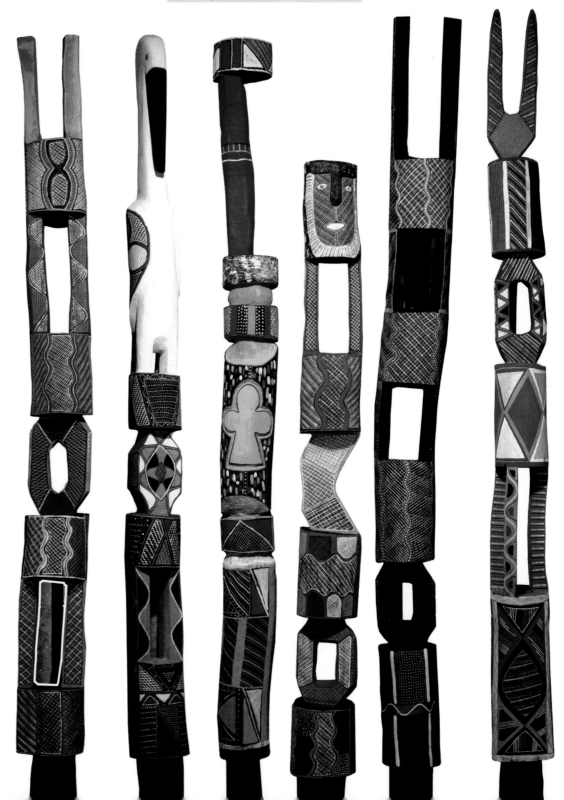

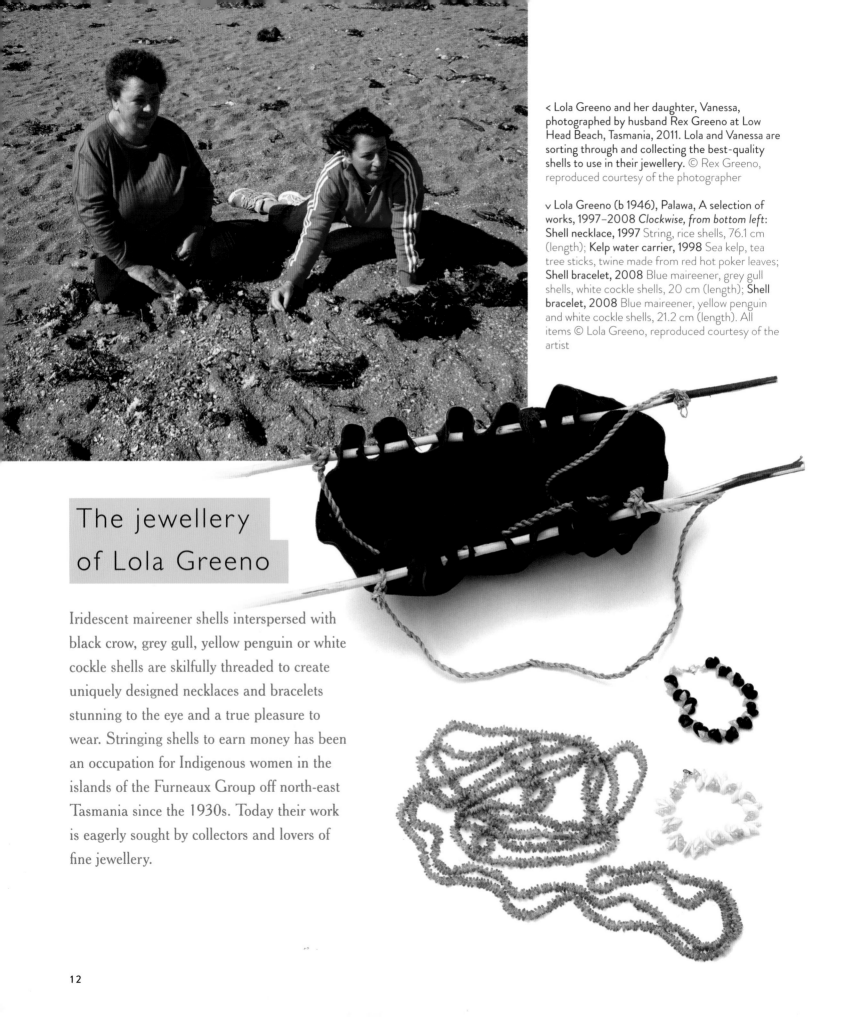

< Lola Greeno and her daughter, Vanessa, photographed by husband Rex Greeno at Low Head Beach, Tasmania, 2011. Lola and Vanessa are sorting through and collecting the best-quality shells to use in their jewellery. © Rex Greeno, reproduced courtesy of the photographer

v Lola Greeno (b 1946), Palawa, A selection of works, 1997–2008 *Clockwise, from bottom left*: **Shell necklace, 1997** String, rice shells, 76.1 cm (length); **Kelp water carrier, 1998** Sea kelp, tea tree sticks, twine made from red hot poker leaves; **Shell bracelet, 2008** Blue maireener, grey gull shells, white cockle shells, 20 cm (length); **Shell bracelet, 2008** Blue maireener, yellow penguin and white cockle shells, 21.2 cm (length). All items © Lola Greeno, reproduced courtesy of the artist

The jewellery of Lola Greeno

Iridescent maireener shells interspersed with black crow, grey gull, yellow penguin or white cockle shells are skilfully threaded to create uniquely designed necklaces and bracelets stunning to the eye and a true pleasure to wear. Stringing shells to earn money has been an occupation for Indigenous women in the islands of the Furneaux Group off north-east Tasmania since the 1930s. Today their work is eagerly sought by collectors and lovers of fine jewellery.

As one of Australia's most respected shell-jewellery makers, Lola Greeno has 20 years' experience in this art form. Born on Cape Barren Island, she lives and works in Launceston, Tasmania, and has achieved national recognition in Object and Craft Australia's Living Treasures award. She designs around the small differences of colours or shape in the shells, creating new patterns that are a hallmark of her beautiful work.

This jewellery-making knowledge is handed down from grandmothers, mothers and aunties. Traditionally, these delicate and delightful shell necklaces had ceremonial and cultural significance and, while this significance remains, Indigenous women now make them for other reasons as well, including as rite-of-passage gifts, cultural and personal heirlooms, souvenirs and wonderful works of art.

Lola collects the shells from the beaches or wades out into the knee-high sea water to find the iridescent, mesmerising maireener shells — which cling to living seaweed — during the spring tides. Shells are carefully gathered one by one, and it can take an hour or two of patient searching to yield a cupful of shells. It requires stamina, patience and a good eye to collect shells for stringing. Greeno washes the shells several times, dries, sorts and pierces them according to size. In traditional times, the shells were smoked over a wood fire to clean off the outer coating, then placed outside for flies and ants to remove the sea snails, and threaded onto kangaroo sinew. Today, the women use a sewing needle, beading and cotton thread.

The jewellery makers also collect tiny rice, cockle, crow and toothey shells from dried seaweed found along the beaches — all of which feature in Lola's works. Some of these shells may already have a natural hole in them, but generally the women carefully pierce them. Rice shells are so small and fragile they can be pierced with a needle. The effort involved in washing, cleaning, polishing, sizing and sorting each shell means that making a necklace or bracelet can take a long time — up to three or four days of repetitive work. Fingers need to be supple and nimble.

Some of these little shells are so tiny, like the little rice shells, they fit under your fingernail, but you probably wouldn't need a heavy tool to make a hole in that, you'd probably use a needle and thread them at the same time. Your fingers become really sore after a while. When I was doing one long one with lots of rice shells, I found that I could probably do 10 or 20 centimetres a day until my fingers were too sore.[4]

This water carrier (left), made from tough bull kelp, is another example of Indigenous craft specific to Tasmania. Making these seaweed containers is a tradition of the Indigenous people of the Furneaux Islands, and of the west coast of mainland Tasmania. The containers solved the problem of transporting small amounts of fresh water: the basket is made from kelp, and tea tree sticks are stuck through the kelp so the basket can be hung from tree branches without spilling. The kelp itself was cured to a leathery material over a smoky fire; burying it in hot sand then set it in the right shape. This kelp water carrier was also made by Lola Greeno, and is a fine example of a craft found nowhere else in Australia.

Lindsey Shaw

Lola Greeno, Shell bracelet (detail), 2008
Blue maireener, yellow penguin and white
cockle shells, 21.2 cm (length)

Marayarr Murrukundja, the welcoming of strangers

Welcome and friendship: it's what the Ganalbingu people of Arnhem Land, Northern Australia, offered Macassan sailors when they arrived each year, for centuries before European settlement. In 1994, John Bulun Bulun (1946–2010) – acclaimed artist, ceremonial leader and songman of the Ganalbingu people – made a series of 12 bark paintings and one canvas that visually represent a ceremony associated with the creation of Ganalbingu lands around the Arafura Swamp and the Macassan story, the Marayarr Murrukundja.

The Macassans' voyages were part of a major trade network centred on the port of Macassar (in present-day South Sulawesi, Indonesia) that stretched from Australia to the courts of Imperial China. They came to northern Australia to collect trepang (sea cucumbers) and trade with Indigenous populations. They had a great impact on Aboriginal communities around the coast and islands of Arnhem Land and the western Gulf of Carpentaria. The response varied. At some times and places the visitors were fiercely resisted; at others there was co-operation. Macassans are remembered in song and ceremony, and their visits and vessels are painted on rock walls and bark, and picked out in lines of stone on the ground.

For the Ganalbingu people, the Macassan times had a profound meaning that continues today. They remember welcoming the Macassans every year with the Marayarr Murrukundja ceremony. They offered friendship to the Macassans, explained who owned the land, how it was made, how to travel safely and what foods to eat. They mapped out for the Indonesians the local plant, land and seabed formations. Through the ceremony, the Macassans could claim a relationship to the Ganalbingu and their land.

In 1993, John Bulun Bulun and others performed the Marayarr Murrukundja ceremony in the Indonesian city of Ujung Pandang, celebrating hundreds of years of contact between his people and Macassan seafarers. Bulun Bulun completed this series of artworks – based on the body painting on the participants in the ceremony – on his return. He also painted the series to help people understand more about Aboriginal history.

During the ceremony, the dancers present a large pole – over three metres tall and decorated with string, feathers and cloth – to their hosts. The pole represents the mast of a Macassan prahu, rolling in rough seas as the participants tug a rope attached to the top of the pole while they dance and sing. When the dancers present the pole to their host group they break into mourning, expressing the sadness they felt when their Macassan friends departed at the end of each trepanging season.

Lindsey Shaw

Both works by John Bulun Bulun (1946–2010) Ganalbingu
> *Lunggurruma*, c1994 Ochres on eucalyptus bark, 90.5 x 26 cm
>> *Marayarr Murrukundja*, c1994 Ochres on eucalyptus bark, 92.6 x 35.3 cm Both works © Estate of the artist/Licensed by Viscopy

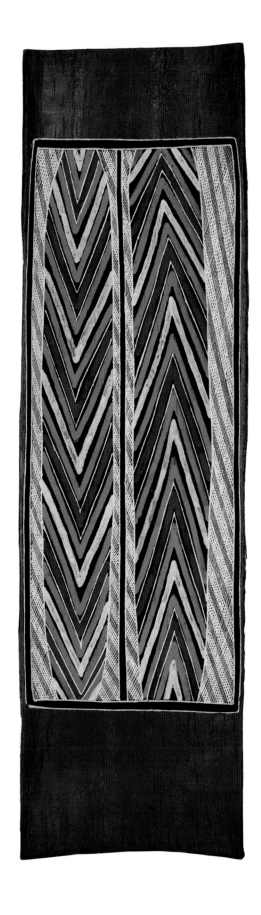
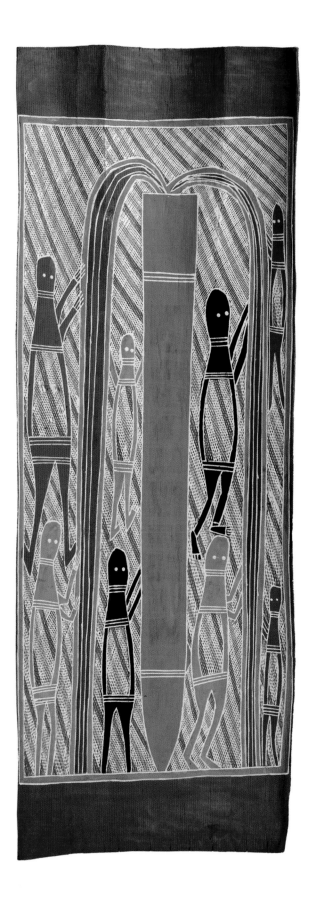

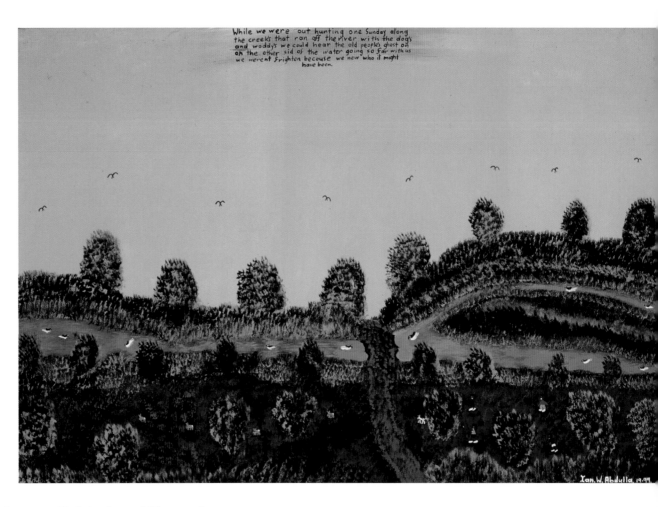

While we were out hunting one Sunday along the creeks that ran off the river with the dogs and woddys we could hear the old peoples ghost on on the other sid of the water going so far with us we werent frighten becouse we new who it might have been.

Ian. W. Abdulla 1999

Stories from the Murray River

Frogs croaking, a pending thunderstorm, kids laughing by the water – Indigenous artist Ian Abdulla's paintings overflow with abundant memories of his life in South Australia's Murray River region in Ngarrindjeri country. Depicting the country between Cobdogla and Katarapko where the river is surrounded by swamp, Ian has painted this family activity of collecting swans' eggs. Some are cooked and eaten fresh on the shoreline, while the others are safely packed for the journey home.

Ian Abdulla was born in Swan Reach, South Australia, in 1947. His family, like other Indigenous people along the Murray River, used their traditional skills and knowledge as much as possible to survive away from the mission and the (then) government's policy of assimilation into white communities.

During his youth there were few permanent employment opportunities – as a boy he picked tomatoes, grapes, apricots and oranges, and drove trucks, tractors and bulldozers on local properties. After 10 years on the Gerard Mission, near Loxton in South Australia, he went to Adelaide for two years, before returning to the Murray to work with the National Parks and Wildlife Service.

In 1988 he completed a course in silk-screen printing, then began painting the following year. He was named South Australian Aboriginal Artist of the Year in 1991. Many of his paintings relate to a 30-kilometre stretch of the Murray River between Cobdogla and Katarapko, where swamps, vineyards and orchards dominate the landscape. Ian depicts significant events from his life along the river: historical highlights and family memories.

He writes on his works – the text sits at the top of the painting, seemingly floating in the sky, telling a simple yet compelling story:

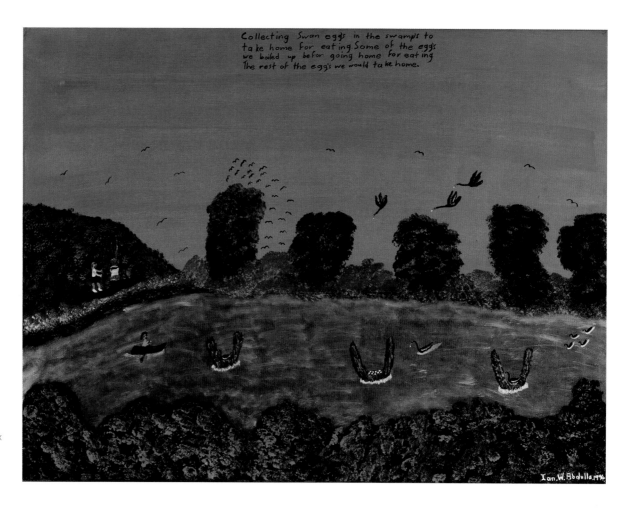

Collecting Swan egg's in the swamp's to take home for eating. Some of the egg's we boiled up befor going home for eating The rest of the egg's we would take home.

< Ian W Abdulla (1947–2011) Ngarrindjeri, *Untitled* [Hearing ghosts while hunting along the creek], 1999 Acrylic on canvas, 122 x 183 cm © Estate of the artist/Licensed by Viscopy

> Ian W Abdulla Ngarrindjeri, *Untitled* [Collecting swan eggs in the swamps], 1994 Acrylic on canvas, 76 x 101.5 cm © Estate of the artist/Licensed by Viscopy

'Collecting swan egg's in the swamp's to take home for eating. Some of the egg's we boiled up befor going home for eating. The rest of the egg's we would take home.'

The museum's collection contains six of Ian Abdulla's paintings. They are big, bold and colourful, depicting the hardships of Indigenous peoples living along the river, and telling childhood stories from the time Abdulla's family lived at the Gerard Mission. In them people fish for pondi (Murray cod) and pilarki (callop, golden perch, yellow belly), catch yabbies and frogs and collect swans' eggs.

These works are full of love for family and for the great Murray River – recording the fish, frogs, storms, ghosts, mudslides and friendships of childhood. He also affirms the culture of rural Aboriginal people, and their determination to stay in their country and to share – especially with the younger generations – their histories and knowledge about people, place and the life of the waterways.

The Murray–Darling Basin is Australia's largest river system, food bowl and inland water-transport corridor. Its waterways have been contested for generations, and now, threatened by salination and erosion, infested by carp and algae and depleted by weirs and dams, the Murray flows wearily. Ian Abdulla's paintings give an insight into how the Murray River once was, and how it could be again. Ian Abdulla died on 29 January 2011.

Lindsey Shaw

A bountiful catch

In a Dreaming story of the Wik-Mungkan people of Cape York Peninsula, Walkalan the bonefish lived as a man at Adeda (a small creek up the Archer River) with his brothers the ironwood and bloodwood trees.

Walkalan went north to visit his sister, Mai Kurp, the mangrove. He demanded she cook his catch of fish, and when she refused they quarrelled. He threatened to spear her, so she struck him on the back with her yam stick. The mark she left can still be seen today on the bonefish.

In revenge, Walkalan hit her on the head with his spear. Mortally wounded, they made peace. Mai Kurp lay down on the bank where the mangroves now grow in the lower reaches of the Archer River, where Wik-Mungkan women gather the mangroves' seed pods. Walkalan returned to his brothers at Adeda. As he said goodbye to them and disappeared back into the water, he promised that there would always be abundant bonefish for men to spear for food in this place. It became a breeding site for bonefish. When men go hunting at this Auwa, or sacred site, they beat the ironwood and bloodwood trees to encourage the fish to emerge from their hiding spot.

In 1988 the museum acquired the sculpture *Fish on Poles* by Indigenous artist Arthur Koo'ekka Pambegan Jr of the Wik-Mungkan language group. Pambegan lived at Aurukun, located on the Archer River. In the 1990s the Wik people, comprising a number of clans of the western Cape York Peninsula, Queensland, became well known for their historic native title claim.

Fish on Poles shows a plentiful catch of bonefish – representing Walkalan the bonefish, an important Ancestral Being in the Aurukun community's economy, traditions and ceremonies. Arthur Koo'ekka Pambegan Jr was a senior member of the Winchanam ceremonial group, and sculptures such as this play a central role in the group's ceremonial dances, which tell of bonefish being hunted at night by spear fishermen in canoes, and re-enact the events that occurred at the sacred site described in the story of Walkalan.

Fish on Poles is made from milkwood and ochres. In the ceremony, the bonefish ancestor emerges from a bloodwood tree, covered with red ochre and riddled with spears – it takes several to kill a bonefish. The fish are painted in broad areas of brown, black and white ochres, similar to ceremonial body paint worn by the dancers.

Pambegan worked alongside his father, creating a number of sculptures. The bonefish and Ancestor Beings from other local stories, such as the flying fox, were recurrent themes in his work. Before he passed away in 2010, Arthur Koo'ekka Pambegan Jr taught these traditions, knowledge and skills to his own son, Alair Pambegan.

Veronica Kooyman

Arthur Koo'ekka Pambegan Jr (1936–2010), Wik-Mungkan *Fish on Poles*, 1988 Natural pigment, milkwood (galor), fibre, dimensions variable © Estate of the artist, reproduced with permission

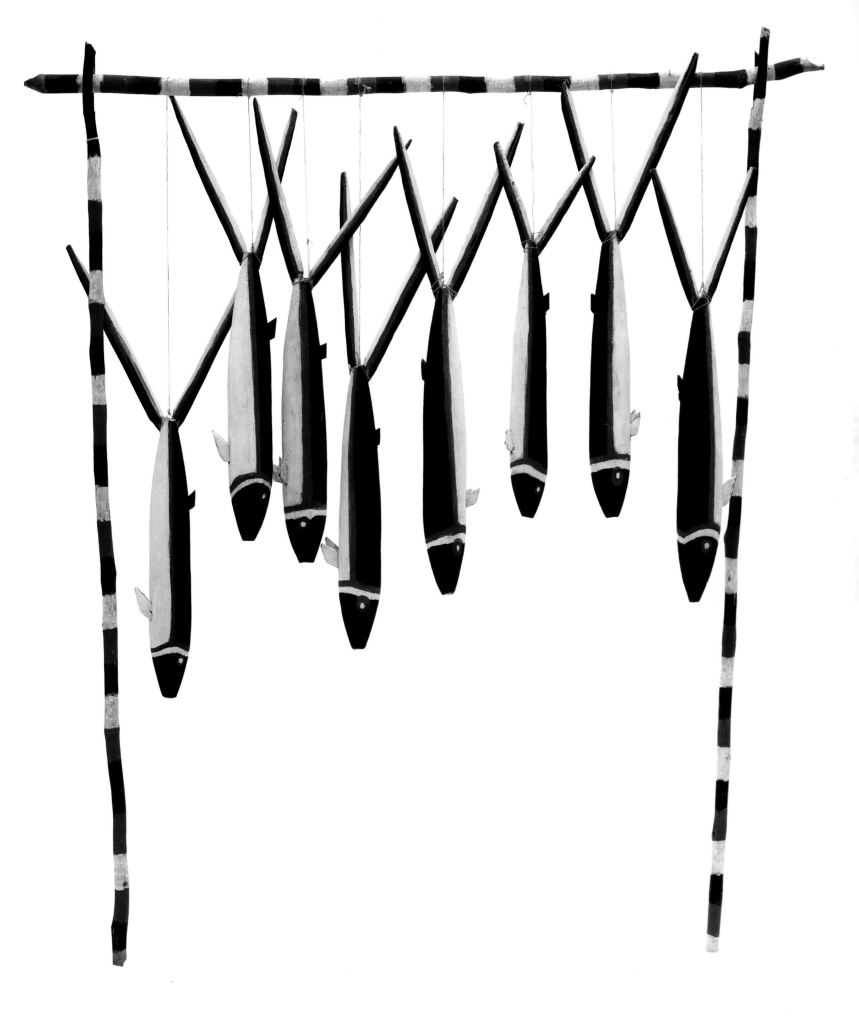

Dances and stories from the Torres Strait

One of Australia's most senior and inventive Torres Strait Islander artists, Ken Thaiday Snr, constructs extraordinary 'dance machines' – this one (at right) is a trevally. Born on Erub (Darnley) Island in the outer Torres Strait, he moved with his family first to Thursday Island and then to Cairns for more work and schooling opportunities. But his island beginnings and culture are important aspects in his life – dances and stories he learned from his father and grandfather. 'Dancing is very important to me because of my father. He was a very good dancer, so this is why I dance, to carry on my culture, to stand in his footsteps as my sons will do for me.'[5]

Language and dance are important cultural markers for people of the Torres Strait – a bold, vibrant culture living between two great landmasses and straddling the waterway that links the Pacific and Indian oceans. Proficiency in both is highly regarded, but dance is the most visible and exciting expression of islander culture. The deep cultural connections Aboriginal and Torres Strait Islander people have with the land and the sea are kept alive through storytelling, art, music and dance. From time immemorial, the seasons have been marked by sightings of specific animals and birds, and changes in vegetation, tides, rains and the constellations. This complex knowledge is passed to succeeding generations, and each island and each clan has its own distinctive performances.

Charles Warusam (1949–2008), lived and worked Saibai Island. Items from a Waia family adult male war dance costume, 1997 *Clockwise, from bottom left*: **Ankleband** Plant fibre, string, 6.5 x 20 x 2 cm; **Headdress** Cassowary feathers, leather, wood, paint, reeds, string, 51 x 78 x 7 cm; **Armband** Cassowary feathers, wood, reeds, string, 13.5 x 30 x 9.5 cm; **Shell necklace** Plant fibre, string, seeds, mother of pearl, 55 x 10 x 6 cm; All items © Estate of the artist

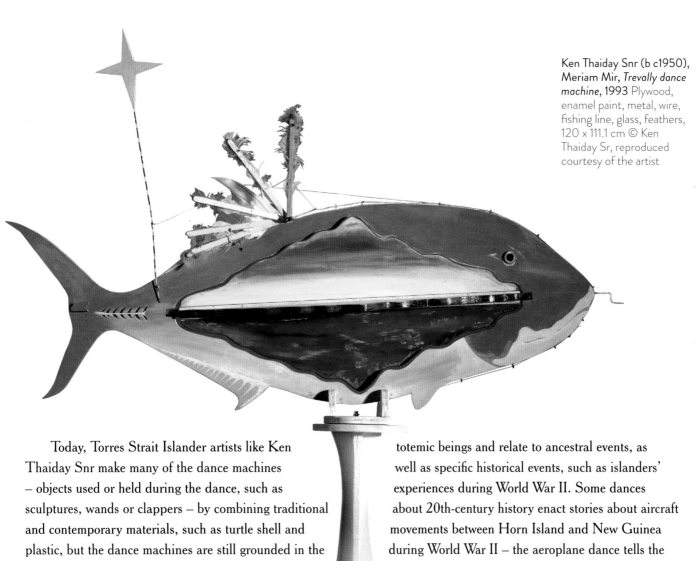

Today, Torres Strait Islander artists like Ken Thaiday Snr make many of the dance machines – objects used or held during the dance, such as sculptures, wands or clappers – by combining traditional and contemporary materials, such as turtle shell and plastic, but the dance machines are still grounded in the artists' traditional expression of ancestral and cultural history and law. Probably the most recognised dance accessory is the dari or dhoeri (headdress). The Torres Strait Islander flag features a white dari with a five-pointed star beneath it, representing the five Torres Strait groups and the importance of stars for this seafaring people. The beat of the warup (drum) resembles thunder, and usually orchestrates the moves at dance ceremonies.

Headdresses are central to the art, theatre and dance of the Torres Strait. Many of the headdresses, masks, body ornaments, dance machines and dance accessories are decorated with, or represent, totemic beings and relate to ancestral events, as well as specific historical events, such as islanders' experiences during World War II. Some dances about 20th-century history enact stories about aircraft movements between Horn Island and New Guinea during World War II – the aeroplane dance tells the story of the flights of Allied aircraft over the Torres Strait, with the dancers moving in 'V' formations. Other dances tell about islander migration in the 1960s.

These accessories (at left) made by Charles Warusam are for a male dancer, and come from Saibai Island (northern Torres Strait). They would have been worn in a traditional war dance – Saibai Islanders are proud of their warrior past.

Dances and storytelling reflect Torres Strait Island peoples' relationships to each other and their pride and joy in their shared identity.

Lindsey Shaw

Fire-breathing fish

With flames shooting from its mouth, *Faga Ofe E'a 1* brings the power and resilience of traditional Polynesian culture to life. Michel Tuffery – of Samoan, Cook Islands and Tahitian heritage – created this dynamic aluminium stylised yellowfin tuna in 1998, for a ceremony that included an act of appeasement to the gods for the seasonal harvest of coral worms.

Faga Ofe E'a 1 is made from aluminium tins – of fish and beef – flattened and joined together with dozens of rivets. The fish breathes fire due to an internal gas tube that spews flames when lit. This kinetic marine creature is full of vitality, and allows Tuffery to explore the traditions of the Pacific region in a contemporary and seriously energetic way. He uses food cans to highlight both how the introduction of imported food items has become part of traditional island life, and how using canned fish has become necessary due to overfishing in the Pacific.

Tuffery's sculptural artworks all have a secondary function, as he choreographs them into his performance artworks. This work was central to a fiery performance of oceanic dancing and drumming that evoked the teachings of the mythological Tangaroa, the Polynesian god of the ocean and sea creatures. This sea-god features in many Pacific mythologies, and everyone gives him due respect when fishing or sailing on the sea. In Maori culture, when people go to sea to fish or to travel, they are representatives of the god Tane (the god of forests, and brother to Tangaroa), who is also Tangaroa's enemy. Because Tangaroa often took pleasure in sinking canoes, flooding the land and eating up the shoreline, it was important to make offerings to him before setting out, in the hope that he would allow safe passage. *Faga Ofe E'a 1* shows how traditional Pacific beliefs remain part of the contemporary culture of the Polynesian peoples of Oceania, and also draws upon the importance of food and feasting in Pacific societies.

Collaboration is a key to the success of Tuffery's performances, and he especially works with young people and South Sea Islanders, teaching them artistic techniques that allow their self-expression to emerge. In particular, he teaches how to use readily available materials – debris, flotsam and jetsam, recyclable packaging and natural fibres – to create and represent the rich current of urban and island history so interconnected with the old traditions.

Michel Tuffery is based in New Zealand. His art focuses on the conservation of the environment and is shaped by his Pacific ancestry. His works encourage discussion about universal issues: environmental damage, the changes in lifestyles of Pacific islanders and the long-term impact of colonisation on Indigenous cultures.

In Samoa, faga'ofe are homemade bamboo cannons which, when fuelled and fired up, shoot out flames and emit very loud bangs – and the black soot marks on this sculpture prove that it is indeed a fire-breathing fish!

Lindsey Shaw

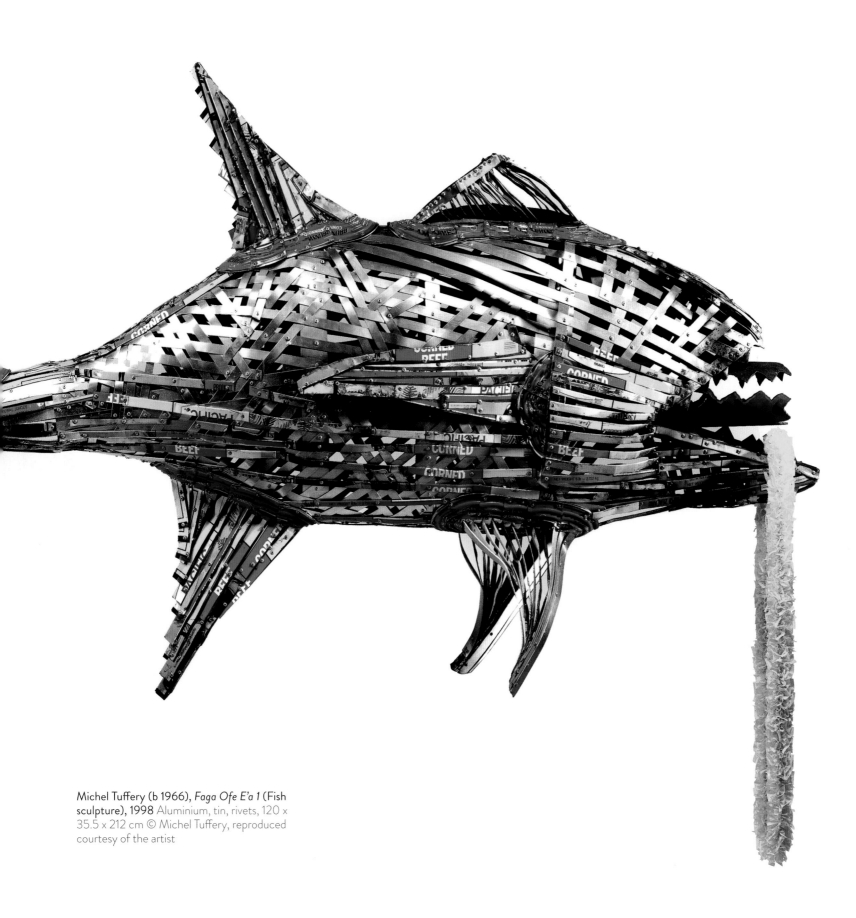

Michel Tuffery (b 1966), *Faga Ofe E'a 1* (Fish sculpture), 1998 Aluminium, tin, rivets, 120 x 35.5 x 212 cm © Michel Tuffery, reproduced courtesy of the artist

2 EXPLORERS AND SETTLERS

When the influential Admiral Antoine de Bougainville completed France's first circumnavigation of the world in 1769, he wrote glowingly of the vast and remote Pacific, urging his government to send expeditions quickly to explore the ocean and report on strategic possibilities. The advice was accepted, but the next major voyage into the Pacific was mounted by rival superpower Great Britain, and commanded by one of the Royal Navy's rising stars, Lieutenant James Cook.

Britain had seized the initiative. In three voyages (1768–79), this one English mariner changed Europe's view of the world, filling in many islands of the Pacific, circumnavigating New Zealand and exploring the east coast of Australia, much of the west coast of North America, and Antarctica. Cook claimed the whole of the east coast of Australia for George III, which led to Britain striking a settlement at Sydney Cove in 1788 – a decisive move in the two-nation race for territorial advantage in the Pacific.

In just 20 years, the Australian National Maritime Museum has secured many significant links with this period of exploration and settlement. The historically accurate replica of Cook's HM Bark *Endeavour* gives visitors a chance to experience living and working conditions on the navigator's first voyage. From *Endeavour*'s passage along Australia's east coast, there's ballast recovered from the seabed, where it was jettisoned by Cook when *Endeavour* became lodged on the Barrier Reef. From Cook's second voyage, there's a unique collection of Polynesian weapons collected by Tobias Furneaux, Commander of HMS *Adventure*.

There are also links with France's Pacific expeditions. These include Gustave Alaux's large 20th-century painting *Bougainville at Tahiti*, a romantic view of the French admiral's arrival in 1768; and the three subsequent voyage accounts of La Pérouse, D'Entrecasteaux and Baudin.

Australia's earlier European visitors – the Dutch, on the west coast – saw no reason to settle in New Holland. Committed traders, they sought substantial profits from spices and other commodities in the East Indies. Early in the 17th century, their navigators determined that the quickest sea route from the Cape of Good Hope (South Africa) to Batavia involved sailing eastwards across the southern Indian Ocean then north along the western coast of New Holland.

Several of their ships, however, came too close to these inhospitable shores, and at least four were wrecked. The first of these, the Dutch East India Company flagship *Batavia*, ran onto a reef in the Abrolhos Islands in 1629. The story of mutiny and murder that unfolded on the islands is one of the dark episodes of Australia's maritime history. Recording this, the museum holds an original copy of Commander François Pelsaert's account of the voyage, as well as a number of artefacts salvaged from the wreck site after its discovery in the 1960s. Under an agreement between the Australian and Dutch governments, the museum is also responsible for an important collection of artefacts recovered from *Vergulde Draeck* (1656), *Zuytdorp* (1712) and *Zeewijk* (1727), three other Dutch ships wrecked off the Western Australian coast.

Bill Richards

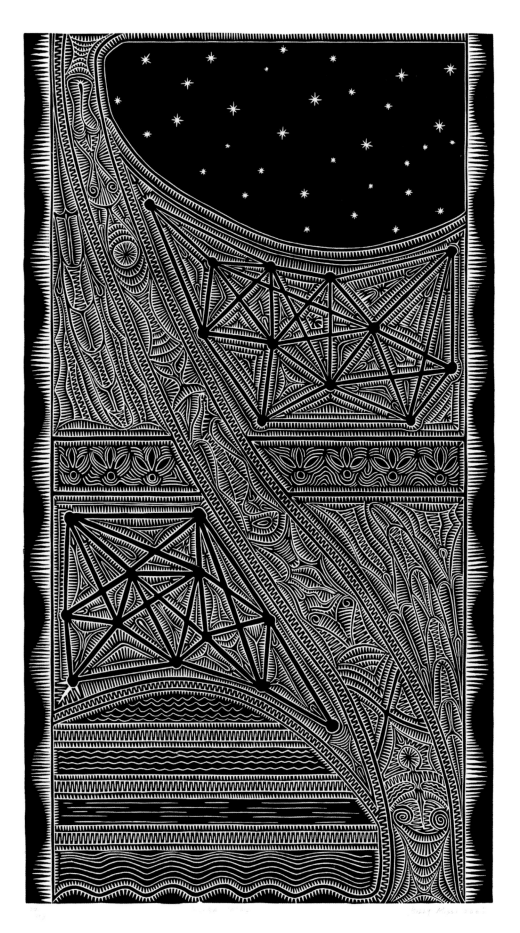

Billy Missi (b 1970), *Kulba Yadail (Old Lyrics)*, 2006. This linocut shows the significance of constellations and seasons in orienting everyday life in the Torres Strait Islands' land and maritime environments. This complex cultural knowledge predates European records of the southern skies. Linocut, 84.5 x 47.5 cm © Billy Missi. Image courtesy of the artist and KickArts Contemporary Arts

Sailing beneath the Southern Cross

Hand on hip and attired in all the trappings of success, Willem de Vlamingh stares out of the canvas and across the centuries, a man supremely poised in his accomplishments. As well he might be – de Vlamingh was employed by the immensely rich and powerful Dutch East India Company and was about to set off on his second voyage to the East.

Founded in 1602, the Dutch East India Company, or Vereenigde Oost-Indische Compagnie (VOC), extracted enormous wealth from its operations in South-East Asia, regularly sending ships and men on the long passage between Europe and Asia. Many mariners died, but for those who survived disease and storms, the rewards were great. Rich in symbolism, this painting shows Willem de Vlamingh against an exotic backdrop, the instruments of his profession at hand. Plainly recognisable among them is a celestial globe.

Like business today, the directors of the Dutch East India Company wanted to minimise risk to their investment. They imposed strict orders on their skippers to sail along proven 'safe' routes, and issued uniform sets of navigation instruments and charts to ships heading to Asia. In an age when determining a ship's position at sea was fraught with uncertainties, knowledge of the stars was a practical aid to navigators, and the most convenient tool for showing the stars was a celestial globe.

In theory, a navigator could verify his general position by comparing the stars above him with the stars predicted for that position by the celestial globe. Any discrepancy alerted him to a problem. Unfortunately, however,

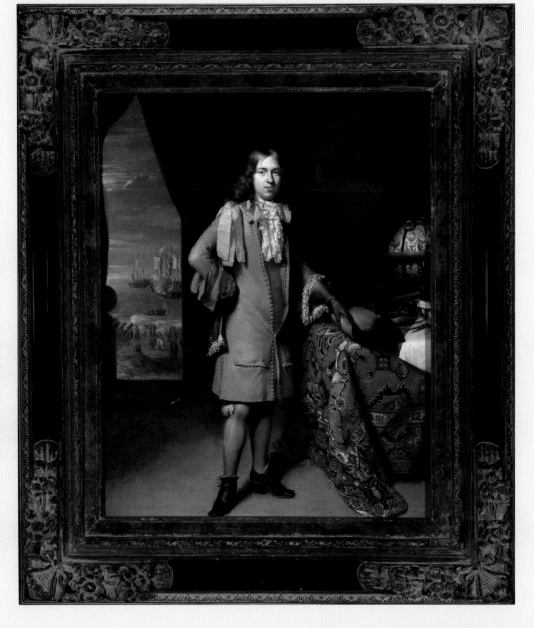

Jan Verkolje (1650–1693) and Nicholas Verkolje (1673–1746) (attrib), Portrait of a Dutch navigator [believed to be Willem de Vlamingh], c1690 Oil on canvas, 62.5 x 50 cm

while a lot was known about the stars visible in the northern hemisphere, much less was known about those in the southern. Also, the renaissance of astronomical knowledge was still in its infancy in the early 17th century.

This important celestial globe (below), made in 1602 by renowned Dutch cartographer Willem Blaeu, features one of the earliest depictions of the Southern Cross. Blaeu studied in Denmark in 1595 under the astronomer Tycho Brahe, who was then working on the first updated star catalogue since ancient times. At about the same time, the first Dutch voyage – under Frederik de Houtman – returned from Asia, bringing information about the Southern Cross. Blaeu's celestial globe reflects both these astronomical advances. In time, Willem Blaeu became the principal map-maker to the Dutch East India Company, a business his sons carried on after his death.

And what of Willem de Vlamingh? In 1696 he was put in charge of the last great Dutch expedition to New Holland, searching for the *Ridderschap van Holland*, a large VOC ship that had disappeared on a voyage to Asia two years earlier. After searching the Southern Ocean without success, de Vlamingh reached the west coast of Australia at a point where Fremantle now stands. In searching the area, de Vlamingh's men became the first Europeans to explore the Swan River, where they were amazed to find black swans.

From there they continued northward to Shark Bay where, on a prominent headland, de Vlamingh found an engraved pewter plate that Dutch skipper Dirk Hartog had left there 80 years earlier. This important discovery underlined Dutch precedence on the coast, and de Vlamingh took it with him when he sailed away, after leaving a new one in its place.

Willem de Vlamingh found no trace of the missing ship, nor anything to recommend New Holland from a mercantile viewpoint. Indeed, his expedition report was so disparaging of the country that the Dutch East India Company showed little further interest in New Holland. He returned to Holland in 1698 and probably retired from the VOC, for his name then disappears from the company records.

The Blaeu celestial globe and de Vlamingh painting reflect aspects of the Dutch connection to Australia spanning more than 400 years. Other poignant evidence of this long association exists in the hundreds of artefacts recovered from the wrecks of the VOC ships *Batavia, Vergulde Draeck, Zuytdorp* and *Zeewijk*, which left their bones on the coast of New Holland.

Nigel Erskine

Willem Janszoon Blaeu
(1571–1638), The Blaeu celestial
globe, 1602 Brass, wood, 33.4 x
23 cm (height x diam.)

Long-lost Dutch treasures

In 1963 something akin to gold fever consumed divers in Western Australia when, after more than 300 years lying forgotten on the seabed, the wreck remains of the Dutch East India Company ships *Batavia* and *Vergulde Draeck* were discovered in the same year. Both had been heavily laden with trading goods when lost, and the first divers to the *Batavia* wreck site found bronze cannons and large parts of the timber hull still preserved beneath the waves, while at the *Vergulde Draeck* site, one of the first discoveries was an elephant tusk. These caused a sensation among treasure hunters and historians alike, as each group battled to secure access to the wrecks. But to understand why these ships were sailing off the coast of Australia, we need to go further back in time.

From about 200 BC, a glistening trail of exotic products stretching between Asia and the Mediterranean had excited the dreams of emperors and traders alike. But when Portugal's Vasco da Gama arrived in Calicut in 1498 – becoming the first European to discover a sea route to India – he changed the dynamics of Asian trade completely. Portugal controlled this trade for 100 years, but by the beginning of the 16th century Holland and England were poised to challenge its monopoly. And part of the Dutch story of trade to Asia is intrinsically associated with the Dutch ships wrecked on the coast of Western Australia and the thousands of objects recovered from them, which now form the ANCODS[1] collection.

In 1602 the Dutch government established a chartered company, the Vereenigde Oost-Indische Compagnie (VOC) – the Dutch East India Company. The VOC ships at first followed the Portuguese route to Asia, until they pioneered a new and much faster route across the Southern Ocean, known as the Brouwer Route, in 1611. Swept along by strong westerly winds, a ship would come close to the west coast of New Holland (Australia) before turning north to the island of Java. These shorter voyages diminished the impact of diseases such as scurvy but, as the volume of Dutch shipping increased rapidly throughout the 17th and 18th centuries, it was almost inevitable that some ships would be wrecked on the coast of Western Australia. In 1629, the *Batavia*, carrying more than 300 passengers and crew, became the first to be lost on the coast when it struck a reef in the Abrolhos Islands. Most of the *Batavia*'s people survived the wreck, but in the ensuing weeks many were massacred as starvation and bloody chaos descended on the islands. Law and order were restored with the return of a rescue ship, but over the next century at least three more VOC ships (*Vergulde Draeck*, *Zuytdorp* and *Zeewijk*) were wrecked on the same coast. The legacy of these four wrecks has been enormous.

Mortar, pre-1656 Bronze, 12 cm overall, from the wreck site of the *Vergulde Draeck* Transferred from Australian Netherlands Committee on Old Dutch Shipwrecks

Realising the historical significance of the discoveries, the Western Australian Government soon passed laws protecting the sites from unauthorised interference. However, when this state legislation was challenged in the courts and it looked as though salvors would be given rights to the wrecks, the Commonwealth Government stepped in, enacting even stronger laws protecting shipwreck sites in all Australian waters. The Dutch Government was also intent on protecting these important sites and, in 1972, the governments of Australia and the Netherlands signed an agreement concerning old Dutch shipwrecks and established a committee to guide the preservation and interpretation of archaeological material raised from these wrecks. Today the ANCODS collection is recognised as a national treasure, opening an extraordinary window to the past.

Nigel Erskine

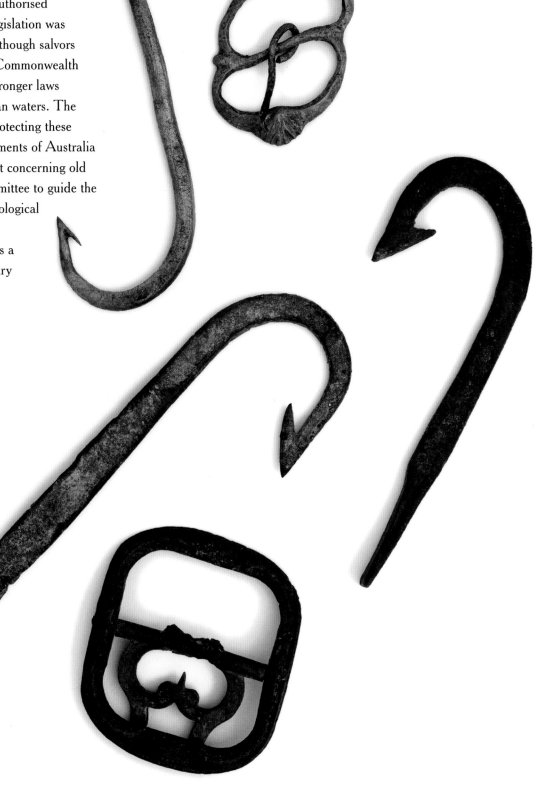

Items recovered from the wreck sites of the *Vergulde Draeck*, *Batavia* and *Zeewijk*, *clockwise from top left*: Fish hook, pre-1656 Brass, 7.2 x 5.3 cm, from the wreck site of the *Vergulde Draeck*; Buckle, pre-1629 Brass, 3.7 x 3.9 cm, from the wreck site of the *Batavia*; Fish hook, pre-1727 Metal, 8.7 x 3.2 cm, from the wreck site of the *Zeewijk*; Buckle with chape, pre-1727 Copper, 4 x 4.5 cm, from the wreck site of the *Zeewijk*; Fish hook, pre-1727 Metal, 9.4 x 3.4 cm, from the wreck site of the *Zeewijk*; All: Transferred from Australian Netherlands Committee on Old Dutch Shipwrecks

Mutiny, murder and mayhem

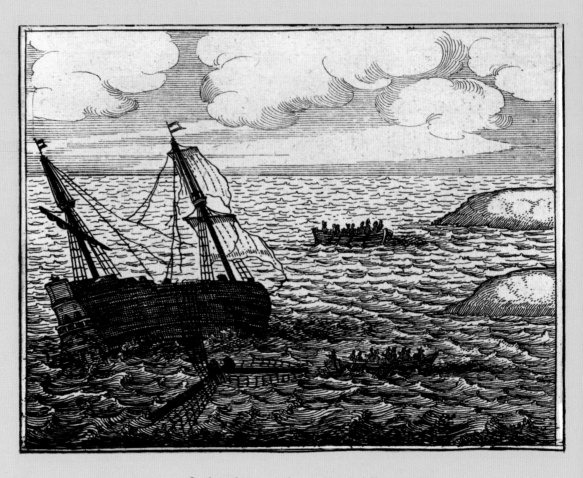

Imagine the scene of chaos. In the darkness of 4 June 1629, tracking way off course, the Dutch East India Company's ship *Batavia* has run aground off the west coast of New Holland. The great ship rolls heavily, shuddering violently as each wave lifts and then drops the hull onto the reef. The darkness is full of shouting and the rumble of breaking waves. Passengers fill the deck, hampering the crew as they fight to cut away the mainmast and launch the boats. The dawn light reveals surf breaking on a low rocky island off to starboard.

The wreck of the *Batavia*,
1629 Engraving, 7.5 x 11 cm

Such is the scene that confronted François Pelsaert, commander of the *Batavia*. The situation demanded decisive action, but Pelsaert dithered, and by the time he decided to abandon the ship most of the water and supplies had been lost. As a result, those who made it through the surf to shore found themselves stranded with almost no supplies. Two of the *Batavia*'s boats had survived, but finding no water on the Abrolhos Islands, where the wreck occurred, Commander Pelsaert sailed off toward the mainland in search of water. It was the last time many of the marooned survivors saw him – by the time he returned four months later, most of them were dead.

Driven far to the north, Pelsaert decided to sail almost 3,000 kilometres directly to the city of Batavia (now Jakarta) in Java, leaving the survivors to their own devices. The commander's departure created a vacuum soon filled by Jeronimus Cornelisz, a minor official who had his own simple

plan for survival. Enlisting a band of roughnecks, Cornelisz planned to murder most of the other survivors to ensure food and water for himself and his men. In a piratical pact, Cornelisz bound his followers to support him, and in the weeks that followed they butchered more than 100 people in an orgy of violence. Cornelisz's plan would have worked but for the integrity of a soldier named Wiebbe Hayes.

In the days after the wrecking, Hayes and a group of men had gone looking for water, and found it on a nearby island. Hearing of the massacre taking place on Cornelisz's island, Hayes and his men armed themselves and prepared for an attack, which came soon enough. The opposing sides were closely matched but the stalemate was finally broken when Cornelisz was captured while leading an attack.

With the remaining pirates regrouping to attack again, either side may have won the battle – but at this critical point the rescue ship *Sardam* appeared, bringing Pelsaert back from Batavia. Faced by the inevitable, Cornelisz's men surrendered.

Under torture Cornelisz confessed that he was part of a group that had plotted to seize the *Batavia* and lead a life of piracy, but that the wreck had forced a change in plans. Anticipating that a search party would eventually arrive, the mutineers planned instead to overpower their rescuers, steal their ship and take to the sea as pirates. Lucky to have survived this plot, Pelsaert ordered the immediate execution of Cornelisz and his supporters. With their bodies hanging from a makeshift gallows, justice was concluded and, after gathering the remaining 150-odd survivors and as much of the *Batavia*'s cargo as possible, Pelsaert sailed away.

The *Batavia* story had the hallmarks of a bestseller and indeed became one when Pelsaert's account was published. The museum's collection includes a 1647 version of his account, with engravings that catalogue in gruesome detail the atrocities inflicted on the *Batavia* victims, ensuring that we never forget this extraordinary episode.

Nigel Erskine

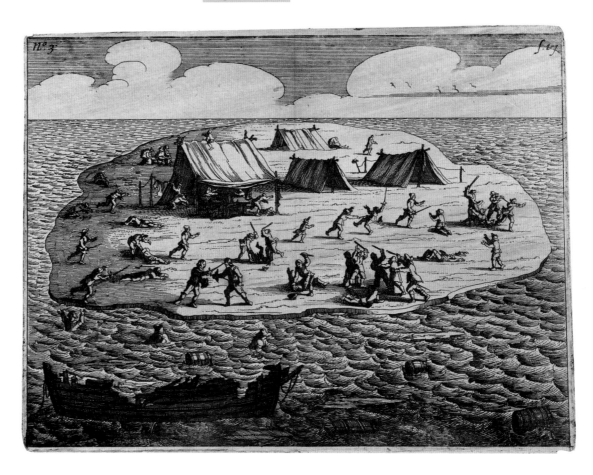

Massacre in the Abrolhos Islands. Engraving, 13.7 x 18.1 cm (sheet) Images from *Ongeluckige Voyagie, van't Schip* Batavia, *nae de Oost-Indien (Unlucky Voyage of the Ship* Batavia *to the East Indies)*, an anonymous compilation based on the official account of François Pelsaert, commander of the *Batavia*, published by Jan Jansz, Amsterdam, 1647

His Majesty's Bark
Endeavour

This highly acclaimed replica of the best-known ship in Australia's history is a wide-ranging ambassador for the museum. At sea she offers adventurous passengers the unique experience of 18th-century seafaring, from learning the ropes and working aloft to 'tricks' at the helm and rocking to sleep in hammocks. In ports around the nation the ship becomes a museum, authentically fitted out from her wood-burning iron galley stove and mess deck to the Great Cabin where officers and scientists lived and worked. To visitors it looks as though those famous figures from our past have just stepped out for a moment.

They include Lieutenant James Cook RN and botanist Joseph Banks, who sailed *Endeavour* from England to Tahiti in 1769 to observe the transit of Venus across the face of the sun. This helped astronomers to calculate the sun's distance from the earth. Cook then searched for a missing southern continent, circumnavigated New Zealand and charted the unknown east coast of Australia, claiming it in the name of King George III. *Endeavour*'s 1769–71 circumnavigation led directly to plans for Britain to establish the colony of New South Wales, which it did in 1788. And it sealed Cook's reputation as one of the greatest navigators ever.

More than two centuries later, the museum's replica of this great ship of discovery has a remarkable dual existence – an authentic example of human-powered, 18th-century technology that also ensures modern standards of health and safety for her crew and passengers. The secret lies in her '20th-century deck', hidden in the lower hold that would once have stored ballast, spare sails, ropes and casks of food and water. Here we find a modern engine room, galley, refrigeration, showers, toilets and laundry. Discreetly,

21st-century electronics enable safe navigation and link the ship to mobile and internet networks, extending the voyage experience to online followers worldwide.

In 1987, when the new Australian National Maritime Museum was still four years from opening to the public, its Interim Council proposed the building of this full-scale, museum-quality replica. The high-profile Bond Corporation, owned by America's Cup-winning yachtsman Alan Bond, began the project in Western Australia. It was to be his corporate gift to the nation to celebrate the 1988 Bicentennial of British settlement.

Intensive research and the survival of detailed British Admiralty records from the 1760s provided a confident template. The ship's construction, while traditional, pioneered several problem-solving techniques. For example, laminated Western Australian hardwood was used to fabricate some of the huge ship's timbers, since sufficient quantities of European oak were no longer available. Highly accurate sails and rigging incorporated some synthetic materials for durability.

Financial difficulties forced the Bond Corporation to withdraw, but a dedicated band of staff and volunteers completed the ship with donations from corporate supporters and the Australian and NSW governments. A charitable trust, the HM Bark *Endeavour* Foundation, was formed and the vessel was launched on 9 December 1993. Over the next 12 years, the foundation's ambitious management sent her twice around the globe. Under a core professional crew, she carried thousands of passengers who paid to experience 18th-century square-rigger sailing on ocean passages, while hundreds of thousands visited the ship in ports all around the world.

The Australian National Maritime Museum assumed management of the ship on 17 April 2005 when the foundation handed the replica over to the Australian Government and disbanded. The government has given the museum additional funding for the ship to be maintained, displayed and kept in sailing survey. Under museum

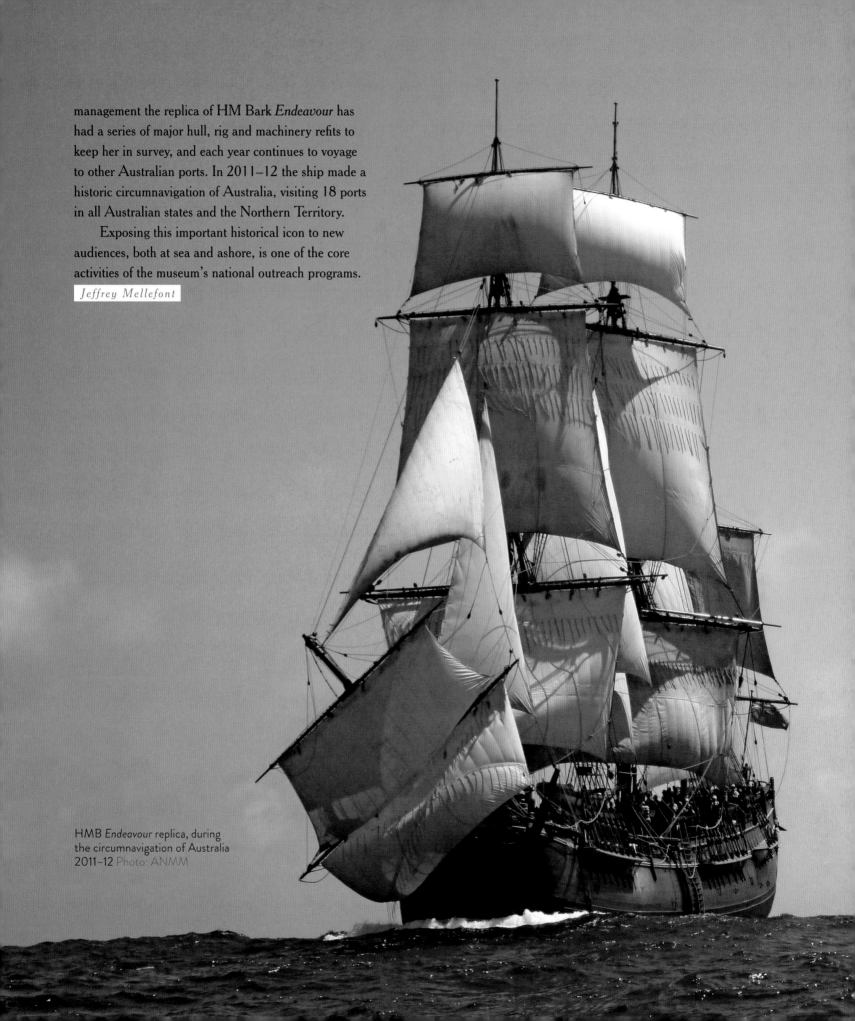

management the replica of HM Bark *Endeavour* has had a series of major hull, rig and machinery refits to keep her in survey, and each year continues to voyage to other Australian ports. In 2011–12 the ship made a historic circumnavigation of Australia, visiting 18 ports in all Australian states and the Northern Territory.

Exposing this important historical icon to new audiences, both at sea and ashore, is one of the core activities of the museum's national outreach programs.

Jeffrey Mellefont

HMB *Endeavour* replica, during the circumnavigation of Australia 2011–12 Photo: ANMM

James Cook remembered

When in June 1770 the *Endeavour* struck a reef off the north-east coast of Australia (near present-day Cooktown), the history of the country could have turned out very differently. Firmly stuck on the reef, Cook ordered the vessel to be lightened in the hope it would float free with the high tide. About 50 tons of material were thrown overboard and the plan worked, but *Endeavour* left an anchor, six cannons and a large amount of iron and stone ballast behind.

In 1969 an expedition from the Academy of Natural Sciences, Philadelphia, relocated the site and recovered much of this material. Thirty-eight iron ballast blocks, ballast stones and other recovered items are now held by the museum within its collection of several iconic objects associated with Cook's three great voyages. Some surprising discoveries included a cannon ball, hemp wadding and black powder charge inside one of the cannons – all still in remarkable condition after 199 years.

Another unique item is associated with HMS *Resolution*, the vessel Cook commanded on his next two voyages of exploration. From 1772–75 and 1776–80 he explored the high latitudes of the Southern Ocean for Terra Australis Incognita, and in the northern hemisphere, searched the American coast for an entrance to the North-West Passage. After Cook's death in a violent skirmish in Hawaii in 1779, his officers

and crew sailed the *Resolution* back to England where it was fitted as a store ship for service in the East Indies. In 1782 the ship was captured by the French and sent to the Philippines. With the end of hostilities in September 1783 the *Resolution* disappeared from records, but is believed to have worked in the French whaling industry under various names until it was condemned at Newport, Rhode Island, USA, in 1792. In 1987 the Newport Historical Society donated to the museum what is believed to be part of *Resolution*'s sternpost.

An embroidery attributed to Cook's wife Elizabeth is a poignant memorial. Sewn with silk on linen, the embroidery is a map titled 'Western Hemisphere' – a part of the world notably revealed as a result of Cook's exploration – and shows the tracks of Cook's ships during his three voyages. Elizabeth is known to have embroidered objects for her husband, such as an unfinished 'Tahiti cloth' waistcoat now in the State Library of New South Wales, which she intended for Cook on return from his third voyage. After his death, she left the waistcoat unfinished.

Elizabeth Cook was born Elizabeth Batts. Her parents ran the Bell tavern in Wapping, where Cook is believed to have stayed when visiting London during his early career in colliers. Cook married the 21-year-old Elizabeth in 1762, during a brief return from duty in Newfoundland. Elizabeth lived to the remarkable age of 93, outliving James Cook by 56 years. Regrettably, she is

Coral concretion from one of the cannons of HMB *Endeavour* with the cipher of King George II Coral, iron oxide, 15 x 28.5 x 42 cm. *Transfer from the Department of Transport and Communications*

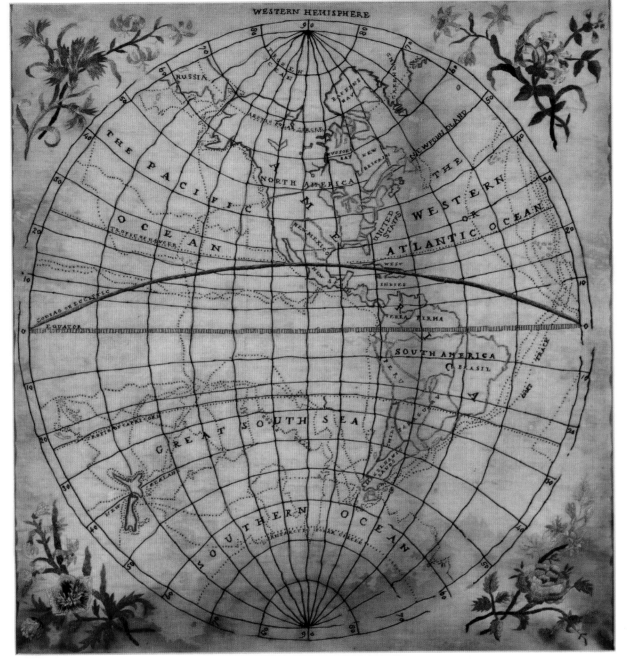

remembered for burning all her letters from her famous husband shortly before her death – depriving posterity of the chance to see anything but his official side.

Despite Cook's enormous contribution to science, he remains an enigmatic figure, and we are fortunate to have objects so strongly associated with his life in the museum's collection.

Nigel Erskine

The Omai Relics

In November 1773, as part of James Cook's second circumnavigation of the world, Commander Tobias Furneaux was in Queen Charlotte Sound in New Zealand repairing his ship HMS *Adventure*. Before rejoining Cook's ship HMS *Resolution*, Furneaux sent a final party ashore to forage for wild vegetables. The next day, his journal records the terrible news of the deaths of the 10 crewmen – all that remained were 'entrails' and 'baskets of human flesh'.[2] The Maori people of the area had formerly been co-operative in trading food and goods. Had the crewmen unknowingly broken Maori law? To this day it's uncertain.

One type of Maori weapon that may have figured in the massacre was a patu: the short, single-handed weapon that the Maori used in close combat. A string threaded through a hole drilled in the handle aided in gripping the weapon and enabled it to be easily slung at the waist. Patu had sharp edges to slash at an enemy, and could also be used to dissect dead flesh. They could be made from whalebone, wood or basalt.

The three weapons in the Omai Relics are a whalebone patu (patu paraoa) and two wooden clubs known as akua-ta. The patu was probably acquired just before the violence broke out at Queen Charlotte Sound, during trading between the *Adventure* crew and the local Maori. Collecting what Europeans called 'artificial curiosities' manufactured by Pacific

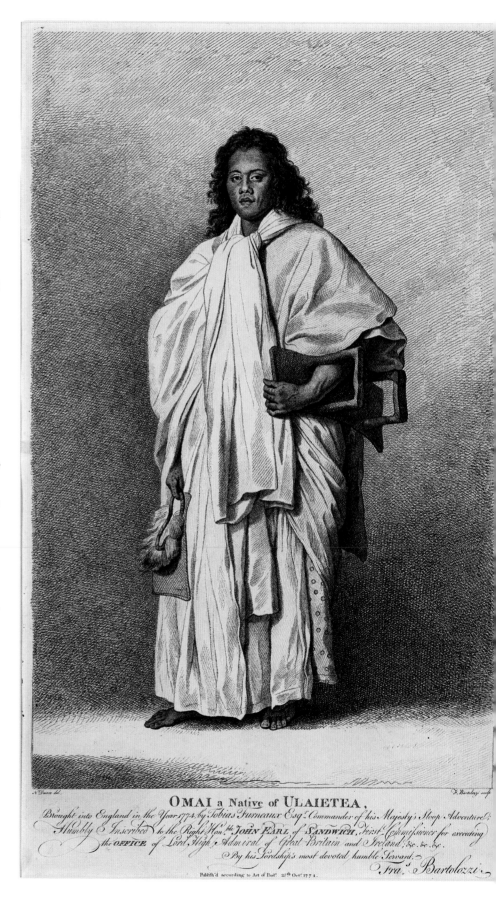

OMAI a Native of ULAIETEA,
Brought into England in the Year 1774 by Tobias Furneaux Esq.r Commander of his Majesty's Sloop Adventure.
Humbly Inscribed to the Right Hon.ble JOHN EARL of SANDWICH, First Commissioner for executing the OFFICE of Lord High Admiral of Great Britain and Ireland; &c. &c. &c.
By his Lordship's most devoted, humble Servant
Fra.s Bartolozzi

Publish'd according to Act of Parl.t 25th Oct.r 1774.

The Omai Relics FROM TOP Decorated club (akua-ta) from Tongatapu in the Tonga group Wood, 115 x 11.8 cm; Rounded hand-club carved from whalebone (patu paraoa), from Queen Charlotte Sound, New Zealand Whalebone, 43 x 11.3 cm. Decorated club (akua-ta) from Tongatapu in the Tonga group Wood, 114.5 x 12.5 cm. *All: Purchased with the assistance of the Australian Government through the National Cultural Heritage Account*

islanders was a lucrative sideline for crews, and Furneaux returned to England with a number of artefacts, including these three.

The other two weapons were collected earlier in the expedition when Furneaux and Cook were at the island of Tongatapu (now part of modern-day Tonga). Tongan warriors made most of their clubs from the hard, heavy wood of the toa tree. Carved designs varied, but commonly include the crosshatched styles seen here. One of the clubs has a patterned group of drill holes at the top, for previous attachments. Some surviving clubs have shell inlay on this section, indicating the high social status of the owner.

These three weapons carried home by Furneaux became known as the Omai Relics due to their association with Omai, the most famous Polynesian of the 18th century. 'Homey' or Omai (correctly pronounced 'mai') was born around 1753 on the Polynesian island of Raiatea just to the west of Tahiti. When the *Adventure* and *Resolution* arrived at the nearby island of Huahine

< Francesco Bartolozzi (1727– 1815) *Omai, a Native of Ulaietea, 1774* Engraving after a portrait by Nathaniel Dance (later known as Nathanial Dance-Holland), 51.5 x 32 cm (image), 53.4 x 32 cm (sheet)

in September 1773, Omai was among the crowds visiting and trading with the European ships. He persuaded Cook and Furneaux to take him back to England with them.

Omai's arrival in England in 1774 caused a sensation. The existence of such a handsome, well-mannered and intelligent 'noble savage' ignited intellectual and popular debates about the origins and destinies of human societies. Omai was presented to the King and Queen, and his portrait was made by numerous artists, including Joshua Reynolds and Nathaniel Dance-Holland. Omai's elegant manners and dress impressed all and, as Joseph Banks's accounting books show, he ran up considerable tailors' bills at the famous botanist's expense.

Within two years public interest in Omai as a celebrity had begun to wane. His wealthy benefactors had taught him little except how to behave like 'a gentleman' – which mainly involved dressing for the theatre, polite manners and how to play card games. Sailing for home, Omai embarked upon Cook's third voyage in 1776 well supplied with gifts that included various livestock, a jack-in-the-box, fireworks and some muskets, powder and shot. Sadly, Omai's life back in his homeland was short. When William Bligh arrived in the islands aboard the *Bounty* in 1788, he found that Omai had died in 1779.

Stephen Gapps

Banks' *Florilegium*

During James Cook's first Pacific voyage of 1768–71, the effects of this epic journey of discovery – with its wonderful new specimens and sights – on the young artist Sydney Parkinson led to his exquisite botanical watercolours.

Joseph Banks – naturalist, patron of science and 'gentleman of large fortune'[3]– accompanied Cook on his first Pacific voyage, subsidising the expedition to the tune of £10,000 (millions of dollars, in today's values). Banks funded the employment of Parkinson, naturalist Daniel Carl Solander, landscape artist Alexander Buchan, secretary and artist Herman Spöring, and four field assistants. When the *Endeavour* returned with abundant new species of plants and animals, it excited the scientific community and fired the public imagination. During his time with the expedition, Parkinson completed some 1,300 sketches and watercolours of botanical specimens and landscape views, and compiled vocabularies of the peoples of Tahiti and New Zealand.

Born in Scotland in 1745, the young Parkinson was apprenticed to a wool draper, but in his spare time learnt the specialised art of botanical drawing. In 1766 he moved to London to pursue his natural history studies, where Joseph Banks offered him a job at the Royal Botanic Gardens at Kew and then invited him to join Cook's expedition.

During the first part of the voyage, Parkinson sketched and completed watercolours of botanical specimens. But after Alexander Buchan died of an epileptic fit in Tahiti in 1769, Parkinson had to perform Buchan's duties as well and he soon fell behind, completing only annotated sketches. He also had to work quickly before the specimens dried out and lost their colour or shape – and, in some cases, before insects ate the specimens and paints as he worked!

Parkinson intended to complete the watercolours when he returned to England, but on the homeward voyage he contracted dysentery and died on 26 January 1771, aged just 26. Parkinson's brother Stanfield later fought acrimoniously with Banks over his brother's personal effects, papers and drawings; as a result, Banks took out an injunction to stop Stanfield publishing before the official account by John Hawkesworth was released. In an act more reminiscent of a soap opera, Stanfield had his brother's papers transcribed (against his agreement with Banks) and published in *A Journal of a Voyage to the South Seas* in 1773, the same year as the official version.

Joseph Banks became a leading light in the natural history field, and was influential in the British Government's decision to colonise New South Wales. He corresponded with Pacific-bound missionaries, funded 'gentlemen' collectors and naval expeditions, and was president of the Royal Society from 1778 until his death in 1820.

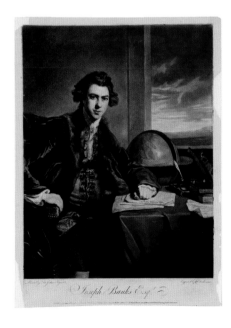

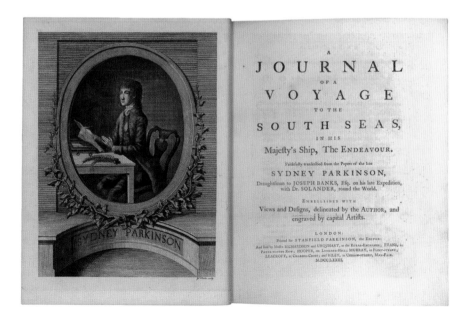

Between 1772 and 1784 Banks employed five artists to complete Parkinson's watercolours, and 18 engravers to cut copper printing plates, with a view to publishing the works in full colour. But the publication never eventuated, and the original watercolours, along with the specimens, were deposited in what became London's Natural History Museum.

For more than a century the works remained unpublished, until *Illustrations of Australian Plants* (1900) and *Captain Cook's Florilegium* (1973) were released, both in monochrome. It seemed that Parkinson's work would never be reproduced in its full beauty. Fortunately, between 1980 and 1990, Alecto Historical Editions, in partnership with the Natural History Museum, published his works in 35 parts, comprising 743 botanical drawings, 337 of which feature Australian plants. The collection, known as *Banks' Florilegium*, records the plants collected by Banks and Solander in Madeira, Brazil, Tierra del Fuego, the Society Islands, New Zealand, eastern Australia and Java. These modern engravings have been produced from the watercolours completed by Banks' artists and the original plates commissioned by Banks himself. Only 100 numbered sets of the *Florilegium* were published, and a complete set of the Australian part is held by the museum.

Lindsey Shaw

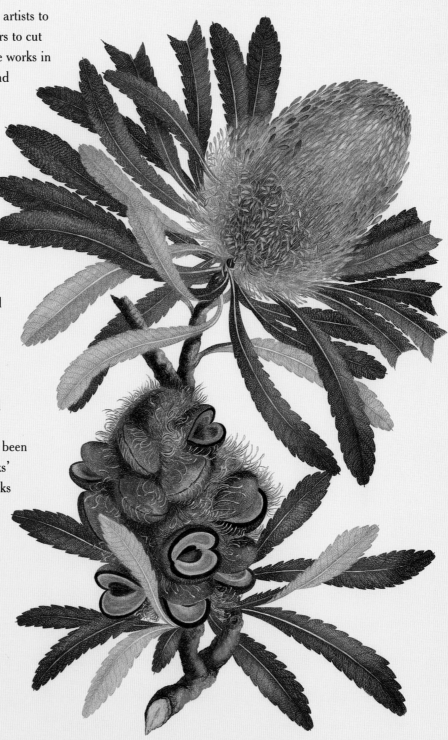

< Sydney Parkinson
(1745–1771) *A Journal of a Voyage to the South Seas, in His Majesty's Ship the* Endeavour, 1773 Frontispiece to book, engraving by James Newton, 29.8 x 24.4 cm

<< William Dickinson
(1747–1823) *Joseph Banks Esq Seated at a Table with a Globe,* 1774 Mezzotint engraving after the painting by Sir Joshua Reynolds, 79.5 x 63.4 cm (sheet)

> *Banks' Florilegium,* Plate 285, *Banksia serrata,* 1983 Engraving, 73.5 x 57 cm (sheet), © Natural History Museum, London *Gift from Dr and Mrs Eric and Margaret Schiller*

The French hero who died in his bed

More romance than reality, Gustave Alaux's painting *Bougainville at Tahiti* captures a moment in 1768, seconds before the French ships drop anchor and are engulfed by the sensuous beauty of Tahiti's lofty peaks and welcoming inhabitants.

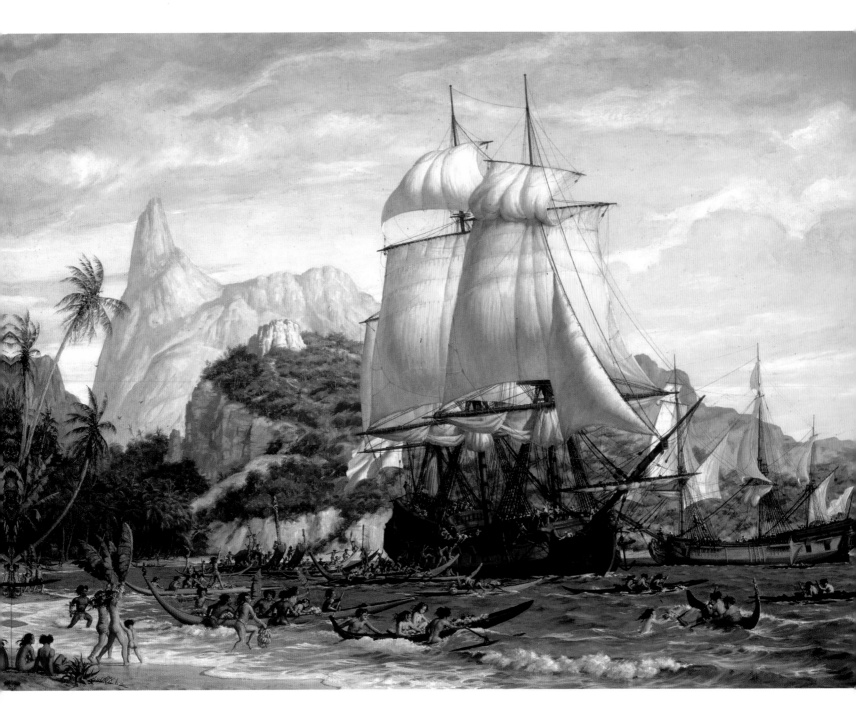

Louis Antoine de Bougainville was not the first European to discover Tahiti, but his description of the Tahitian welcome to his expedition was breathtaking and helped build a vision of paradise that became the dream of sailors (and later artists) for generations to come – a place full of 'ease, innocent joy and every appearance of happiness'.[4] Gustave Alaux painted several works in the 1920s and 30s based on historical figures such as Christopher Columbus and the Marquis de La Fayette, and the monumental figure of Bougainville was certainly a fitting subject.

Bougainville served in the French army at Quebec during the Seven Years War (1756–63) and was appointed a naval captain in 1763, as a result of his plan to relocate French settlers from Quebec to the Falkland Islands. However, the plan did not go down well with Spain (which maintained a claim to the islands) and Bougainville was soon forced to abandon it, but not before he conceived the idea of becoming the first Frenchman to lead an expedition around the world. Surprisingly – given Bougainville's lack of experience – he received official support for his idea, and in 1766 set off from Brest in command of the frigate *La Boudeuse*.

Sailing south to Brazil, *La Boudeuse* was joined by the support vessel *L'Étoile*. In just over two years, they sailed through the Magellan Strait and on to Tahiti, Vanuatu, the Solomon Islands and New Guinea, before returning to France by way of the Moluccas, Mauritius and the Cape of Good Hope. Bougainville crossed the Pacific a year before Cook and almost became the first European to sight the east coast of Australia. However, it was not to be – when sailing west and only a few days from the Australian shore, the discovery of a low reef in his path caused him to turn north and follow a route around New Guinea instead.

Bougainville's evocative account of the voyage quickly proved an inspiration, and he became a principal advocate for further French voyages of exploration. He was a fine mathematician with a strong interest in science, and was instrumental in planning the La Pérouse, D'Entrecasteaux and Baudin expeditions through the tumultuous years of the end of the French monarchy, the French Revolution and the rise of Napoléon Bonaparte.

Indeed, Louis de Bougainville proved adept at navigating the political shoals of revolutionary France and, although briefly arrested for his royalist sympathies, he also helped plan Napoléon's expedition to Egypt in 1798, was a member of the Bureau des Longitudes and the president of the court martial of French naval officers after France's defeat at Trafalgar. He died peacefully at his home in 1811.

Fittingly, like that of the great Joseph Banks, Bougainville's name is commemorated through a botanical species: the exquisitely coloured bougainvillea collected by Bougainville's botanist Philibert Commerçon at Rio de Janeiro in 1768.

Nigel Erskine

Gustave Alaux (1887–1965)
Bougainville at Tahiti, c1930 Oil on canvas, 210 x 280 cm © Estate of Gustave Alaux Licensed by ADAGP, Paris, through Viscopy

After two centuries of debate, it is surprising to discover a new aspect of William Bligh's character, revealed in his beautifully carved intaglio ring. Featuring the bearded head of a Greek philosopher, it opens a door on the personal attitude to life of one of history's most controversial figures.

The secret of William Bligh's ring

The neoclassical movement – triggered by the discovery of the archaeological remains of Herculaneum and Pompeii at the foot of Mount Vesuvius – reached its height in the 1790s, when William Bligh was about to set off on his second voyage for breadfruit. Popular interest in classical antiquity had a major influence on aesthetic tastes in Western architecture and art and, at a more personal level, on the jewellery of the day – such as Bligh's ring.

Who is the bearded man? The answer lies in the encyclopedic works of James Tassie, published in 1775 and 1791. Tassie was a Scottish gem engraver and modeller who perfected a method of casting gems and cameos in glass, with such stunning success that his work rivalled that of Wedgwood. His reputation opened doors to private collections throughout Europe, and he made plaster impressions of about 15,000 antique carved gems that became the basis of his descriptive catalogues. Apart from inspiring his own modelling, Tassie's research helped classify and identify many representations on ancient gems. And it is here, under the general heading of 'Philosophers', that the luxuriantly bearded and coiffed head of Epicurus appears.

Tassie's identification of the philosopher was based on a bronze bust excavated at Herculaneum inscribed with Epicurus's name, but another very similar head (also named) was discovered in Rome in 1742. So the bearded man on Bligh's ring is the third-century-BC Greek philosopher Epicurus, who founded Epicureanism, the school of philosophy summed up in the words 'Eat, drink, and enjoy life today, for tomorrow you may die'.

Just when Bligh acquired the ring is uncertain. The case bears the label and address of jeweller John Miers at 111, Strand, London – Miers occupied the shop from 1791 to about 1810, years encompassing Bligh's second breadfruit voyage, his naval service at the battles of Camperdown and Copenhagen, and his tumultuous governorship of New South Wales. In a sense, these episodes were a continuum of a life pursued passionately, when – with death often present and the future unpredictable – an Epicurean philosophy on life may have sustained Bligh. The extent that Bligh was influenced by the philosophy of Epicurus will never be known, but the ring sheds light on yet another aspect of his highly controversial character.

After Bligh's death, the ring passed to his daughters, and in the 1840s they presented it to George Suttor, a free settler to New South Wales who had been a prominent supporter of Bligh during the Rum Rebellion and associated court martial of Major George Johnston. The ring is now one of the treasures of the museum.

Nigel Erskine

< Letter from Fanny Bligh, presenting her father William Bligh's ring to George Suttor, one of Bligh's supporters during the Rum Rebellion. It reads:
'30 June
32 Royal Crescent
My Dear Sir
It would have been a great gratification to me and my sister Jane, although a sad one, to have taken a personal farewell of you today. We would also have asked you to have allowed us to have put upon your finger an antique ring which formerly belonged to our dear Father, as the most acceptable token we can think of as a memento of our grateful remembrance ...'

^ Bligh's ring in its case, bearing the label of the jeweller, John Miers of London

For millennia the oceans and seas remained a barrier surrounding and separating the landmasses of the earth, creating a checkerboard of distinct cultures nurtured in isolation from each other. Gradually, however, mariners built watercraft sophisticated enough to sail and explore beyond the horizon. But how did they find their way in this constantly changing world? The answer lies in the development of the science of navigation.

Not lost at sea

Early long-distance voyages were made hugging the coastline, but to venture out of sight of land, navigators had to locate themselves in relation to celestial bodies such as the sun and stars. To use these bodies, mariners needed an instrument that could measure their angular height above the horizon.

The backstaff is the earliest instrument in the museum's collection that was used for this purpose. Made of wood, it used small sliding vanes attached to its two arcs to determine the height of the sun above the horizon. Although invented in the late 16th century, it was popular with mariners into the 18th century due mainly to its simplicity, and because navigators could measure the height of the sun without actually staring at it. On the down side, the backstaff could only read angles up to 65 degrees, a significant limitation that precluded its use for a noon-day sight, when the sun is often much higher in the sky. For that, the navigator needed a more sophisticated instrument: the octant.

Invented in the early 18th century, and incorporating mirrors, the octant allowed a new level of accuracy. Using it, a navigator could view a reflection of the sun or star alongside the horizon and read the angle off on a precisely engraved scale. Octants were made from wood, metal and often ivory, and are beautiful examples of the instrument-maker's craft. They remained popular until displaced by the even greater accuracy of the sextant, made of metal and fitted with telescopic sights. Sextants owed much to the ingenuity of the Industrial Revolution and new machines that could create highly accurate engraved arcs. With their improved optics and micrometer adjustments, sextants were a quantum leap in navigation science, resolving the last problems associated with taking accurate sights and defining latitude. That just left the small problem of longitude …

> Nautical instrument makers' shop sign, 1795–1812
Nicknamed 'The Little Admiral', such figures were commonly used in the late 18th and 19th centuries to indicate a business dealing in nautical instruments.
Wood, paint, gesso, 101.6 x 34.2 x 47 cm

The story of John Harrison's struggle to invent a timekeeper capable of maintaining accurate time at sea is fascinating. The basic principle behind Harrison's idea is that the sun's movement is analogous to the hand of a watch moving around a dial, where 0 degrees longitude (the Prime, or Greenwich, Meridian) represents 12 o'clock on the dial. If you imagine looking down at the earth from above the North Pole, the earth's equator can be thought of as defining a very large clock face. The sun (the hour-hand of our clock) moves at a regular speed, so that in 24 hours it travels through 360 degrees – that is, 15 degrees each hour, one degree every four minutes and so on. Given these details, by noting the exact time the sun is directly overhead, and comparing that time with the time at the Prime Meridian, the longitude east or west of the Prime Meridian can be accurately calculated. The principle is not complex, but to work it requires a clock that maintains the time at Greenwich within an accuracy of seconds.

The museum's Hewitt and Sons chronometer is a good example of how timekeepers had evolved by the mid-19th century. Slung in gimbals to keep it level with the horizon whatever the ship's movement, and protected in a wooden case, this type of chronometer became the standard for mechanical timekeepers until late in the 20th century when, once again, more accurate technologies such as GPS – one of the marvels of the 21st century – became available. Knowing where you are has been the Holy Grail of navigators since people first ventured out on the sea, and our present technology is an awesome breakthrough and another step in the continuing evolution of navigation science.

Nigel Erskine

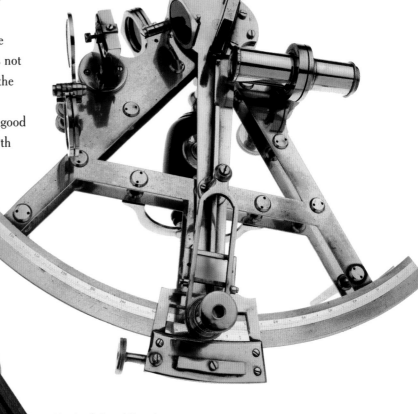

< Hewitt & Sons Victorian two-day chronometer, c1860 Steel, glass, wood, 17 x 17 x 17 cm *Purchased with the assistance of the National Association of Watch and Clock Collectors*

∧ Troughton and Simms Double-framed sextant, 1810–60 Copper alloy, wood, glass, 10.9 x 26 x 30 cm

The forger and a First Fleet curio

A small silver medallion showing the First Fleet convict transport *Charlotte* at anchor in Botany Bay on the day of its arrival on 20 January 1788 seems an unlikely candidate to be the first ever artwork made by an Australian convict.

Known as *The* Charlotte *Medal*, it is believed to have been engraved sometime between 20 and 26 January by one of the ship's convicts – thief, mutineer and forger Thomas Barrett – for John White, the Surgeon-General of the First Fleet, who was also on the *Charlotte*.

Material from the First Fleet is extremely rare, and *The* Charlotte *Medal* is both a graphic record of the fleet's arrival and one of the few contemporary portraits of a First Fleet vessel. The museum also holds another such portrait, of the First Fleet storeship *Borrowdale*. It was painted by a major maritime artist of the 18th century, Francis Holman, shortly before the *Borrowdale* accompanied the *Charlotte* on its long voyage out to Botany Bay.

The 11 ships of the First Fleet – six convict transports, two escorting naval ships and three store ships – set sail for Australia on 13 May 1787. *Charlotte* was a three-masted, two-decked ship and carried 44 marine officers and privates and 89 male and 20 female convicts.

The fleet's Surgeon-General, John White, was a well-connected Royal Navy man, reportedly intelligent, humane and diligent in his work caring for the people of the First Fleet and the new colony. One of his charges was Thomas Barrett, whose two death sentences – one for theft, the other for taking part in a shipboard mutiny – had been commuted to transportation for life.

It appears that Barrett first came to the notice of Surgeon White when he was caught during the fleet's layover in Rio de Janeiro trying to pass off counterfeit quarter dollars he had forged out of pewter spoons, old buttons and brass buckles. White records in his diary that he was amazed at the forger's ability to manufacture fake coins while under almost constant surveillance and without access to tools.

White was impressed by Barrett's skill with metal, and quite likely commissioned this memento of the First Fleet's arrival at Botany Bay – the medal appears to be made from a piece of a surgeon's silver kidney dish. On the front we see a fully-rigged ship at anchor and the words 'The *Charlotte* at anchor in Botany Bay Jany. th 20, 1788';

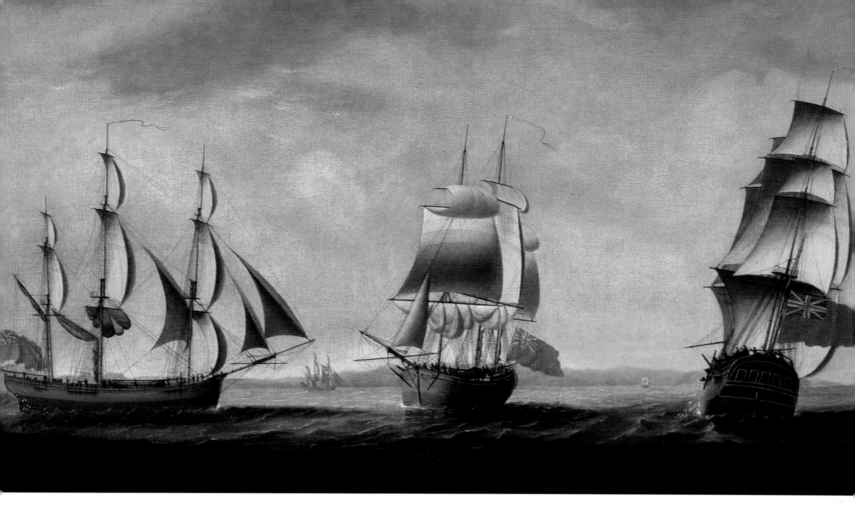

< Thomas Barrett (d 1788) *The Charlotte Medal*, 1788, *front, top, and back.* Silver, 7.4 cm (diam.) *Purchased with the assistance of the Australian Government through the National Cultural Heritage Account*

∧ Francis Holman (d 1790) Three views of the First Fleet Storeship *Borrowdale*, c1786 Oil on canvas, 72.8 x 118.7 x 5.4 cm

on the back is a very short but accurate description of the voyage, which must have been provided by one of the ship's officers.

We will never know for sure whether Thomas Barrett was the artist, but he was the only known forger on the *Charlotte* with the skills and talent to produce such a beautiful work of art from the minimal resources available. However, his talent for escaping the wrath of justice evaporated when he had the dubious honour of being the first person in the colony to be hanged.

In those terrible early days of the colony, when starvation, illness and rebellion were ever-present threats, Barrett was arrested, charged, tried, convicted and executed for stealing 'pease and beef' from the public store. Governor Arthur Phillip, whose powers were almost absolute, made an example of Barrett but exercised his humanity in sparing Barrett's two accomplices the noose.

An avid amateur naturalist and author of one of the first books on the new colony of New South Wales, Surgeon John White continued attending to the health of the convicts, guards and government establishment until he returned to England in 1794, due to his own ill health. He took with him, we presume, this silver medallion, which had a long line of owners – including Princess Victoria, daughter of Queen Victoria, and Prince Louis of Battenberg, First Sea Lord of the Admiralty – before coming to the museum.

Kieran Hosty

Any news of La Pérouse?

About to face the guillotine in 1793, King Louis XVI asked if there was news of the fate of La Pérouse and his men, who had been sent out to explore the Pacific eight years earlier. But the truth was to remain unknown for more than three decades. Meticulously planned and equipped, the expedition should have been a triumph but became instead a national tragedy, a mystery that seemed to cast a malevolent spell on France's fortunes for a generation to come.

^> General Milet-Mureau, editor (1756–1825) Title page, *Atlas du Voyage de La Pérouse (Atlas of the Voyage of La Pérouse)*, 1797 Engraving, 63.5 x 47 cm

>> François Peron (1778–1846) and Louis de Freycinet (1779–1842) *Voyage de Découvertes aux Terres Australes ... (Account of a Voyage of Discovery to New Holland)*, 1807 Plate 38, *Nouvelle-Hollande, Nouvelle Galles du Sud, Vue de la Partie Méridionale de la Ville de Sydney ... 1803 (View of the Town of Sydney 1803)* Engraving by Pillemont after the original by Charles Alexandre Lesueur, artist on Baudin's expedition, 35 x 52.5 cm

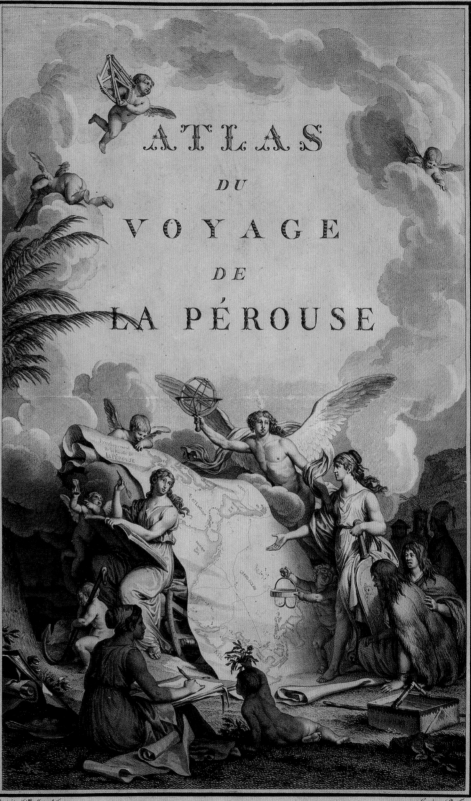

ATLAS
DU
VOYAGE
DE
LA PÉROUSE

Dessiné par J. M. Moreau le jeune.

Gravé par Ph. Triere.

Jean François de Galoup, Comte de La Pérouse – a veteran of the French conflicts in Canada and America – was appointed to lead the Pacific expedition in 1785. The great Captain Cook was dead (killed in Hawaii six years earlier), and a period of peace provided France with a new opportunity to investigate the scientific, political and commercial possibilities of the still largely unknown Pacific basin.

Rounding Cape Horn, La Pérouse's ships *La Boussole* and *L'Astrolabe* criss-crossed the Pacific from Chile to Alaska, and on to Asia, before finally arriving in Kamchatka (Russia) in 1787. There, he received orders to sail to Botany Bay to investigate the site of a planned new British settlement. Importantly for history, while at Kamchatka La Pérouse despatched his charts and journals overland to France. These reached Paris a year later, the last word from the expedition. Although La Pérouse's ships arrived safely in Botany Bay in 1788, when they left, they vanished completely.

In 1791 the French sent an expedition to search for La Pérouse – Antoine Raymond Joseph de Bruni D'Entrecasteaux was in overall command of the ships *La Recherche* and *L Espérance*. Over the next two years they searched the western Pacific without solving the mystery. D'Entrecasteaux did, however, survey part of the south coast of New Holland (Australia), discovering several protected bays and a magnificent channel in Van Diemen's Land (Tasmania), where the expedition made contact with Aboriginal people and gathered scientific collections.

Unfortunately, D'Entrecasteaux died of scurvy in 1793 off the coast of New Guinea, the same year that Louis XVI's execution in January ended the French monarchy. The world was in flux and when *La Recherche* and *L Espérance* reached the Dutch East Indies, the expedition disintegrated into political factions. In a final ignominy, the expedition's charts and scientific collections were later captured by British ships.

The incomplete account of La Pérouse's discoveries was finally published in 1797, by which time any real hope of finding survivors had faded. The sumptuously engraved folio atlas and four text volumes of the official expedition account now hold an important place in the museum's collection. But there is more to this intriguing story.

Embroiled in the politics of revolution, and battling enemies outside its borders, it was not until 1800 that France mounted another expedition, this time under the command of Nicolas Baudin. In the years since La Pérouse's disappearance, Britain's colony in New South Wales had taken root and the entire continent now warranted much closer investigation. But even before this expedition departed, ominous signs of discord were appearing between Baudin, his officers and the scientists packed aboard the expedition ships *Le Géographe* and *La Naturaliste*.

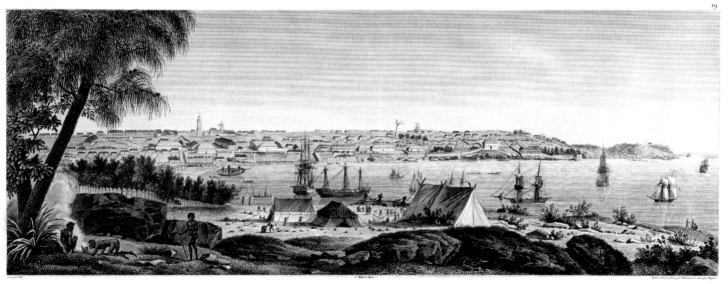

NOUVELLE - HOLLANDE : NOUVELLE GALLES DU SUD.

Vue de la partie méridionale de la Ville de SYDNEY Capitale des Colonies Anglaises aux Terres Australes, et de l'Embouchure de la rivière de Parramatta (1803.)

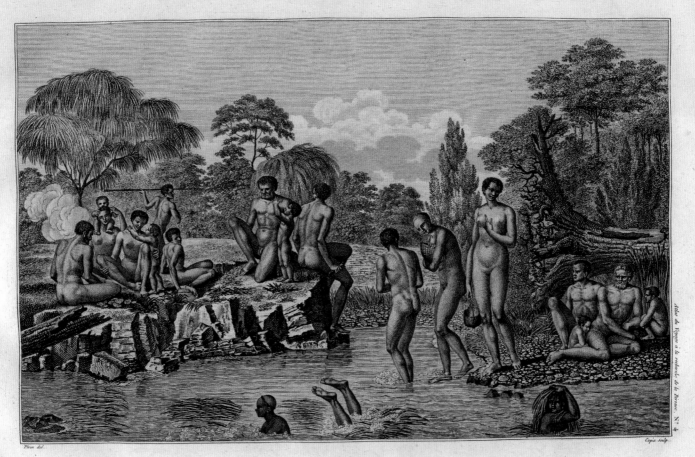

PÊCHE DES SAUVAGES DU CAP DE DIEMEN.

The voyage south round the Cape of Good Hope brought tensions to a head, and when Baudin's ships finally reached Isle de France (Mauritius), many found excuses to leave the expedition. Despite delays, Baudin pushed on, arriving off the west coast of New Holland in May 1801. Exploring large parts of the south, west and north coasts over the next two years, Baudin's expedition made extensive scientific observations and detailed surveys which, although much delayed in publication, highlight the achievement and tenacity of the French in the face of considerable obstacles.

The museum holds the official accounts of all three of these French expeditions. And what of La Pérouse? The mystery was finally solved in 1826, when a Pacific trader, Peter Dillon, found the remains of *La Boussole* and *L'Astrolabe* at Vanikoro in the Solomon Islands.

In 2009 a French scientific expedition carried out extensive work on the island and wreck sites. Based on a combination of archaeology and local oral histories, it now appears that some of La Pérouse's expedition survived and built a boat to escape the island. What happened to them remains one of the great mysteries of the Pacific.

Nigel Erskine

Jacques-Julien Houton de Labillardiere (1755–1834)
Atlas pour Servir à la Relation du Voyage à la Recherche de La Pérouse (Atlas to Illustrate the Account of the Voyage in Search of La Pérouse), 1811 Plate 4, *Pêche des Sauvages du Cap de Diemen (Aborigines of Cape Diemen Fishing)* Engraving, 58.5 x 44 cm

Cannibals, catastrophe, adventure and the high seas! The aptly named *Le Tour du Monde, ou Jeu du Petit Voyager* (*A Trip Round the World, or Game of the Little Traveller*) complements a rendition of the most famous tale of shipwreck, desert islands and rescue: Daniel Defoe's *Robinson Crusoe*. Playing these 19th-century games allowed French children to partake in sea-based adventures and traverse exotic lands around the globe from the comfort of their home.

Perilous adventures on the high seas

In the 19th and 20th centuries, France had the second-largest colonial empire across Africa, Asia, Oceania and the Americas. Stories of daring adventures filtered back to Paris and captured the national imagination. As they played games like these, the children of France also engaged in the historical exploits of their countrymen and the development of French colonial wealth and might.

A particular highlight of the museum's collection is a beautifully and brightly illustrated book, *Voyages et Glorieuses Découvertes des Grand Navigateurs et Explorateurs Français* (*Voyages and Glorious Discoveries of the Great French Navigators and Explorers*), written and illustrated by Edy Legrand in 1921. It is typical of the Art Deco period and the pochoir technique – a style using multiple stencils for a single image, which is then hand-coloured, producing vibrant and colourful illustrations with crisp outlines. Paris in the 1920s and 30s was the centre of illustration, design and craft, with artists from all over the world travelling to live in the city, pioneering and perfecting various techniques such as pochoir. Heavily influenced by the Japanese practice of fabric stencilling, pochoir was often used in luxury French fashion and textiles journals as well.

Here, Edy Legrand recounts the exploits of France's greatest navigators and explorers, with vivid illustrations of the exotic lands and inhabitants of the New World and the Pacific, who are regularly portrayed as supplicant to French domination. In the words of Legrand himself, the

Edy Legrand (1892–1970)
Cover from *Voyages et Glorieuses Découvertes ...*, published by Tolmer, 1921 Pochoir print, 39 x 28.6 cm © Estate of Edy Legrand

*Son œuvre accomplie Cavelier de la Salle, entouré de ses courageux compagnons, prend solennellement possession de la Louisiane.
Accourus de toutes parts, les chefs des nombreuses tribus indiennes viennent rendre hommage au grand Français et lui font leur soumission.*

ESPAGNE. COMBAT DE TAUREAUX.

ÉCOSSE. HABITANTS DES MONTAGNES.
ÎLES-BRITANNIQUES.

< Edy Legrand (1892–1970)
Double-page illustration
from *Voyages et Glorieuses
Découvertes ...*, published by
Tolmer, 1921. Depicts the French
taking possession of Louisiana
from the Indigenous tribes, from
a chapter about explorer René-
Robert Cavalier, Sieur de La
Salle Pochoir print, 39 x
49.2 cm © Estate of Edy
Legrand

great 'mystère a l'océan' – the disappearance of the 18th-century naval officer and explorer La Pérouse, and the subsequent ill-fated search party – is a feature of this book. The colour, vibrancy and style of the illustrations convey the excitement of exploration to exotic and distant lands.

Today these luxury novelties give us access to the French interpretation of their rapidly expanding world.

Veronica Kooyman

« Charles Letaille
(1815–1908) Mounted
Espagne card from the
game *Le Tour du Monde*
[*A Trip Round the World*], c1840
Ink on paper, wood, 9.4 x 7.3 x
1.5 cm

< Mounted *Écosse* card from the
game *Le Tour du Monde* [*A Trip
Round the World*], c1840 Ink on
paper, wood, 6.4 x 10.5 x 1.5 cm

∧ *Robinson Crusoe d'après Daniel
Defoe* [*Robinson Crusoe after
Daniel Defoe*], c1890 Board game
box, 3 x 54 x 37.5 cm

53

François-Edmond Pâris, a decorated veteran of the Crimean War who rose to the rank of admiral, was no ordinary naval officer. Over three voyages to the Pacific from 1826 to 1841, he created the definitive encyclopedia of traditional, non-European vessels from around the globe. Published in France in 1843, Pâris's *Essai sur la construction navale des peuples extra-européens* is one of the highlights of the National Maritime Collection.

Admiral Pâris and his extra-européen boats

With a delicate painterly hand, Pâris produced rustic scenes of virtually every type of 'native' watercraft he encountered – from canoes in Greenland to Arab dhows, Chinese junks, Malay prahus and Pacific outriggers. His encyclopedia included meticulous, scientific plans of their structure and rigging as well as vibrant scenes of how they were used.

Born in 1806, Pâris graduated from the French naval academy as a hydrographer in 1824. His flair for drawing and painting soon secured him a place on a voyage of scientific exploration. In 1826 he joined *L'Astrolabe* (named after one of the vessels of the ill-fated La Pérouse expedition of 1785) for its world voyage, led by Captain Jules Sébastien César Dumont d'Urville. The young Pâris worked under *L'Astrolabe*'s official artist Louis de Sainson (who later produced the remarkable *Atlas historique* of this 1826–29 voyage).

When *L'Astrolabe* reached Australia, Pâris surveyed King George Sound in Western Australia – not yet formally colonised by Britain – and later Jervis Bay, south of Sydney. Here the young officer found time to sketch an Aboriginal bark canoe or, as he titled it, *Pirogue en ecorce de la baie Jervis*.

Pâris's next voyage to the South Pacific had quite a different focus: in 1829 Cyrille-Pierre-Théodore Laplace was given command of an expedition to secure French colonial interests in Indochina and other places in Asia and the Pacific, and Pâris was active sketching and painting during the expedition. Despite some trading setbacks in China, Laplace's voyage was generally regarded as a success

and the French Government authorised the publication of his account, which included 24 plates by Pâris of various ports and towns.

By this time, Pâris was also compiling his own notes, sketches and watercolours of non-European watercraft. His initial manuscript for his *Essay on non-European naval architecture*, now held in Paris at the Musée National de la Marine, includes many views and architectural drawings that were later engraved or made into lithographs. On his return to France, Pâris's increasing portfolio of work was recognised and he was awarded France's highest decoration, the Légion d'Honneur.

In 1837, Pâris embarked on a third major voyage in the frigate *Artémise*, circumnavigating the globe one more time. While inspecting a steam engine in a foundry in southern India, his sleeve caught in some machinery and his arm was severely injured. It was later amputated but, in the best naval tradition, this didn't stop the energetic Pâris from continuing his work and career. *Artémise* visited Hobart and Sydney – the third time for the well-travelled Lieutenant Pâris – and, after striking a reef in Tahiti, sailing the Californian coast and suffering an outbreak of cholera on board, it returned to France in April 1841.

Pâris's three expeditions provided him with such a comprehensive body of work on watercraft from around the globe that he could now claim to have completed the definitive study. The French monarch King Louis Philippe I agreed, and Pâris's drawings and notes were published by royal decree. France's most notable printers, engravers and lithographers were employed on the project, and several artists helped copy Pâris's art for printing. The vast majority of the craft Pâris recorded have since disappeared from use, making his plans and sketches even more significant today.

Stephen Gapps

∧ Both works by Admiral François-Edmond Pâris (1806–1893) Plate 49, *Grande Jonque de Guerre (Grand Junk of War)* Engraving, 28 x 39 cm (image), 35.5 x 55 cm (sheet)

> Plate 7, *Beden Safar de Mascate, au Mouillage et à la Voile (Beden Safar of Muscat, at Anchor and Under Sail)* Lithograph, 23 x 37 cm (image), 35.5 x 55 cm (sheet)

Better than a dog's breakfast

A model ship in the museum's collection is made almost entirely of mutton bones. It was built by a French prisoner of war (presumably a sailor) during the Napoleonic wars and, far from being rough, it is a wonder to behold. Prisoners made models like these to earn money, but there are many other reasons for making model ships.

Prisoner-of-war bone model of 50-gun frigate, 1799–1800 Mutton bones, copper rivets, 43 x 57 x 14 cm *Gift from The Australian Institute of Navigation*

For centuries before paper plans, ships were built from scaled-up models skilfully carved by master shipwrights. Because a ship's hull is symmetrical, it can be represented very practically in a half-model, giving the basic information required to build a full-scale hull. Shipbuilders specialising in particular trades – such as whaling or coal, where hull shapes did not change – could build several more-or-less identical ships from a single half-model. Half-models often had no decorative features, because they were made as functional tools.

Many models are also built as commemorative pieces, such as the museum's model of the *Duyfken*, a small

Dutch vessel associated with the first European landing on Australian soil. The model was built in the lead-up to the 400th anniversary of the Dutch landing, and as there are no surviving plans of the ship, the details of our model are based on historical research. Displaying the high stern and fine lines typical of 17th-century Dutch ships, the model reveals the construction that made the *Duyfken* such a capable vessel. The *Duyfken* was not regarded as an important

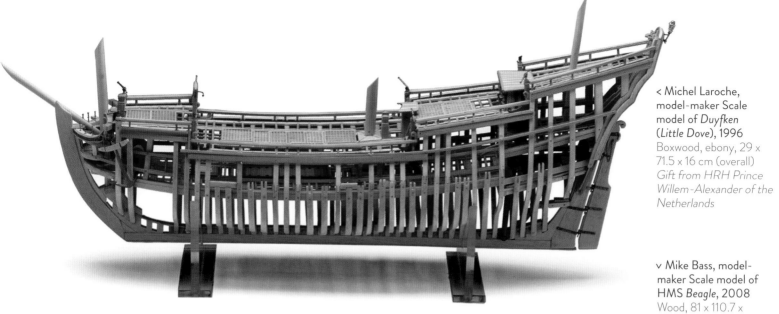

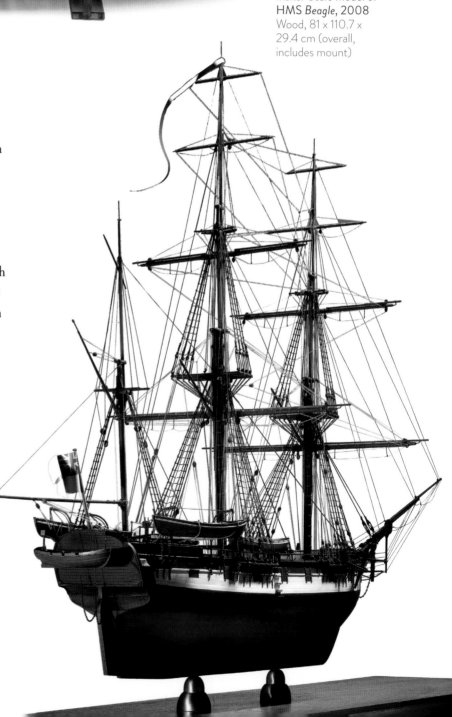

vessel in its own time, but famous ships such as Nelson's *Victory* or Cook's *Endeavour* were, and these ships' plans have provided a fertile source for hundreds of models in the centuries since. But this is not always the case with well-known ships, as the museum discovered in 2008.

Leading up to the 150th anniversary of the publication of Charles Darwin's book *On the Origin of Species*, the museum planned an exhibition on Darwin, including his voyage on HMS *Beagle*. No model of the *Beagle* could be found, and the museum commissioned this model from a local model-maker. The *Beagle* was built as a 10-gun brig (a mizzen mast was added later), and we began our research by obtaining copies of the original plans from London. The journals of several *Beagle* crewmembers gave us information on the masting, rigging, armament and many other details, and armed with this information the model-maker was soon shaping the hull. Today, professional model-makers use new technologies and materials, and the museum's *Beagle* is made of a synthetic resin and painted by airbrush. The real *Beagle* spent years in the stormy waters of Patagonia and Tierra del Fuego, and the maker finished the model to reflect this hard service, with weathered copper sheathing, rust stains and other signs of wear and tear. The result was very popular, demonstrating that models continue to fill an important place for all who are fascinated by the sea.

Nigel Erskine

3 MIGRANTS AND REFUGEES

Since the First Fleet dropped anchor in 1788, close to 10 million settlers have moved from across the world to start a new life in Australia. They have arrived in waves, encouraged by the 1850s gold rushes, or to escape adverse conditions at home such as the Industrial Revolution's social upheavals in 19th-century Britain, the two world wars and the aftermath of the Vietnam War in the 1970s. Collectively, these migrants have helped shape a unique British-based and now multi-cultural society on the perimeter of Asia. The museum's collection includes a rich diversity of objects that link us with people who arrived at different stages in Australia's history.

In the late 18th and first half of the 19th centuries, the initial influx of largely British settlers, including more than 160,000 convicts, established primary industries such as wool-growing in the Australian colonies. Conditions were often harsh and dangerous. William Moreton's love token attests to the distress of those held on Britain's convict hulks, and Samuel Elyard's painting *Burning of the Bark* India *of Greenock* shows vividly the risks associated with migration under sail. Personal belongings salvaged from the seabed after the loss of another migrant vessel, the *Dunbar*, on the rocks of Sydney's South Head in 1857 recall one of Australia's most horrifying maritime disasters.

With the catchphrase 'Populate or perish!' ringing through the community, Australia stepped up its immigration in the years after World War II. It offered assisted passages to British migrants, encouraged migration from European countries and finally, in the 1970s, repealed the restrictive White Australia policy framed after Federation in 1901 to stem an imagined influx of 'yellow peril' from the north.

More than seven million new settlers have now crossed Australia's shores since 1945. It's estimated that one in four of today's 22 million Australians was born overseas, in any one of 185 migrant-contributing countries. The museum holds substantial collections of personal and family belongings that people brought to their new home country from England, Austria and China, among other places. Interestingly, migrants have cherished the same mementos regardless of their cultural background: photos, heirlooms and items that reflect links to family and homeland.

One of the museum's most fascinating collections of migrant family belongings is that of Vietnamese refugee Tan Thanh Lu, his wife, Tuyet, and their children. It includes the fishing boat *Tu Do* in which they escaped Vietnam after the fall of Saigon in 1975, and navigated to Darwin with a map torn from the top of a school desk, items they carried with them on the voyage, photographs and recorded oral histories.

Some aspects of immigration policy can be deeply divisive. In Australia there has been discrimination against new arrivals and bitter disagreement on the treatment of refugees and asylum seekers. The museum collection includes items relating to such issues, including a lifebuoy from MV *Tampa*, the Norwegian cargo ship that figured in a political storm in 2001 when it rescued more than 400 asylum seekers from the Indian Ocean and was denied permission to enter Australian waters with these 'passengers' on board.

Bill Richards

Commonwealth Department of Information *Australia Land of Tomorrow*, 1948. This poster promoted Australia as a place of opportunity and prosperity for prospective European migrants after World War II. It relates to a major shift in Australia's immigration policy, which had previously prioritised British migration, and reflects the government's bid to 'populate or perish'. Lithograph on paper, 98.6 x 73 cm (image), 101.8 x 76.4 cm (sheet)

Hens, hulks and tokens of love

In January 1853 Edward Hunt, a labourer from Manchester, England, was convicted and sentenced to transportation. His crime? Stealing 'one tame and reclaimed fowl, called a hen'. The transportation document – stating that Hunt had pleaded guilty and that, as this was his second recorded offence, he would be transported overseas for seven years – is typical for the period.

The government author of the document (see p. 62) does not state whether Hunt was transported to Western Australia, Gibraltar or Bermuda. However, as no convict called Edward Hunt arrived at any of those places after 1852, he may have died on board a hulk awaiting transportation or, more optimistically, he may have stayed in England, his sentence remitted to penal servitude in one of the new purpose-built prisons there.

Until the early 19th century most local prisons in Great Britain and Ireland housed vagrants, minor

criminals and those awaiting trial or sentencing. Nearly all other convicts were condemned to pay a fine, or to some form of capital punishment or transportation overseas.

The American War of Independence (1776–81) ended the export of convicts to North America. Instead, many prisoners were sent to temporary floating prisons, or hulks, on the River Thames and at Portsmouth, Plymouth and Cork (Ireland), where they were employed in river cleaning, stone collecting, timber cutting and dockyard work. These hulks also held convicts awaiting transportation, and were places of reformation and education, where inmates could be taught a trade. Great Britain's last prison hulk, HM Prison Ship *Weare* in Portland Harbour, Dorset, was closed in May 2005.

If Hunt did end his days on board a prison hulk, his place of confinement may have been like the *York*, represented here by this cutaway model. Built in 1807 as a 74-gun ship, HMS *York* was decommissioned and converted into the prison hulk *York* in 1820 to hold convicts awaiting transportation to Australia. Up to

Peter Heriz-Smith, model-maker Cutaway model of the prison hulk *York*, 1987 Timber, metal, 60.6 x 123.4 x 46 cm

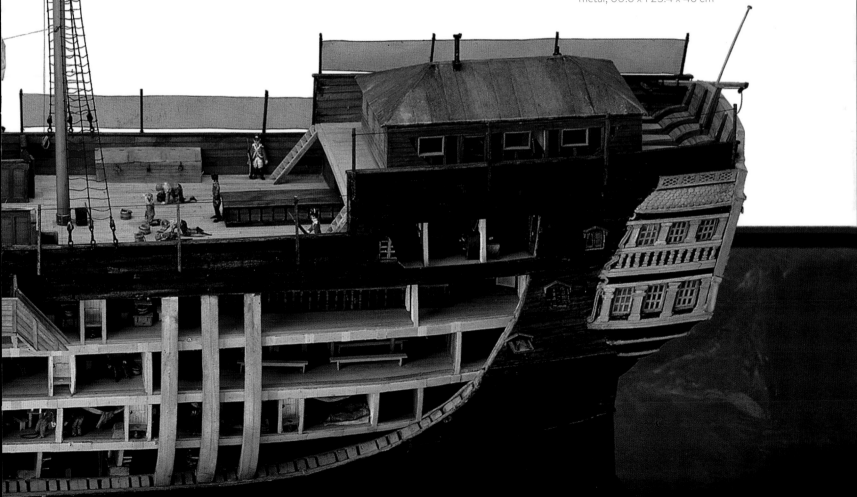

Borough of Manchester, IN THE COUNTY OF LANCASTER. (TO WIT.) } THE JURORS for our Lady the Queen, upon their Oath, present That *Edward Hunt* late of the Borough of Manchester, in the County of Lancaster, *Laborer*

on the *Tenth* Day of *January* in the *Sixteenth* Year of the Reign of our Sovereign Lady Victoria, by the Grace of God of the United Kingdom of Great Britain and Ireland, Queen, Defender of the Faith, with Force and Arms, at the Borough aforesaid, and within the jurisdiction of this Court

LARCENY.

One tame and reclaimed fowl called a hen

of the Property of *Daniel Foxwell* ———————————————— then and there being found, feloniously did steal, take, and carry away, against the form of the Statute in such case made and provided, and against the Peace of our said Lady the Queen, her Crown and Dignity.

AND THE JURORS aforesaid, upon their Oath aforesaid, do further present that at the General Quarter Sessions of the Peace, holden by adjournment at *Salford* in and for the said *County* the *Third* Day of *July* in the *eleventh* Year of the Reign aforesaid, and before the committing of the said Felony, for which he is above indicted, the said *Edward Hunt* ———— was convicted of Felony, and that the said Felony for which the said *Edward Hunt* is now above indicted, was committed by *him* after such previous conviction of *him* the said *Edward Hunt* for Felony as last aforesaid, against the form of the Statute in such case made and provided, and against the Peace of our said Lady the Queen, her Crown and Dignity.

PREVIOUS CONVICTION.

Pleads Guilty

Transported Seven Years

FELONY, No. *24.*

AUSTIN, ATTORNEY.

^ Transportation document
pertaining to Edward Hunt, 1853
Ink, vellum, 19.1 x 34.3 cm

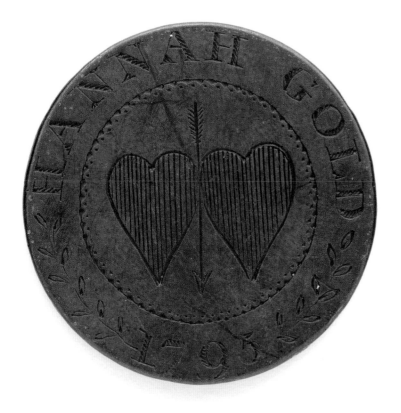

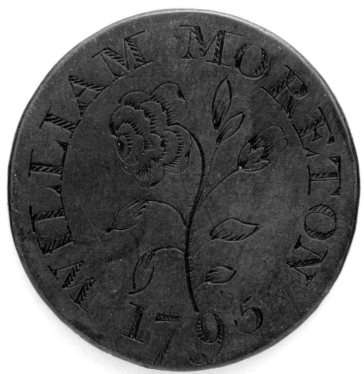

500 convicts and their guards lived, ate and slept in the ship's extremely cramped conditions. Serious overcrowding led to a mutiny in 1848, and the hulk was finally taken out of service and broken up – ironically by convict labour – in 1854.

Between 1788 and 1868, more than 160,000 men, women and children (as young as seven years old) were convicted and transported to the Australian colonies by the British and Irish governments. Although many of these convicts were habitual or professional criminals, a small number were political prisoners, social reformers and one-off offenders.

Convict transportation caused much human anguish – the isolation of the Australian colonies, and the high cost of the passage to or from them, meant that separation from loved ones, except for a lucky few, was for life. Before being transported, many convicts spent months on board hulks such as the *York*, where some memorialised their sorrow by engraving, or asking or paying another convict to engrave, low-denomination copper coins, such as this 1795 Anglesey Penny. It is a love token from William Moreton to Hannah Gold, engraved with their names, a rose on one side, and on the other, two hearts linked by an arrow.

Some makers wrote rhyming couplets such as 'When this you see, think of me'. Others carved images of themselves in chains, depicted signs of freedom such as a broken lock, chain or shackle, and engraved their names or initials alongside those of their loved ones. When they were transported, the makers left their tokens behind as mementos of a former life.

Kieran Hosty

Convict love token, from William Moreton to Hannah Gold, 1795 Copper, 3.4 cm (diam.)

The burning of the barque *India* in 1841

A spilled glass of medicinal rum and the simple accident of a candle falling onto it caused this horrific ship fire, which killed 18 men, women and children, all migrants seeking a new life in the Australian colonies.

Samuel Elyard's watercolour, painted around 1841, commemorates the terrifying inferno that destroyed the ill-fated *India*, carrying 198 crew and bounty immigrants to Australia. The painting is based on a sketch by Robert Allan, a survivor of the wreck. Under a smoke-filled sky, the ship is in flames. Dozens of figures cling to the bowsprit, some are being lowered by ropes, while others jump into the sea or grapple with a capsized longboat. Three boats, full of survivors, row away from the *India*, while a lone man floats on wreckage.

Born on the Isle of Wight in May 1817, Samuel Elyard was the son of an English naval surgeon who emigrated in 1821 to New South Wales due to health and financial problems. From an early age, Samuel showed a talent for portrait painting and studied under John Skinner Prout and Conrad Martens before specialising in landscapes. No doubt his own recollections of his childhood passage to Australia on board the *John Bull* in 1821 helped inspire this dramatic and thought-provoking painting.

The wooden, three-masted *India* sailed from Greenock, Scotland, on 4 June 1841. On board were 186 Scottish emigrants, including many young families from a single Scottish village who were travelling with their own church minister. There was also a group of single girls who had been specially selected by the Board of Emigration as prospective domestic servants and possible wives for single men in the Australian colonies.

The *India* passengers would have been prepared for many trials on the voyage, including unsavoury captains and crew, monotony and boredom, poor food, storms, icebergs, pirates, shipwreck and sickness caused by the cramped and unsanitary living. Being surrounded by water, one of the perils they least expected was fire, but wooden ships, with their towering canvas sails and rigging sometimes soaked with oil and pitch, were like giant fireworks – and once a fire started it was almost impossible to control.

The authorities and the *India*'s captain, Hugh Campbell, and crew were well aware of the huge dangers posed by fire at sea, and strict rules were laid down and enforced on board ship. The *India*'s cooking stove stood on fireproof bricks, fire buckets and pumps were always at the ready, pipe smoking was banned below deck, and only special 'fireproof' lanterns were supposed to be used. But in the almost subterranean existence below deck, people often used illegal lighting (such as candles) to bring some homeliness to the austere conditions of the steerage-class passengers' accommodation.

Once the fire took hold, the flames quickly spread, engulfing the *India* and forcing the passengers to abandon all their belongings and crowd onto the ship's bowsprit, huddling away from the wall of flames.

Luckily, help was at hand. As the flames overwhelmed the ship and the *India* began to sink, the French whaling barque *Roland* – shown in the painting – soon arrived, attracted by the thick smoke and the pyre-like glow in the sky. It rescued the surviving passengers and crew and took them to Rio de Janeiro.

Seventeen people drowned in the burning of the *India*, another child died in Rio de Janeiro and on 2 October, a young passenger, Eliza Quinn, fell overboard and drowned, raising the number of voyage casualties to 19. Some passengers were either sent back to Scotland or left behind in Rio, and the remaining 159 bounty immigrants set off for Australia on the *Grindlay* (of Liverpool). They finally arrived at Port Phillip Bay on 22 October 1841, some four and a half months after leaving Scotland.

Kieran Hosty

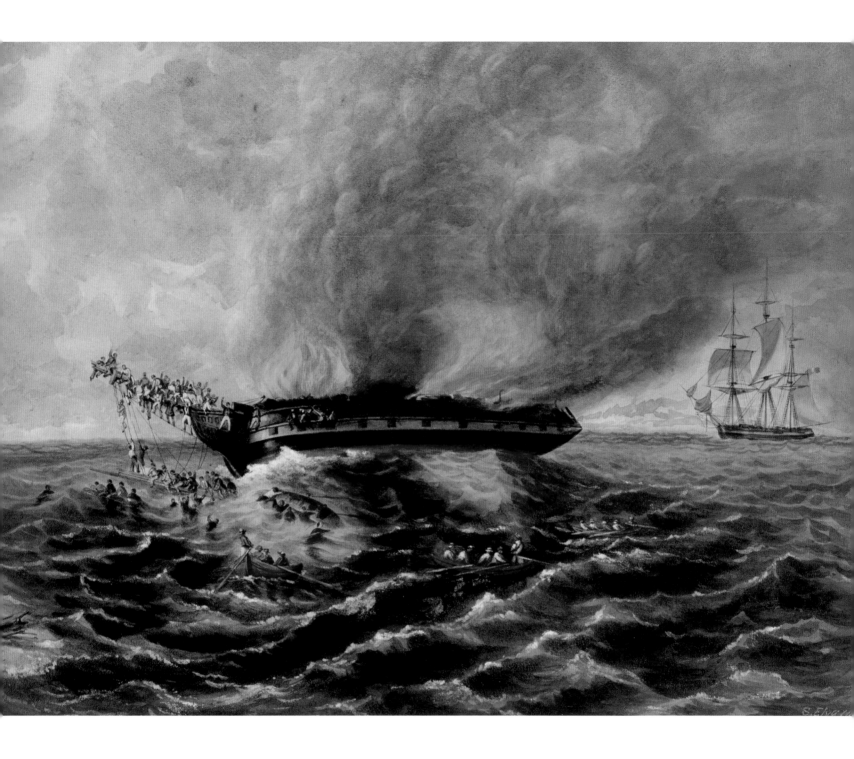

Samuel Elyard (1817–1910)
Burning of the Barque India *of
Greenock,* c1841 Watercolour on
paper, 41.7 x 55 cm

Dr John Coverdale was born at Kedgeree in India in 1814, the son of the local postmaster. His mother, Julia, was the daughter of Captain Speak, of Britain's East India Company. Although never stated publicly, Julia Speak's mother was 'a native of India', making John Coverdale Anglo-Indian and no doubt accounting for his nickname, 'Black Jack', while commandant of Port Arthur.

A passage from India

Dr John Coverdale (1814–96)
Letter from John Coverdale to his son Percy, 1870s. To keep the letter affordable to post, or if paper was scarce, people often wrote in this cross-letter style.
Ink on paper, 19.8 x 12.2 cm

After his father's death, John was sent to Scotland, where he graduated with a university medical degree in 1835 and soon made two trips to India as ship's surgeon. One wonders why Dr Coverdale decided to migrate to Australia following his return to England in 1837 – did his Anglo-Indian parentage make him uncomfortable in class-conscious England, or did he want, like so many others, to try his luck in a new country? Whatever the case, Coverdale used his qualifications and experience to work as surgeon on board the *Perthshire* on its voyage to the convict colony of Van Diemen's Land (Tasmania) in 1837.

As a ship's surgeon (or Surgeon-Superintendent, as they were known), Coverdale was kept busy. He was responsible for the general health and wellbeing of passengers and crew, protected women and children from abuse, sorted out disputes and grievances, inspected the food and accommodation, allocated work rosters and schedules, and oversaw the division of food and water rations. He also managed any sickness, illness, disease outbreaks or contagions on board ship, performed operations, amputations and dental work, assisted in births and, when all else failed, buried the dead.

Despite the best intentions of many surgeons, the unsanitary conditions on board passenger ships in the first half of the 19th century – along with inadequate medical knowledge of diseases such as measles, typhus, cholera, whooping cough and chicken pox – meant that the death

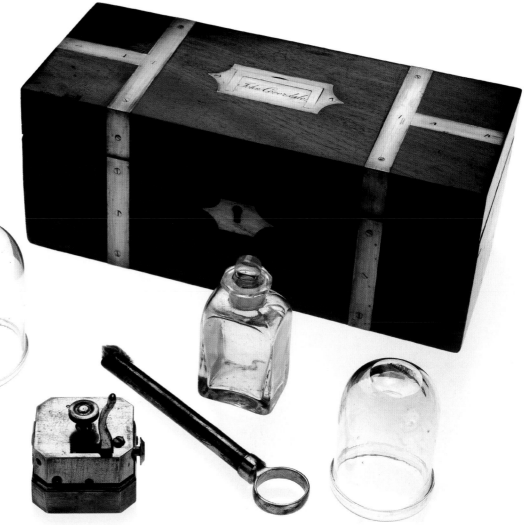

Bleeding kit owned by Dr John Coverdale, 1830–70. Features a brass scarifier (foreground, left), five glass moxibustion cups (one each at extreme left and right), a leather tourniquet, glass spirit bottle (back, centre) and a brass taper (front, centre) Mahogany, brass, velvet, glass, steel, brown leather, cotton, 9.8 x 25.3 x 10.6 cm

rate among the very young and the very old on some ships coming to Australia was as high as 25 per cent.

Luckily for the passengers and crew on the *Perthshire*, Coverdale was an experienced ship's surgeon, the vessel was relatively uncrowded and the voyage out was comparatively quick and uneventful – no deaths were reported.

In 1838, Coverdale's spinster sister Julia accompanied Anne Harbroe from England to Van Diemen's Land. Coverdale married Anne just 16 days after her arrival and they settled permanently in Van Diemen's Land, establishing a surgical practice in Richmond. However, they struggled to make a living over the next 15 years. The situation improved when Coverdale took up the post of Surgeon-Superintendent of the Queen's Asylum for Orphans in New Town, Hobart, in 1865, at almost three times his existing salary.

In 1874 Coverdale moved to the penal settlement of Port Arthur as Surgeon-Commandant. Although responsible for the care, welfare and supervision of convicts and pensioner and insane ex-convicts – a job by all accounts he performed very well – Coverdale also planted expansive

gardens there and corresponded regularly with his son Percy in Hobart about his various horticultural successes and failures.

Judging by the surviving letters, the Coverdales were happy at Port Arthur, but the colonial government had other ideas for it. Port Arthur was considered a blot on the landscape, part of the infamous 'convict stain' and something most respectable Tasmanians (the name of the colony was changed in 1854) wished to forget. In 1877 Coverdale was ordered to close the settlement, transfer the remaining convicts to Hobart and take the 'lunatics' to the Cascades Asylum, where he continued to look after them in his new role as Medical Superintendent until his retirement in 1889.

Kieran Hosty

On 20 August 1857, in the pitch darkness of a stormy winter's night, the *Dunbar* – only moments from safety at the end of an 81-day voyage from Plymouth, carrying immigrants and well-to-do colonists returning to Sydney – missed the entrance to Port Jackson and crashed into the sheer sandstone cliffs of South Head. The heavy seas quickly pounded the ship to pieces, and all but one of at least 122 souls on board perished – leaving behind these fragile relics and memorials of past lives.

Sydney's worst maritime disaster

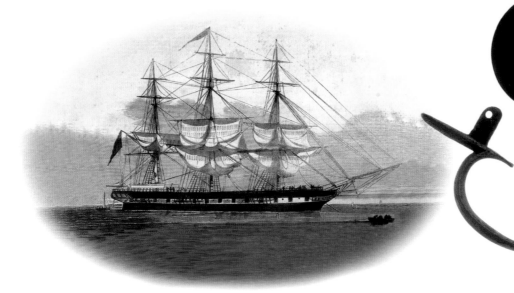

As dawn broke, Sydney awoke to dreadful scenes of debris and battered corpses carried into the harbour on the tide. The impact of the disaster was profound: some of the victims were well-known, prominent citizens. Some 20,000 people lined George Street for the funeral procession, and there was a massive outpouring of grief in the colony – still evident today with the yearly *Dunbar* service at St Stephen's Church in Newtown.

The tragedy quickly spawned a small industry commemorating the disaster. Accounts and pamphlets were published, poems and paintings made. Despite authorities prohibiting the plunder of wreckage washing ashore,

∧ Artist unknown *The Dunbar New East Indiaman*, 1853 Hand-coloured wood engraving, 13 x 24 cm

> A small selection of the museum's *Dunbar* collection, purchased with the assistance of the Andrew Thyne Reid Charitable Trust

memorabilia made from the ship's timbers began to appear. Furniture, tableware and souvenir boxes have survived, passed down as treasured mementos of an incredible event on Sydney's doorstep.

One such relic is a solid timber chair known as 'the Captain's Chair'. The mid-19th-century diary of Florence Fraser, the great-great-grandmother of the last owner, says it was recovered from Bondi beach. But it is in excellent condition – with no signs of damage or repair – suggesting that it was not *Dunbar* cabin furniture or cargo, since it would be most unlikely to have washed ashore unscathed. Unusually, the seat and back are carved from a single timber, probably an angular piece of the ship's framing called a 'knee', which would have originally help support one of *Dunbar*'s deck beams. Once this was salvaged, the Captain's Chair was probably created by a local cabinet-maker dabbling in *Dunbar* souvenirs.

Most of the ship's cargo, fittings and passenger belongings sank onto the rocky seabed of the wreck site. Mid-19th-century salvage technology enabled some larger items, such as the anchors, to be raised, but countless smaller items remained wedged in crevices for another century, awaiting discovery. From the late 1950s, devotees of the new

The Captain's Chair, constructed from timber salvaged from the wreck of the *Dunbar*, 1857 Timber, 190.7 x 69.1 x 82 cm Photo: Merinda Campbell, ANMM *Gift from Helen and Peter Isbister*

sports of spear fishing and scuba diving found easy pickings in the shallow waters below the Signal Station at South Head, just a short dinghy-ride from the harbour in calm weather.

In the 1960s, diver John Gillies retrieved a trove of artefacts from the *Dunbar* site. Over 10 years, sometimes using explosives to break up concretions, Gillies recovered a huge range of items, among them coins, which were modified and turned into jewellery; trade tokens, which had been used in the 1850s as cash at popular stores and shops in Sydney; cutlery; personal effects, including watches, jewellery, wedding bands, earrings, gold denture plates (some complete with teeth), buttons and buckles; and furniture, gaslight and plumbing fittings.

Around this time a growing number of divers started raising public and government awareness of the historical and archaeological treasures that lay buried beneath the sea. Under historic shipwreck legislation, the *Dunbar* was protected. In 1993, the Australian Government offered an amnesty so that material from protected shipwrecks could be recorded, and John Gillies declared his collection of more than 5,000 *Dunbar* objects. The museum acquired this significant collection to prevent it from falling into private hands or being broken up.

Other relics – including anchors, ballast blocks, coins and crockery fragments – remain on the seabed, and the site, now surveyed and monitored with the aid of the museum's maritime archaeology program, is itself a memorial to those who perished so miserably in the *Dunbar* tragedy on that night in August 1857.

Kieran Hosty

In 1909, eight-year-old Lily Knapton and her mother departed Liverpool on the White Star liner SS *Runic*. They were migrating to Australia to join Lily's father, who was working as a tailor in Melbourne, Victoria.

A child's journey

In the early 1900s children played, ate and slept in the same cabins as their parents and often made their own fun on the long journey to Australia. Lily packed her favourite toys to play with on *Runic*, including a child hand-puppet, a miniature tea set and a delightful pair of Japanese celluloid dolls. The dolls – delicately painted and finely dressed – represent the type of toys available to little girls in the early decades of the 20th century. Knitting needles, balls of wool, patterns and an unfinished embroidered pillowcase helped Lily pass the time, while a simple rope quoit and ball made by a sailor on *Runic* also kept her entertained during the eight-week voyage to Australia.

Runic carried British migrants on a regular service from Liverpool to Sydney from 1901, the same year the *Immigration Restriction Act* was passed by Australia's new Federal Parliament. The Act placed certain restrictions on immigration and reflected the government's desire to build a white Australia. The government's preference was for British immigrants and it offered cheap fares to attract them to Australia. Many Britons, including Lily's father, saw emigration as a chance to find work and establish a new life for their family.

The collection includes a series of books from Lily's schooling in England and Australia over a 10-year period from 1907 to 1917.

TOP LEFT Miniature photograph of Lily Knapton, c1909 *Silver gelatin print 2.1 x 1.5 cm*

Lily Knapton's dolls, c1909, girl (left) and boy (above) *both celluloid, paint, elastic, 8 x 3.5 x 2.5 cm All: Gifts from Gary McPherson*

Copy books and drawing books from Lily's early school days contain arithmetic tables and handwriting exercises in elegant cursive script, while exercise books from her later studies in Australia include lessons on hygiene and housewifery. In a lesson titled 'Care of sick' in 1917, 16-year-old Lily writes about the selection and preparation of a room and bedding for a patient:

> The room should be large, lofty and airy. It should have a fire place with open chimney and windows that open top and bottom. A north westerly aspect is the best. The walls and floors should be thoroughly clean and dry. Large carpets should not be laid on the floor but small strips of carpet or mats may be placed beside the bed. The bed should be of wood or iron about three or three and a half feet wide and the full length of the patient. The best bed or (bedding) mattress is horse hair or air. The sheets should be soft and light, blankets new.

The schoolbooks span a pivotal period in Lily's life and reveal fascinating details about social conditions, education and gender roles in the British Empire at the turn of the 20th century. Lily treasured these books, as well as her childhood toys, all her life as mementos of her homeland, her voyage on *Runic* and her subsequent settlement in Australia. The charming collection was donated to the museum in 1996, and provides a rare insight into the nature of childhood and children's journeys from Britain in the early 1900s.

Kim Tao

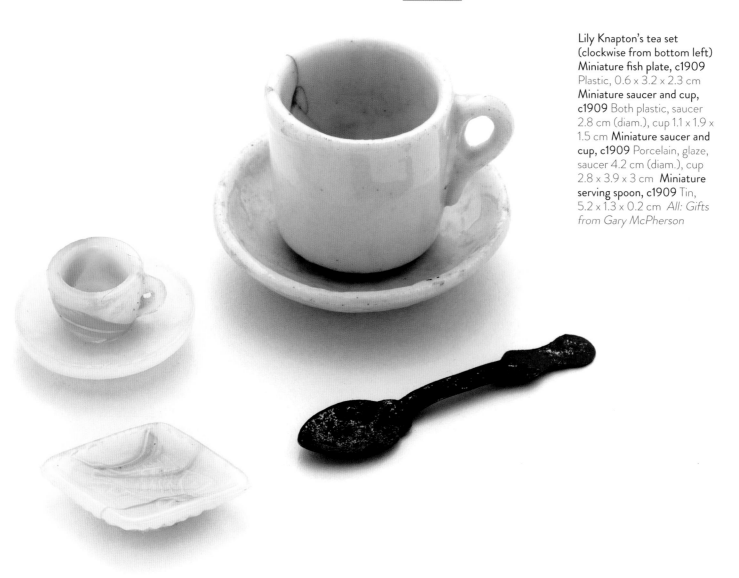

Lily Knapton's tea set (clockwise from bottom left) Miniature fish plate, c1909 Plastic, 0.6 x 3.2 x 2.3 cm Miniature saucer and cup, c1909 Both plastic, saucer 2.8 cm (diam.), cup 1.1 x 1.9 x 1.5 cm Miniature saucer and cup, c1909 Porcelain, glaze, saucer 4.2 cm (diam.), cup 2.8 x 3.9 x 3 cm Miniature serving spoon, c1909 Tin, 5.2 x 1.3 x 0.2 cm *All: Gifts from Gary McPherson*

Door to freedom

A few days before boarding the Orient liner SS *Orama* for Australia in June 1939, Jewish migrant Arthur Lederer wrote 'Doors', a poem reflecting on his family's desperate search for a new home away from Nazi-occupied Europe:

> 'Some doors have hearts it seems to me/They open so invitingly;/You feel they are quite kind – akin/ To all the warmth you find within … /Oh, may mine be a friendly door;/May all who cross the threshold o'er/Within find sweet content and rest,/ And know each was a welcomed guest.'

The poem is now part of an evocative collection that includes photographs of Arthur Lederer and his wife, Valerie, enjoying the Salzburg Festival in pre-World War II Austria; a passport issued to their only son, 16-year-old Walter; and treasured keepsakes from the family's home in Vienna. The collection reflects the Lederers' long journey to Australia, via Czechoslovakia, and also provides fascinating glimpses into their former life in Austria.

Born in 1889, Arthur Lederer was a talented Viennese tailor who made gala uniforms for European royalty and high society. On the eve of Adolf Hitler's march into Vienna in March 1938, Arthur was working on Archduke Otto of Austria's coronation robes, believing that the exiled monarch would return.

In November that year, the Lederers attempted to flee the escalating Jewish persecution in Nazi-occupied Austria. They travelled by taxi from Vienna to the Austria–Czechoslovakia border, but were held up by the German Gestapo and imprisoned. Released after three days, they returned home to Vienna.

Four weeks later they again tried to escape. The family purchased passports in December 1938 and travelled by

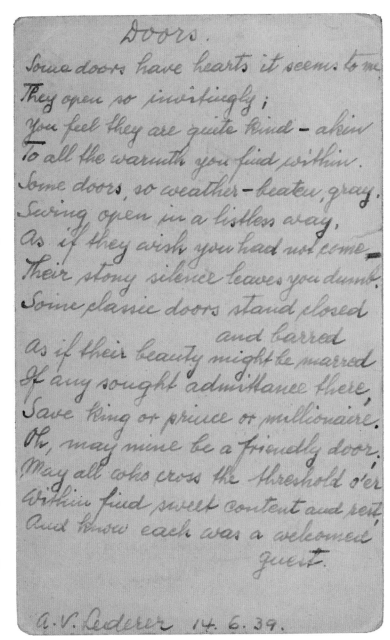

ʌ Arthur Lederer's handwritten poem 'Doors', 14 June 1939
Postcard, 14 x 8.6 cm

v Valerie Lederer's front door key to the family's house in Vienna, 1938
Metal, 9.5 x 2.3 cm (length x width)
Both: Gifts from Walter and Jean Lederer Donated through the Australian Government's Cultural Gifts Program

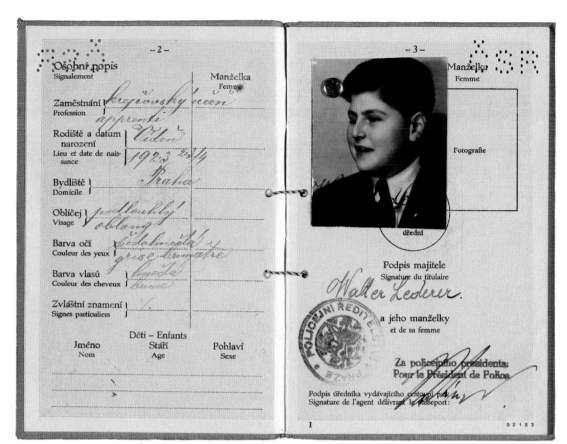

Austrian Airlines to Prague, Czechoslovakia. The League of Nations (forerunner to the United Nations) issued them with Nansen passports, an internationally recognised identity card provided to stateless refugees.

Arthur then started appealing to his well-connected clients for help to escape Europe, in letters that are now at the heart of this collection. Most clients did not respond, perhaps fearing they would be persecuted by the Nazis for assisting Jews. Eventually Lady Max Muller, wife of the British Ambassador to Spain, provided them with tickets to Australia on *Orama* and the £300 arrival money required by the Australian Government. Arthur later wrote to Lady Max Muller, who helped the family through the Quaker relief organisation Germany Emergency Committee, to say, 'I shall never be able to express all I feel of gratitude for the human kindness and the generosity of heart which make you take up all the incessant work for us emigrants'.[1]

Walter Lederer recalled that Lady Max Muller's £300 'actually gave us the very first start to begin life in Australia'.[2] He also remembered how his mother would still carry the key to the family's front door in Vienna, even after they had found safety in Australia. 'Perhaps she thought she may go back one day,' Walter said. One of the most poignant items in the Lederer collection, the key reflects the migrant's ever-lingering nostalgia for home and a 'friendly door' to 'sweet content and rest'.

Kim Tao

Displaced persons

In *Displaced Persons*, 20 crisp cotton handkerchiefs – traditionally used to wave farewell and wipe away tears – provide the canvas to explore the twin biographies of photomedia artist Anne Zahalka and painter and installation artist Sue Saxon. The series, created in 2003, 'traces the narrative of [their parents'] journeys to Australia from Europe with the uniting thread of the good ship *Surriento*'.[3] Delicately stitched white words contrast different dimensions of the migrant's physical and emotional journey, while in the centre of each handkerchief, images and documents retrieved from the artists' family albums reflect and amplify these words.

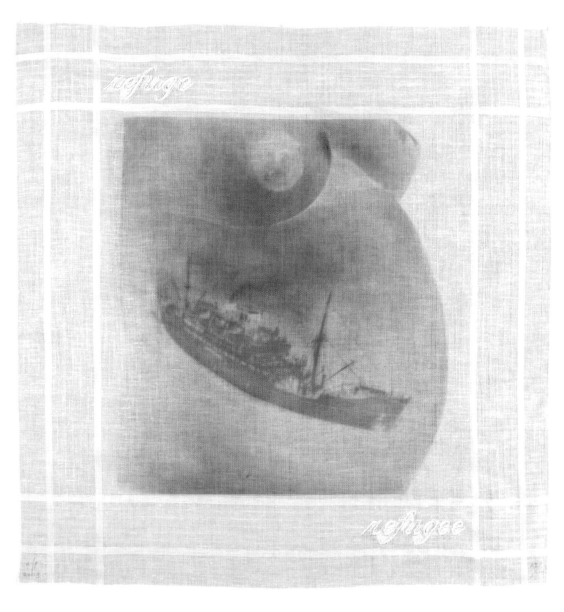

Sue Saxon (b 1960) and Anne Zahalka (b 1957) *Refuge/Refugee*, 2003 Screenprint on linen, 45.5 x 44 cm © Sue Saxon and Anne Zahalka, reproduced courtesy of the artists

Anne Zahalka's and Sue Saxon's families share a similar history. Anne's mother, Hedy, fled Austria to escape Nazism in 1936. Later, Hedy and Anne's father, Vaclav, escaped Prague after the Communists seized power in 1950. Anne says, 'After the Communist takeover of Czechoslovakia, my mother wanted to find a place as far

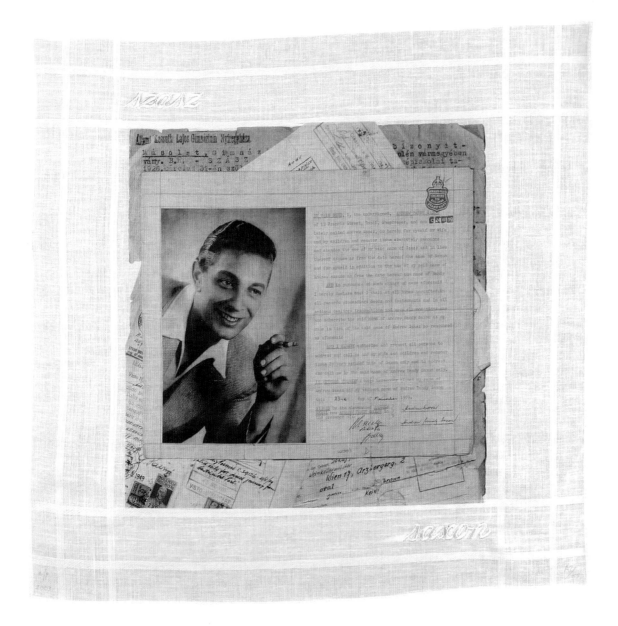

away from Europe and its traumatic past as possible.'[4] Similarly, Sue Saxon's father, Bandy Szasz, saw Australia as representing 'the greatest distance between a blood-soaked Europe and a new future'.[5] He survived the German occupation of Hungary during the war using false papers, but was later driven out. Displaced from their homelands, both Anne's and Sue's parents migrated to Australia in 1950 on the Flotta Lauro liner *Surriento*.

Displaced Persons explores this shared history, addressing the complexities of the migrant journey while also urging audiences to connect these experiences with those of more recent migrants. 'For Anne and me,' Sue says, 'the making and exhibiting of *Displaced Persons* acknowledged not only our families' struggle to find a safe place to live and flourish, but for the difficulties faced by all refugees.'[6]

In *Refuge/Refugee* (p. 75), the ship *Surriento* appears suspended in Sue's pregnant belly, signalling hope for the future as well as hinting at the intense feelings of apprehension that accompany new life. Migration, particularly for the displaced, can be likened to rebirth – a new life, a new home, a new identity. Two works, *Vaclav/Paul* and *Szasz/Saxon*, refer to the

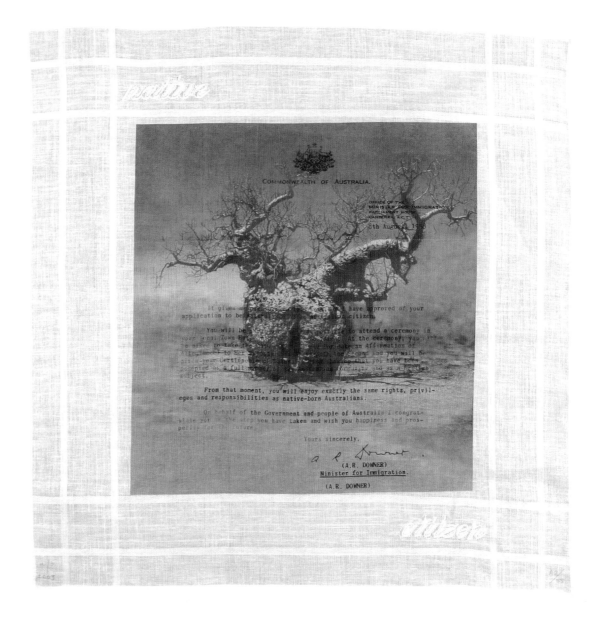

anglicising of both artists' fathers' names – a common practice among migrants who feared bigotry and wished to blend in quickly. An arresting snapshot of Bandy Szasz adjoins the deed-poll document confirming his change of surname. It raises the question of what else this quintessentially European-looking man sacrificed to 'fit in', and is a poignant reminder of how migration often necessitates a denial of cultural identity.

 Displaced Persons also encourages audiences to confront contemporary issues. *Native/Citizen* features Vaclav Zahalka's Australian citizenship document over a sepia image of a hollow boab tree in Western Australia, once used as a police lockup for Aboriginal offenders. Anne acknowledges the irony in the official text granting her father 'the same rights, privileges and responsibilities as native-born Australians'. At the time Vaclav migrated to Australia, its Indigenous people had few rights and even fewer privileges. The work implies that for all its fresh promise, this isle of refuge was no stranger to racism and intolerance. Issues of dispossession are historic and enduring.

Lindl Lawton and Kim Tao

White Russians Ilia Seiz Pocrnja and his wife Katherine fled to China in 1918 after the Bolshevik Revolution. In 1919 Ilia co-founded the English Language School in the northern city of Harbin, home to a vibrant Russian community until the Japanese occupation in the 1930s drove many away. Ilia helped Russians in Harbin to apply for visas for Australia and South America, but was harassed by the police and branded a spy working for Britain and the United States.

Stateless

Ilia, Katherine and their adult son Eugene were forced to leave China after the Communist revolution and establishment of the People's Republic of China in 1949. They packed their precious belongings – Russian vinyl records, photographs, and stamps and language books from the Harbin school – into a Chinese silk-lined trunk, now part of the museum's collection.

Eugene Seiz remembered, 'My father said don't believe [the Communists] son, they have not at all freedom in their country. You can find real free world only in British countries or US. I believed my father. Our only hope was to get visa to Australia.'[7]

In 1955 a Russian family in Sydney sponsored the Seiz family's migration to Australia on the Royal Interocean liner SS *Tjibadak*. When they arrived, the word 'stateless' was stamped on their immigration papers, even though they had lived in both Russia and China. Decades later, Eugene's daughter Natalie Seiz – who knew little about her family's migration – discovered these papers in the National Archives of Australia. Natalie recalls:

When the documents came in it became much more personal. Before, I used to just think about it at a distance. Now they were really real people, and they had a life. And I didn't know anything about that life. I started realising how tough their life was towards the fifties when the Communists were coming

> The Seiz family's belongings. (Clockwise, from bottom left): English/Russian dictionary, 1905 Book, 26.5 x 17 x 5.5 cm; Russian record album, late 1800s–early 1900s Phonograph records, vinyl, ink on paper, leather, 26.5 x 30 x 5 cm; Chinese character stamp from English Language School, Harbin, 1919–1942 Wood, 3.5 x 4.8 x 8 cm
All: Gift from Natalie Seiz

Tax Invoice

3/04/2016 10:50:18 AI

ABN: 35 023 590 988

Australian National Maritime Museum

2 Murray St, Darling Harbour

SYDNEY, NSW 2000 Tel. 02 9298 3698

SO#: Receipt #: 366820
3/04/2016 Store: 0010
Assoc: Cathy Cashier: Cathy

Bill To: BIG TICKET ANMM BIG TICKET

ITEM		QTY	PRICE	EXT PRIC
3030	100 STORIES I	1	39.95	39.9
3209	P/C: JAMES CF	1	1.20	1 2
8019	P/C - ENDEAV(1	1.20	1 2

3 Unit(s) Subtotal. 42.3(

RECEIPT TOTAL: **42.3(**

Tend: 42.3(

CrCard: 42.35 VISA
0000 Exp /

Signature_____

WE DO NOT REFUND FOR
CHANGE OF MIND PURCHASES

The Receipt Total Includes $ 3.85 GST

Your purchase helps support the Museum and
preserving Australia's maritime heritage- Thankyou

in, especially when my grandfather's school was shut down [by the Japanese in 1942]. I started wondering, where were they getting an income? And it could've been my father was working in a field somewhere, just trying to get some money for the family. That could've been a reason that he gave up [his medical] studies. I just don't know.[8]

In Sydney, Ilia worked as a trimmer at the Dunlopillo factory in Bankstown, Katherine found work in the kitchens at the Imperial Service Club in Barrack Street, and Eugene established the Abode real estate agency. Katherine was an active member of the Russian Catholic congregation in Sydney. She would listen to her classical records, which she carried on her long journey from Russia to Australia, as reminders of a distant life in Petrograd (now St Petersburg). Natalie says:

> She was nostalgic about St Petersburg and living there. Russia was always home …
> I don't think she ever really felt she belonged [in Harbin] in the same way that she did in Russia. That was evident in that she didn't really speak Chinese. I think my father did, but my grandmother seemed to be that stateless person, an outsider, yet within a country. It seemed that when she came here she was still an outsider in Australia. She learnt a bit of the language, enough to get by, but she never became really confident in speaking it.

When Katherine died in 1990, Natalie inherited her possessions from Russia and China, which she treasures as 'a reminder of my father's and grandmother's lives'. The language books, in particular – including this English–Russian dictionary used by her father – take on even greater significance as symbols of her grandfather's livelihood

Portrait of Ilia Seiz, early 1900s
Photograph, 35.5 x 30 cm *Gift from Natalie Seiz*

in Harbin and his desire to resume a teaching career in Australia, her father's childhood, and the challenges many migrants face in learning a new language. For Eugene, 'in Australia is only one difficult thing – language. But if you working on this language – try to speak everywhere in English including home – you will pick it up very quickly. Then everything will be alright.'

Kim Tao

In 1949, Lois Carrington (née Griffiths) was an enthusiastic 21-year-old, recruited to teach English to postwar migrants. Like many of her colleagues, she was fresh from university – a student of Russian, French and Latin – and thrown in at the deep end with limited resources. But, as Lois watched a Dutch puppeteer stage a play at Bathurst's migrant camp, she realised that puppets both lighten the mood and reach across cultural and language barriers. More than 50 years later, the delightful puppet troupe she created to help her students learn English was welcomed into the museum's collection.

Puppets taught postwar migrants

'My father thought it would be good to have Russian up my sleeve, because then I would get a good job in trade', Lois Carrington said.

We were actively recruited [by the Australian Government] and went to Bonegilla Migrant Reception Centre which had been open for a couple of years. Then we learnt on the job … From Bonegilla I was sent to Benalla camp, which was pretty lonely. I sat down with my needle and thread and a few scraps of fabric. The first puppets were three little pigs, and although crudely made were wonderfully effective. 'Three little pigs' has a lot of repetition. It's a good story to learn, if you think about it.[9]

Learning English was a key tenet of the Australian Government's official policy of assimilation after World War II. Migrants were offered classes aboard their ships, in Australia's migrant reception centres and in the workplace. Australia pioneered the style of English teaching – 'Situational English' – that is now embraced worldwide:

instead of focusing on vocabulary and grammar, students learn complete English sentences using film, role play and props. 'The time-honoured translation/grammar way of teaching a language just would not have worked in a classroom which might seat 20 different nationalities,' Lois explained. 'We used English, English all the way. And all the time, we acted this out. We created a situation.

It all ran on sentence patterns. Today you would call it role playing.'[10]

In 1955 Lois was appointed a shipboard education officer on the Italian migrant liner *Toscana*. Gigi the clown, one of her two marionettes (or string puppets), was among the puppet troupe she packed for each voyage. Lois used them for reinforcing lessons and drills.

> I would already have taught them a sentence like, 'There isn't any butter on the table but there is some jam'. They would hear puppet A say to puppet B, 'There isn't any butter on the table but there is some cheese'. And they recognised it and were grinning.[11]

Lois's puppets – which included clowns, animals and even a hippie – also acted out children's stories and 'Australianisation' scenes, demonstrating how to buy a bar of soap or a train ticket, or post a letter.

Lois recalled that class enrolments aboard *Toscana* skyrocketed when her often multilingual migrants discovered that their new country was monolingual. 'They knew Australians spoke English,' she said, 'but what did I mean that was the only language they spoke? It dawned on them that I actually meant that! Oh boy, they all came to school then.'[12]

She also remembered being thronged in Perth, their first port of call, by groups of excited migrants, thrilled that they had actually managed to buy a pound of cherries or a bus ticket.

Lois left *Toscana* in 1956 and later returned to Bonegilla as a teacher, where she soon put her puppets to work again. In 1959 she married George Carrington, whom she met while studying at Melbourne University, and in 1968 they and their young children Mim and Ed shifted to Papua New Guinea for six years, where Lois used her puppets to teach English in Port Moresby. On returning home, Lois worked at the Australian National University's linguistics department for more than 20 years, retiring in 1996. Her grandchildren embraced the puppet family, using them to act out their favourite stories at home behind their couch, before the puppets were generously donated to the museum in 2006.

Lindl Lawton and Kim Tao

< Lois Carrington (1928–2008) *The Big Bad Wolf and Two Little Pigs*, 1948–1960 Fabric hand puppets, 37 x 16 x 12 cm (wolf), 35 x 18 x 6.5 cm (pig), 42 x 20 x 7.5 cm (pig) © Estate of the artist, reproduced with permission *Gift from Lois Carrington*

ʌ Lois Carrington (1928–2008) *Gigi the Clown*, 1948–1960 Marionette, papier-mâché, fabric, wood, string, leather, metal, 58 x 24 x 11 cm © Estate of the artist, reproduced with permission *Gift from Lois Carrington*

> *English for Newcomers to Australia, Students' Book One*, 1956 Book, 21.5 x 14 x 1.5 cm *Gift from Lois Carrington*

ENGLISH FOR NEWCOMERS TO AUSTRALIA

Students' Book One

4th Edition - September, 1956

Like many refugees after World War II, artist Gina Sinozich abandoned her homeland for a destination she knew almost nothing about. From 1956 to 1957, she and her family made the voyage from Istria, Croatia (in the former Yugoslavia), to Australia. It was only years later in 2000, when Gina was 70 years old, that she completed her first painting.

Gina's journey

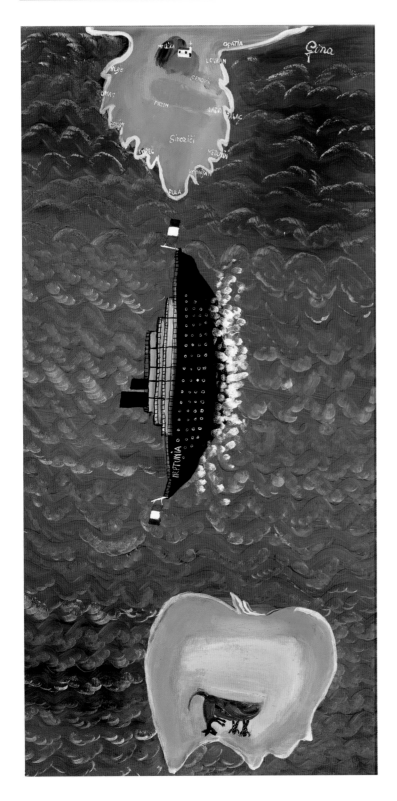

The museum commissioned a series of 14 paintings by Gina Sinozich in 2003. Naïve in style and playful in tone, they tell an intensely personal and powerful story.

We Are Sailing from the Known to the Unknown shows a Croatian landscape stippled with significant sites: the village of Senovik, where Gina was born; Sinozici, the town where her husband Eugen's family lived; and a cherished church in the foothills of Mount Ucka. The Lloyd Triestino liner *Neptunia* steams vertically Down Under to a seemingly uninhabited Australia, represented by a clutch of tourist clichés: Aboriginal people, Uluru and a kangaroo.

It was Gina who finally made the decision to leave. After World War II, Croatia was absorbed into the Communist republic of Yugoslavia, governed by Marshall Josip Tito. Life for the Sinozich family was difficult and food was scarce. Gina wanted a more secure future for her children, Michael and Jenny.

In April 1956 Gina and her children slipped across the Italian border on the pretence of visiting her mother in Trieste. Eugen followed several months later. Gina could not risk telling anyone, even close family, that they were leaving. 'We left everything,' she says. 'We didn't take nothing with us, not even a photo.'[13] In the poignant *Our Precious Things We Left Behind* Gina recreates, on a rain-swept wharf in Rijeka, an imagined farewell to loved ones.

> *Our Precious Things We Left Behind*, 2003 Oil on wood, 46 x 60.5 cm

< All works by Gina Sinozich (b 1930) *We Are Sailing from the Known to the Unknown*, 2003 Oil on wood, 90 x 45 cm

>> *All Our Possessions When We Arrive in Melbourne 16.8.1957*, 2003 Oil on wood, 30 x 40 cm
All works © Gina Sinozich, reproduced courtesy of the artist
All: Gifts from Gina Sinozich

Gina applied for political asylum in Italy and was sent to a migrant hostel in Udine sheltering 3,000 other refugees. It was 'not a happy place,' Gina recalls. Food was monotonous: 'every day was macaroni and tomatoes and powdered milk.' Several families were bundled into the same room, and refugees lived in limbo waiting months, sometimes years, for their papers to be processed.

After many months, Gina finally found her family's name – 'Sinozich departing Genoa' – on the hostel notice board. Asked to choose between Australia and Canada, Gina and Eugen chose Australia, 'a new country' that they believed offered greater opportunities for their children. Gina treasured her ticket for the *Neptunia*. 'At last we were going somewhere,' she says. 'Just to go away from the hostel and start something positive.'

In July 1957 *Neptunia* departed Italy for Australia. 'The boat was beautiful inside,' Gina remembers. 'We had a second-class dining room and a bottom-class sleeping quarters. There was always vino at every meal. They would have magic shows, English classes, picture shows. And I saw huge whales – it was the first time I saw whales.'

After a month at sea, travelling the Suez route, *Neptunia* finally docked in Melbourne. Gina recalls, 'It was a beautiful day. I was so happy. Finally we put our foot down on the soil that we wanted.' The family spent several weeks at Bonegilla Migrant Reception Centre near Wodonga, Victoria, before moving to Sydney. Gina remembers that Bonegilla, with its private rooms, 'smorgasbord' of food and 'even a little bit of pocket money', seemed paradise compared to the trials of Croatia and Italy. 'I could never forget it. The table was full of meat and there was this big dish of fresh milk. And the people from the kitchen said take as much as you like. Can you imagine giving the kids fresh milk after 18 months?'

The last painting in the series, though modest, is perhaps the most moving. *All Our Possessions When We Arrive in Melbourne 16.8.1957* shows three small brown cardboard suitcases inscribed 'Sinozich – Genova to Melbourne, Australia'. The image speaks volumes about how much refugees left behind, and with just how little new lives were started.

Lindl Lawton and Kim Tao

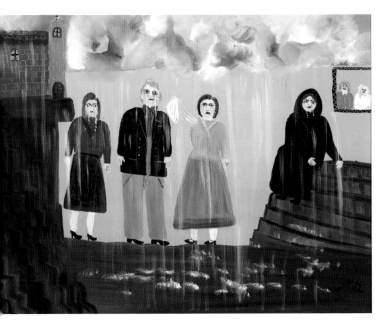

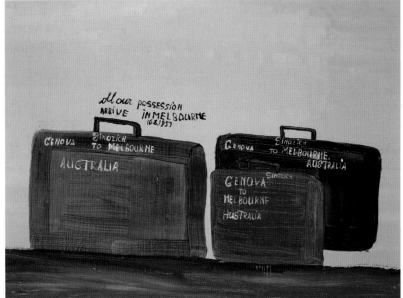

Tu Do – a fishing boat used by refugees – made an intrepid 6,000-kilometre voyage from Vietnam to Darwin in 1977. Its captain, 30-year-old Tan Thanh Lu, used a simple compass and a map torn from the lid of a school desk to guide the vessel to Australia. As they neared Darwin, a golden beach with two sunbathers appeared like a beacon of hope. Tan was so relieved that he hurled himself into the water, swimming two kilometres to the shore with the aid of a buoy.

A fishing boat called *Freedom*

After the fall of Saigon to Communist forces in 1975, thousands of Vietnamese fled their country, many in overcrowded, leaky boats headed for Australia. The exodus coincided with a major shift in Australia's immigration policy – which had previously favoured British migrants – and most were allowed to stay.

In 1975, Tan Lu owned a thriving general store on Phu Quoc Island in Vietnam's south. With three friends he pooled resources and built a boat that he named *Tu Do*, meaning 'Freedom'. Although built specifically for the voyage, to keep it inconspicuous it was constructed like typical fishing craft used on the island. Tan initially used it for fishing to avoid suspicion and to help pay for crucial supplies which were hidden in his fellow voyagers' homes.

When he was ready to escape, Tan staged an engine breakdown so that surveillance of *Tu Do* would be relaxed. He installed a more powerful replacement engine by night and his group of 38 passengers set off in the dark on 16 September 1977, pushing the boat across kilometres of tidal shallow water to maintain silence before starting

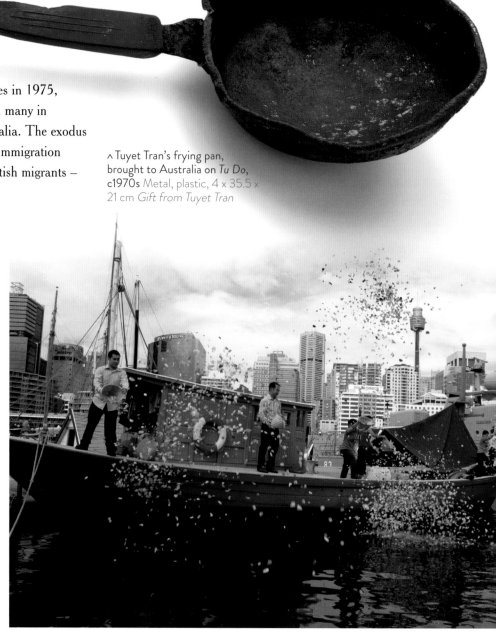

∧ Tuyet Tran's frying pan, brought to Australia on *Tu Do*, c1970s Metal, plastic, 4 x 35.5 x 21 cm *Gift from Tuyet Tran*

the motor. The children had been given cough medicine to keep them quiet, but, as they reached deeper water, a head count revealed that Tan's six-year-old daughter Dzung had been left sleeping on the shore. They returned to fetch her and the voyage began. On board were Tan's pregnant wife Tuyet, 27, their other infants Dao and Mo, and relatives, friends and neighbours.

With gold and cash hidden about the vessel, *Tu Do* outpaced the notorious Gulf of Thailand pirates who preyed on boat people. Turned away from one port in Malaysia, the group managed to land in Mersing, where eight exhausted passengers disembarked as refugees. After a month, and unsuccessful approaches to US Embassy officials, Tan bought more supplies and sailed for Australia with his remaining 30 passengers. Off Flores in Indonesia they rescued another Vietnamese refugee boat that had run aground and towed it across the Timor Sea, landing near Darwin on 21 November.

The Lu family was then transferred to the Wacol Migrant Centre in Brisbane, where son Quoc was born. Years later Tuyet said:

> When I think about leaving Vietnam I'm still scared. There were storms and many times waves as big as *Tu Do* crashing down and I thought, 'That's the end of it'. To leave Vietnam was a big risk but now I see the future for my children is much better.[14]

While at Wacol, Tan arranged to sell *Tu Do*, and was charged import duty. The museum acquired the boat in 1990, extensively overhauled it and replaced planking as required (more than 80 per cent of the original timber survives). *Tu Do* is one of just three refugee boats held in Australian museum collections, and the only one that is floating and operational.

The *Tu Do* collection – including oral histories of the Lu family, photos of their arrival in 1977 by photojournalist

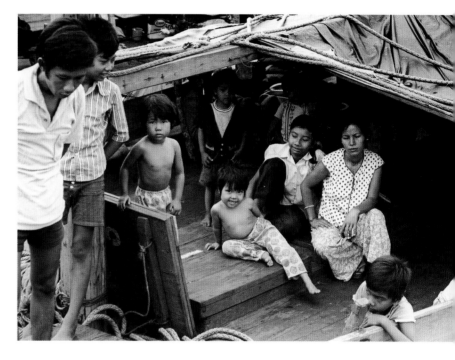

Michael Jensen, and possessions they took on the voyage, such as Tuyet's favourite frying pan – personalises the Vietnamese exodus, giving museum visitors a powerful insight into refugee journeys. With Tan's help, the museum also sourced replicas of crockery, clothing and provisions taken on board. Tan Lu died in 2003. His son Mo reflects: 'My Dad named the boat *Tu Do* to remind everyone about where they were going and what they were going to. I didn't realise how much my parents experienced. That is a story I want passed on to my son.'[15]

Kim Tao, Lindl Lawton and Helen Trepa

< *Tu Do* is relaunched by the Lu family after its restoration by the museum, 2005. Tan Thanh Lu built this 18.25-metre boat in 1975 on Phu Quoc Island, Vietnam. Pictured (from left) are his sons Quoc and Mo, daughter Dzung and, at extreme right, wife Tuyet and daughter Dao, throwing rose petals to bless the boat that carried them to freedom.

> Michael Jensen (b 1943) Lu family on the deck of *Tu Do* in Darwin Harbour, 1977. Tan Thanh Lu (left, in white shirt), daughters Dzung and Dao (standing and sitting on the hatch) and Tuyet (in spotted shirt), shortly after arriving in Darwin. Silver gelatin print, 26.2 x 39.4 cm © Michael Jensen, reproduced courtesy of the photographer

Thi Nguyen was only 12 years old in 1987 when she and her family took to sea in a small fishing boat to escape oppression in Vietnam. Her sculptures *History*, *Fate* and *Destiny* grew out of this experience. In *The Last Leg*, Australian artist Claire Bailey, the daughter of British migrants, reflects on immigration to Australia since the First Fleet. Both works acknowledge the importance of the boat and migration by sea in Australia's history.

History, Fate, Destiny and The Last Leg

The Nguyen family spent two and a half years in a Hong Kong refugee camp before being allowed to migrate to Australia in 1990. Thi created these three boat sculptures — *History*, *Fate* and *Destiny* — for her NSW Higher School Certificate examination in 1994. Together they symbolise the struggle and spirit of all Vietnamese refugees.

Thi modelled *History*, the largest boat, from clay and then bound it with leather, string and bands of copper inscribed in Vietnamese to symbolise the past and emphasise the importance of traditions and culture for all Vietnamese people.

Fate, also made from clay, is delicately interwoven with brittle twigs, sticks and leather thonging. Two small clay hands caught in the rigging hint at the fragility and uncertainty of life.

Destiny appears as a conventional and seaworthy craft, with a sail made from a map and a makeshift lamp and chicken bones placed inside. The use of found objects suggests the resourcefulness of the refugees and how they adapted to survive the long and hazardous sea voyage and their new country. Together, the three boats tell a compelling story about the survival of Vietnamese refugees.

'My refugee boats are an interpretation of my direct experience when leaving Vietnam', Thi has said. 'The three boats … symbolise the delicate uncertainty of the captive human struggle in the sea of life … I have tried to capture the timeless, universal nature of endeavouring for survival by combining found objects in an innovative and symbolic manner.'[16]

While *History*, *Fate* and *Destiny* embody a personal migration experience, *The Last Leg* is Western Australian artist Claire Bailey's response to witnessing three waves of immigration to Australia. Claire says:

My parents were part of the post-World War II immigration from England. As a child I saw pictures on TV of refugees from Vietnam arriving in boats that hardly seemed bigger than a bathtub. Now more people arrive from Afghanistan, Iraq or Pakistan on boats that barely

Thi Nguyen (b 1975) *History*; *Fate*; *Destiny*, all 1994 Three sculptures made from clay, leather, string, copper, gold, metal, paper, 12 chicken bones (Clockwise from bottom left) *History*: 49.5 x 83 x 34 cm; (hanging) *Fate*: 44 x 88 x 34 cm; *Destiny*: 109.5 x 55 x 62.5 cm, all © Thi Nguyen

seem able to float. I want this work to remind people that the whole fabric of Australian culture is influenced by the migration of people arriving by sea – not only the epic voyages of recent boat people, but of all the voyages, starting with the First Fleet. I called it *The Last Leg* for all those people that get all that way and then are turned around on the last leg of the journey between Indonesia and Australia.[17]

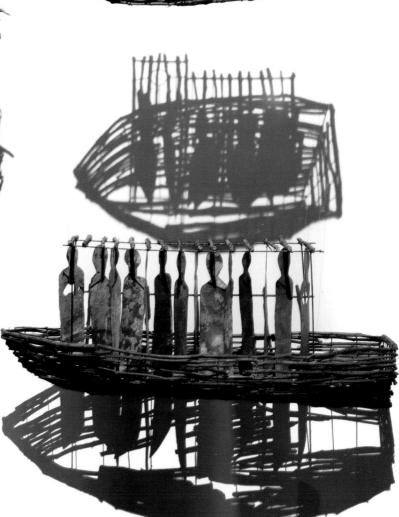

The Last Leg comprises six boats pieced together from brittle sticks and rusty wire. Their metal passengers are made from a lifeboat ballast tank. All these materials suggest the precarious, homemade nature of refugee boats bound for Australia.

The work can be interpreted in several ways. The map of Australia excised from the hearts of some passengers may represent hopes and dreams, new or lost, or leaving hearts behind in distant homelands. The caged passengers in one vessel allude to Australia's immigration policy at the turn of the 21st century and the controversial practice of mandatory detention for asylum seekers.

The Last Leg is displayed suspended from the ceiling, giving the boats a dreamlike quality, and tempting audiences to contemplate the aspirations of people who crowd into such vessels seeking a better future. Fashioned from brittle materials and found objects, these sculptures make a powerful and poetic statement about the flimsiness of many refugee boats and the fragility of refugee lives.

Kim Tao, Helen Trepa and Lindl Lawton

Claire Bailey (b 1960)
Three sculptures from the six-sculpture work, *The Last Leg*, 2005, photographed in situ in the museum. All wood, steel, brass; 300 x 200 x 500 cm (entire work when displayed) © Claire Bailey, reproduced courtesy of the artist

Snakeheads and smugglers

In 1999, people smugglers tried to transport 69 illegal immigrants from China to Australia on *Kayuen*, a Panama-registered coastal freighter. The passengers, mostly male Chinese nationals, paid about AUD$40,000 each to secure a passage in appalling conditions, hidden in false compartments under sand ballast in the ship's cargo hold. A false bottom cut into the ship's firebox provided entry to the compartments, which, observed Rear Admiral Russ Shalders, Director General of Coastwatch, 'you wouldn't have found unless you were a naval architect'.[18]

Kayuen left Fuzhou, in south-east China's Fujian Province, in late March 1999. On 17 May it was intercepted by HMAS *Fremantle* off Jervis Bay, on the south coast of New South Wales, following a three-week joint surveillance operation by the Australian Customs Service, Australian Federal Police, NSW Police, Coastwatch, the Royal Australian Navy and the Royal Australian Air Force.

Authorities searched the vessel thoroughly and discovered the illegal immigrants in conditions they described as 'pitiful'. The ship's firebox, through which the passengers accessed their compartments, is now part of the museum's collection. The bright yellow structure, pictured (right) in situ, evokes the miserable, clandestine nature of *Kayuen*'s voyage from China.

Other items in the collection – such as pillows, blankets, water, beer, Chinese music CDs and English language books – reflect futile attempts to make the journey more comfortable in quarters which, according to media reports, had no sanitation, ventilation or water supply.[19] A Chinese shrine (above) with an incense bowl, libation cups and two candlesticks with characters signifying 'good luck' and 'wishes will come true' represents the immigrants' hopes and prayers for a safe passage.

Kayuen's passengers were part of a new wave of illegal boat people making the long journey to Australia from China, Iraq, Pakistan, Sri Lanka and Afghanistan since the 1990s. In contrast to Indochinese boat people in the 1970s and 80s, who organised their voyages collectively and shared

costs among passengers, these more recent Chinese boat people bought passages from Fujian-based gangs known as 'snakeheads'. In Australia they are referred to as people smugglers.

Since the late 1980s, sophisticated people-smuggling operations have been run out of Fujian Province, a gateway to the West for increasing numbers of Chinese seeking a new life or work opportunities. In April 1999, just weeks before *Kayuen*'s arrival, a boatload of 60 illegal Chinese immigrants who landed at Scotts Head on the NSW north coast had been told by people smugglers that they would get jobs at the Sydney 2000 Olympic Games and that an amnesty on illegal immigrants would be declared for the new millennium.

The arrival of *Kayuen* attracted significant media attention because it exposed the vulnerability of Australia's entire coastline – not just the more usual landing places along the northern and western shores. It also followed closely on two other high-profile arrivals of illegal Chinese boat people – the Scotts Head landing and one at Holloways Beach, north of Cairns, Queensland. As with these previous groups, the illegal immigrants on *Kayuen* were taken into custody and deported. Police later charged an Australian man for his role in the illegal immigration of non-citizens to Australia and he was sentenced to 12 years in prison.

Kim Tao

< Shrine from the illegal immigrant vessel *Kayuen*, c1990 Steel locker containing incense bowl, electric candlesticks, libation cups, 55.7 x 47.3 x 17 cm (shrine overall) *Gift from Department of Immigration and Multicultural Affairs*

∧ Below-deck sleeping quarters assigned to immigrants on *Kayuen*, c1990

> Foreign Language Teaching and Research Press English comprehension book from the illegal immigrant vessel *Kayuen*, 1990s Book, 19.9 x 13.9 x 1.3 cm *Gift from Department of Immigration and Multicultural Affairs*

∧ The false firebox in situ on *Kayuen*, c1990. The immigrants were hidden in specially constructed compartments below deck, their only access through this firebox, which measures just 73 cm wide.

The *Tampa* collection

When MV *Tampa* rescued 433 asylum seekers from their stricken fishing boat KM *Palapa 1* in the Indian Ocean on 26 August 2001, it sparked a political storm in Australia and worldwide. This lifebuoy, part of the standard safety equipment on board, connects us to this dramatic and controversial episode in *Tampa*'s working life.

Under pressure from some of the desperate asylum seekers, Rinnan headed for the offshore Australian territory of Christmas Island, but was denied permission to enter Australian waters. When some passengers' health deteriorated, Rinnan sent a Mayday signal and sailed toward Christmas Island. *Tampa* was then boarded by Australian special forces, who ordered the ship to turn around.

Following an intense political stand-off, the asylum seekers were transferred to HMAS *Manoora*. Most were taken to the Pacific island of Nauru as part of Australia's 'Pacific Solution' (2001–08). This aimed to stop refugees reaching Australian territory, where they could legally claim asylum, detaining them in co-operating

At the time of the rescue, the Norwegian *Tampa* had a crew of 27 and was not licensed to carry more than 50 people. Despite this, its captain, Arne Rinnan, shifted course to help the asylum seekers, who were mainly from Afghanistan. Captain Rinnan recalled:

> After we had rescued these people we had 438 extra people [including five crew from *Palapa 1*] on board, and that means the ship is unseaworthy … [20]

> Several of the refugees were obviously in a bad state and collapsed when they came on deck to us. Ten to 12 of them were unconscious, several had dysenteria [dysentery] and a pregnant woman suffered abdominal pains.[21]

foreign countries while their status was assessed. A small number of asylum seekers was eventually granted refugee status and resettled in Australia.

Tampa's operator, Wallenius Wilhelmsen Logistics, later donated a life jacket and lifebuoy to the museum. They represent the tension between international obligations for safety of life at sea and Australia's domestic policy on refugees and asylum seekers.

Lifebuoy from MV *Tampa*,
c1984 Reinforced plastic,
75 cm (diam.) *Gift from
Wallenius Wilhelmsen Logistics*

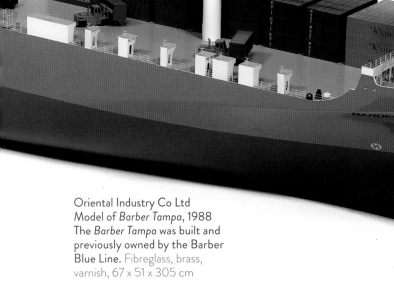

Oriental Industry Co Ltd
Model of *Barber Tampa*, 1988
The *Barber Tampa* was built and
previously owned by the Barber
Blue Line. Fibreglass, brass,
varnish, 67 x 51 x 305 cm

While this lifebuoy vividly recalls this defining event, this spectacular model, more than three metres in length, shows the museum's interest in the ship long before the name *Tampa* became known to every Australian in 2001. In 1988, as the museum was collecting for its first exhibitions to open to the public in 1991, curators commissioned this model of the *Barber Tampa*, as the *Tampa* was previously known, as a case study for exploring roll-on roll-off (RoRo) container shipping, global trade, heavy industry, contemporary ship design and the safety of life at sea.

The significance of this last theme was illustrated in 2002 when Captain Rinnan and *Tampa*'s crew and owner received the Nansen Refugee Award from the United Nations High Commissioner for Refugees. The award honoured their commitment to the principle of rescue at sea, despite the risk of long delays and large financial losses for Wallenius Wilhelmsen.

The *Tampa* incident drew extensive media coverage in Australia and overseas. Images of asylum seekers huddled among stacked containers on deck dominated newspaper front pages, while headlines relayed the 'storming' and 'seizure' of *Tampa* and the ensuing 'refugee showdown'. The incident inflamed political and public debate about refugees, asylum seekers and border protection at the turn of the 21st century. The question of how to deal with asylum seekers arriving on unauthorised voyages remains one of the most polarising issues in contemporary Australia.

Kim Tao and Kimberly O'Sullivan

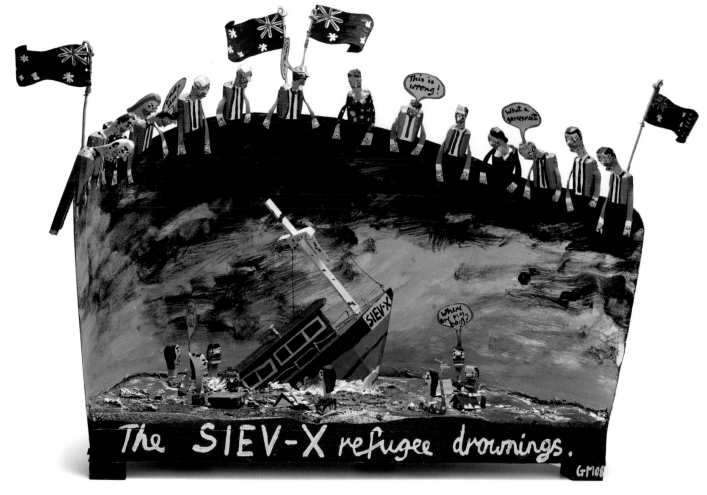

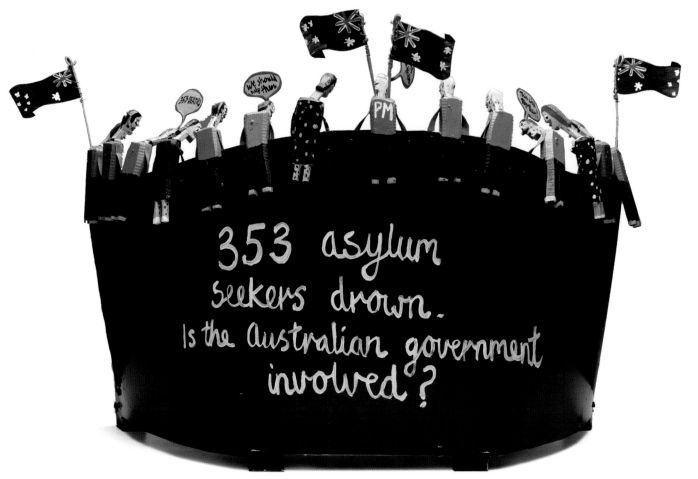

This work by Victorian artist and social commentator Glenn Morgan reflects on the loss of 353 lives at sea when the asylum seeker boat SIEV X sank en route from Indonesia to Australia in 2001. Morgan argues, 'The [Australian] bureaucrats and government knew it was happening and let it happen, simply for the sake of curtailing immigration. The figures looking over the edge of the work are those government figures watching on, uncaring. I wanted to make a point about that disregard.'[22]

SIEV X affair

On 18 October 2001 a decrepit, overcrowded fishing boat left Bandar Lampung in Sumatra, Indonesia, carrying more than 400 asylum seekers who had fled Iraq and Afghanistan. Many were women and children desperately attempting to join husbands and fathers in mandatory detention centres or on Temporary Protection Visas (TPVs) in Australia. After a night sailing in foul weather, the boat – later known as SIEV X ('Suspected Illegal Entry Vessel Unknown' in the language of Australian border-protection and immigration authorities) – floundered en route to the offshore Australian territory of Christmas Island.

Three hundred and fifty-three people drowned: 146 children, 142 women and 65 men. More than 100 people survived the initial sinking and floated helplessly for 20 hours, 'like birds on the water', as survivor Ahmed Hussein put it.[23] By the following day, only 44 remained alive and were picked up by passing fishermen. One more survivor was rescued some 12 hours later.

Faris Kadhem was the first survivor to be rescued. He escaped Iraq and boarded SIEV X with his wife, Leyla, and their seven-year-old daughter, Zahra. Faris says:

> After [the sinking] I see my wife not far [away], I think about three metres. After Zahra she call me, 'Baba, come help me'. Leyla, she call me, 'Faris bring my daughter for me please'. I swim but I cannot make it. She gone. Never never I see her. I see her never. I lose my family. I lose Leyla. I lose Zahra. Everything.[24]

Faris was one of only seven survivors to be settled in Australia.

The topic of seaborne asylum seekers has been controversial in Australia since the end of the Vietnam War. Recent Australian governments have taken determined steps to deter refugees from arriving in an uncontrolled manner, such as mandatory detention for unauthorised arrivals, and TPVs for unauthorised arrivals assessed as genuine refugees (but with no rights to have family join them, or to re-enter the country if they leave).

The SIEV X tragedy happened only two months after the MV *Tampa* incident (see pp. 90–91). Shortly after *Tampa*, another refugee boat – SIEV 4 – had sunk after being intercepted by the Royal Australian Navy, which pulled its passengers from the water. This incident generated claims – later shown to be erroneous – that asylum seekers had deliberately thrown children overboard in order to secure refuge in Australia.

Unlike these highly televised incidents, there is no confirmed visual documentation of SIEV X or its sinking. This makes Glenn Morgan's sculpture all the more significant. While the work's whimsical, childish appearance is at odds with the seriousness of the subject, the presence of onlookers in suits and office attire is an explicit commentary on the role of government and bureaucracy in refugee policy. It is a theatrical, tactile, narrative artwork that captures Morgan's feelings of disgrace at the SIEV X affair.

Kim Tao

< Glenn Morgan (b 1955) *SIEV X Affair*, 2008 (front, top, and back) Sculpture, wood, steel, paint, 54.8 x 91.4 x 35 cm
© Glenn Morgan, courtesy Glenn Morgan and Place Gallery

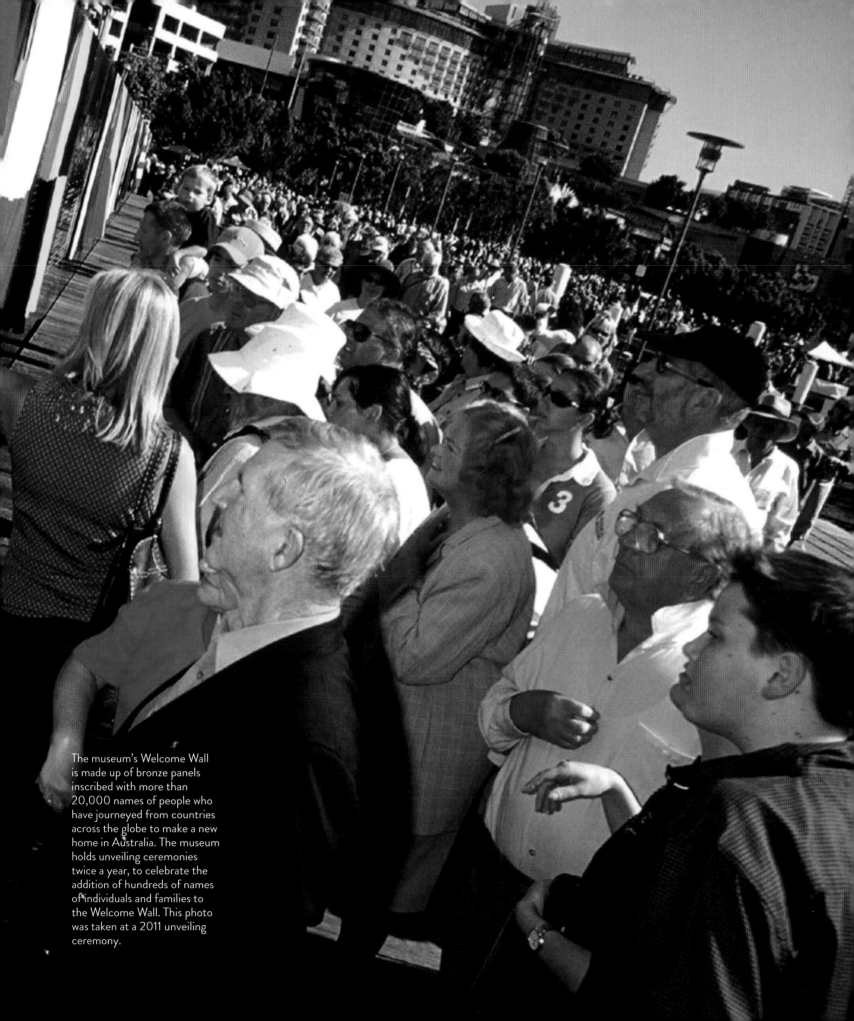

The museum's Welcome Wall is made up of bronze panels inscribed with more than 20,000 names of people who have journeyed from countries across the globe to make a new home in Australia. The museum holds unveiling ceremonies twice a year, to celebrate the addition of hundreds of names of individuals and families to the Welcome Wall. This photo was taken at a 2011 unveiling ceremony.

4 SAIL AND STEAM

Australia, the island continent with ports strategically located around its coastline, has always looked to commercial shipping for sustenance and strength.

The 'blue highways' that linked the early colonies to the rest of the world were clearly lifelines delivering essential foods and manufactured goods to the settlers. Today, more than 99 percent of Australia's imports and exports are still carried on ships. And it's very big business. Cargoes worth more than $150 billion are currently shipped in through Australian ports each year, and cargoes valued at almost $180 billion are shipped out.

The Australian National Maritime Museum collection traces the story of shipping in Australia from the first square-rigged sailing ships that called into Port Jackson through to the container ships, bulk carriers and passenger liners of today.

Covering most phases of this evolution, the museum has a comprehensive collection of ship portraits – the 'pinups' of our maritime history. They range from works by well-known names to minor maritime artists who have created significant paintings and sketches of vessels. There are works by George Frederick Gregory and his family, for instance, whose painting studio recorded much of the shipping traffic through the port of Melbourne from the mid-19th to the mid-20th centuries. Other 19th-century artists represented include Frederick Garling and Joseph Fowles, and from the 20th century, Fred Elliott and Dennis Adams.

Another artwork of a very different kind, recalling the hard labour and tough conditions of the waterfront, is the celebrated *Sydney Wharfies Mural* – painted by waterfront worker artists on the walls of their union canteen in Sydney. The mural, with its powerful labour movement imagery, was carefully peeled from its original site and conserved for the museum collection.

The museum is also fortunate to hold rich collections of material from Australian shipping companies such as Burns, Philp & Co, which opened up trade with the islands of the Pacific in the 19th century and later pioneered passenger and tourist services in the region. McIlwraith McEacharn & Co, another successful Australian shipping company that started out transporting migrants from Britain to Queensland in the 1880s, is also well represented.

For individual perspectives on life at sea, the museum has gathered the personal collections of seafarers and shipmasters, and collections of shipwright tools that provided the livelihoods of hardworking artisans.

Important to the ships that plied the coast were the lights that guided them. The museum collection includes several different types, including the 21-metre-tall Cape Bowling Green lighthouse from North Queensland, now reconstructed on the Darling Harbour foreshore, the lightship *Carpentaria* and the large lens from Tasman Island lighthouse off south-east Tasmania.

Bill Richards

RGW Bush *To the Far East by P&O* ... , 1910. This travel poster advertising Peninsular & Oriental Steam Navigation Company (P&O) services to the Far East features the SS *Maloja* steaming through calm waters. In the early 1900s the age of sail was all but over and the construction of fast, majestic, comfortable and safe passenger travel steam ships reflected the height of modernity. Colour lithograph poster, 95 x 62 cm (sheet)

Each working day in the 1840s, Frederick Garling rowed out from Sydney's Circular Quay to visiting ships, boarding each vessel to check inbound cargoes and determine duty to be paid. Working as a customs officer for more than 30 years, he developed an in-depth working knowledge of the rigging and lines of ships, which he applied to his growing body of watercolours centred on the port of Sydney.

Australian ship painting and commerce

Garling painted the world around him: the landscapes, ships, yachts and mercantile life of the growing colonial port, from the urgent convict era through to the busy decades after the gold rushes. Garling became Australia's most prolific

19th-century maritime artist, specialising in marine views after he was dismissed from the customs service in 1859. For the next 14 years until his death, he earned his living painting formularised views of ships for the captive and generally eager market of shipping lines, visiting shipmasters and local yacht owners.

The museum holds a growing collection of ship paintings by Garling and his contemporaries. These include Joseph Fowles, who painted marine and topographical views

∧ Arthur Victor Gregory (1867–1957) SS *Oonah* passing Point Lonsdale, 1908
Watercolour on paper, 27.5 x 52.5 (sheet)

< Joseph Fowles (1810–1878) Untitled [Auxiliary steamer passing Fort Macquarie flying a variant of the colonial flag and the coat of arms], 1850s
Oil on canvas, 38 x 53 cm
Gift from Mary Rae Thomas

> Frederick Garling (1806–1873) *The* Alexander, *Captn Phillipson getting under weigh off Macquarie Fort Sydney N.S.Wales 1847*, 1847 (detail)
Watercolour on paper, 35 x 47 cm (sheet)

in oils and who, in 1848, published his *Views of Sydney*; and George Frederick Gregory Snr, a ship's carpenter who arrived in Melbourne and jumped ship at the height of the gold rushes.

The lure of the gold rush proved irresistible but fruitless, and Gregory soon needed other employment. With previous art training, he established a marine art studio, to take advantage of the increased traffic through the port. The studio was prolific and lasted well into the next century. George Frederick had a large family by two wives. Two of his sons, George Frederick Jnr and his younger half-brother, Arthur Victor, followed him into the maritime painting business, Arthur Victor working in the Melbourne studio until his death in 1957. George junior worked in Adelaide, Sydney and Newcastle, attached to the studios of photographers such as Alfred Dufty and Sam Hood, producing extremely formulaic broadside ship portraits.

Many other ship painters worked around the country well into the 20th century – including John Alcott, Walter Barratt, George Bourne, Reginald Arthur Borstel, William Edgar and George Woolston. On the whole, their work exhibits a refreshing honesty. They adopted a workmanlike approach to capturing the disappearing ships of sail and steam, in league with the photographic studios that replaced them. The buyer would carry the image home to distant ports as a proud souvenir of

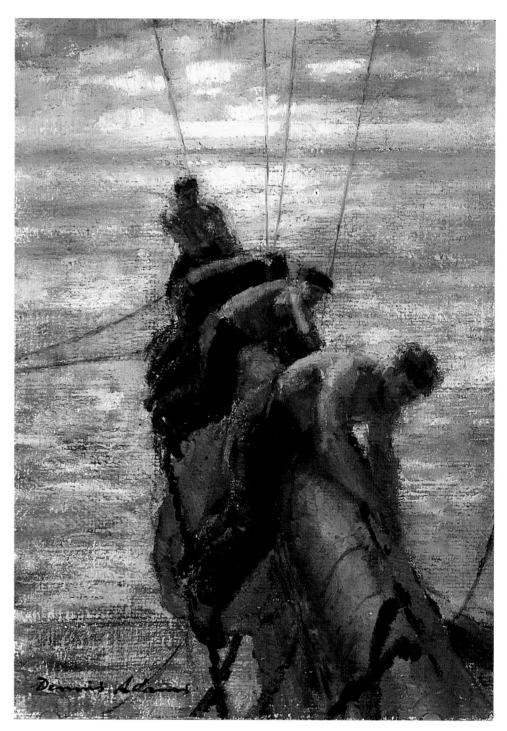

Dennis Adams (1914–2001) *Changing Sails*, Herzogin Cecilie, **1935** Oil on canvas on plywood, 24 x 16.8 cm © Estate of the artist, reproduced with kind permission of Ann Adams

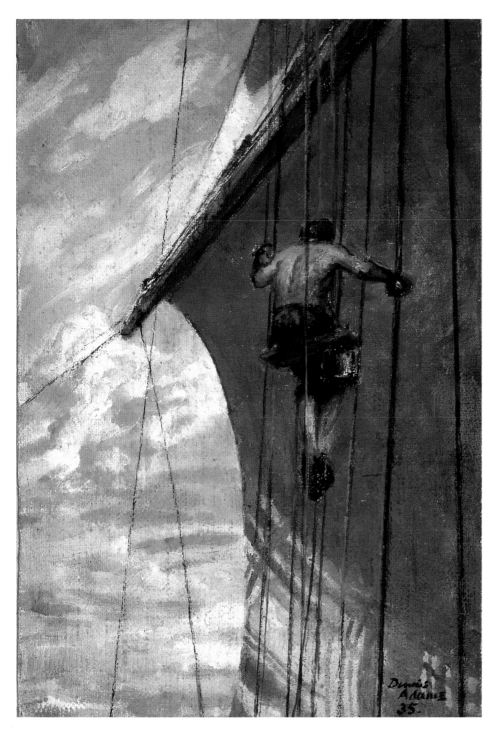

Dennis Adams (1914–2001) *Tarring down Backstays*, Herzogin Cecilie, **1935** Oil on canvas on plywood, 35.5 x 24.3 cm © Estate of the artist, reproduced with kind permission of Ann Adams

their working lives, where it would then be cherished and displayed in place of a father or husband away at sea.

During World War I, Gustaf Erickson, an entrepreneur from the Åland Islands in the Baltic Sea, bought up the last ships of sail at scrap-iron prices and brought them back into commercial service in the grain trade between Europe and Australia. The excitement and adventure of these final years of sail lured a more romantic artist, Dennis Adams, who was to take a different view of the workings of a ship.

In 1935, young Adams went to sea on the last windjammers, knowing that they would soon disappear. He sailed to London on Erickson's *Herzogin Cecilie* to study art, and returned three years later on the *Lawhill*. He climbed the rigging with paintbox in hand, and sketched all aspects of shipboard life: the helmsman at the wheel, changing sail, reefing in sail on the yards, hauling on the lines, the cook in the galley, clothes drying on board, caulking the timber deck. After an appointment as an official war artist during World War II, Adams built a career as a maritime artist and sculptor, returning to those last ships of commercial sail he knew so well, which by then had indeed vanished.

These artists provide a glimpse into the strength of Australia's maritime past, the ships that carried people and cargo to and around Australia, and the masters and crew who sailed on them.

Daina Fletcher

During a dark night on 9 March 1910, the newly built, luxurious coastal passenger liner SS *Wyreema* was heading inside Port Jackson. Meanwhile, the collier SS *Currajong* was travelling out of the harbour en route to Cairns. Nearing Bradley's Head, the *Currajong* apparently cut the turn too fine and the much larger liner slashed open the heavily laden collier, which quickly sank, with the loss of a crew member.

The trials and tribulations of sea captains

His family kept and cherished the testimonial and a few other items from his career, including his binoculars with inscribed leather case. Few people travelling aboard a Manly ferry today probably realise that as they round Bradley's Head they pass over a popular dive site: the mangled remains of the steam collier SS *Currajong*.

After the collision, the *Wyreema* returned to its berth for a safety survey and initial investigation, then continued on its voyage. The vessel's captain, John Elliot Meaburn, was an experienced officer who had worked since the 1880s as a captain of coastal steam passenger and cargo vessels along the eastern seaboard. After the *Currajong* collision, Meaburn had his master's ticket withdrawn.

This caused a small public outcry from coastal communities that had long associations with the captain and his vessels. Various testimonials to Captain Meaburn's 'skill and capacity as a careful Commander' and 'character as a gallant seaman' were printed in newspapers. One testimonial was signed by supporters and presented to Meaburn. It is handwritten in beautiful gothic calligraphy in the style of an illuminated manuscript, lavishly decorated, bound in leather and stored in an oak case. The testimonial is a stunning example of the esteem felt for sea captains by Australian maritime communities during the 19th and early 20th centuries.

A court hearing exonerated Meaburn of any wrongdoing, and he continued his career.

The museum has several other such collections. Of particular note are the extensive and rich collections of material from the careers of Captain Robert Basil Vincent McKilliam and Basil Moffitt de Bohun Helm.

Scottish-born McKilliam sailed with the Aberdeen White Star Line between 1876 and 1908. Apprenticed at the age of 14, McKilliam served under famous captains such as Robert Kemball, and on the well-known clipper ships *Thermopylae* and *Salamis*, mostly on the Britain to Australia run. In 1913 he brought his family to live in Sydney and was appointed Assistant Manager of Darling Island Wharf; he then worked as a Superintendent Stevedore from World War I up to the Great Depression.

The McKilliam collection spans the period 1876–1905, wonderfully documenting McKilliam's life at sea with significant objects such as telescopes and uniforms and more humble but poignant items such as a lock of his hair. Such objects, as well as letters and photographs, were tangible links for families who often didn't see their sea captain fathers and husbands for months on end.

ˇ Studio portrait of Captain Robert (Basil Vincent) McKilliam, c1900
Silver gelatin print, 16.4 x 9 cm

< Leather-bound book containing signed testimonials to Captain Meaburn in oak box, c1910 Leather, paper, timber, metal, 37 x 32 x 5.2 cm

Captain Basil Helm's sewing kit, or 'housewife', containing a variety of sewing and darning threads and needles, spare buttons and pins that Helm would have used to darn his uniform, **1919–54** Cotton, wool, thread, metal, paper, 15.7 x 10.5 x 4.5 cm (closed), 15.7 x 21.5 x 1.8 cm (open) *Gift from Margaret Royds*

> Two pages with signatures of supporters of Captain Meaburn's testimonial

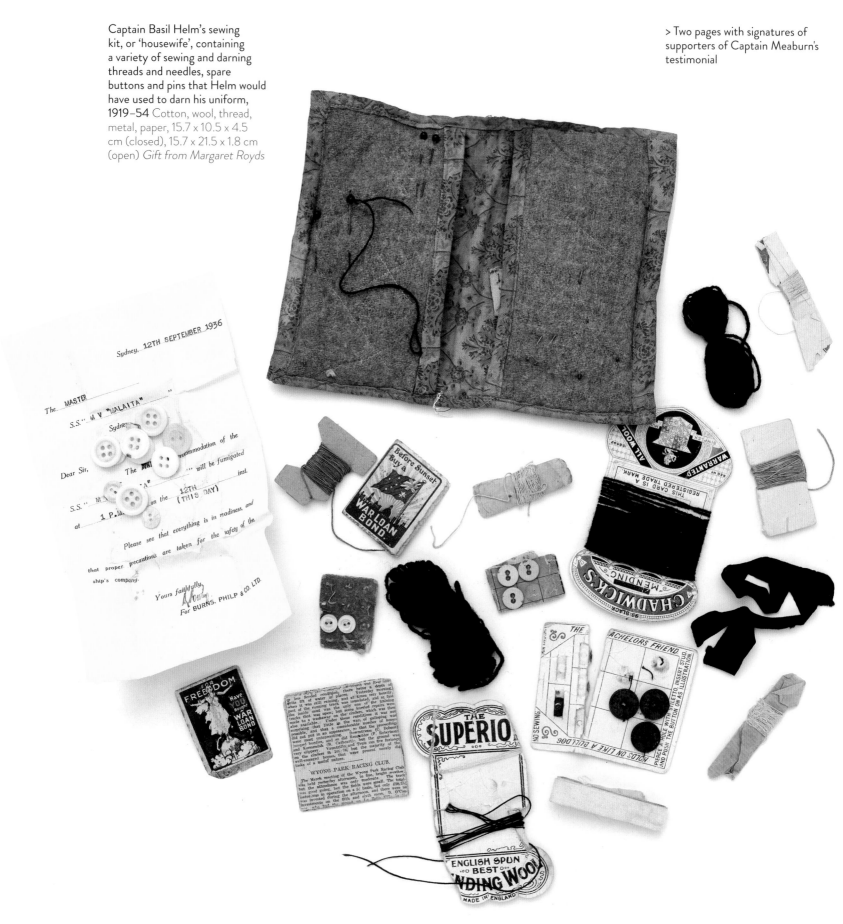

Basil Moffitt de Bohun Helm avidly hoarded all sorts of memorabilia of his life at sea. Helm began his four-year apprenticeship at the age of 15 with the Burns Philp line, then served on various Australian coastal ships with Howard Smith Company until 1928, when he returned to Burns Philp. In 1938 Burns Philp sent him to Scotland to attend the fitting out of their new liner MV *Bulolo*, and to return on the commissioning voyage as chief officer.

During World War II, Helm joined the Queensland Coast and Torres Strait Pilot Service and provided valuable help as a pilot to US naval and military officers navigating the South-west Pacific waters. He remained in the Torres Strait Pilot Service until 1954. The Helm collection comprises all manner of personal items of a 20th-century sea captain, including notebooks, charts, sewing kits and brush and comb sets.

The three collections comprehensively and poignantly document the personal and professional lives of sea captains in various periods of Australian maritime history. They bring to life three quite different careers, connected by the thread of a life at sea.

Stephen Gapps

A portrait of power

This large, dark and sombre portrait speaks of industry and wealth. Attributed to well-known marine artist Fred Elliott and painted in the early 1900s, it features the owners of the McIlwraith, McEacharn & Co shipping line: Sir Malcolm Donald McEacharn (standing) and Andrew McIlwraith. They are depicted here at the peak of their success, surrounded by objects, such as a globe, that symbolise their power and company interests. On the desk lie the specifications of the SS *Karoola*, the company flagship built in 1909.

The portrait reflects an important phase in Australian maritime history – the height of shipping line 'empires'. In the 19th century, shipping was essential to commerce in Australia. It provided the infrastructure for the European settlement and development of the country. Ships reached people's lives in a personal and immediate way: delivering groceries to small towns, carrying passengers between ports and bringing immigrants on long voyages to Australia. With the huge influx of people and goods during the gold rushes of the 1850s, passenger and cargo shipping boomed and many shipowners became shipping company magnates. Small owner–builders often dreamed of one day establishing their own fleet and shipping line.

Malcolm McEacharn was the son of a Scottish master mariner who died when his ship, *Brahmin*, was wrecked near King Island, Bass Strait, in 1854. In 1866 he joined a London shipping office, rising to a senior position by the age of 21, when he began his own ship-broking business.

Another Scotsman, Andrew McIlwraith, joined his father's shipping business in 1868 and fostered commercial relationships with his brothers, who had established businesses in Melbourne and Brisbane.

The two Scottish businessmen saw opportunities in the colonies, and in 1875 combined forces to found the shipping firm McIlwraith, McEacharn & Co. Within a year they had contracted to carry cargo and migrants to the booming colony of Queensland and had begun to build up a fleet of 10 ships sailing under the name of the 'Scottish Line'. In 1879 McIlwraith organised the chartering, and fitting out with a freezing plant, of the steamer *Strathleven*, the first ship to successfully transport a cargo of frozen meat from Australia to the United Kingdom.

By the early 1900s, the competition for passenger trade was fierce and shipping companies were forced to provide vessels more comfortable than the converted cargo ships then in use. In 1909, McIlwraith & McEacharn's *Karoola* won an enviable reputation for its salubrious accommodation and size – it was the first Australian ship to exceed 7,000 tons. The company maintained the advantage in 1912 by commissioning *Katoomba*, which was larger and more luxurious than any of its generation of passenger ships.

With the growth of rail, road and then air transport, Australian shipping declined during the 20th century. But McIlwraith, McEacharn & Co was a survivor. It bought failing shipping lines and continued the original owners' policy of diversifying business interests until in 1964 it merged with the Adelaide Steamship Company to form Associated Steamships.

If McIlwraith and McEacharn are looking out from their grand portrait – nearly three by two metres in size – with a certain satisfaction, they have the right. The company they established lasted for more than 100 years – a long time in the expensive, risky and often cut-throat shipping industry.

Stephen Gapps

Frederick Elliott (attr) (1865–1940s) Untitled [Andrew McIlwraith and Malcolm Donald McEacharn], 1910 Oil on canvas, 270 x 185 cm (framed) *Gift from McIlwraith McEacharn Limited*

When British shipwright Alfred Luther Lake migrated to Sydney in 1911, he brought his toolbox. His son Bernard followed his father's trade and, when he became an apprentice in 1940, inherited his father's tools and used them for the rest of his working career. Another British shipwright, William Higham, migrated to Australia in 1920 and brought with him tools that his father had used since the 1890s. William retired from work as a shipwright in 1960.

Family heirlooms

A shipwright is always very particular with his tools, knowing exactly how a certain tool performs, or suits a particular type of wood. Tools were jealously guarded and often stamped with ownership marks so they wouldn't go into the wrong toolbox. They were handed down through generations of shipwright families. The shipwright's use of wood planes, hand-drills, adzes and chisels changed very little between the 19th and early 20th centuries, and if kept in good condition, they could be used for many years. These collections of shipwrights' tools reflect this tradition.

The Lake tools date from the late 19th century to the 1950s. Alfred Lake worked as a shipwright at several sites around Sydney Harbour, including Cockatoo Island dockyards, Chapman's dock, Mort's dock and Drake's shipyards. His son Bernard began his apprenticeship with the Australasian United Steam Ship Company in Sydney. He also worked at Cockatoo Island and then for the Maritime Services Board at Goat Island. The Lakes' wooden block planes and adzes with their canvas protective covers show the signs of many years of good service.

The Higham tools were owned by father and son Thomas and William Higham, and used from the late 19th century in London to the 1950s at Garden Island, Sydney. They include handmade wood planes, drills and drill bits, adzes, axes, saws, chisels, caulking tools, dividers, measures, mauls, gouges, hammers, sharpening stones, draw knives, routers and many other tools and associated items. They are all housed in four purpose-built or modified toolboxes. Many of the tools are carefully engraved with the initials 'WH' and 'TH'. The tools engraved with William's initials would have been in use for at least 50 years, if not longer.

Alfred Charles Thomas Higham began working as a shipwright with his brother at Piper's Wharf, near Greenwich on the River Thames, London, in the 1890s. At a time when most commercial vessels were steam driven, Thomas was employed constructing sailing barges. These were heavy haulage carriers, which were still using sail because it was cheap and only required a crew of two. With their shallow draught and flat bottom they could go inshore, across shallows and up tidal creeks. Many would also cross the channel and go into European inland waters or, with masts lowered, could be used on canals.

Thomas's son William worked with his father at Greenwich until he migrated to Australia in 1920. He initially worked in Newcastle, but returned to England when the Great Depression hit in 1930. In 1939, William was seconded to the Australian Navy and came back to Sydney, working at Garden Island as a shipwright until he retired in 1960.

Both collections comprise very complete ranges of shipwright's tools, and tell personal, inter-generational stories of the shipwright's trade.

Stephen Gapps

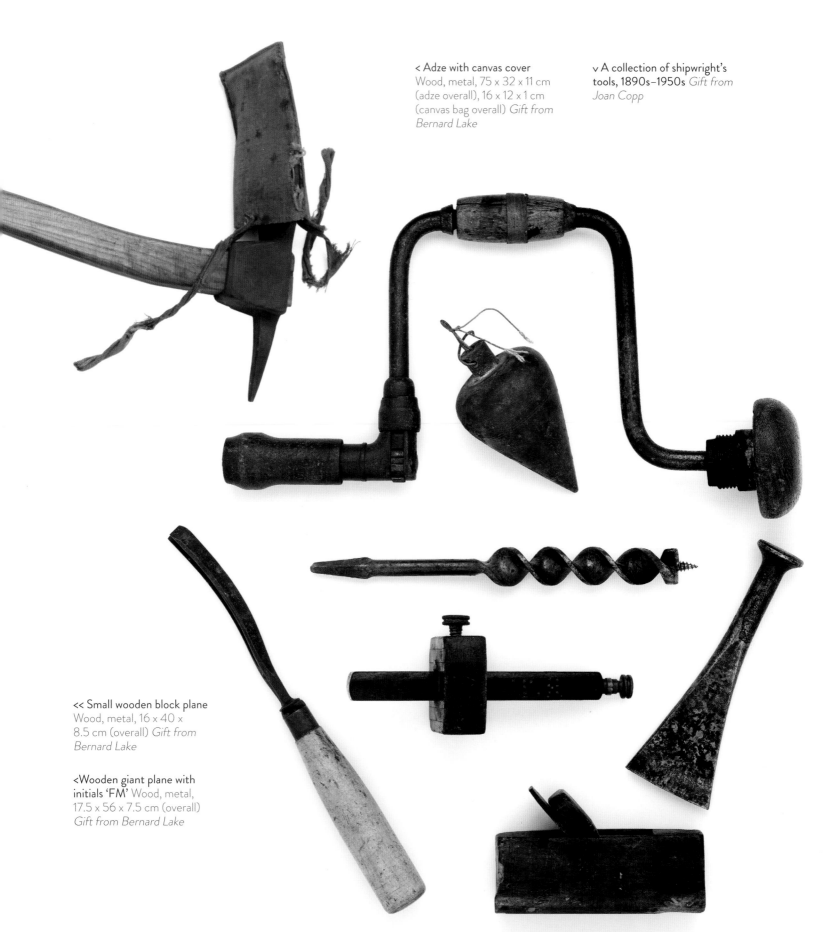

< Adze with canvas cover
Wood, metal, 75 x 32 x 11 cm
(adze overall), 16 x 12 x 1 cm
(canvas bag overall) *Gift from
Bernard Lake*

v A collection of shipwright's
tools, 1890s–1950s *Gift from
Joan Copp*

<< Small wooden block plane
Wood, metal, 16 x 40 x
8.5 cm (overall) *Gift from
Bernard Lake*

<Wooden giant plane with
initials 'FM' Wood, metal,
17.5 x 56 x 7.5 cm (overall)
Gift from Bernard Lake

Model stories

These shipbuilders' models of *Westralia* and *Bulolo* are incredibly intricate and painstakingly detailed, and were handmade to scale. Before the development of computer-aided design, such models were critical three-dimensional blueprints for the construction of vessels. They were also works of art, and often became 'presentation models', mounted in glass cases and proudly displayed in the offices of shipowners.

The shipbuilder's model of the two-masted, single-funnelled coastal steamer SS *Westralia (I)* is a particularly fine example. It was constructed by an unknown model-maker for shipbuilder James Laing, whose company built the *Westralia* at their Deptford Yards at Sunderland, England, in 1897.

S.S. "Westralia".
BUILT BY
JAMES LAING,
DEPTFORD YARDS
SUNDERLAND.
FOR MESSRS HUDDART, PARKER & CO LIMITED
MELBOURNE.
LENGTH 327·4 FEET | DEPTH 20·5 FEET.
BREADTH 41·2 FEET | NET TONNAGE 1819 TONS
GROSS TONNAGE 2742 TONS.
1897.

The *Westralia* was commissioned by the prominent Australian shipping line Huddart, Parker & Co, which originated in the successful trading activities of James Huddart, his uncle Captain Peter Huddart and TJ Parker during the Victorian gold rushes. James Huddart and Parker formed Huddart, Parker & Co in 1876 and the business rapidly expanded to become a major Australian shipping company by the late 19th century. The discovery of gold in Western Australia in the 1890s sparked another boom, and in 1897 Huddart Parker commissioned the construction of *Westralia (I)* to service the route between Melbourne and Fremantle. For a time, it was the largest passenger ship operating in Australia and was extremely luxurious, with electric lighting, modern bathrooms and finely carved oak and teak panelling in the public rooms.

The steamship of 2,742 tons carried cargo as well as 180 first-class and 200 steerage passengers. It was sold

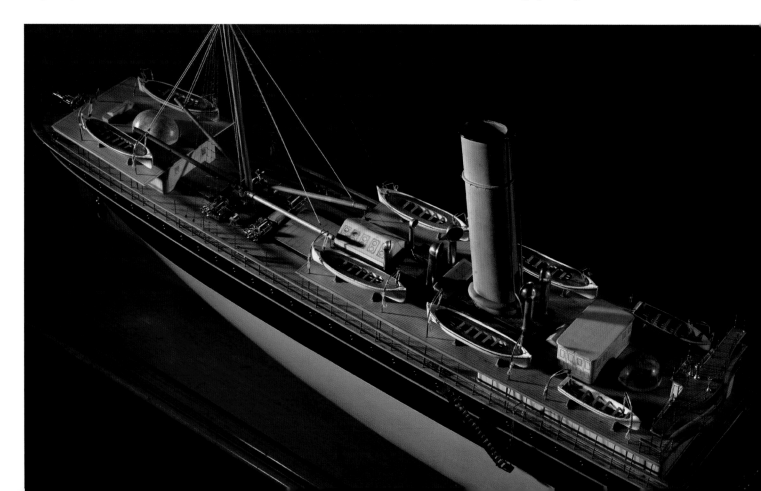

in 1927 to WR Carpenter & Co in Sydney and towed to New Guinea, where it was used as a coal and copra hulk in Rabaul Harbour until it was sunk by a Japanese bomb during World War II.

Shipbuilders' models are also often rare surviving visual records of vessels with extraordinary stories. This exquisite 1:36 scale model of the two-masted cargo–passenger ship MV *Bulolo* was made by Barclay Curle & Company, Glasgow, Scotland, in 1938. The vessel itself was commissioned by Burns, Philp & Co, to fulfil its mail service contract with the Australian Government. However, *Bulolo* ran only eight trips around Pacific islands before being requisitioned by the merchant navy at the start of World War II.

The graceful ship was transformed into an armed merchant cruiser. By January 1940 it was repainted in the Australian Navy colours and equipped with seven 6-inch and two 3-inch anti-aircraft guns, depth charges and several types of small arms. Now HMS *Bulolo*, the cruiser escorted convoys in the Atlantic Ocean for the next two years. Due to the vessel's armament and considerable speed it was also used to search for German raiders and assisted in the recapture of Vichy French ships.

In April 1942 *Bulolo* was transformed again – this time fitted with a sophisticated communications system to coordinate army, navy and air force operations. *Bulolo* then took part in the Operation Torch landings in North Africa.

In 1944 HMS *Bulolo* became the flagship of Commodore Douglas Pennant, and on 6 June it led D-Day assault ships off the Normandy coast, where it was hit by shell fire from the German defences, with the loss

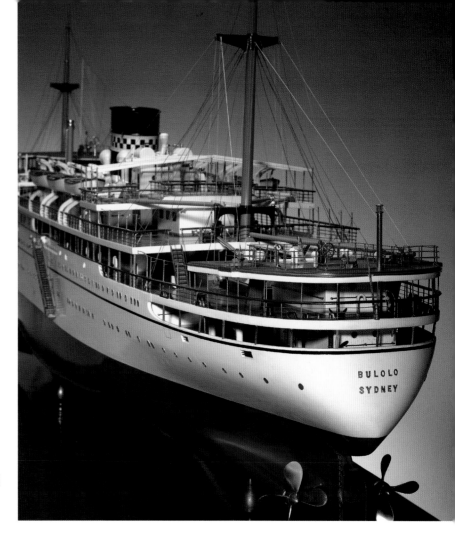

of several lives. It remained off the beaches directing the assault. *Bulolo*'s varied military career ended with its role as a headquarters ship in the 1945 Allied reoccupation of South-East Asia, where it was present for the Japanese surrender of Singapore. Some of the original Burns Philp crew had remained with the ship right throughout the war.

Bulolo was restored to its stately origins as a passenger–cargo vessel and handed back to Burns Philp in 1948. It returned to a quieter life in the Commonwealth Pacific mail service and as a luxury passenger liner complete with cinema, stateroom and swimming pool. For 20 years it was the largest liner regularly travelling between Australia and Papua New Guinea. *Bulolo*'s eventful career came to an end in 1968, when the much-travelled vessel was sold to a Chinese company for scrap.

Stephen Gapps

< James Laing, Model of SS *Westralia* (I), 1897 Wood, silver (plated) fixtures, string, iron, copper, paint, 116 x 258 x 46 cm (overall)

> Builder's model of MV *Bulolo* owned by Burns, Philp & Co, 1938 Wood, bronze, brass, 258 x 44 x 93.2 cm (overall) *Gift from Burns, Philp & Company Limited*

Pacific visions

From humble beginnings in Queensland in 1865, by the early 20th century a small Townsville-based trading company – Burns Philp – had become a household name across Australia and synonymous with the Pacific. The company had turned its focus to the many islands and sea lanes to the east of Australia and established a fleet of Australian-based Royal Mail steamers and trading vessels.

One key to their success was that Burns Philp quickly realised the opportunities its trading networks offered for general tourism – passengers were welcome. It was the first company to offer cruises specifically planned for tourists. As early as 1884, Burns Philp advertised a 'New Guinea excursion trip', and by the 20th century the 'Pacific cruise' had become an institution – passengers armed with box brownie-style cameras were kept busy photographing Fijian dancers and purchasing souvenir carved Tongan war clubs.

The museum's collection of Burns Philp material is extensive and diverse, ranging from important artworks to humble passenger lists, postcards and photographs of vessels, and ships' menus (often souvenired by passengers as mementos). Interesting examples of ships' silverware and cutlery include a pickle fork and an ashtray shaped like a life preserver. All are embossed with the ubiquitous Burns Philp symbol, the Scotch thistle, which also features in a series of leadlight panels recovered from the Burns Philp Sydney offices. There are numerous passenger tickets, crew uniforms and personal items, ship logs, ledgers, purchase books and other archival material.

Brothers (Sir) James and John Burns arrived in Australia from Scotland in 1862, and by 1865 had set up as storekeepers in Brisbane, Queensland. James struck out on his own and joined the Gympie gold rush in 1867, establishing stores at the goldfields. Just a year later he had made large profits and, after returning to Scotland

following the death of his father, brought the rest of his family to Townsville where, in 1872, he opened a store that supplied all the North Queensland goldfields.

The astute businessman established the nucleus of a fleet by chartering the *Isabelle* in 1873, to ensure regular supplies to his stores. Constant attacks of malaria, however, led him to move to Sydney, from where he financed his Townsville manager, (Sir) Robert Philp, as a partner in a new firm that was formalised as Burns, Philp & Co Ltd in 1883.

Burns had established a store on Thursday Island in Torres Strait in 1880, which gave the expanding company a base to enter the pearling industry and to participate in the exploitation of New Guinea after the Queensland colonial government had annexed it in 1883.

In the mid-1880s the company briefly entered the Pacific island labour trade, commonly known as blackbirding. Burns was always uneasy about the trade, and withdrew from it when some crewmembers from his vessel *Hopeful* were prosecuted for malpractice. The company continued to expand and began shipping between Australia and the south-west Pacific, running numerous plantations and warehouses in Samoa, the New Hebrides, and the Solomon, Gilbert and Ellice islands.

By 1914 Burns Philp had established a tourist department, advertising tours to Lord Howe and Norfolk islands. The company maintained a near monopoly on passenger services to Melanesia and other areas of the Pacific until World War II. Company ships were instantly

< Leadlight glass panel showing Burns, Philp & Co thistle in the roundels, c1900. This leadlight glass panel adorned the Sydney offices of the shipping line Burns, Philp & Co Ltd Lead, glass, paint, 27 x 41 x 1 cm (overall)

∨ Brett Hilder (1911–1981) MV *Tulagi* at Sydney Island, 1959. Between 1955 and 1958 the British Government moved inhabitants of the overpopulated Sydney (now Manra) Island in the Kiribati group to Gizo Island in the Solomons. The last 220 people were taken off Sydney Island in September 1958 aboard the Burns Philp vessel MV *Tulagi*, and the event was captured in Hilder's poignant watercolour. Watercolour on paper, wood, glass, 67.5 x 82 x 4 cm (framed) © Estate of the artist, reproduced with permission

recognisable – and fondly remembered – by their black funnels with a black-and-white check band, and their Scotch thistle flag. Burns Philp was listed on the Australian Stock Exchange until 2006.

Brett Hilder, the youngest son of renowned watercolourist Jesse Jewhurst Hilder, was a crew member on Burns Philp ships from 1927. Hilder travelled extensively to the Dutch East Indies and South Pacific Islands, and eventually became a ship's master. During World War II, he began painting watercolours of landscapes, cartographic details and portraits of the people and places he visited. The National Maritime Collection includes several of Hilder's watercolours and sketch maps.

Ships' captains and crew members such as Brett Hilder often kept artistic and literary records of their voyages, which documented Australia's longstanding economic and cultural engagement with the exotic Pacific islands.

Stephen Gapps

Funny place for a lighthouse

The museum's collection contains many strange and fascinating items, including a lighthouse in the middle of a city, a huge lighthouse lens in the middle of a museum, and a red lightship with the name *Carpentaria* emblazoned on the side tied up at a wharf.

Beacons, bonfires, lighthouses and lightships have been a part of maritime history for more than 2,000 years. Some sources state that it was the Phoenicians who first used bonfires to mark ports and safe harbours as early as 500 BC. As shipping technology improved and trade routes became longer and more complex, maritime knowledge was complemented with charts, sailing directions and eventually beacons, buoys, cairns, lighthouses and lightships, which guided seafarers and warned them of dangers.

In Australia, the first navigational beacon was established at South Head as early as 1793, marking the entrance to Sydney Harbour and the fledgling colony at Sydney Cove. The first lighthouse – the Macquarie Lighthouse, designed by the convict architect Francis Greenway – opened in 1818.

Up until Federation in 1901, each colony operated its own navigational aids, including lights and lightships, under the loose direction of the Australian Commission of Coastal Lights. Following Federation, the Commonwealth Government took over the running of all navigational aids, including 104 crewed lighthouses and 18 automatic lighthouses not directly associated with individual ports and harbours. Among these were the Cape Bowling Green lighthouse in North Queensland, and the lighthouse on Tasman Island, south-east Tasmania – the former, and the lens from the latter, are now in the museum's collection.

The 21-metre-high Cape Bowling Green Lighthouse – the Cape is believed to have been so named by James Cook, due to its resemblance to a flat bowling green – stood on a flat, sandy headland some 70 kilometres south of Townsville from 1874 until 1987, when it was superseded by fully automatic light. A highly significant lighthouse in its day, it lit part of the Inner Route, a major shipping channel that allowed vessels to safely traverse the coast of Queensland inside the Great Barrier Reef. It was prefabricated in Brisbane, built out of curved steel plate bolted to an inner frame of Australian hardwood, and then reassembled at Cape Bowling Green. To protect the historic lighthouse from damage it was dismantled in 1987, and then slowly reassembled on the museum's north wharf in 1994.

The Tasman Island lighthouse was also automated in 1977, and this time just the lens was transferred to the museum's collection – but what a lens! Manufactured by the Chance Brothers in England in 1905, the six-metre-high lens and clockwork mechanism were shipped out to Tasmania and hauled up 250-metre-high cliffs. The 127 glass prisms, which allowed the beam to be focused so that it could be seen by ships more than 30 miles (55 kilometres) away, were then carefully reassembled on the top of Tasman Island. Today the light shines (at a reduced wattage) throughout the museum's main exhibition building.

Arguably the most eye-catching of the museum's floating fleet is the bright red Commonwealth

> Messrs D & C Stevenson, Edinburgh, Scotland, designers Cockatoo Island Dockyard, Sydney, Australia, builders, Commonwealth lightship *Carpentaria* (CLS4), 1917 *Various materials Transfer from Department of Transport and Communications*

Lightship 4 (CLS4), better known as *Carpentaria*, the name emblazoned on its iron hull. Constructed at Cockatoo Island Dockyard in Sydney between 1916 and 1917, the Commonwealth Government had four of these uncrewed, fully automatic lightships built to the design of Scottish naval architects D & C Stevenson (related to the writer Robert Louis Stevenson) and destined to operate in the isolated and cyclone-prone waters of the Gulf of Carpentaria, marking the Merkara Shoals and at Breaksea Spit north of Sandy Cape in Queensland.

Over time the lightships felt the full fury of seas and tropical cyclones, with two of them lost or damaged beyond repair. CLS4 also spent considerable time in the Gulf, but its last station before retirement in 1985 was in Bass Strait.

Kieran Hosty

> Chance Bros & Co Ltd, Tasman lighthouse lens and pedestal, 1905 *Cast iron, flint glass, 600 cm (overall) Transfer from Australian Maritime Safety Authority*

< John & Jacob Rooney, Chance Bros & Co Ltd, Cape Bowling Green lighthouse, 1873–74 *Iron, wood, copper, bronze, brass, glass, paint, 2100 x 640 cm (overall) Gift from the Department of Transport and Communications*

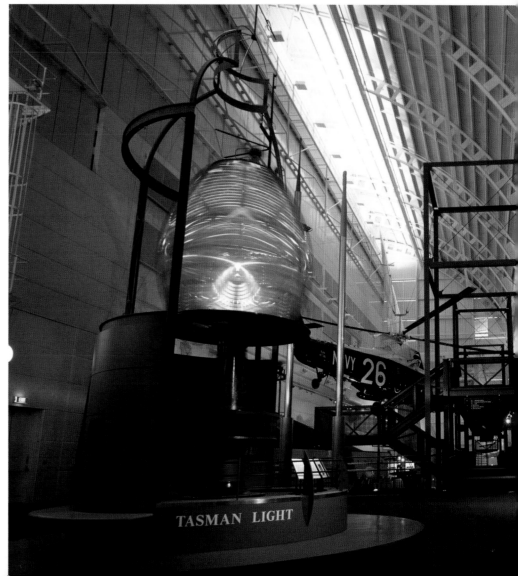

The site in East Darling Harbour now called Barangaroo was once labelled 'the Hungry Mile' by Sydney waterfront workers who, under the infamous 'bull' casual labour system that operated prior to World War II, tramped from wharf to wharf in search of a job. Wharfies were selected daily and, as the work was dangerous and backbreaking – with cargo unloaded from ships mainly by hand – employers would choose the strongest, or their favourites.

Artworks from the waterfront

This banner, painted by Edgar Whitbread in 1903, was commissioned by the Painters' and Dockers' Union of Port Jackson. It depicts the steamship *Niagara* entering dry dock, and was carried in Eight-hour Day parades and May Day marches until 1990.

The origins of artistic output in trade unions can be found in the intricate and beautiful procession banners of the mid to late 19th century. After the first strikes by stonemasons in 1856 for an eight-hour day – based on the English socialist Robert Owen's 1817 call for '8 Hours Work, 8 Hours Recreation, 8 Hours Rest' – tens of thousands of workers took part in annual parades in major Australian cities. Communities across the nation held carnivals, picnics and theatrical performances – annual celebrations that, for many years into the 20th century, drew the largest crowds across Australia. The highlight of the parades was each trade union's banner – often lavishly decorated with highly symbolic themes and images reflecting the struggles, achievements and aspirations of the trade union movement.

The history of waterfront work was closely tied to that of trade union campaigns for safe and secure employment. These struggles were to be immortalised in a huge and evocative artwork on the walls of the Sydney Waterside Workers Federation canteen, which trade unionists have called the 'Sistine Chapel of the trade union movement' – the *Sydney Wharfies Mural*.

The mural was the brainchild of Waterside Workers Federation (WWF) member Rod Shaw, who in 1953 began painting scenes of waterside worker and general labour movement history on the union's canteen walls. But it became a collective effort, painted over nearly a decade by a number of artists, watched by curious and interested waterside workers while they ate their lunches.

The work was an organic process, executed on the plaster walls in paint, crayon, pastel and pencil by WWF members and supporters such as Clem Millward and Evelyn Healy, who were recognised artists. As it grew, it wended its way around doors, corners, pilasters and a chimneypiece, depicting a grand sweep of events from the history of the WWF, the labour movement and Australia.

The mural was painted in a style reminiscent of socialist realism. Its subjects include the struggle for the eight-hour day, prominent maritime union leaders such as Jim Healy, anti-conscription campaigns, the General Strike of 1917, the bitter police confrontations of the late 1920s, and the history of the Australian Communist Party – the prominence of which in mid-20th-century Australian politics is often forgotten. From the 1980s, maritime industries moved away from the port of Sydney, and in 2008 the last cargo ships docked at the wharves along the Hungry Mile. In 1991, mindful of its national significance, the Maritime Union of Australia supported the careful removal of the mural from the canteen building and its preservation in the Australian National Maritime Museum collection.

Edgar Whitbread (d 1958) Niagara *Entering Dry Dock*, 1903 Trade union banner, oil on cotton duck, varnish, 254.2 x 308 x 4 cm (overall) *Gift from the Federated Ship Painters and Dockers Union of Australia*

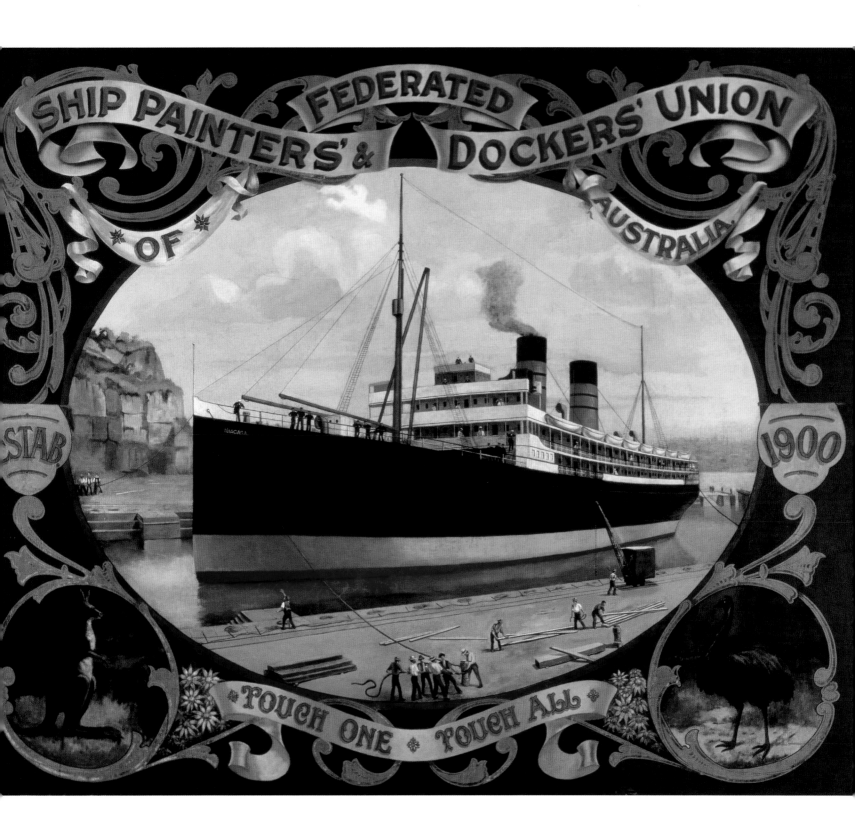

∧ Detail from *The Sydney Wharfies Mural*, 1953–65.

< Mural in situ, wrapping around the canteen walls, 1990. Rod Shaw, Harry McDonald, Evelyn Walters (Healy), Vi Campbell (Collings), Sonny Glynn, Pat Graham, Clem Millward, Harry Reed and Ralph Sawyer (artists) Mural panel, paint on plaster, steel, dimensions variable © Maritime Union of Australia, reproduced with permission *Gift from Maritime Union of Australia.*

The mural was not an isolated example of working-class art. It was an integral part – arguably a culmination – of the artistic and cultural activities supported by the Sydney branch of the Waterside Workers Federation. These included poetry, theatre and the establishment of a WWF film unit, which made films such as *Indonesia calling* (1946). Directed by Joris Ivens, the film recreated the famous maritime workers' boycott of Dutch shipping, which was transporting troops and arms for the recolonisation of Indonesia by the Dutch after World War II.

Stephen Gapps

5 SERVING AUSTRALIA

It's been said that the Navy established modern Australia.

It was an officer of Britain's Royal Navy, the young Lieutenant James Cook, who took possession of the entire east coast of the continent for King George III in 1770. Another officer of the Royal Navy, Captain Arthur Phillip, was placed in command of the First Fleet to bring the first European settlers – convicts and their military supervisors – to New South Wales. Phillip was appointed governor of the new colony, and was followed in this role by three more navy officers: John Hunter, Philip Gidley King and William Bligh.

While leadership then passed to military and civilian personnel, the Royal Navy maintained a strong presence in the Australian colonies for strategic purposes through the 19th century, a period when Britannia was the world's acknowledged ruler of the waves – and other European powers were seeking to expand their colonial interests in the Pacific.

Around the middle of the century, Britain's colonies in Australia set up their own navies, with voluntary personnel, to support the Royal Navy and attend to each colony's concerns at sea. Finally, after Federation, the new Commonwealth Government established the Royal Australian Navy in 1911 to defend the nation and protect its maritime boundaries. The entry of the first RAN fleet through Sydney Heads in 1913 was an event that stirred national pride.

The museum has a rich collection of objects that link today's audiences with these and other important milestones of naval activity in Australia and on the high seas. One piece that straddles three naval eras is the striking, hand-carved and painted ship's figurehead portraying Admiral Lord Nelson. This wooden Nelson served the Royal Navy, the Victorian Navy, and finally the Royal Australian Navy – detached from his ship, he invoked naval traditions at RAN establishments on land.

The museum collection also includes items that provide direct links to naval service in recent memory – objects from ships involved in the Iraq war, artworks featuring naval peacekeeping operations and cartoons pointing to difficulties encountered with the RAN's new Collins class submarines.

Two of our biggest attractions have come direct from the RAN – the Daring class destroyer HMAS *Vampire*, and the Oberon class submarine HMAS *Onslow*. Both are open for inspection, displayed as they appeared in their recent service.

Similarly, the superb Australian-built replica of James Cook's ship HM Bark *Endeavour*, when it's 'at home' at the museum, is open for inspection, showing vividly what life was like at sea on a Royal Navy ship in the second half of the 18th century.

Bill Richards

The museum's Daring class destroyer HMAS *Vampire* in dry dock

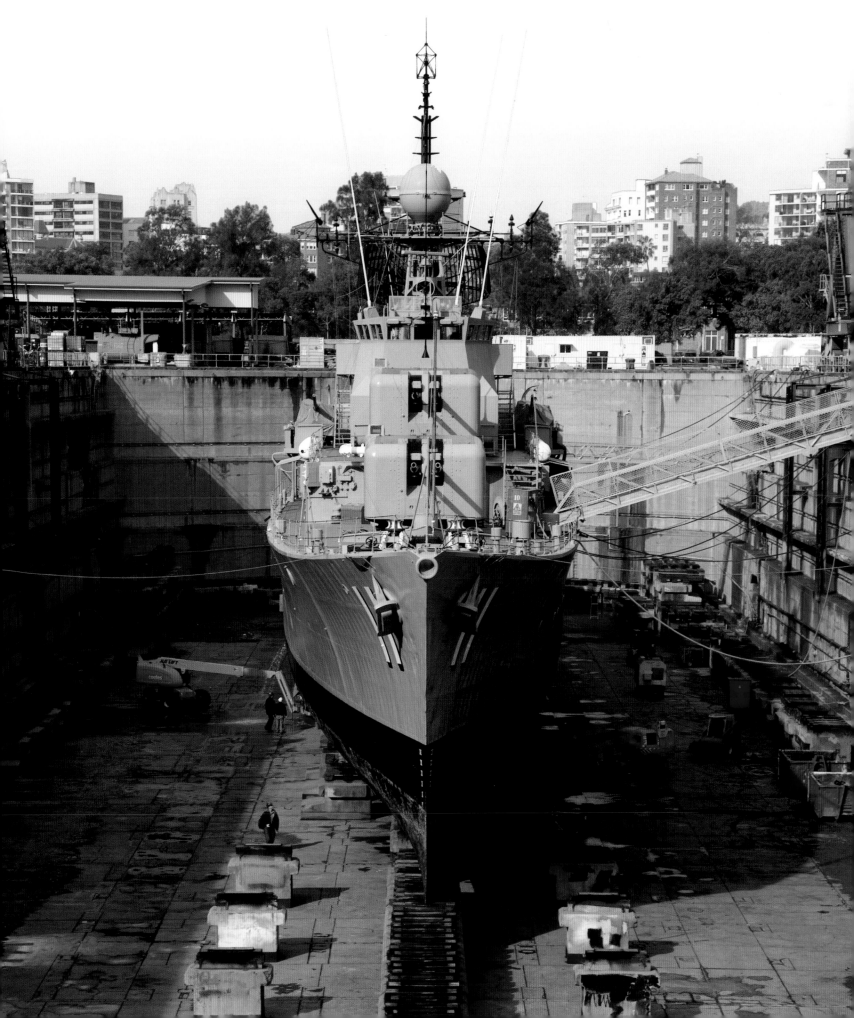

The gunship, the Cold War warrior and the TV star

Moored at the museum's wharves and easily spotted from Pyrmont Bridge are the 119-metre Daring class destroyer HMAS *Vampire*, the 90-metre Oberon class submarine HMAS *Onslow*, and the 33-metre Attack class patrol boat HMAS *Advance*. Each has its own unique story to tell.

Vampire – variously nicknamed 'the Mean Machine' and 'the Bat' – is the last big destroyer built in Australia and the last Australian example of a gunship (carrying conventional guns as its main armament rather than the guided missiles of today's Royal Australian Navy). It served in the RAN from 1959–86, participating in many exercises and joint operations with other navies, and making troop escort runs to Vietnam in the 1960s. *Vampire* ably contributed to Australia's defence during the often tense Cold War years. Decks and compartments are open for viewing and it's as though the ship's company has just gone ashore, but when Action Stations comes alive and

the sounds of the 4.5-inch guns being loaded reverberate through the ship, you know this was once a bustling and efficient warship. *Vampire* has been described as 'a happy ship' by most of those who served aboard, although photographs and tales tell of searing heat in the boiler rooms and hanging on tightly as the ship ploughed through heavy seas.

The museum's other Cold War warrior is *Onslow*, one of six Oberon class submarines that served in the RAN from the 1960s to the 2000s. Stealthy, silent and secret, *Onslow* could go to sea for several months and stay underwater for more than six weeks at a time, periodically using the snort system to draw air in while running at periscope depth. It undertook intelligence gathering, photographic reconnaissance, mine laying, surveillance, anti-submarine warfare and hunting enemy surface ships. This multipurpose role, and its endurance and virtually silent operation, enabled *Onslow* to successfully track Soviet submarines moving into the Arabian Gulf from Vladivostok via the Coral Sea and the Great Australian Bight on several occasions. Submariners are volunteers and a close-knit group who rely on each other for the safe running of the boat. Being confined in a steel tube deep underwater takes a special kind of person – being claustrophobic is not an option! Submariners contend with a lack of fresh air and sunlight when submerged and, in the Oberons, the fumes of the diesel engines.

HMAS *Advance* is the third of 20 Attack class patrol boats built for the RAN in two Queensland shipyards between 1967 and 1969 for general patrol and survey work in Australian and New Guinean waters. A survivor of Darwin's Cyclone Tracy in 1974, *Advance* is still recognised for its starring role in the first series of the ABC-TV production *Patrol boat* (1979) as HMAS *Ambush*.

Patrol boat HMAS *Advance* (32.76 metres) on sea trials off Sydney Harbour, flying the Australian National Maritime Museum flag

Advance's real-life role was to undertake control of illegal fishing, seaward and harbour defence, coastwatching duties, smuggling and immigration control, search and rescue, anti-infiltration and counter-insurgency control, servicing of local navigational beacons, occasional inshore survey work, to be a target towing vessel, and to act as a training vessel for Reserve officers and sailors and for general training in small ship handling. *Advance* could handle almost anything, although it was renowned for having an uncomfortable rolling motion at sea. Stores were taken on board for 14-day deployments, and working in the tropics and among the islands and reefs of northern Australia was not always a comfortable time for its company of 14. With a top speed of 24 knots, the patrol boat was ready for quick responses.

The three vessels are historic artefacts in their own right, and their preservation requires a regular investment of considerable financial, industrial and human resources. However with our ship keepers, managers and volunteers, our fleet is in very capable hands.

Lindsey Shaw

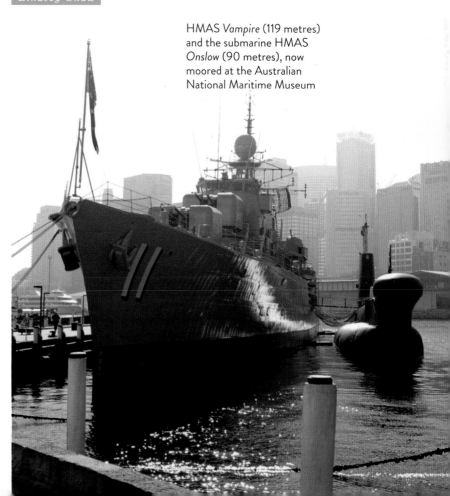

HMAS *Vampire* (119 metres) and the submarine HMAS *Onslow* (90 metres), now moored at the Australian National Maritime Museum

Lord Horatio Nelson never visited Australia but his impact in setting the values and traditions of the Royal Australian Navy (RAN) has loomed large. The great naval tactician and British admiral of the late 18th and early 19th centuries also features prominently in the museum's collection, in the form of a 1,500-kilogram figurehead from HMS *Nelson*. The celebrated image of Nelson – the sight of his right eye lost at the Seige of Calvi, Corsica, in 1794 against the French, and his right arm lost in the Battle of Santa Cruz de Tenerife in 1797 against the Spanish – is still a symbol of naval heroism.

Horatio Nelson's Australian connection

HMS *Nelson* was a wooden 120-gun First Rate of Line battleship. When it was launched at Woolwich naval dockyard in 1814, *Nelson*'s design was already outdated, as such large ships were then no longer necessary, and the ship lay idle and unfinished for almost 40 years. In 1854 came the first of many conversions and alterations, and in 1860 it was fitted with a steam engine and single propeller. This was done at the Portsmouth naval dockyard, where it was decided a new figurehead was needed. The original had been a bust of Lord Nelson in his naval uniform, complete with large gilt epaulettes, and supported on either side by a trumpeting female figure – probably representing Fame and Britannia. The 1860 figurehead was designed and carved for the significant sum of £54, and is the one we see today: Nelson's right sleeve is empty and folded against his chest, and he carries a telescope in his left hand. Drawings from the period show two trailboard carvings which carried Nelson's now-famous words 'England Expects Every Man' and 'To Do His Duty' – but unfortunately the whereabouts of these is unknown.

In the 1860s, the colonial government of Victoria requested a vessel from the British Admiralty for training local naval volunteers. HMS *Nelson* was fitted out and commissioned as HMVS (Her Majesty's Victorian Ship) *Nelson* in 1867. From 1868 to 1891 it was a familiar sight on Port Phillip Bay. From 1878 to 1881, it was modified and reduced to a single-decker. *Nelson* was taken out of service in 1891, the boilers removed in 1893 and the remaining ship sold in 1898. Towed to Sydney, the ship was slowly dismantled and the grand figurehead was given to the NSW Naval Brigade. The remnant vessel became a coal lighter, then a coal hulk and finally, in the 1920s, *Nelson* was completely dismantled in Tasmania, having served Britain and Australia well for more than 100 years.

The figurehead itself has a less well-recorded history. After being given to the NSW Naval Brigade in 1898 and proudly displayed at the Battle of Trafalgar centenary celebrations in 1905, it spent much of its time at the parade grounds of the naval reserve at Rushcutters Bay. In 1911 it was transferred to the new RAN and was later sent to HMAS *Cerberus* in Victoria – the RAN's training establishment – where it remained on open display until its transfer to the museum in 1988.

Lindsey Shaw

Portsmouth naval dockyard, England Figurehead of Admiral Lord Horatio Nelson, 1860 *Wood, paint, 298.4 x 203 x 136 cm Transferred from the Department of Defence*

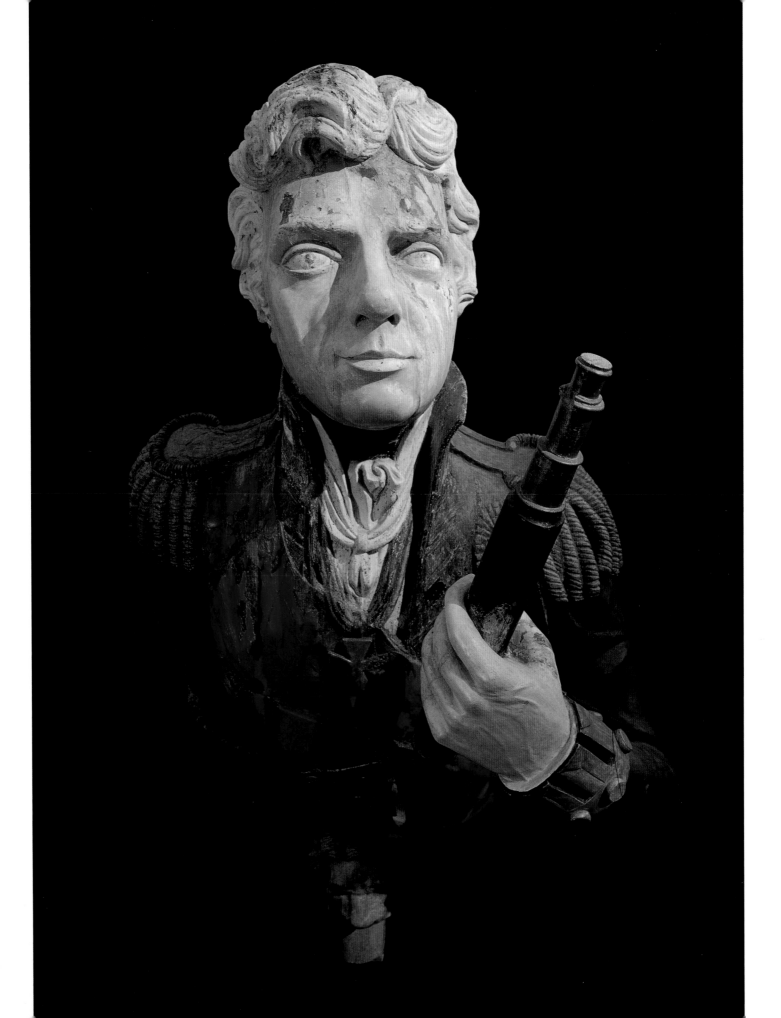

In 1859, the colonial assemblies of Australia and New Zealand joined forces and successfully lobbied the British Royal Navy (RN) to review its strategic zoning of the world's oceans, and to establish the Australia Station as a separate command, responsible for the safe charting and passage of ships around the Australian and New Zealand coastlines. The Australian colonies of Queensland, New South Wales, Victoria and South Australia had their own volunteer navies but, wary of invasion, they wanted more coastal protection than the RN provided. By the 1880s, the colonial governments were becoming increasingly alarmed by Russian warship activity in the Pacific.

The Royal Navy protects Australia

Between 1859 (when the Australia Station was officially proclaimed) and 1913 (when the Imperial Australian Squadron was formally disbanded), 15 British flagships and their attendant squadrons were on duty around Australia and New Zealand and some parts of the South Pacific, including New Guinea, Fiji and the Solomons.

At a scale of 1:48, this single builder's model represents three Royal Navy Pearl class, third-class protected cruisers all built in Britain in 1889 and 1890:

HM Ships *Katoomba*, *Mildura* and *Wallaroo*. There were three classes of protected cruisers in which the vital machinery spaces were protected from exploding shells by thick armour, with the third-class ships being the smallest, and primarily used for patrols and protection. This trio served in Australian and New Zealand waters as part of the Auxiliary Squadron until 1906.

Their main duties were routine cruising and patrol work. *Katoomba* was also used as a recruitment ship, visiting major Australian ports in 1905 in an attempt to encourage young men to pursue an exciting career in the navy. *Mildura*'s greatest honour came when it was a unit of the naval division that visited New Zealand during the Duke and Duchess of York's tour in the Royal Liner *Ophir* in 1901. The royal

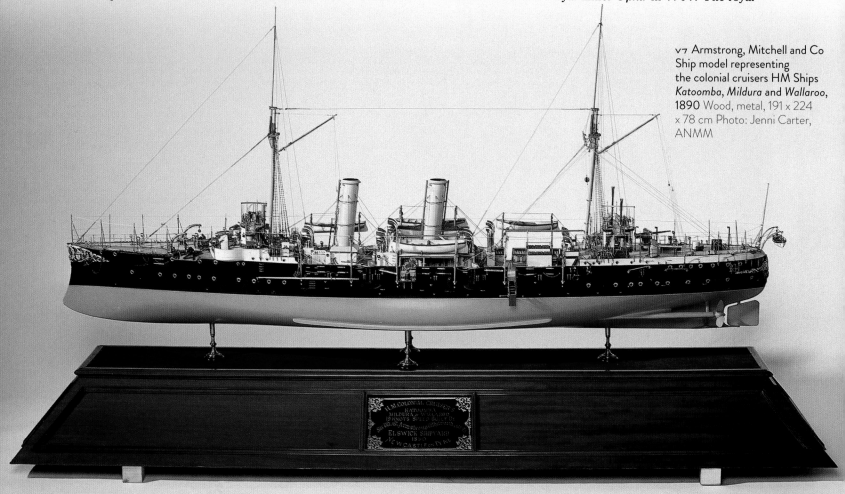

v7 Armstrong, Mitchell and Co Ship model representing the colonial cruisers HM Ships *Katoomba*, *Mildura* and *Wallaroo*, 1890 Wood, metal, 191 x 224 x 78 cm Photo: Jenni Carter, ANMM

tour was an eight-month goodwill tour to Commonwealth countries around the world, and the Duke's main task was to inaugurate the first Australian Federal Parliament in Melbourne. *Wallaroo* spent much time in New Zealand waters and in 1900 was deployed to China, serving briefly in operations to subdue the Boxer Rebellion.

After spending all their working lives in southern seas, the ships were paid off (decommissioned from service) and sold for scrap – although *Wallaroo* extended its life in various harbour jobs, and was finally sent to the ship-breakers after World War I.

This ornately carved presentation launching box (below, complete with ceremonial mallet and chisel) was made for the launch of the Royal Navy's second-class protected cruiser HMS *Encounter*, built at HM Dockyard, Devonport, England, specifically for service on the Australia Station. A silver plaque on its lid records that the ship was launched by Lady T Sturges Jackson on 18 June 1902. On commissioning in 1905, *Encounter* sailed for Australia, where it served for six years, and was then presented on loan to the newly formed Royal Australian Navy (RAN) as a seagoing training ship.

On 1 July 1912 it was commissioned as HMAS *Encounter*, and entered Port Jackson on 4 October 1913 as part of the first Australian fleet unit. During World War I, *Encounter* was stationed in northern waters and took part in operations against German New Guinea (now Papua New Guinea), followed by patrol duties in the Fiji–Samoa area, the waters off Malaya and the East Indies, and more patrol and escort duties in the Pacific, Southern and Indian oceans.

Encounter became a permanent unit of the RAN in 1918, and was used as a seagoing training ship,

known as the 'Old Bus'. In 1923 it was disarmed, renamed HMAS *Penguin*, and moored alongside Garden Island, Sydney, as an accommodation vessel. The ship was stripped for scrapping in 1929, and on 14 September 1932 its hulk was sunk off Bondi beach – a long and eventful life for a warship now in more than 70 metres of water, safe from the treasure hunters.

Lindsey Shaw

> HMS *Encounter* launching box, 1902 Wood, silk, silver, 24.7 x 43 x 34 cm Photo: Jenni Carter, ANMM

The raider *Emden*

'*EMDEN* beached and done for!' Captain John Glossop sent this triumphant signal from HMAS *Sydney* on 9 November 1914. The destruction of the German raider in the Indian Ocean was the biggest naval event in the first year of World War I.

SMS *Emden* was a Dresden class light cruiser of the Imperial German Navy, named after the city of Emden in north-west Germany on the Ems River. In the last months of 1914, *Emden* had been raiding Allied shipping in the Indian Ocean, causing chaos in commerce and sinking or capturing 23 merchant vessels and two Allied warships. The exploits of *Emden*'s crew were seen as the most successful of the entire German Imperial naval fleet in terms of their sheer daring and tonnage of Allied shipping sunk or captured.

While escorting the first ANZAC convoy from Australia to the Middle East, the light cruiser HMAS *Sydney* was detached to investigate reports of a strange warship off Direction Island in the Cocos Archipelago. The vessel was the *Emden*, which had just detached a shore party – under the command of executive officer Hellmuth von Mücke – to destroy the British cable and wireless station. *Emden* stood out to meet *Sydney*, opening fire on the Australian warship at 9.40 am. The German cruiser, hopelessly outgunned by the modern, more powerful and faster *Sydney*, was pounded almost beyond recognition before being driven ashore on North Keeling Island. After one hour and 40 minutes in battle, *Sydney*'s casualties

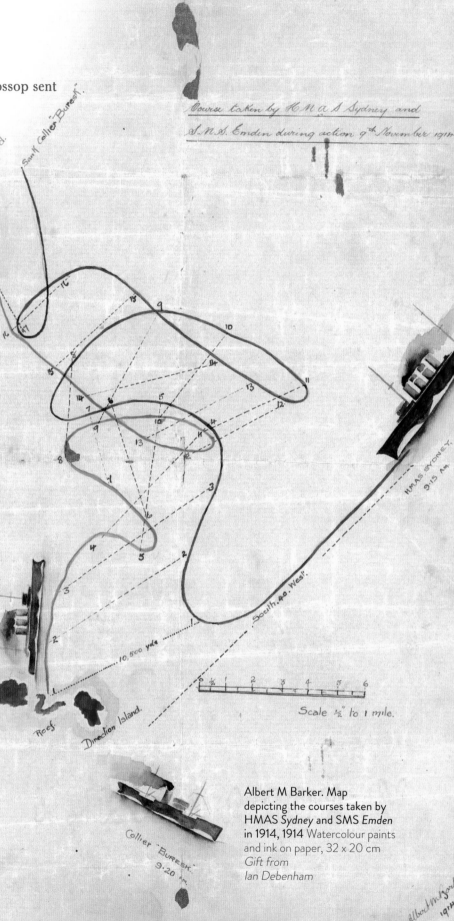

Albert M Barker. Map depicting the courses taken by HMAS *Sydney* and SMS *Emden* in 1914, 1914 Watercolour paints and ink on paper, 32 x 20 cm
Gift from
Ian Debenham

numbered four men killed and 12 wounded; *Emden* lost 131 lives, with 65 wounded and 110, including the captain, Karl von Müller, taken prisoner.

During the *Sydney–Emden* confrontation, von Mücke and his shore party seized the Cocos Islands' 120-ton, three-masted copra-carrying schooner *Ayesha*, and made for neutral Padang on Sumatra, where they were able to rendezvous with a German merchant vessel. Von Mücke's men made their way to Turkey via the Red Sea and the Arabian peninsula. They eventually reached Germany and received a heroes' welcome in May 1915.

The destruction of SMS *Emden* by HMAS *Sydney* was big news worldwide. Allied shipping could again move safely into the Indian Ocean and Australians were jubilant, believing the nation had proved itself on the world stage. Australia produced many souvenirs to mark the momentous event and, when *Sydney* was decommissioned in 1928 and sent to Cockatoo Island Dockyard for scrapping, the dockyard workers also made a myriad of souvenirs from the ship's different materials, most notably the brass shells and timber decking. These included ashtrays, bowls, picture frames, mantle clocks, walking sticks, desk sets and other household items.

But what of the other side of the story? Germans saw the naval battle as a heroic defeat and in 1916 Germany built a new *Emden* with the Iron Cross on its bow – a great honour for the ship's complement and a dedication to the men of the first

> H Ziegler, designer SMS *Emden* Von Muller medallion, c1918 (front, top, and back) Metal, 3.5 cm (diam.)

Emden. Four more ships have proudly carried the name, and descendants of the men on the first *Emden* have been permitted to add Emden to their surname if they so wish. The battle was so well remembered that more than a decade after the event, the German film *Kreuzer Emden* (*The raider Emden*) premiered, recalling Germany's heroic activity in the Great War. This movie poster was produced for the American release of the film in 1928.

This battle in the Indian Ocean showed that the Royal Australian Navy had come of age and that the *Emden* was a worthy foe. The material that commemorates this sea battle covers both perspectives, with medals produced by Germany and Australia as well as detailed accounts, drawings and histories of this naval event.

Lindsey Shaw

> The Otis Lithograph Co, Cleveland, Ohio, USA. *The Raider* Emden, 1928 Lithograph poster, 93 x 59 cm (image), 107 x 72.7 cm (sheet)

HMAS *Sydney* lost with all hands

On 19 November 1941, off the Western Australian coast, HMAS *Sydney* went into battle with the German auxiliary cruiser HSK *Kormoran*. *Sydney*'s bridge was destroyed in the first attack and torpedoes hit the forward gun turrets. *Kormoran*'s engine room was hit and fire raged until the captain ordered it to be abandoned, the mines on board detonated and the ship blown up. German survivors reported seeing *Sydney* ablaze. All 645 men on board *Sydney* perished. *Kormoran* also sank, killing 78 of its 393 crew. The wreck sites of both ships remained unknown until 2008.

HMAS *Sydney* was named after the first *Sydney*, which destroyed the German raider SMS *Emden* in World War I. During World War II, *Sydney* patrolled Australian waters until April 1940, then headed for the Mediterranean.

Sydney distinguished itself in action against an Italian force at the Battle of Cape Spada, Crete, on 19 July 1940. The Allied squadron – under the command of Captain John Collins aboard *Sydney* and accompanied by British Royal Navy destroyers – was patrolling the Aegean Sea when it came across two Italian cruisers sailing from Tripoli to Leros. A running battle followed, with the Italians altering course several times, leaving large smokescreens in their wake. *Sydney* was hit in the foremost funnel, while one of the Italian ships, *Bartolomeo Colleoni*, was hit by *Sydney* gunfire and British torpedoes, and sank.

This complex hand-drawn linen chart (above, right) shows *Sydney*'s daily movements in the Mediterranean Sea from 10 June to 3 October 1940, including its operations during its battle against the *Colleoni*. The chart was initially drawn by a draughtsman on board *Sydney* and then officially updated after each return to harbour. It informed the Commanding Officer of the daily progress of ship and boat operations, and was also referred to in operational reports or letters of proceedings.

By January 1941 *Sydney* needed a refit and its company needed rest, so the ship returned to Australia. After a triumphant homecoming in Sydney and a refit at Garden Island, *Sydney* and its new commander, Captain John Burnett, took up new duties as a convoy escort.

Off the Western Australian coast on 19 November 1941, the cruiser sighted what appeared to be the Dutch merchant ship *Straat Malakka*. *Sydney* repeatedly signalled for identification. The merchant ship avoided replying, then suddenly dropped its disguise and opened fire – revealing itself as the German armed auxiliary cruiser HSK *Kormoran*. The fierce sea battle had begun.

< Photograph of Warrant Engineer Frederick William Reville, 1940
Silver gelatin photographic print, 13 x 8.5 cm *Gift from Pauline Humphreys*

> Track chart from HMAS *Sydney* (II), June to October 1940 Ink on linen, 101.5 x 60 cm

∨ Wetzell Gummi, manufacturer HSK *Kormoran* life jacket, 1930s. This life jacket helped First Lieutenant Messerschmidt survive the sinking of the *Kormoran*. Fabric-covered rubber, plastic lids, fabric straps, 75 x 52 x 1.5 cm *Purchased in the memory of John Allott-Rodgers*

Some 315 Germans survived, and spent the rest of the war in Victorian internment camps. One survivor, Oberleutnant Messerschmidt, was wearing this life jacket when rescued from the ocean. When released from internment in 1947, he gave many of his possessions to prison guards he had befriended, including his life jacket to Warrant Officer H Scanlon. It is a nondescript article belying its historical importance, and was, apart from the clothes he was wearing, Messerschmidt's only personal possession from the ship.

For decades there were theories and stories about what had happened and where the ships ended up on the sea floor. In 2001, the Finding Sydney Foundation was formed with the sole intent of finding the wrecks and laying the sailors to rest. With the aid of world-famous specialist wreck finder David Mearns, the *Kormoran* was found on 12 March 2008, and the *Sydney* on 16 March, some 12 nautical miles apart. One of Australia's greatest maritime mysteries was solved. Both ships bore testament to their fierce battle. The damage to *Sydney* showed extremely accurate gunfire from the Germans, and substantiated much of what the German survivors recounted. It also appears that *Sydney* sank quickly after extensive damage to its forward section caused the bow to fall away from the ship and the remainder to flood.

After the wreckage was found in 2008, the museum acquired this photograph of *Sydney*'s Warrant Engineer Frederick William Reville (left), taken on 19 September 1940. Inscribed with a simple greeting to his family, it is one of only a handful of identified photographs in our collection relating to the men who died in the great *Sydney–Kormoran* battle. As an engineer on board *Sydney*, Fred Reville may have been among those trapped below deck with no chance of survival as the ship sank to its final resting place, 2,468 metres below the surface of the Indian Ocean.

Lindsey Shaw

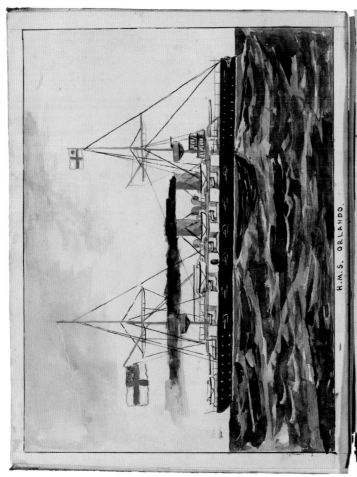

It's not easy to balance the call of the sea with love for family and home. Despite James Conder's sister writing to him in 1891, 'Dear Jim, don't join!', when he was 19 years old, it was only the start of Conder's career, which spanned four different navies in the service of Australia.

One man, four navies

James (Jim) Bryance Conder was one of thousands of ordinary Australian sailors who helped to shape Australia's naval history. His naval career took place during a time of transition, with Britain ceding control of Australia's naval defence to allow full local responsibility with the formation of the Royal Australian Navy (RAN). It also highlights what a strong imprint the Royal Navy had on the RAN.

The 19-year-old Conder first sailed with the merchant ships *Ellora* and *Avenger* before joining the Royal Navy in

1891. He served in the flagship of the Australia Station, HMS *Orlando* – which was escorting the ships of the new Australasian Auxiliary Squadron (paid for by the colonies, but manned by the Royal Navy) around the coasts, giving the colonists a close-up view of their fleet. The young Jim first signed up for six months, with an option to extend to 12 years, but chose to leave and return to family and home in Melbourne. He may have been swayed by that somewhat emphatic letter from his sister Alice in 1891, who wrote on behalf of their mother: 'Whatever you do don't sign any papers to join for twelve years or any longer'. Instead, he joined the Victorian Colonial Navy and was posted, in

< James Conder (1872–1954)
Under Canvas, Notes from a Sailor's Log: Volume 2, 1889–1937. Here James Conder depicts HMS *Orlando*, naval flagship of the Australia Station, and writes about his years serving in the Royal Navy. Handwritten journal, 2.4 x 26.2 x 21.2 cm

> The young James Conder in the Victorian colonial navy uniform, about 1894 Photograph, 27.8 x 22.8 x 2.5 cm

v James Conder (1872–1954) Broadside port view of gunboat HMVS *Albert*, c1900. James Conder was posted to HMVS *Albert* during his time with the Victorian Naval Brigade. Oil on canvas, 47.1 x 57.2 x 3.2 cm (framed) *All: Gifts from Robert Murphy*

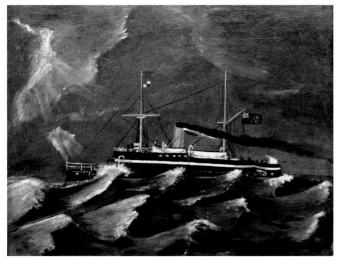

navy, married Victoria Agnes Nihill and became a policeman.

But in 1904 he returned to the sea and naval life, joining the transitional Commonwealth naval defence forces, formed after Federation. His first ship was HMS *Katoomba* where, as bosun's yeoman, he helped train new recruits. This third period of naval service continued in HM Ships *Challenger* and *Psyche* and included voyages to Fiji, the New Hebrides (now Vanuatu), Singapore and New Zealand, as well as regular and routine cruises to Australian ports.

In 1909 Conder left naval life once again for shore-based civilian work until 1913, when he was recruited to the RAN Naval College at Osborne House in Geelong, Victoria. He remained with the college – through its moves from Geelong to Jervis Bay, New South Wales, and then Crib Point, Victoria – until 1937. He was a study corporal, training midshipmen in the practices of the Royal Navy and helping to ensure that its traditions were carried into Australia's navy.

Later in life Jim Conder described his seagoing years in his memoirs. For each of his children he produced a two-volume handwritten journal, lovingly illustrated by him, and including photographs, poems, concert tickets and other mementos. His journals tell of the conflict between his love of the sea and his desire to be with his wife and family. His memoirs for his daughter Alice, with some other articles recalling his naval life, were donated by family members to the museum in his memory.

'So as we journey onwards, we often sit and dream of what was, what is and just what might have been.'
– James B Conder

succession, to the turret ship HMVS *Cerberus* (the remains of which can still be seen today at Black Rock in Port Phillip Bay), the old battleship HMVS *Nelson* (whose wonderful figurehead of the famous admiral is on display in the museum; see p. 125) and the gunboat HMVS *Albert*. In 1896, some four years into his service Conder left the

Lindsey Shaw

During their 2007 Middle East deployment, HMAS *Toowoomba*'s aircraft call sign was 'Bluetongue'. The *Toowoomba* crew designed a patch with the motto 'These are the cards we've been dealt', and the image of a blue-tongued lizard holding a spanner and wearing a jester's hat, with the flags of Australia and Iraq behind it. The museum's naval collection ranges from professional and personal mementos of servicemen and women, such as the *Toowoomba*'s patch, to paintings by Australia's war artists and the razor-sharp observations of our best political cartoonists.

Australian war artists – including contemporary artists Robert McRae and George Gittoes, both represented in the museum's collection – have been part of the theatres of war since World War I, and continue to be embedded with Australian military forces in conflicts or peacekeeping missions today. They create a personal and informed representation of a particular conflict or exercise, recording everything from the actions of war to the routine and mundane.

Robert McRae was appointed an official artist for the Royal Australian Navy Naval History Unit in 2008. He painted, drew and photographed events in the Persian Gulf, mainly on board HMAS *Arunta* as part of the third rotation of RAN ships to the Persian Gulf for Australia's role in

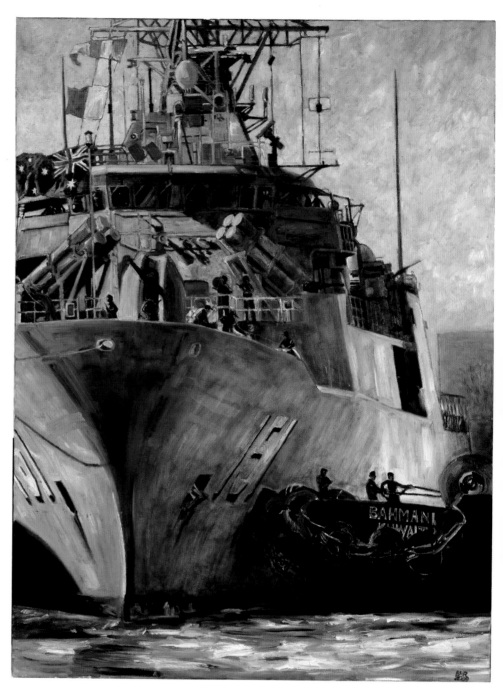

Robert McRae (b 1954) Arunta *Berthing at Kuwait Harbour*, 2008 Oil on canvas, 120 x 90 cm (framed) © Robert McRae, reproduced courtesy of the artist

Operation Slipper Iraq. McRae's *Arunta Berthing at Kuwait Harbour* depicts the Anzac class frigate HMAS *Arunta* (CMDR Tim Brown) berthing in Shuwaikh port in Kuwait Bay during its Middle East deployment in 2008. During *Arunta*'s visit to Kuwait City, General Ahmed Al Mulla, chief of the Kuwaiti Navy, requested that Commander Brown visit him to explain *Arunta*'s presence and duties in the Gulf. This is one of eight paintings in the collection by McRae of the modern RAN undertaking various exercises and patrols.

Australia's participation in patrolling the Persian Gulf and enforcing sanctions against Iraq has required continuous rotation of RAN ships since sanctions began in 1990, following the first Gulf War. Each deployment lasts six months and involves stopping and searching suspect ships for illegal arms or goods, as well as general patrol work.

The museum has collected items covering many of the locations and actions in which RAN ships and personnel have been involved – the 2009 yearbook of HMAS *Toowoomba*'s deployment history is an example. The frigate was deployed on its second mission to the Middle East Area of Operations (MEAO), and was the first RAN ship to intercept a Somali pirate threat during Operation Slipper – Australia's military contribution to the international campaign against terrorism, maritime security in the MEAO and countering piracy in the Gulf of Aden. Commissioning and decommissioning booklets demonstrate the continuing traditions and ceremonial procedures that are part of naval life. But, along with the formal and official, the collection also includes unofficial mementos such as patches, baseball caps and T-shirts designed and worn by RAN ships' companies, all representing the men and women who serve in the RAN today.

Australia's rich tradition of political cartooning captures and conveys complex events with humour, and the navy is not immune to the cartoonist's pen! No fewer than seven cartoonists are represented in the collection, covering such topics as seaborne asylum seekers, Australia's involvement in the Iraq war and the trials and tribulations of the Collins class submarine. This witty cartoon by Peter Nicholson comments on the engine troubles experienced by the submarines in the 1990s – problems that were often blown out of proportion by some media, but resulted in a variety of wonderful comic creations.

Lindsey Shaw

∧ 816 Squadron, HMAS *Toowoomba*, uniform patch, 2007 Fabric, 10 x 8.5 cm *Gift from Sea Power Centre Australia*

> Peter Nicholson *Collins class Submarine Beached*, 1998 Cartoon, handmade wove paper, ink, watercolour and gouache paints, 29 x 38.4 cm © Peter Nicholson, reproduced courtesy of the artist

Workhorse of the air

At 6.55 am on Christmas Day 1974, the National Disasters Organisation received a call from a Darwin police sergeant: 'Darwin's been blown to pieces ... for God's sake send help!' Silence followed for several hours. Cyclone Tracy had hit the city, triggering a national emergency relief operation.

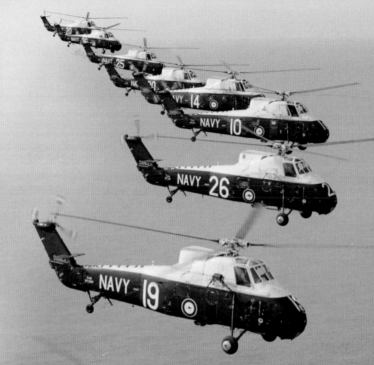

A fleet of Westland Wessex helicopters flying in formation – number 26 was later transferred to the museum from the Australian Department of Defence. Photo: Navy Imagery Unit

Defence personnel from around Australia rallied to help, voluntarily returning from Christmas leave. The Royal Australian Navy (RAN) sent a flotilla of vessels, led by the flagship aircraft carrier HMAS *Melbourne* complete with seven Westland Wessex helicopters. During the 17-day relief operation they flew for 304 hours, moving 7,824 people and 108,955 kilograms of stores. They ferried personnel and equipment ashore, lifted heavy material such as generators to the top of high buildings, and lowered crew for repairs to high-tension power lines. Operation Navy Help Darwin was one of the biggest logistical peacetime exercises undertaken in Australia.

What was the origin of these invaluable workhorse helicopters? In 1963, the first of 27 Westland Wessex

Mk 31A helicopters arrived from Somerset, England, for the Naval Air Station in Nowra, New South Wales. They replaced the fixed-wing element of the Fleet Air Arm after Gannets and Sea Venoms had been withdrawn from service.

Westland Aircraft, founded in 1915, was known for the range of aeroplanes it built for the RAF before and during World War II, including Spitfire and Seafire variants. After 1944, the company moved into helicopter development and production, and while known as the Westland Wessex, the helicopter was in fact Westland's interpretation of the American-designed Sikorsky Choctaw.

Wessex helicopters are most closely associated with the RAN's 725 and 817 Squadrons, serving with them until

June 1975, although they also later served with Squadrons 723 and 816. The Wessex first took part in search and rescue operations in March 1963 – the leader of a formation of RAAF Sabres had to eject near Lake Bathurst, and was reported to have landed near a red farmhouse. They found him waiting for the rescue team, safely sipping whisky on the farmhouse verandah. When HMAS *Melbourne* was involved in collisions with HMAS *Voyager* (in February 1964) and USS *Frank E Evans* (in June 1969), Wessex helicopters performed search and rescue, giving key support in locating survivors and directing rescue craft to them.

Between 1968 and 1970 most of the Wessex fleet was updated and converted to the Mk 31B version. The improvements included a new sonar system for detection of submerged submarines, installing a high-powered Napier Gazelle turboshaft engine, a new radar system, improved Tacan navigation and ultra-high-frequency communication systems.

Both the 817 and 725 Squadrons were active during the Vietnam War, and four Wessex helicopters were assigned to anti-submarine escort duties with the former aircraft carrier HMAS *Sydney*, which was recommissioned to carry troops.

In 1976, the Wessex's anti-submarine warfare role was superseded, and for the next 13 years the helicopters worked in utility support, training, and search and rescue operations until they were phased out of service in 1989, replaced by the Westland Sea King Mk 50 anti-submarine helicopter. Wessex helicopter Number 26 was transferred to the museum from the Australian Department of Defence in 1991.

Veronica Kooyman

> Westland Helicopters Ltd Westland Wessex helicopter, c1963. Number 26 is now suspended from the ceiling of the Navy gallery in the Australian National Maritime Museum. Metal, magnesium alloy, 493.8 x 408.4 x 1545.3 cm (height x width x length) *Transferred from Department of Defence*

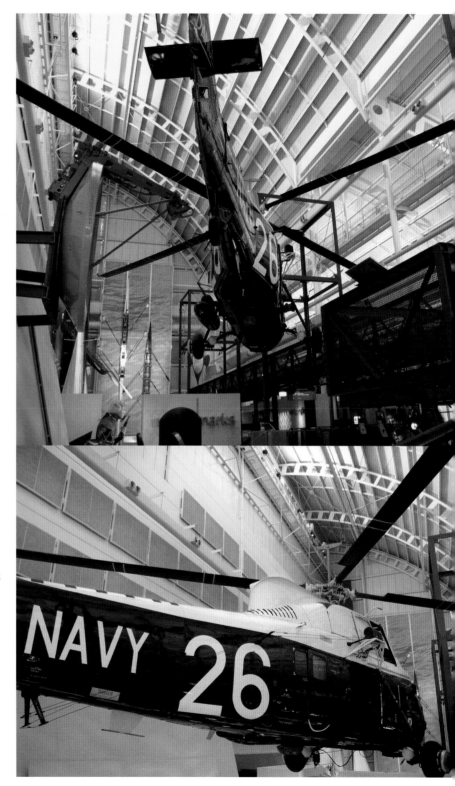

6 LINKED BY THE SEA

Captain Thomas Reed, commander of the American trading ship *Alliance*, laid the foundation for a long-lasting maritime friendship when he pioneered a new trade route around the Cape of Good Hope, across the southern Indian Ocean, around Van Diemen's Land and up the east coast of Australia to China in 1787.

From then on, American traders on their way to China to load cargoes of tea, silks and porcelains for their home market would often stop and sell American produce to the infant settlement at Port Jackson. And then it wasn't long before Australian traders were out with their American counterparts seeking profits on the rapidly developing trade routes of the Pacific.

From those beginnings, Australian and American mariners have been crossing paths and sharing experiences at sea and in ports down through the generations.

Their ships went whaling and sealing in the same seas, tacked back and forth carrying diggers to the gold rushes on both sides of the Pacific, lined up alongside each other against common enemies in the Pacific and other theatres of war and, in a spirit of keen competition, their sailors and surfers have competed against each other in top-level contests.

The USA Gallery, a unique attraction at the Australian National Maritime Museum, derives from a US$5 million gift from the United States to celebrate the bicentenary of European settlement in Australia in 1988. The gallery researches the two countries' shared maritime history, and considers this as part of the close alliance that has developed between them over two centuries.

A feature of the museum right from its opening in 1991, the USA Gallery was dedicated by President George Bush in January 1992 and visited by his son President George W Bush in 2003.

The USA Gallery's contributions to the museum's collection offer insight into the different phases of this sometimes co-operative, sometimes competitive international association. Individual pieces have a wealth of stories to tell. From the earliest period, there are two superb examples from the American China trade: one, a fine 56-piece porcelain dinner service purchased in China and taken home to America by an officer on the *Alliance*; the other, a beautiful and bounteous punchbowl manufactured in China around 1820 and intriguingly decorated with a panoramic view of Sydney Town.

One of the more recent acquisitions is the ship's bell from the American cruiser USS *Canberra*. President George W Bush presented this to (then) Prime Minister John Howard in Washington DC on 10 September 2001, the day before the terrorist attacks on the World Trade Center in New York and the Pentagon in the national capital.

Bill Richards

∧ Henry Gritten (1818–1873) *Hobart Town 1856*. The settlement of Hobart on the Derwent River is depicted below the impressive peak of Mount Wellington. Anchored in the harbour are several sailing and steam vessels of various nationalities, including (front, left) a three-masted clipper ship flying an American flag, and a paddle steamer, possibly the *Kangaroo* (front, centre). Oil on canvas, 62 x 82.5 cm *Purchased with USA Bicentennial Gift funds*

This superb Chinese punchbowl (c1820) and the lavish dinner services commissioned by the Dale and Train families (in 1799 and 1856 respectively) are examples of fine Chinese porcelain commissioned by the wealthy citizens of Sydney and Melbourne and American merchants whose trading routes with China brought them through Sydney in the early 1800s.

Precious porcelain – from China to the world

The Chinese punchbowl is a rare and beautiful work of decorative art – inscribed 'View of the Town of Sydney in New South Wales', it features a panoramic view of Sydney Cove, illustrating the hills and vegetation surrounding the cove and the building of the developing colonial city. The interior rim is ringed with a floral motif of Chinese peonies and the bottom of the bowl features an illustration of a group of Indigenous Australians. It was decorated in China around 1820 by Chinese craftsmen copying motifs and scenes from early published engravings and sketches of the colony. It was likely a special purchase, commissioned by a wealthy or prominent citizen of Sydney Town who was involved in the colony's early trade with Asia, to commemorate a wedding or government appointment. The bowl retains a ghostly family monogram on the side, within the gilt foliage.

Western merchants and sea captains involved in the global expansion of the China trade began to commission chinaware to their own designs, often for their own use. This created a vigorous demand for fine Chinese artworks, pewter wares and silver work, with styles evolving as a result of cultural interaction.

China had exported its fine porcelain bowls for many centuries. While topographical views were common subjects, it's the Sydney scenes that make this punchbowl – and a companion bowl held by the State Library of New South Wales – so rare. It is believed that the two were produced as

∧View of the Town of Sydney in New South Wales, c1820 and detail of a group of Indigenous Australians depicted on the inside of the punchbowl Punchbowl, enamelled porcelain, 17 x 44.8 x 44.8 cm *Gift from Peter Frelinghuysen through the American Friends of the Australian National Maritime Museum and partial purchase with USA Bicentennial Gift funds*

a 'harlequin pair': this bowl portrays Sydney from Dawes Point on the western side of Sydney Cove, and the library's presents a complementary view from Bennelong Point on the opposite side of the cove.

In addition to its intrinsic beauty, the punchbowl is an important historical document, demonstrating Sydney's growing significance as a port along the important trade route between the United States' east coast and China in the early 19th century.

In the late 1700s, American ships in the China trade sailed unladen

directly to Canton, because the Chinese were not interested in Western merchandise. The porcelain trade from China to America had begun in 1784 and quickly flourished – by 1830, America was China's principal trading partner.

In 1785, the merchant ship USS *Alliance* undertook the voyage to China by a new route, up the east coast of Australia, through the Solomon Islands and the Dutch East Indies (Indonesia). In December 1787, the *Alliance*, with Richard Dale on board as first mate, is thought to have seen Australia a few weeks before the First Fleet arrived. On his final voyage to China on the *Alliance* in 1799, Dale commissioned a lavish 56-piece dinner service for his family in Philadelphia, which the museum acquired in 1991.

The establishment of the penal colony in New South Wales offered US traders a second market on the route to China. Now American merchants could profitably export US commodities for sale to the colonial government and then continue on to China to reload their ships with tea, silks and porcelain to sell back in the United States. This trading route reaped profits on both the outward and inward cargoes.

This 61-piece Canton famille-rose dinner service (below) was made for George Francis Train in 1856. Famille-rose enamel ware allowed a greater range of colour and tone than was previously possible, enabling the depiction of more complex images, including flowers, figures and insects painted in detail with a mixture of pigment and oil, before firing in a kiln. Train – an American-born, Melbourne-based gold rush entrepreneur – had set up a successful shipping and import company based on his family mercantile business in Boston. He bought his family dinner service during his voyage back to the United States.

Paul Hundley

∧ Serving pieces from a Chinese export dinner service made for Richard Dale, c1799 Porcelain *Purchased with USA Bicentennial Gift funds*

> Serving pieces from a Canton famille-rose dinner service made for George Francis Train, c1856 Porcelain *Purchased with USA Bicentennial Gift funds*

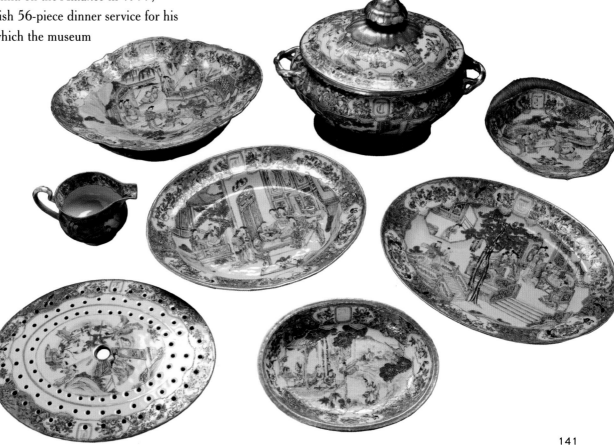

In search of Antarctica

'Sharks … were so ravenous they bit at the oars … The number of birds on the island was incredible … The various snakes, the many-colored fish, the great eels, enormous and voracious sharks, shells, large mollusks, spiders … all gave a novelty to the scene, that highly interested and delighted us. In the afternoon we returned on board, loaded with specimens.'[1]

So wrote Lieutenant Charles Wilkes, when the US Exploring Expedition (the 'Ex Ex') landed at Honden Island in the Paumotu Group, now known as the Tuamotu Archipelago in French Polynesia, on 19 August 1839. They found it uninhabited, but rich in wildlife. These watercolour paintings were done in August 1839 just before the expedition's arrival in Sydney, and feature fish collected at Honden Island. The paintings, with exquisite detail, are inscribed with descriptive notes and the artists' names in pencil.

The Ex Ex (1838–42) was America's first formal voyage of exploration charged with a specifically scientific mission: to undertake a monumental hydrographic and ethnographic survey of the Pacific and Antarctic regions. The flagship USS *Vincennes*, under the command of Wilkes, and the six ships of the fleet logged 87,000 miles on the expedition's global voyage.

Few stories of the sea embody more adventure than that of the US Exploring Expedition, which visited exotic new lands and endured shipwrecks and the stresses of life at sea for so many years. The Ex Ex set out from Hampton Roads, Virginia, in 1838, and for the next four years the scientists and sailors enthusiastically collected natural history and ethnographic specimens across the Pacific.

Among the scientific corps were two artists, Alfred Agate and James Drayton, who used a relatively new invention, the camera lucida, which projected the virtual image of an object onto paper for tracing. Agate, Drayton and the naturalist Titian Peale used this to create images of hundreds of specimens and artefacts, as well as portraits of the many different peoples they encountered.

The vessels arrived in Sydney on 29 November 1839. Wilkes then took the ships and part of the crew on a voyage to find and chart the Antarctic coastline, leaving the expedition team of ethnologists, naturalists and artists in Australia to collect, record and document what they discovered in this little-known region of the world. In Australia, geologist James Dana mapped the rock formations between the Shoalhaven and Hunter rivers. Expedition members also collected objects from the Indigenous Australians with whom they came in contact. Wilkes returned to Sydney to re-provision and collect his remaining crew, and the expedition departed on 19 March 1840, returning to Virginia in 1842.

The Ex Ex was an outstanding success that allowed America to join the ranks of the international scientific community. The artefacts and natural history specimens collected were the basis for the Smithsonian Institution's permanent collection, and the Ex Ex collection documents most of the world they explored, including North and South America, Asia, Australia, New Zealand, Hawaii, Samoa, Tonga and Fiji, and numerous other Pacific island groups. The Aboriginal objects – boomerangs, spears, digging sticks and possum-skin cloaks – are now part of the collection of the Department of Anthropology of the Natural History Museum, Smithsonian Institution, and are the earliest, rarest and most important objects the department possesses.

The expedition reports were planned as 24 volumes of the scientific results of the US Exploring Expedition. However, the volume on ichthyology was never funded by the US Congress due to the looming Civil War. The manuscript has also been lost — thus these images are first published here.

Paul Hundley

< Artist unknown A fish from Honden Island, 1839 Watercolour on paper, 14.8 x 23.5 cm

> William H Dougal (1822–1895) A fish from Honden Island, 1839 Watercolour on paper, 18.5 x 30.5 cm

> Joseph Drayton (1795–1856) A fish from Honden Island, 1839 Watercolour on paper, 18.5 x 27.5 cm

> Joseph Drayton (1795–1856) A fish from Honden Island, 1839 Watercolour on paper, 18.3 x 27.5 cm
All: Purchased with USA Bicentennial Gift funds

Greyhounds of the deep

This small white card (below, right), brightly printed with red and gold highlights, advertises the sailing of the *Hattie E Tapley* from Boston, bound for Sydney and Brisbane, in 1881. Much as the American clipper ships of 1849 sailed from US east coast ports to San Francisco to supply the California gold rush, these Australian Line clipper ships carried goods to supply the Queensland gold rush of the 1880s. Other American clippers such as the *Red Jacket* and *Lightning*, in the 1856 painting (right), fairly earned their description as 'greyhounds', racing each other from the northern hemisphere to Australia in a heady competition of speed and grace.

The clipper ship was the height of technological development between 1850 and 1880. Fuelled by the worldwide rush for gold and fanned by the wealth that it created, the clippers transported goods and people from continent to continent in ever-decreasing times. In the early days of the Californian gold rush, it took more than 200 days for a ship to travel from New York to San Francisco, a voyage of more than 16,000 miles. In 1851, however, a clipper called *Flying Cloud* made the same journey in only 89 days, a headline-grabbing world record that the *Cloud* itself beat three years later – and that record remained unbroken until 1989.

This was the age of global economic development, and clipper ships embodied a microcosm of this world – from the sailors of the fo'c'sle to the aristocracy in the grand saloon.

It was all part of the American Dream – not of conquest but of peaceful international trade. England was the great sea power of the time, and English ships — the cumbersome East Indiamen — were slow, heavy and powerfully armed. Although they carried cargo, they were more closely akin to the warship than the merchant trader.

Then suddenly a new ship appeared — the Yankee clipper. It was long and lean, with a beautiful, sweeping, sheer line, and such clouds of snowy canvas flying from its lofty spars as to make the old salts shake their heads and predict the clippers would capsize at their piers before even getting under way. 'Never, in these United States, has the brain of man conceived, or the hand of man fashioned, so perfect a thing as the clipper ship,' wrote Samuel Eliot Morison, an American historian noted for his works on maritime history.[2]

There was fierce competition between shipping companies and individual captains. The rivalry of one anticipated race from Liverpool to Melbourne, between the *Red Jacket* and *Lightning* (and the two competing shipping lines), grew each day, and large sums of money rode on the outcome. It was a high-stakes, exciting competition. The victor could claim to have the fastest ships and command top dollar for passenger fares to Australia — although there seems to have been some kind of gentlemen's agreement between the rivals, concerning the matter of too much competition related to passenger fares.

This magnificent oil painting by Captain Thomas Robertson depicts three famous American clippers –

< Wayne Masters, model-maker Scale model, Clipper ship *Lightning*, 1989 Timber and mixed materials, 57.3 x 34.5 x 105.5 cm (height x width x length) *Purchased with USA Bicentennial Gift funds*

> Thomas Robertson (1819–1873) *The* Red Jacket *in Hobson's Bay*, 1856–57. The ships include *Lightning (left)*, *James Baines (centre)* and *Red Jacket (right)*. Oil on canvas, 125.6 x 186.2 x 11 cm *Purchased with USA Bicentennial Gift funds*

∨ Clipper card for the *Hattie E Tapley*, 1881 Ink on card, 16.7 x 10 cm *Purchased with USA Bicentennial Gift funds*

Lightning, *Red Jacket* and *James Baines* – at anchor in Hobson's Bay. Port Melbourne is visible in the background, as viewed from Point Gellibrand. A small rowing boat carrying five people can be seen in the foreground. The pennant indicates that the seated figure may be a reporter for the Melbourne newspaper *The Argus*.

And what of the *Hattie E Tapley*? While in Brisbane, the first mate was involved in a violent incident. The Brisbane newspaper reported:[3]

> Mr Reid, an officer of the American barque *Hattie E Tapley*, came out of a hotel with one of his sailors, named Harlem. Both of them had been drinking. The officer told the man to go aboard, and on his refusing he fired five shots at him from a revolver, one ball grazing Harlem's hand.
>
> A Constable Ryan tried to arrest Reid, who drew his knife and seriously stabbed him in the arm, breast and other places. One wound would have been fatal, except the knife struck the constable's watch.
>
> Reid was afterwards arrested by other policemen, and was remanded in custody. He was eventually tried and sentenced to prison for the attacks.

Paul Hundley

What do a 19th-century tale of a ship's company marooned on a Pacific island, a portrait of a ship's captain painted around 1838, and a harbour scene commissioned by a 21st-century museum all have in common? An American sea captain named Peter Martin Coffin.

Captain Coffin and the *Julia Ann*

In 1994 the museum acquired the *Narrative of the Wreck of the Barque 'Julia Ann'*. This rare book, published in 1858, tells a fascinating tale of shipwreck and survival during a voyage between the goldfields of Australia and California. *Julia Ann* was a regular visitor to the Australian colonies from the United States, and an example of the strong maritime links of commerce and migration between the two Pacific nations.

Julia Ann first sailed for Sydney on 12 April 1853 under the Empire City Line of San Francisco, with 10 passengers in the cabins and 110 in steerage. The vessel carried imports of shovels, hoes, boots and shoes for the booming population of the Australian goldfields. It made two more journeys to Sydney in 1854, and on both trips took a cargo of coal from Newcastle for the return voyage to California.

In July 1855, the vessel left San Francisco for Sydney a fourth time, carrying supplies for the colony that included wheat, oats, bran, barley, timber, axe handles, stoves and shovels. The ship left Sydney for the last time in September 1855 under the command of Captain BF Pond, with Captain Peter Coffin as first officer, bound for San Francisco with passengers and another cargo of Newcastle coal.

The voyage started out as did so many others of the times, with rain and rough weather causing discomfort and seasickness among the passengers, aggravated because almost half of them were under the age of 18. Twenty-seven days later, the *Julia Ann* struck a reef surrounding Scilly Island, the westernmost atoll of the Society Islands, approximately 400 nautical miles west of Tahiti. Two women and three children drowned in the wrecking. The remaining passengers and crew were marooned on a deserted islet for two months before their rescue. They survived on sea turtles and sharks, which they caught in the lagoon.

In 1995 a portrait of a Captain Peter Martin Coffin came into the museum collection. Painted in 1838, it shows Captain Coffin seated, holding a copy of Bowditch's *American Practical Navigator*, with one of his vessels, the *Columbus*, in the background. This is the same Captain Coffin who would later sail as first officer aboard the ill-fated *Julia Ann*.

< Benjamin Franklin Pond *Narrative of the Wreck of the Barque* Julia Ann, 1858 Book, 22.6 x 14.8 cm *Purchased with USA Bicentennial Gift funds*

∧ Isaac Sheffield (attrib) (1785–1866) Portrait of Captain Peter Coffin, 1833–1840 Oil on canvas, 84.5 x 71.4 x 6.3 cm *Purchased with USA Bicentennial Gift funds*

> David Thimgan (1955–2003) Julia Ann *Entering San Francisco, 1852*, 1999 Oil on canvas, 80.5 x 106 cm *Purchased with USA Bicentennial Gift funds*

Captain Peter Coffin, a descendant of one of the original Nantucket settlers, Tristram Coffin, was master and log-keeper of several whaling vessels that visited the South Pacific fisheries. The *Columbus* is known to have been on a whaling voyage between 1834 and 1838. It is possible that this portrait was done upon his return when Peter Coffin, born 31 March 1796, would have been about 42 years old.

In his later years Coffin left the whaling trade and sailed for California during the 1849 gold rush, leaving Nantucket in October of that year. Perhaps, like many 'Fortyniners', Coffin met with little luck at the diggings, because he resumed sailing aboard commercial vessels out of San Francisco from about 1853. He was 59 years old, with years of experience in the Pacific, when he served on the *Julia Ann*.

The museum commissioned David Thimgan in 1998 to produce *Julia Ann Entering San Francisco, 1852*, from historical details known about the vessel. Thimgan was widely considered to be one of the foremost experts on west-coast shipping during the 19th century. His paintings achieve realism and authenticity, due to their historical accuracy.

Paul Hundley

Race to the goldfields

A Race to the Gold Diggings of Australia is undoubtedly the most beautiful example of known gold-rush games, and it perfectly captures the optimistic mood and spirit of the first wave of the gold rushes. Spin the teetotum, then move your vessel forward to start a voyage of adventure!

The discovery of gold in Australia lured tens of thousands of prospectors from vastly different places such as America, Britain, Europe and China. It also fired the imagination of countless stay-at-home travellers. This rare 1855 children's race game, from Plymouth to Port Phillip, depicts the departure for the goldfields, the voyage to Australia and a detailed picture of the gold diggings themselves. The paper game-sheet is set out on an oval – players move their miniature ships around it in a clockwise direction. In the centre, a large illustration depicts the Australian goldfields. In the foreground, men scramble for nuggets the size of boulders. In the background, tents are pitched under a single palm tree, and to the left, two ships are anchored in a cove. On the board itself are marked various landmarks of the journey, including Batavia, Mauritius, Madagascar, the Cape of Good Hope, St Helena, Ascension, Sierra Leone, the Cape Verde Isles, the Canary Isles, Madeira, Lizard Light and Plymouth.

Children's board games offer an insight into the ideals and values of the society that manufactured them. During the 1800s, most British and American children's games emphasised the value of hard work and persistence, such as *The Checkered Game of Life*. The point of the game was for players to move along a track from Infancy, avoiding Ruin, to reach Happy Old Age. Squares were labelled with moral positions, from honour and bravery to disgrace and ruin. During the 19th century, dice were associated with gambling and were not used in children's games. Instead, an instrument known as a teetotum – a numbered spinning tool – was used to tell a player how many places to move. The gold rush brought a different focus, though – it glorified the chances of quick wealth in an exciting new colony.

In many ways, the discovery of gold in Australia echoed the Californian gold rush of 1840. Edward Hargraves discovered gold in New South Wales in 1851 after returning from the California diggings on a voyage similar to the one depicted in the game. The ensuing gold rush tripled Australia's population in just 10 years. Miners came from vastly differing countries and backgrounds, but mixed in the harsh conditions on the diggings. This had far-reaching consequences for Australian politics, economics and technology. Most of the gold was exhausted in Victoria and New South Wales by 1861, but the impact of the gold rush continues to be felt 150 years later.

One of the side arms favoured by American and Australian miners for protection on the goldfields was this six-shot 44-calibre Colt revolver (above) made in the United States for civilian issue. It is the largest of the Colt revolvers and was very popular during the 1800s, largely because its innovative design allowed multiple shots without constant reloading. Its previous owner, Major Edward J Millett MBE (a prominent collector of militaria), described finding the revolver '… in pieces on the dirt floor of a shed in Ballarat'.[4]

In November 1854 dissident miners in Ballarat called on Boston-born businessman George Francis Train (see also p. 141) to send them $80,000 worth of Colt revolvers. The entrepreneurial Train declined their request because no payment had been included. Only six days later, he

< Colt second model Dragoon
percussion revolver, c1850
Metal, wood, 5 x 33 x 14 cm
*Purchased with USA Bicentennial
Gift funds*

leased six wagons to the government to transport troops
to the Ballarat goldfields. Expensive gold-digging licences
and variable returns had made miners resentful toward the
Victorian colonial government. Throughout 1854 tensions
had simmered, as diggers refused to pay for the licences.

On 3 December, violence erupted as miners
exchanged fire with troops from within a stockade at
Ballarat, Victoria – this became known as the battle
of the Eureka Stockade. A group of American miners
at the stockade formed the Independent California
Rangers Revolver Brigade, and preferred this type of
Colt revolver. Is it possible this very one was used at the
Eureka Stockade? We may never know.

Paul Hundley

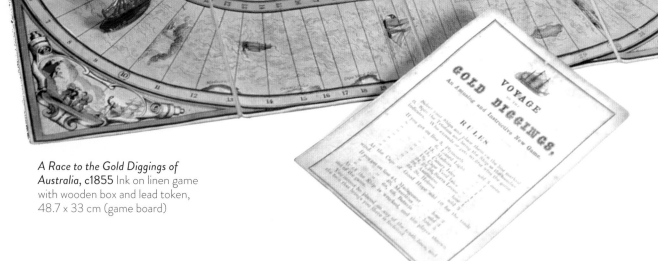

*A Race to the Gold Diggings of
Australia*, c1855 Ink on linen game
with wooden box and lead token,
48.7 x 33 cm (game board)

The American Civil War comes to Australia

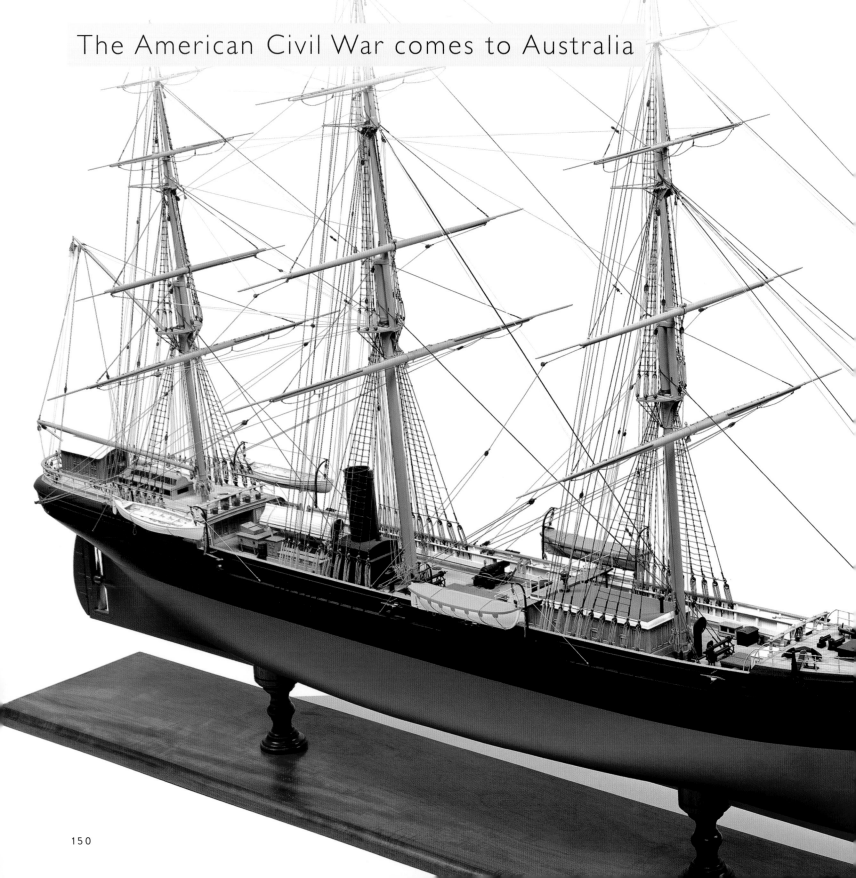

The American Civil War spread far beyond the shores of the United States. At the start of hostilities on 12 April 1861, 11 southern slave states declared their secession from the United States and formed the Confederate States of America (the Confederacy); the other 25 states supported the federal government (the Union). One month later, Queen Victoria proclaimed British neutrality. The *Shenandoah* incident in early 1865 was the most significant event of Australian–American interaction during the Civil War period.

The CSS *Shenandoah* was a 790-ton steamer that entered Confederate naval service on 14 October 1864, under the command of Lieutenant James I Waddell. Its main aim was to strike Union whaling fleets in the Bering Sea north of the Alaskan Peninsula, and Melbourne was a convenient port at which to re-provision on its way. On 25 January 1865, *Shenandoah* sailed into Hobson's Bay, at the northern end of Port Phillip Bay, and anchored near Williamstown.

This carte de visite photograph of Lieutenant Waddell is one of only three from this period and, with its attribution to a known Australian photographic studio, is possibly unique. It was taken while

< Boucher-Lewis Inc. Scale model, CSS *Shenandoah*, 1991 Timber and mixed materials, 99 x 73 x 188 cm (height x width x length) *Purchased with USA Bicentennial Gift funds*

∧ Batchelder and O'Neill, photographers Carte de visite photograph of Lieutenant James Waddell, 1865 Photograph for visiting card, 10.2 x 6 cm *Purchased with USA Bicentennial Gift funds*

Victoria R

Victoria by the Grace of God, Queen of the United Kingdom of Great Britain and Ireland, Defender of the Faith &c &c &c. To All and Singular to whom these Presents shall come, Greeting! Whereas by the First Article of a Treaty, concluded and signed at Washington on the eighth day of May, One Thousand Eight Hundred and Seventy one, between Us and Our Good Friends The United States of America, it was stipulated and agreed that in order to remove and adjust all complaints and claims on the part of the United States, growing out of the acts committed by the several vessels which have given rise to the claims generically known as the "Alabama Claims", and to provide for the speedy settlement of such claims, which are not admitted by Our Government, that all the said claims, growing out of acts committed by the aforesaid Vessels, and generically known as the "Alabama Claims", should be referred to a Tribunal of Arbitration composed of Five Arbitrators to be named in the following manner, that is to say. One shall be named by Us; one shall be named by the President of the United States; His Majesty The King of Italy shall be requested to name one; the President of the Swiss Confederation shall be requested to name one; and His Majesty The Emperor of Brazil shall be requested to name one; and it was further stipulated and agreed that in case of the death, absence, or incapacity to serve of any, or either of the said Arbitrators, or in the event of either of the said Arbitrators omitting, or declining, or ceasing to act as such, We, or The President of the United States, or His Majesty The King of Italy, or The President of the Swiss Confederation, or His Majesty The Emperor of Brazil, as the case may be, may forthwith name another person to act as Arbitrator in the place and stead of the Arbitrator originally named by such Head of a State; and it was further stipulated and agreed, that in the event of the refusal or omission for two months after receipt of the request from either of the High Contracting Parties, of His Majesty The King of Italy, or The President of the Swiss Confederation, or His Majesty The Emperor of Brazil, to name an Arbitrator either to fill the original Appointment,

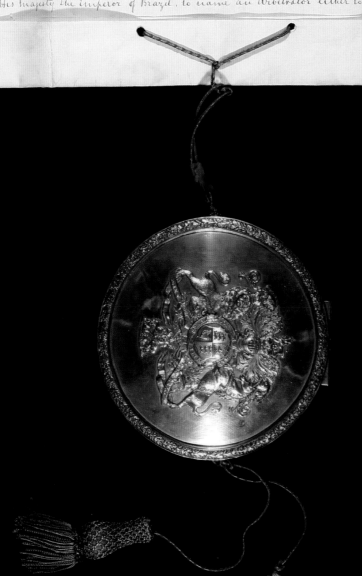

CSS *Shenandoah* was at Melbourne. Waddell is in full uniform, seated on a desk chair with his cap lying on the desk top. The reverse of the photograph reads 'Photographed by Batchelder & O'Neill, 41 Collins Street East, Melbourne'. These photograph cards became enormously popular and were traded among friends and visitors.

The day after *Shenandoah*'s arrival, more than 7,000 people travelled from Melbourne to view the ship. There was plenty of local interest and several 'official functions' were held, including a gala ball in Ballarat. During its month-long visit, *Shenandoah* divided Australians on whether to support the ship, and also provoked a war of words in the local press. *The Age* condemned the Confederates, while *The Argus* firmly supported them.

Following *Shenandoah*'s arrival, there were calls for the Victorian colonial government, headed by Governor Sir Charles Darling, to enforce neutrality. But the United States consul, William Blanchard, insisted that *Shenandoah*'s Confederate crew be arrested as pirates. Darling ignored this, satisfied with the ship's request for neutrality so it could effect repairs and take on fresh supplies. Nineteen of its crew deserted at Melbourne, and some gave statements of their service to the US Consul's office there.

The possibility that *Shenandoah* would recruit British subjects during its time in Victoria created tension between Darling and Blanchard. Despite Waddell ordering his crew to deter all British recruits and allowing searches of the vessel by Australian police and troops, 42 British subjects were recruited in Victoria before the *Shenandoah* left on 18 February 1865.

Unaware that the war had ended, *Shenandoah* continued to attack Union whalers in the Arctic and Pacific oceans and, in doing so, fired the last shot of the Civil War. In November 1865, seven months after the end of the war, Captain Waddell surrendered the *Shenandoah* in Liverpool, England. Ten years later, in 1875, he returned to America and continued a maritime career as a merchant captain.

The 1:48 scale model of the *Shenandoah* (see p. 150) was commissioned by the museum. It is 1.8 metres long and approximately one metre high. Four model-makers worked on the vessel's hull and rigging.

The Alabama Claims Tribunal was a board of inquiry set up in Geneva in 1871 to assess US claims against Britain for damages inflicted by British-built Confederate ships. It found Great Britain responsible for all acts committed by the *Shenandoah* after leaving Melbourne, due to the colonial government's negligence in not protecting their sovereignty as a neutral country. The court awarded damages of £820,000 against Britain to the US Government, for use of the port at Williamstown by the CSS *Shenandoah*.

Paul Hundley

Commission signed by Queen Victoria, Alabama Claim, with Seal and Skippet, 1871. This commission sets out the nomination process for a tribunal of arbitration to hear the United States' claims for compensation related to Confederate Navy commerce raiders during the Civil War.
Silver vellum, vellum 38.1 x 52.6 cm
Purchased with USA Bicentennial Gift funds

The Great White Fleet enters Sydney Harbour

When the United States' Great White Fleet of 16 enormous battleships arrived in Sydney in 1908, it was a huge public event. More than half a million Sydneysiders – nearly half the city's population – turned out to view the US Atlantic Battle Fleet (painted white during peacetime) entering Sydney Harbour on Sunday 20 August. The celebrations continued over the eight days the fleet was in port. This striking painting of the arrival captures the euphoria of the greatest Australian event since the Federation celebrations seven years earlier.

The celebrations in Sydney alone included a state banquet at the town hall and a parade of 14,000 US sailors down George Street, one of the major thoroughfares. Landmarks, including the Town Hall, Fort Denison and Customs House, were illuminated in red, white and blue welcome signs. A five-storey replica of the Statue of Liberty presided over the festivities from the front of the *Daily Telegraph* newspaper office on King Street.

The US fleet had set out from Newport News, Virginia, in December 1907, to visit six continents, 26 countries and 32 ports – more than any other navy had done at the time. It carried more men (614 officers and 13,504 other crew) and consumed more coal (435,000 tons) than had any other naval expedition. It was the largest fleet ever to circumnavigate the globe. Led by the flagship *Connecticut*, the 16 ships sailed in four divisions of four ships which, in total, weighed 237,140 tons and carried 972 guns. The impressive nature of this naval display is vividly depicted in this painting's brilliant white ships and the festively dressed audience that came to witness it.

With the assassination of US President William McKinley in 1901, Theodore Roosevelt, not quite 43, became the youngest president in the nation's history. He brought new excitement and power to the presidency, as he vigorously led Congress and the American public toward progressive reforms and a strong foreign policy. In 1907, Roosevelt proposed to send the Atlantic Battle

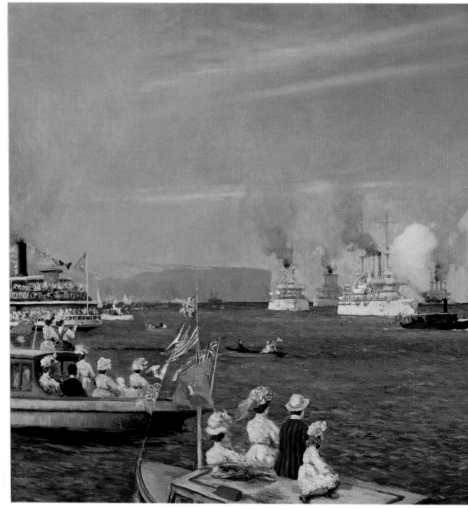

Fleet of the US Navy on a world voyage, for several reasons. It was a chance to give the navy practice in seamanship that it could not otherwise obtain. It would also be a political and public relations exercise to build support for more naval construction. And, with US concern about Japan's rising aggression and expansionist foreign policy, it was a symbolic demonstration that America had arrived as a world power and could intervene militarily anywhere in the world.

Australia's political motives in welcoming the US fleet were complex as well. At Federation, the Australian Government had realised that its naval forces could not adequately protect the country. At the time, Australia relied on the British Admiralty to provide naval vessels and crews, and the few ships in the colonial defence forces were old and of doubtful strategic value. When Britain signed the Anglo–Japanese Alliance in 1902, it withdrew its battleships from the Pacific, leaving the defence of the British Empire to the Japanese.

Bypassing the British Home Office and protocol at the time, Prime Minister Alfred Deakin directly invited President Roosevelt to send the Great White Fleet to Australia. In response, Roosevelt included Sydney, Melbourne and Albany on the fleet's 43,000-mile, 14-month itinerary.

The Great White Fleet's visit had a significant impact on Australian society, politics and defence, far beyond an exciting day on the harbour, as depicted in this painting. It led to Australia asserting its independence from Britain and forming a new alliance with America. Australians' response to the American fleet's visit also fuelled acknowledgment that Australia needed its own navy, with King George V authorising the development of the Royal Australian Navy in 1911.

Paul Hundley

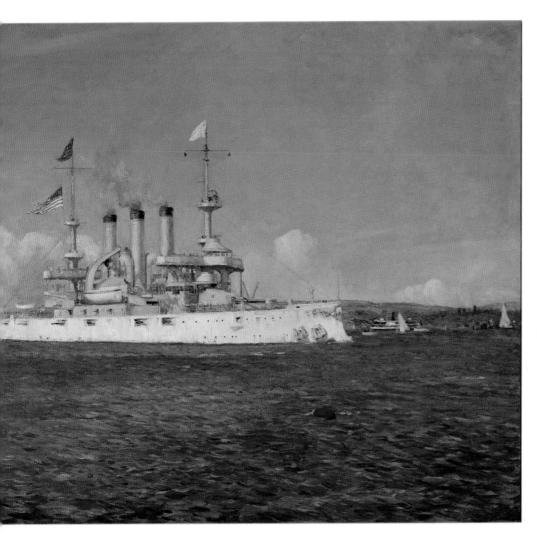

Artist unknown *The Great White Fleet Entering Sydney Harbour,* **c1908** Oil on canvas, 140 x 225 x 10 cm *Purchased with USA Bicentennial Gift funds*

Patriotism, persuasion and propaganda

In 1942 the United States Office of Facts and Figures produced a series of posters with slogans such as 'This man is your friend. Australian. He fights for freedom'; or the chillingly simple 'Someone talked!' The posters were motivational tools appealing to a sense of patriotism or the darker emotions of rage at the human cost of war. They swayed public opinion and spread propaganda – all part of a national and international campaign to support the Allies during World War II.

Concerns about national security intensify during war. Limiting talk about the war in public and private became central to maintaining national security in America during World War II. Silence meant security. 'Someone talked!' represents a World War II specialty: the poster to stop careless talk. Some of these posters were dominated by images of death, tragedy and loss. Others show vibrant, happy, healthy men heading off to war, and warn that it's up to those on the home

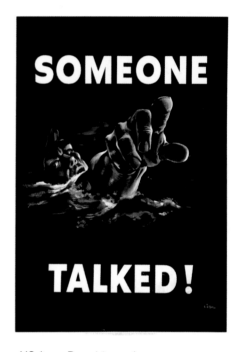

front to keep them safe. Whether the practical results of the 'careless words' campaign matched the size of the poster effort remains unanswered. But secrecy was a priority of the government at this time, as the large numbers of posters related to it show.

'This man is your friend' encapsulates the alliance between America and Australia. As part of the war in the

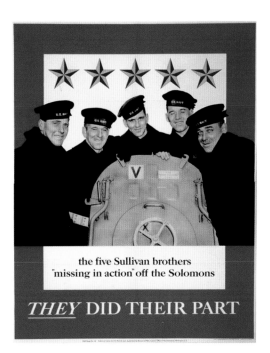

Pacific, thousands of American troops came to Australia. Many were housed in makeshift camps in Melbourne, Brisbane and Sydney. In a show of hospitality, Australian families graciously shared their rationed food, inviting US servicemen into their homes for family meals.

During World War II, the military still upheld policies of racial restriction and segregation. 'Above and beyond the call of duty' refers to Dorie Miller, a black American sailor who was restricted to the job of cook aboard the USS *West Virginia*, where he received no gunnery training. But during the Japanese attack on Pearl Harbor, he took control of an anti-aircraft gun, firing and hitting several Japanese planes. After pressure from the black

press, Miller was awarded the Navy Cross. The military later used Miller in a war bond tour to raise money for the war effort, just as they did white war heroes.

The war placed immense pressure on American industries. More than 10 million men were at war, so the United States enlisted a large number of women into the workforce. This was motivated solely by the political and economic realities of the time, with little regard for its effect on the female workers. In July 1944, when the war was at its peak, more than 19 million women were employed in the United States.

Although millions of women stepped up to serve their country, their jobs were not made easy by their male colleagues or husbands. American women faced discrimination in hiring practices, job placement and pay rates. One third of female employees were mothers of children living at home, and were also expected to maintain their normal duties in the family routine of the 1940s, cooking, cleaning and washing. Directly appealing to women became a major element in poster propaganda. 'This is our war … Join the WAAC' asks women to enlist in the armed forces. The message was that Americans needed to share in the burdens of serving the country, and that not to make sacrifices for victory was unpatriotic.

A large part of the war propaganda effort focused on sacrifice. When the five Sullivan brothers were killed on the cruiser *Juneau* on 11 November 1942, one American family lost five sons. Public sympathy swelled, and this recruitment poster (above) helped to boost enlistments. As a result of this incident, the US military ruled that brothers could not serve aboard the same ship or in the same regiment.

Paul Hundley

Australia's Betsy Ross

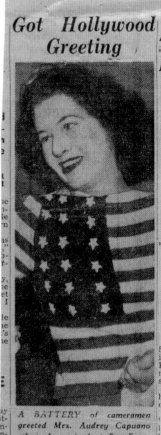

'A battery of cameramen greeted Mrs Audrey Capuano when she arrived in San Francisco on the bride ship *Monterey* on Monday. The reason was Mrs Capuano, formerly Miss Audrey Wesley of Adelaide, was wearing this sweater which she had made in the pattern of the United States flag.'[5]

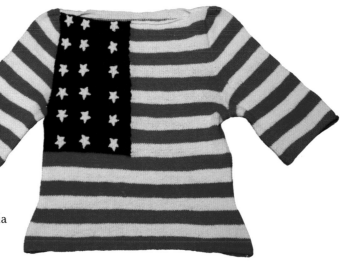

Audrey Wesley was born in Strathalbyn, South Australia, in 1924. At the age of 18, at one of the town's weekly dances, she met American Private First Class Angelo 'Bob' Capuano of the US Army's 32nd Division Reconstruction Corps. It was 1942, and he had arrived in South Australia after his convoy had been diverted to the Battle of the Coral Sea, en route to New Guinea. They married at St Mary's Cathedral, Sydney, in August 1944. Audrey then had to wait another two years for her passage to the USA on the SS *Monterey*. While she waited, she knitted this Stars and Stripes jumper to wear on her voyage to her new husband and homeland.

During World War II between 12,000 and 15,000 Australian women married American servicemen. Some of these war brides migrated and lived in the United States, while others returned to Australia in the years following the war, with or without their husbands. War brides often encountered public scrutiny and disapproval for their decision to marry foreign servicemen, with many Australians, specifically men, resentful of Americans 'taking their wives'. For many women, American servicemen filled the vacuum created when Australian men were stationed overseas. During the campaign in the Pacific, thousands of American troops were stationed in Australia, at a time when many of Australia's young men were fighting in Europe and the Middle East.

Got Hollywood Greeting

A BATTERY of cameramen greeted Mrs. Audrey Capuano when she arrived at San Francisco on the bride ship Monterey on Monday. The reason was that Mrs. Capuano, formerly Miss Audrey Westley, of Adelaide, was wearing this sweater, which she had made in a pattern of the United States flag.

Betsy Ross The Second

CENTRE OF ATTRACTION when the liner Monterey arrived at San Francisco yesterday with Australian war brides was Mrs. Audrey Capuano. She wore this Stars and Stripes sweater she had knitted herself. The Americans promptly named her Betsy Ross II. Betsy Ross made the first Stars and Stripes. (See Story, Page 6.)

Audrey left Sydney on the SS *Monterey* in a group of 410 Australian war brides in April 1946. She was photographed at her Sydney departure in her Stars and Stripes jumper, and 15 days later musical bands and more photographers were on the wharf to meet the group at San Francisco. Audrey was hailed in the American press as 'Betsy Ross the Second', after the legendary

had been launched in October 1931. During World War II, it joined convoys laden with troops and supplies, often voyaging to Australia, and once transported (then) Australian Prime Minister John Curtin to America to confer with President Roosevelt. In the postwar years, the ship was refitted and renamed the *Matsonia* in 1956, providing a first-class-only service between Hawaii and the American

<< Audrey Capuano (b 1924) Hand-knitted Stars and Stripes jumper, c1945 Wool, 45 x 69.5 cm *Gift from Audrey Capuano*

<< *Barrier Miner*, 26 April 1946 Newspaper clippings report on Audrey's sensational arrival in the United States wearing her Stars and Stripes sweater

< Estelle Studio, photographer Audrey Capuano (née Wesley), 1945 Reproduced courtesy Audrey Capuano

> Bell from SS *Lurline*, 1932, sister ship to SS *Monterey* Cast copper alloy, iron, 39.7 x 37.9 cm (height x diam.) *Gift from Kerry and John Snelgrove*

>> Audrey Capuano with the sweater, at the time she donated it to the museum in 1994 Photo: Jenni Carter, ANMM

Philadelphia upholsterer who some claim made the first flag during the American War of Independence. In 1870, Ross's grandson, William J Canby, presented a paper to the Historical Society of Pennsylvania in which he claimed that his grandmother had 'made with her hands the first flag' of the United States. That claim gained fame as Betsy Ross was promoted as a patriotic role model for young girls and a symbol of women's contributions to American history.

The SS *Monterey*, on which Audrey and her fellow war brides sailed to San Francisco, was one of four new liners, including SS *Lurline*, designed by William Francis Gibbs and built for the Matson Lines' Pacific services. It

mainland from 1957 to 1962, mixed with the occasional Pacific cruise, until the rise of air travel led to the ship being laid up in 1962.

'We had a big reception in Honolulu before arriving in San Francisco. The bands were there playing. They really made us feel welcome,' Audrey remembered, years later.[6] She travelled by war bride train to Pittsburgh, Pennsylvania, and was met by Bob at the station at about 1 am. She settled there, where she retained strong links with other Australian war brides, setting up the Australian Wives' Club. After a long marriage and four children, Bob passed away in 1988. Audrey still lives in Pittsburgh.

Paul Hundley

In honour of an ally's loss

HMAS *Canberra* was sunk, with the loss of 84 crew members, during the disastrous night-time battle of Savo Island near Guadalcanal on 9 August 1942. It was one of the first major naval engagements in the Pacific involving a mixed force of American and Australian vessels fighting side by side against the Japanese, and was a serious defeat for the Allies. The common sacrifice of Australian and American sailors and vessels was emblematic of the two countries' alliance, born in the grim early days of World War II in the Pacific.

USS *Canberra* (CA-70), a Baltimore class heavy cruiser, was commissioned on 14 October 1943. At the request of President Franklin Roosevelt, the US cruiser was named in honour of the Australian cruiser HMAS *Canberra* and christened on 19 April 1943 by Lady Alice Dixon, wife of the Australian ambassador to the United States. It is the only American naval vessel ever named in honour of an ally's sunken vessel or a foreign capital city.

In 1952, USS *Canberra* was refitted as a guided missile heavy cruiser and designated CAG 2; it served another 18 years before being decommissioned in 1970, when this bell was removed. On 10 September 2001, President George W Bush presented the bell to (then) Prime Minister John Howard to commemorate the 50th anniversary of the ANZUS alliance. In a speech commemorating this anniversary, John Howard said, '... the ANZUS Treaty is of fundamental importance to both our countries and the goodwill and mutual support implicit within it will never be taken for granted. It is a relationship that has been nourished over the years by leaders from both countries.'

Arthur Beaumont's portrait of USS *Canberra* – *Battle Ready* – was owned by Peter Kalita Sr, who served on *Canberra* between 1964 and 1966 during the Vietnam War. Upon his discharge, Pete somehow came into possession of this painting, which his family says had been aboard the ship. He had *Battle Ready* on his office wall at the Veterans' Medical Center in Lincoln, Nebraska, where he worked for 25 years as a licensed rehabilitation counsellor. His last request before his death was to find a new home for his painting, and it was donated to the museum by his wife, Bonnie Kalita.

Although Arthur Beaumont was not an American citizen by birth, he felt deep love and respect for his adopted country. His classical training as an artist and his fascination with the sea and sailing vessels led him into an association with the US Navy that lasted nearly five decades, and included commissions to paint formal portraits of several naval officers – including Vice Admiral William D Leahy in the 1930s – and studies of the fleet for the navy.

Paul Hundley

USS *Canberra* ship bell, 1943
Nickel plated brass, 47 x 52 x 52 cm *Loaned by US Navy, Naval History and Heritage Command*

"BATTLE READY" USS Canberra (CAG2)

Arthur Beaumont 1964

Arthur Beaumont (1890–1978) *Battle Ready*, portrait of USS *Canberra*, 1964 Watercolour on paper, 75.7 x 87.4 cm Gift (in loving memory of Peter Kalita, Sr) from his wife, Bonnie and his sons, Peter Jr and Anthony, through the American Friends of the Australian National Maritime Museum. On behalf of Peter's family, the Naval Heritage Foundation of Australia Inc (Mackenzie J Gregory, President) has facilitated the presentation and display of this gift

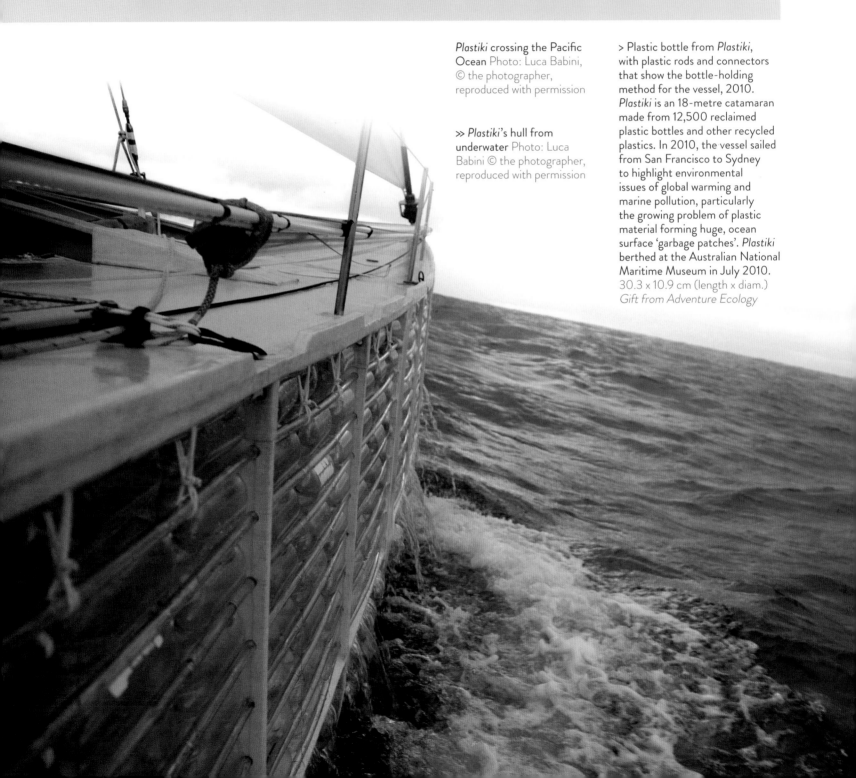

7 INDUSTRY AND ENVIRONMENT

Plastiki crossing the Pacific Ocean Photo: Luca Babini, © the photographer, reproduced with permission

≫ *Plastiki*'s hull from underwater Photo: Luca Babini © the photographer, reproduced with permission

> Plastic bottle from *Plastiki*, with plastic rods and connectors that show the bottle-holding method for the vessel, 2010. *Plastiki* is an 18-metre catamaran made from 12,500 reclaimed plastic bottles and other recycled plastics. In 2010, the vessel sailed from San Francisco to Sydney to highlight environmental issues of global warming and marine pollution, particularly the growing problem of plastic material forming huge, ocean surface 'garbage patches'. *Plastiki* berthed at the Australian National Maritime Museum in July 2010. 30.3 x 10.9 cm (length x diam.) *Gift from Adventure Ecology*

In Australian waters, whales are now followed by whale watchers rather than hunters. Yet historically, whale hunting was an important industry that helped establish Britain's colonies in Australia. Whale oil and whalebone were profitable on international markets, and whaling and sealing were major export industries from the early 1800s to the 1830s. Whaling also served to establish new stations and communities around the coast, away from the colonies' ports and major settlements.

The museum pays close attention to Australia's maritime industries, past and present, the direction of their development and their relationship with the environment. Demand for whale products went into decline later in the

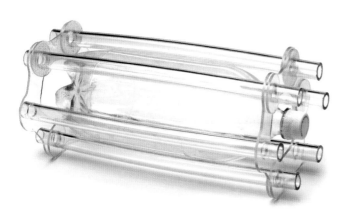

19th century. Even so, it became clear that some species were dangerously depleted, and the Australian Government banned whaling in 1979.

Highly prized in the museum's Australian whaling collection is an illustrated log kept by Captain Henry William Downes on the 19th-century whaler *Terror*. His lively account of a 10-month expedition out of Boyd Town, New South Wales, in 1846–47 describes the often dangerous hunt and life on the high seas at that time.

The extensive scrimshaw collection includes, remarkably, a portrayal of the same ship, *Terror*, skilfully engraved on the lower jawbone of a sperm whale. There are also vivid paintings of whalers and a great diversity of whale products, including an unusual whale-oil lamp clock.

The fishing industry is represented in many different ways. There's *Thistle*, the smallest vessel in the museum fleet, built in 1903 as a specialist Bass Strait barracouta fishing boat. And the collection of underwater photographers Ron and Valerie Taylor contains stunning studies of sharks and puts the case for more stringent conservation measures.

The museum also focuses on Australia's working harbours with their shipping movements, cargo handling, dry docks and shipbuilding. The Samuel J Hood Studio collection of some 9,000 photographs – primarily of Sydney Harbour, its port facilities and shipping through the first half of the 20th century – has proved a rich resource for historical study and research.

Sydney Harbour activities are the focus of work by the

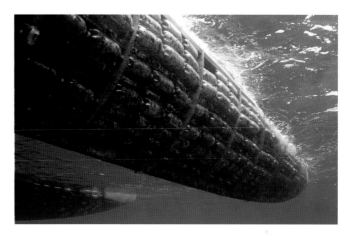

renowned photographer David Moore and a panoramic view of the harbour in 1907 painted by artist Muriel Binney. These show vividly how the urban waterway went through its busiest industrial phase before the introduction of containerised cargo and the removal of much shipping to Botany Bay in the second half of the 20th century.

The collection includes plans and working drawings from Australian ship and boatbuilders. Among these is a collection of plans, photographs, models, tools, company papers and personal memorabilia from the Halvorsen family, who migrated from Norway in the 1920s and established a company that became nationally famous for beautifully designed and built pleasure cruisers.

Bill Richards

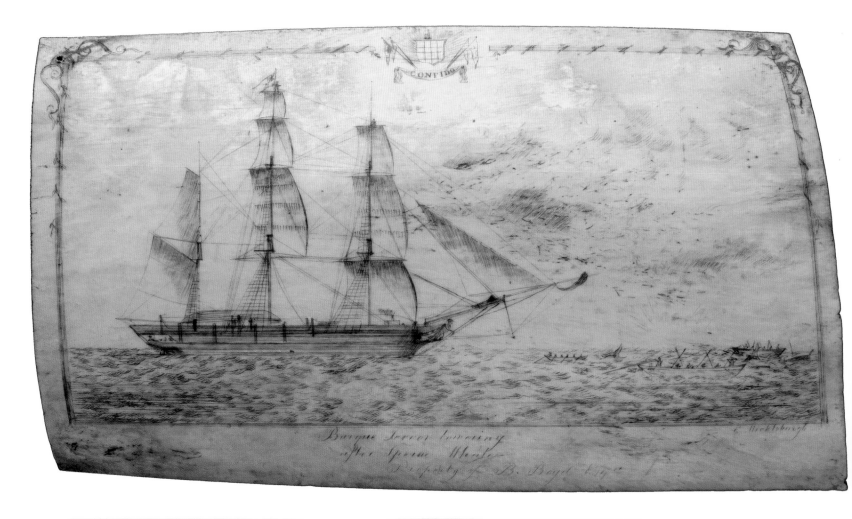

Captain Downes,
Captain Mickleburgh
and the barque *Terror*

'Jacky Wahoe (3rd Mate) alternately swearing and roaring like a mad man in broken English as he sent his lance home, hit [the whale] hard, he has no friends, hurrah hurrah look out for you boys, he is dying, he is in his flurry, and so he was going round in no small rate, described a complete circle, turned his head up towards the Sun and resigned himself over to the Slayer.'[1]

∧ Edward Mickleburgh (1814–1890) *Barque Terror Commencing after Sperm Whales*, scrimshaw, 1840s Whale pan bone panel, 19.5 x 34.5 cm

< Henry William Downes (d 1847) Cover, *Log Book of the Barque* Terror, *Whaler. Henry William Downes Master. South Seas.*, 1846–47 Illustrated manuscript, 34.5 x 29.2 x 2.8 cm

Henry William Downes (d 1847) Double page from *Log Book of the Barque Terror, Whaler. Henry William Downes Master. South Seas.*, 1846–47 Illustrated manuscript, 34.5 x 29.2 x 2.8 cm

This frenetic account of a sperm whale's death during a whaling venture in 1846–47 comes from a beautifully illustrated log by Henry William Downes, master of the barque *Terror*. One of the finest shipmaster logs in the museum's collection, it is complemented by an extremely rare scrimshaw ship portrait of *Terror* on a plaque of whalebone. Together they bring to vivid life the voyages of a ship owned by one of the most famous and colourful figures in colonial Australian commerce, Benjamin Boyd.

Boyd was a Scottish-born entrepreneur who sailed his raffish schooner yacht *Wanderer* to Australia in 1842 to manage vast pastoral holdings and shipping interests that included whaling, an important economic activity in the colonies. He established a shipping base, Boyd Town, in Twofold Bay, southern New South Wales.

Henry William Downes had accompanied Boyd to Australia, and on 17 September 1846 began the log of a whaling voyage on Boyd's barque *Terror*. The 10-month voyage ranged across the south-western Pacific to the isles and coasts of New Caledonia, the Solomons and Vanuatu. Downes's *Terror* log is a rich record of life at sea in the perilous pursuit of the whale, written with a witty and literary appreciation of the language and manners of the whalemen, several years before Herman Melville would immortalise sperm whaling and whalers.

> With a yell of delight the lookout said 'Oh Oh a Very purty Spoat, My Word.' Where away? 3 miles on the Weather beam, the 2nd mate was by this time aloft & passed the word to lower the boat & coming to my ear, whispered 'a beauty, a 60 Barrel fellow'.[2]

More than just a skilled and lively writer, vividly conveying the spirit of those intrepid times, Downes was also an accomplished watercolour artist, illustrating his

closely written pages with some 100 views of places and peoples they visited, whales, ships, boats and rigging, and crewmembers at various pursuits.

Art of a different sort flourished on whale ships to relieve the tedium of weeks or months between whale sightings. Scrimshaw – engraving and fashioning objects from the teeth and bones of whales – provided popular mementos of a dangerous livelihood. Many sailors were illiterate and most scrimshaw is anonymous. While vessels, a favoured subject, were often detailed and accurately portrayed, they were rarely named.

The scrimshaw shown on the previous page defies both those norms. It's a pan bone plaque – a nearly flat panel

from the lower jaw of the sperm whale – signed by the artist and inscribed as a presentation piece. The artist was Captain Edward Mickleburgh, a recognised scrimshander, and on it he inscribed 'Barque Terror Commencing after Sperm Whales, Property of B. Boyd, Esq'. At the top of the whaling scene is engraved the crest of the Scottish Boyd clan and their motto, 'Confido' ('I confide').

Edward Mickleburgh was a highly accomplished British engraver of detailed naval scenes on pan bone. Born in England in 1814, he was a mariner whose seafaring life took him to the Australian colonies, across the Pacific to the United States and back again. We know he was on the coast of Victoria in the early 1840s, while the barque *Terror* was whaling out of Boyd Town between 1843 and 1847. The exact nature of the connection between Boyd and Mickleburgh is not known, but his finely crafted pan bone links him directly to characters and events of our maritime history in a way that scrimshaw rarely does.

Paul Hundley and Daina Fletcher

Henry William Downes (d 1847)
Double page *from Log Book of the Barque* Terror, Whaler. Henry William Downes Master. South Seas., 1846–47 Illustrated manuscript, 34.5 x 29.2 x 2.8 cm

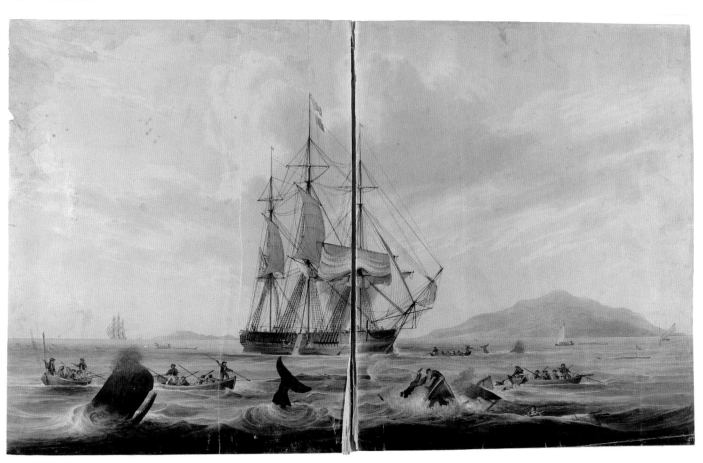

In pursuit of the whale

In the early 1800s, crews armed with handheld harpoons or 'irons' hunted whales from small open boats. The iron did not kill the animal, but was used merely to attach a rope to it – resulting in a wounded, angry whale. A long struggle could ensue, with the crew being towed by the whale as it struggled to rid itself of the harpoon. American whalers called this a 'Nantucket sleighride', after the port of Nantucket, USA, the heart of North American whaling.

A whale could smash a longboat to pieces as it thrashed and tried to dislodge the harpoon. Many whalers died in such incidents. Only when the giant mammal had tired could they plunge a long 'killing lance' into its lungs or heart, usually causing a slow, lingering death.

As Oswald Brierly depicted in his 1847 watercolour *Amateur Whaling, or a Tale of the Pacific* (see p. 168), whaling was a gruesome and dangerous business, and whalers would take any help they could get. Brierly's dramatic scene reflects events at Benjamin Boyd's whaling station at Twofold Bay on the south coast of New South Wales. Here, whalers in the 1840s noted that pods of killer whales often assisted in their hunts by herding migrating whales into bays and keeping the animals on the surface, making it easier for the hunters to kill the trapped whales. The men often rewarded the killer whales with the prize of the dead whale's tongue and lips.

Whaling was Australia's first export industry and was a major activity in the early colonies during the first half of the 19th century. Despite the hazards and incredible efforts involved in whaling enterprises – with voyages often lasting years rather than months – whale oil was in great demand as a major source of lighting and a fine lubricant (see pp. 172–73). A single sperm whale could contain three tons of sperm oil in its head cavity.

Until the rise of coal, kerosene and, later, petroleum as fuels, the demand for whale oil also drove inventiveness in whale hunting. In the 1830s, large muzzle-loaded guns that could fire a harpoon were developed. The guns were often mounted on a swivel at the bow of the longboat. Surprisingly, they were met with initial reluctance – according to Captain Henry Murdoch of the whaling ship *Nassau*, writing in 1856, whalers did 'not like to shoot a whale anymore than a sportsman would shoot a trout'.

The advantages of the harpoon gun soon became obvious. Whalers did not need to approach the

Harpoons for Greener gun, W Fowler manufactured, 1860s Both metal (left) 126.6 x 14 cm, (right) 120.6 x 15.8 cm (both length x breadth)

whale so closely and the gun was more reliable and accurate than hand-thrown harpoons. By the 1850s they were standard on whaling vessels around the world. The Greener gun was widely held as the best of all the many variations in design. William Greener from Birmingham, England, produced the first of his swivel-mounted guns in 1837. The massive double-barrelled gun fired two steel harpoons. The harpoons shown on the previous page are from a Greener gun and have double barbs, also known as stop withers, to ensure the harpoon would hook into the whale's flesh.

The era of modern whaling had begun. With steamships and the invention of harpoons with explosive heads, what was once something of an equal contest between whale and whaler soon became a slaughter. By the 1860s some species of whale were already near extinction.
Stephen Gapps

Oswald Walter Brierly (1817–1894) *Amateur Whaling, or a Tale of the Pacific*, 1847 (detail) Watercolour, paper, 61.5 x 111 x 4 cm (framed) *Purchased with USA Bicentennial Gift funds*

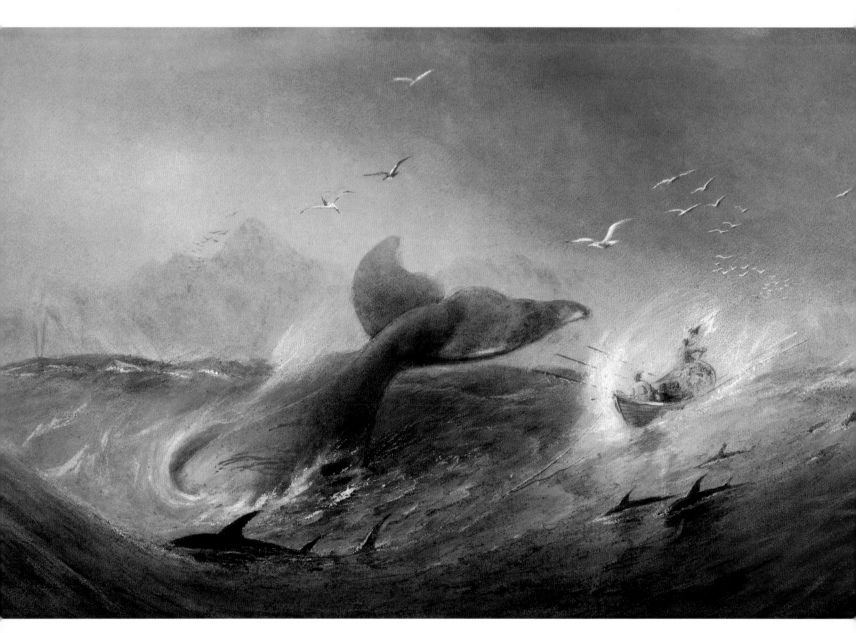

From the sea comes a marvellous canvas

The Great Britain Iron Steamship, carved by CH Wood in 1843, commemorates the launch of the (then) largest iron ship ever built. It is a fine example of scrimshaw, a little-known nautical decorative art. It features a detailed description of the wondrous ship: 'she is one hundred feet longer than our largest line of battleship. Her length from figurehead to taffrail is 322 feet.' The GB was one of the better-known passenger ships on the England-to-Australia run, making 27 return voyages and transporting more than 25,000 eager immigrants from 1852 to 1881, at that time the greatest number of immigrants borne by any single ship to Australia.

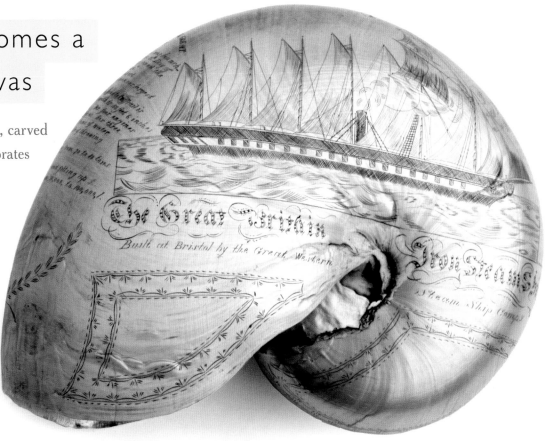

C H Wood (active 1840–65)
Nautilus shell depicting SS *Great Britain*, 1843 (front, top, and back) Scrimshaw nautilus shell, 14.8 x 18.5 x 9.2 cm

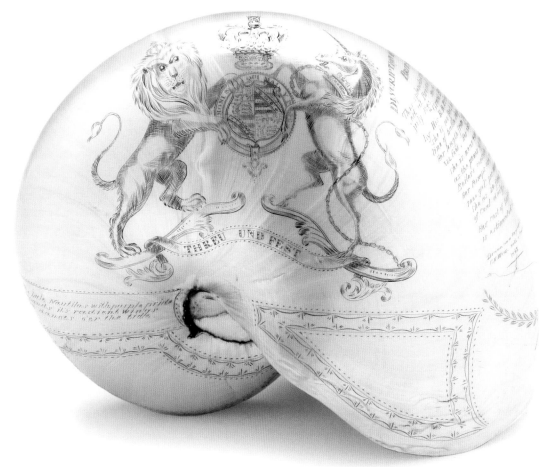

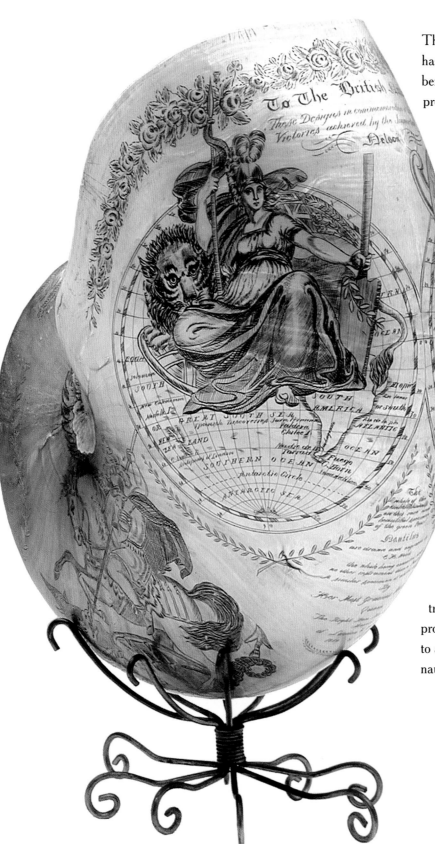

The shell itself is a pearly nautilus – the outer layer has been carefully removed to reveal the lustrous layer beneath. CH Wood was a mysterious English artist who produced elaborate presentation pieces incised in the manner of whalers' scrimshaw. His background is not known, but he may have trained as an engraver or gunsmith. He used a penknife to engrave the designs and script on this shell. Between the 16th and 18th centuries, when 'artificial curiosities' were all the rage, such nautilus shells were treasured collectors' pieces. Their popularity continued in the 19th century, and now their age, beauty and subject matter ensure they are highly sought after by individual and institutional collectors.

An unknown scrimshander engraved this pilot whale jaw (right), which depicts a female nude wrapped in a large piece of fabric, surrounded by a decorative border of foliage. The maker of this piece has left the whale's teeth in the jaw. Scrimshaw commonly features images of women, and whalers often depicted them in erotic or risqué poses. This jaw is one of several collected by one of the museum's early patrons, Desmond (Des) Liddy.

Commemorative depictions of Admiral Lord Horatio Nelson – who died in the hour of his greatest triumph, at the Battle of Trafalgar in 1805 – were mass produced to celebrate his victories and his life. Dating to about 1851, CH Wood's intricately engraved large nautilus shell commemorates Nelson's most famous

C H Wood (active 1840–65) Shell commemorating Admiral Lord Horatio Nelson's battles, c1851, featuring the figure of Britannia. Engraved nautilus shell, 21.5 x 18.5 x 6 cm

battles. The primary engraving is a map of the world in two parts (with Australia marked as New Holland). The allegorical figures of Britannia and Fame dominate this section of the shell. To the left of Fame is a Royal Coat of Arms, while to the right of Britannia is an intricate and lively image of St George slaying the dragon. Above Britannia and Fame is a decorative floral band.

Titled *To the British Nation*, it is one of several that Wood produced. It commemorates the Battle of Cape St Vincent of 1797, the Battle of the Nile of 1798, the Battle of Copenhagen of 1801, and Nelson's last and most famous victory, the Battle of Trafalgar. Interestingly, although the shell was made as a tribute to Nelson, he does not feature other than in script.

Des Liddy collected scrimshaw over a 40-year period and was a world-renowned expert on scrimshaw authentication. He donated 22 pieces to the museum in 1996, and the museum acquired 24 more pieces from his collection at auction in 2000. Together they are known as the Liddy Collection, reflecting their international significance.

Paul Hundley and Lindsey Shaw

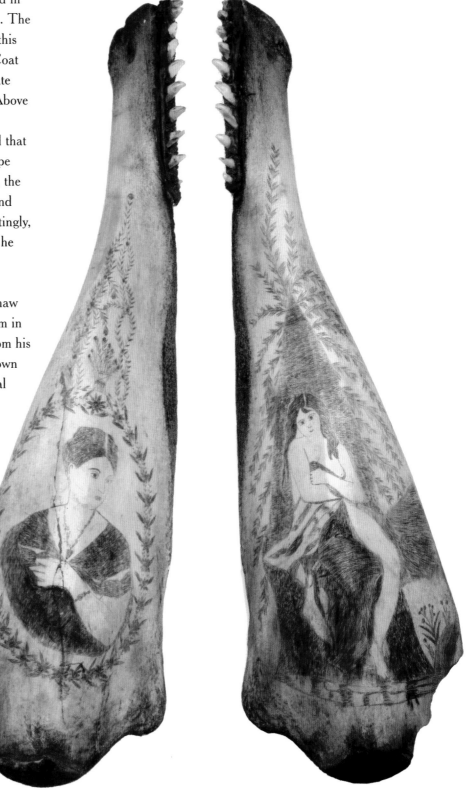

Maker unknown Two scrimshaw whale jaws, depicting portrait of a lady (left) and a provocative woman, 19th century Scrimshaw whale jaws, ink, both 53.5 x 15 x 5 cm

By the light of the clock

In 1865, New Bedford-born William Nye returned to his home town and started his oil business, first out of the kitchen of his home, then from a small storefront. He sold a wide assortment of oils: burning oils, lubricating oils, even castor oil and salad oil. But Nye was out to dominate the market in lubricating oils for delicate machinery, such as watches, clocks, chronometers and, later, sewing machines, typewriters, bicycles and electrical instruments. The finest whale oil came from sperm whales: just one could yield about 13,500 litres, or 192,000 bottles of Mr Nye's oil. He based his trademark on the famous 1829 lithograph of a sperm whale by maritime artist WJ Huggins.

Whaling played an essential part in 19th-century life. Industry and households depended on whale products, for which there were no substitutes. Whale oil was highly prized because it burned at a very steady rate, very brightly and with little smoke. The pure, clean oil from sperm whales was a superior product for lighting, and the finest candles were made from the whale's wax-like spermaceti. But these candles were an expensive luxury item.

The American whale-oil lamp was introduced to Australia in the early 19th century. Because whale oil burned so evenly, it could be depended on to keep time. The oil-lamp clock, used from the mid-18th century until the mid-19th century, was a variation and improvement on the candle clock. The oil-lamp clock had hourly divisions marked as Roman numerals on a metal mount that encircled the glass reservoir containing the oil. As the level of oil fell in the reservoir, the passage of time was read from the markings on the mount. For each hour the whale oil burnt, the oil lowered to the next marked level and another hour had passed. Like the candle clock, the oil-lamp clock also provided light, but it was less prone to inaccuracies in materials or those caused by draughty rooms.

A variety of other lamp fuels were also available in the United States, Australia and Europe during the 19th and early 20th centuries and, by the late 1830s, alcohol blends had replaced increasingly expensive whale oil in most parts of the world. In the United States by the 1850s, camphene – a blend of alcohol and turpentine – cost 50 cents per gallon, much less than whale oil, which was $1.30 to $2.50 per gallon. Camphene was about the same price as coal oil, which was the product first marketed as kerosene.

For decades after the decline of the whaling industry, William Nye obtained oil from beached animals – whales and porpoises naturally stranded by low tides. Subsequent owners sourced oil from small Caribbean islands that continued to hunt marine mammals for food, but by the mid-20th century, even this was impractical. With the passage of the US *Marine Mammal Protection Act* in 1972, it became illegal for any American company to import raw material from marine mammals. Nye's company was permitted to deplete its existing inventory of dolphin-head oil until 1978, when it shipped the last bottle of whale oil ever sold in the United States. The same company, now Nye Lubricants, Inc, is still in business today, creating specialised oils from synthetic products.

Paul Hundley

< Whale oil lamp clock, c1840.
The turned pewter column
supports a spout-shaped lamp.
The glass reservoir is secured by
a pewter strap embossed with
roman numerals (4 to 12 then 1
to 5), which note the hour as the
oil level decreases.
Pewter, glass, 33.9 x 13.2 cm
(height x diam.)

> William F Nye, manufacturer
Whale oil bottle, c1840 Mr Nye's
trademark was based on an image
of a sperm whale by WJ Huggins.
Glass, 16 x 4.5 x 2.6 cm.

In eastern Indonesia during each whale migration season, the villagers of Lamalera set out at first light in a fleet of handbuilt boats. The vessels are moved by paddles and oars and when the wind is right, the crew will set their woven palm-leaf sails. They've made most of their lines and ropes from handspun cotton or palm leaf and bark, and their weapons – all forged from scrap iron – are long knives, a gaff, sometimes an iron lance, and iron harpoons set on bamboo poles up to six metres long. When the crew sights a whale, the harpoonist balances on a bamboo platform at the bow, then leaps out over the water to add power to his thrust as he hurls the harpoon into the whale.

A dangerous livelihood

Lamalera – on the rugged island of Lembata, near Flores north of West Timor – has no arable land, so the villagers depend on the ocean for their staples and barter sea produce for food from inland farms. Sea-hunting is deeply enmeshed in the cultural and spiritual lives of Lamalerans. They believe their boats have souls that endure through continual repair and rebuilding, and every step in boatbuilding has its own ceremony to bring success. In the 1920s their animist religious beliefs changed when Catholicism took hold, but many central traditional practices remain.

Lamaleran whaling boats, called tena and pledang, are built without nails, dowelled and tied together. Lamalerans decorate and paint them with eyes at the bow. Every boat has a maddi – a distinctive sternpost carved with a spiral motif and a variety of other figures or designs, some Christian, some from ancestral times. The maddi symbolises the ears and mouth of the boat, believed to be near the sternpost.

Each boat is owned and managed by a kind of corporation linked to a clan – there are 19 in the village of about 2,000 people living in a cluster of hamlets around a small beach. The fishing catch is shared under a system of rights and obligations that rewards everyone who has had a part in building, equipping, maintaining and operating the boat. Each clan has its own process for distributing different species of the fishing catch, which can include giant manta rays, turtles, sunfish, sharks, smaller toothed whales and dolphins. But the fishers' favoured target is the small sperm whale, which provides them with large reserves of meat to dry and trade.

The museum's collection of Lamalera material features an array of tools and artefacts associated with whaling and Lamaleran cultural traditions, including harpoons, oars, boatbuilding tools, handmade rope and ikat woven cloth. Some objects are most intriguing, such as a glass Fanta bottle that was recycled for use as a container for holy water during Catholic ceremonies. In the 1920s a German Catholic priest had persuaded the villagers to substitute holy water for blood sacrifices in their ceremonies.

International bans on whaling activities only apply to commercial whaling – the International Whaling Commission exempts genuine subsistence whaling. The Lamalerans' catch is comparatively small and their lifestyle is hard and precarious. Their records for more than 40 years indicate an average of about 20 sperm whales caught a year. By tradition they hunt only toothed whales, and their major target, sperm whales, are not endangered. They use every bit of the whale, except the skull. This they treat with respect as housing the spirit of the whale, and keep it with others at the end of the beach. For the hunters themselves, it is highly dangerous work. The harpoonist flings himself bodily into the water next to a sperm whale, which can be up to 12 metres or so long – about the same length as their small boats.

Patricia Miles and Stephen Gapps

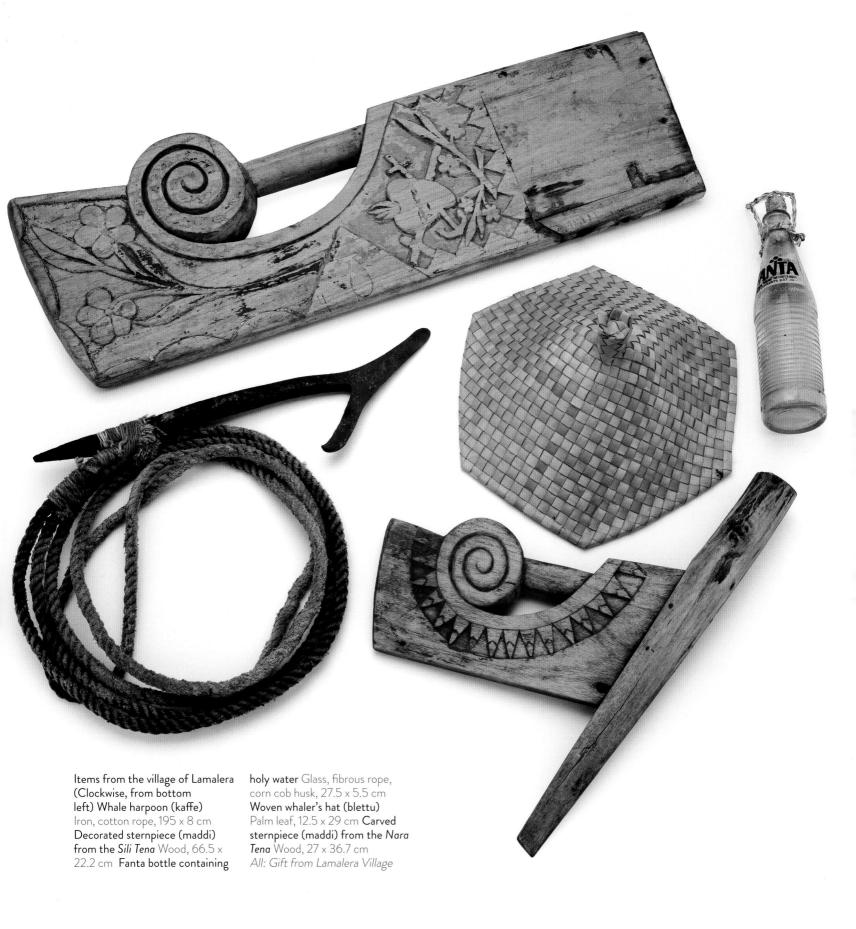

Items from the village of Lamalera (Clockwise, from bottom left) Whale harpoon (kaffe) Iron, cotton rope, 195 x 8 cm Decorated sternpiece (maddi) from the *Sili Tena* Wood, 66.5 x 22.2 cm Fanta bottle containing holy water Glass, fibrous rope, corn cob husk, 27.5 x 5.5 cm Woven whaler's hat (blettu) Palm leaf, 12.5 x 29 cm Carved sternpiece (maddi) from the *Nara Tena* Wood, 27 x 36.7 cm *All: Gift from Lamalera Village*

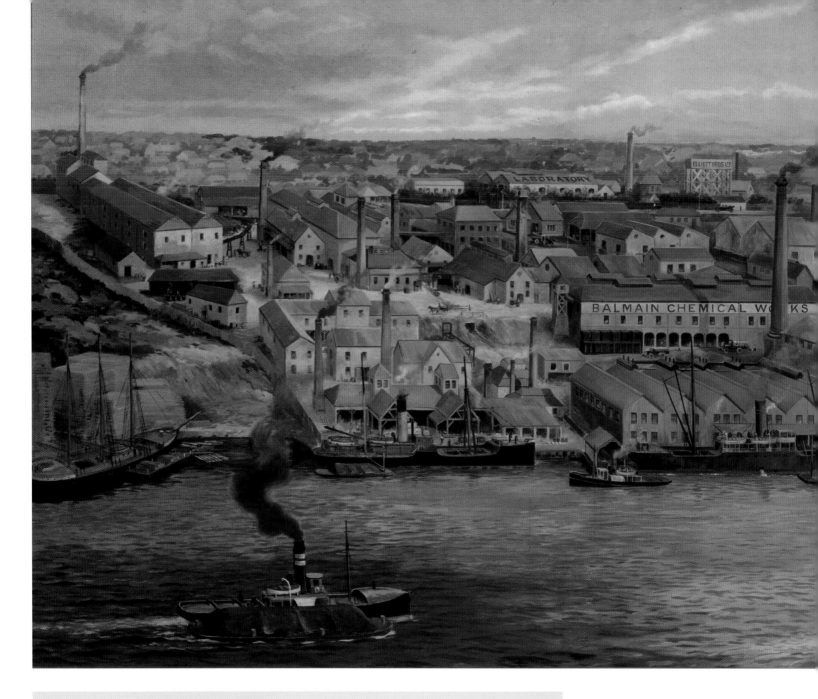

Coal dust, chemicals and waterfront life

Around the turn of the 20th century, the now-fashionable suburbs of Balmain and Rozelle in Sydney's inner west were permanently blanketed in thick black smoke and the noxious fumes of chemical factories and a sulphuric acid plant. There were also foundries, sawmills and drying kilns. Residents' washhouse coppers, kitchen stoves and domestic fireplaces, all fuelled by coal or wood, added to the mix. Along with steam locomotives, steamships and the dust blown from coal stockpiled for ships' bunkers or holds, the blight of toxic chemicals meant that only those who had to work in Rozelle lived there.

Charles Henry Hunt (1857–1938) and James William Reed (1856–1931) *Elliotts & Australian Drug Limited Chemical Works & Laboratory – Rozelle*, c1919 Oil on canvas, 197 x 288 x 11.5 cm *Gift from Huntsman Chemical Company Limited*

The painting shows a conglomeration of pharmaceutical and chemical factories and laboratories, including the Balmain Chemical Works on Terry Street, Balmain, the fertiliser company George Shirley Limited and, of course, the Elliot Brothers building. On the left of the painting we can see elemental sulphur being transported by barge to the wharves, and in the centre of the painting it is being taken by tramway skips to the sulphuric acid plant in the top left corner. In the open building below the plant, coopers are making barrels for the sulphur. The chimneys belching dark smoke on the far right of the painting are part of the Balmain Garbage Destructor and Power Plant, built in 1904.

All this industry required a workforce, and from the 1860s the Balmain–Rozelle area had seen the construction of rows of workers' cottages and terrace houses – visible in the background of the painting. Waterfront workers, in particular, needed to live near the wharves as their casual labour system often required being at work in a moment's notice, or working long, 24-hour shifts. While these industries offered employment, many workers and their families lived in crowded and often squalid conditions – particularly in times of economic hardship and depression such as occurred in the 1890s and 1930s.

The legacy of industrial pollution in areas like Rozelle was that, by the 1970s, the place was so degraded it had become dilapidated, dotted with empty homes and rundown factories and warehouses. The suburb's transformation reflected the wider transformation of the working harbour and, by the 1980s, with the removal of many industries to the western suburbs of Sydney, it was to become a thriving area once more, ready for renovation and renewal. The 1919 painting is an excellent record of its past heyday, and a reminder of its past ills.

Stephen Gapps

This painting celebrates the industrial development typical along the foreshores of much of Sydney Harbour in the early 20th century. Commercial artists Charles Henry Hunt and James William Reed painted this bird's-eye view of Rozelle in 1919, for the Elliot Brothers' chemical works catalogue. The work encapsulates the energy of a busy waterfront servicing nearby factories. At the time, this was a scene of great industrial progress.

Muriel Binney

Sydney Harbour Foreshores at Sunset – a 20-metre-long panorama of Sydney Harbour – is an unforgettable work of art, with its 360-degree watercolour view of harbour life. Painted in four lengths as an architectural frieze designed for the home, it is a sweeping view of the harbour's horizons, nooks, crannies, bays, beaches and boats, all bathed in the delicate tones of a late winter's evening. It was painted in 1907 by amateur artist Muriel Mary Sutherland Binney, who went on to pursue her interest in inventing rather than painting, yet left this incredible view of her home town.

Muriel Binney was born in St Kilda, Victoria, in 1873. Both her parents' families were photographers and the young Muriel was schooled in arts and music. She was 33 years old when she painted this panorama, and lived in Elizabeth Bay with her husband, a doctor, and one small child. She produced this work for the First Australian Exhibition of Women's Work, held in Melbourne in 1907, which aimed to showcase women's work – to counter perceived neglect of their art, craft and industry – and to open up new avenues of work for women in professions and industries until then dominated by men.

Binney also had an eye on business opportunities that might arise from the exhibition, applying at the time to copyright the frieze design and to produce a fold-out postcard or Christmas card. Although not awarded a prize in Melbourne, *Sydney Harbour Foreshores* was selected for the New South Wales Court of the Australian Pavilion at the Franco–British Exhibition held in London in 1908. There Binney's panorama and the child's cot she designed were two of only three exhibits by women and she was awarded silver medals for both.

∧ Muriel Binney (1873–1949) *Sydney Harbour Foreshores at Sunset, Panel III, Manly to Watson's Bay*, 1907 Watercolour on paper on linen, 50 x 425.2 cm (height x length)

< Commonwealth of Australia Registrar of Copyrights, Muriel Binney's certificate of registration of copyright in *Sydney Harbour Foreshores at Sunset*, 1907 Ink on paper, 32.8 x 20.2 cm

> Silver medal certificate diploma awarded to Muriel Binney at the Franco–British Exhibition in 1908 Ink on paper, 39.1 x 47.5 cm *All works donated by Jeremy Grover, conserved with the assistance of the Vincent Fairfax Family Foundation*

FRANCO-BRITISH EXHIBITION 1908
SHEPHERD'S BVSH, LONDON
DIPLOMA FOR SILVER MEDAL
AWARDED TO
Mrs M Binney, New South Wales,
for
Frieze

Hon. President.
President.
President de la S. F.
Chairman of Executive Committee
Imre Kiralfy
Commissioner General

All by Muriel Binney (1873–1949)
All: *Sydney Harbour Foreshores at Sunset*

ʌ *Panel I, Woolloomooloo to Entrance of Parramatta River, Neutral Bay and Fort Denison, 1907*
All watercolour on paper on linen, 50.4 x 433 cm (all height x length)

ᵥ *Panel II, Mosman to St George's Head [sic], 1907,* 50 x 541 cm

Ꮙ *Panel IV, Vaucluse to Garden Island, 1907,* 50 x 541.9 cm

All donated by Jeremy Grover, conserved with the assistance of the Vincent Fairfax Family Foundation

In *Sydney Harbour Foreshores* our viewpoint is from the middle of Sydney Harbour with a shifting perspective of its major bays and landmarks, from the entrance of the Parramatta River in the west to the Heads in the east. We are variously just south of Fort Denison, south of Bradley's Head, and off Clifton Gardens.

Working from photographs, Binney drew a variety of working and leisure craft to animate this harmonious and eye-catching panorama of harbour life. An omnipresent ferry makes its way around the harbour, and in Farm Cove HMS *Powerful*, the flagship of the Australia Station, lies at anchor. The foreshore is dotted with navigational markers, and Old South Head Road cuts its way to the Macquarie Light and from there to Watsons Bay, where the home of the Doyle fishing family is nestled. We can

also see the old timber Domain Baths, the ferry terminal at Lavender Bay and the buildings at Clifton Gardens, while the Garden Island Naval Base is still an island. Binney shows special natural landforms such as the sandstone grotto caves on Clark Island in the soft light of dusk, as a quiet harbour winds down from a working winter's day in August 1907.

As a panorama it is unusual; Binney painted it at a time when most other examples of this genre were photographic. And while photography in the early 20th century tended to give equal weight to all features, Binney's painterly technique allowed her to highlight favoured aspects, and she has emphasised harbour life – the boats and navigational markers – rather than its landforms or buildings.

Binney did not develop a career in the arts, but focused on inventing in later years, exhibiting and patenting a cigarette smoker's complete outfit, a body harness and a portable shoe stand and travelling case. Her artistic legacy remains this impressive panorama which stayed in the Binney family until presented to the museum, in six pieces, with sections cut out for ventilation grates and doorways. It was donated with other papers, certificates and the photographic studies used to create it, which all helped in the major conservation program carried out to restore it to its appearance at that ground-breaking First Australian Exhibition of Women's Work in 1907.

Daina Fletcher

In the 1890s, young photographer Samuel (Sam) John Hood developed an excellent strategy for a lucrative business in ship and crew portraits. He would hitch a ride on a tugboat to photograph sailing vessels ready to enter Sydney Harbour and, with his portfolio under his arm, would then board the ship and convince the captain to let him sell photographs to the crew – with the promise of a similar oil painting for the captain or a free portrait. With the captain's assent, Hood's bill for photographs was deducted from the crew's wages, so they didn't have to 'pay' a penny upfront.

Hood's harbour

He would then rush back to his city studio or his home studios in Balmain and, using a trick of the trade, paint the sails (based on the particular ship's rigging plan) onto a photograph of the vessel, which he would then rephotograph and present to the crew as postcards. Apparently, few sailors saw through his retouching techniques (often also applied by skilled marine artists such as Walter Barratt, Reginald Arthur Borstel, George Frederick Gregory and John Allcot).

The turn of the 20th century marked the end of the sailing ship era and the growing dominance of steam vessels. This had implications for Hood's business, as steamship crews were less inclined to request photographs of their vessels. During the 1910s, he continued to produce studio portraits and ship photography, but in 1918 he transferred to Dalny Studio at 124 Pitt Street, Sydney, which had a contract to supply photographs to the Melbourne newspaper *The Argus* and the national weekly tabloid *The Australasian*. This soon also included the Sydney newspapers *Daily Guardian*, *Daily Telegraph Pictorial*,

Samuel J Hood Studio
Launching of HMAS Warrego *(II) at Cockatoo Island Dockyard, 10 February 1940.* Shipwrights who had 'railed up', or readied a vessel for launch on the slipway, were customarily rewarded with a keg of beer. Nitrate negative, 8 x 10.5 cm

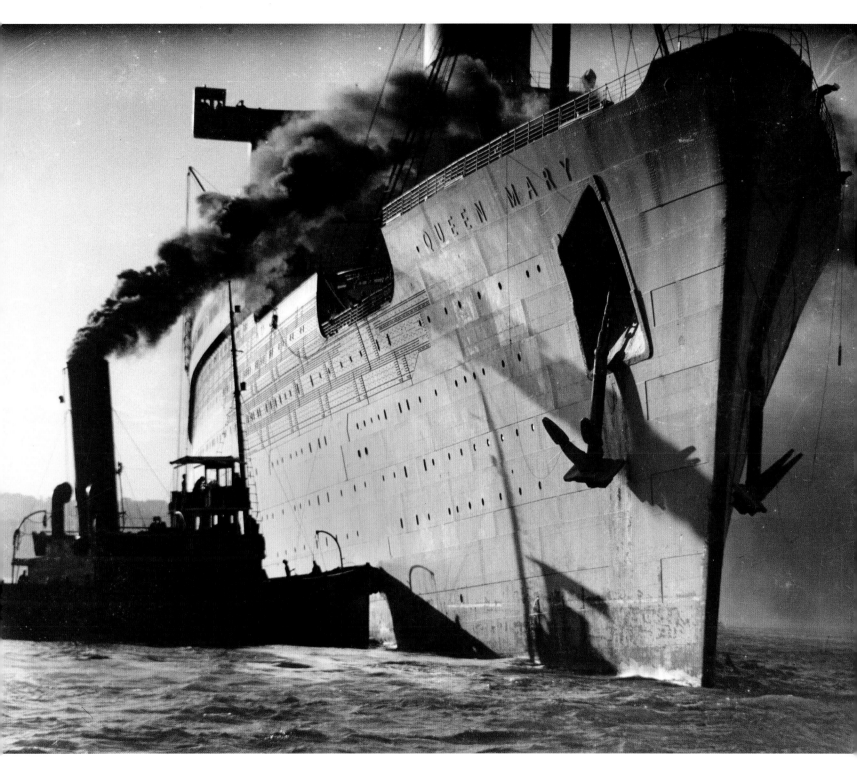

Samuel J Hood Studio Queen
Mary as Troopship, May 1940
Nitrate negative, 8 x 10.5 cm

Labour Daily, *Daily News*, *Sun* and *The Sydney Morning Herald*. By the 1920s, Hood had moved from ship postcards to the newspapers' social and sport pages. With an excellent eye for everyday subjects, he was a leader in the early development of photojournalism.

The entire collection of the Samuel J Hood studio is enormous – of about 33,000 images, the museum holds more than 9,000, primarily related to maritime scenes. The industry around, and activity on, Sydney Harbour during the busy early to mid-20th century remained some of Hood's favourite subjects. His iconic photograph of the troopship *Queen Mary* in 1940 captures the drama of manoeuvring a large vessel on the harbour. His photographs of machinery and ship construction at Cockatoo Island Dockyard are both valuable records

and celebrations of industry. Hood's portraits of ships' crews proudly posing with their pets show his ability to narrow his focus from the grand sweep of the harbour to more personal moments. From the 1930s, employees at Hood's Dalny Studio included his children Ted and Gladys, as well as several other photographers who went on to successful careers as press photographers for various newspapers. At the outbreak of World War II, Hood, aged 67, was recruited by the Ministry of News and Information to document the armed services. This period also witnessed the decline of formal studio portraits, which led the Hood studio to pursue more commercial commissions.

Sam Hood continued working at his studio up to his death in June 1953. He had used the same modified Folmer & Schwing Graflex camera for more than 40 years. Hood's oeuvre was primarily commercial and journalistic but, importantly, his studio created a vast, rich and detailed archive of daily life in 20th-century Sydney.

Stephen Gapps

Samuel J Hood Studio
SS Strathgarry Crew, c1910
Nitrate negative, 9.1 x 15.3 cm

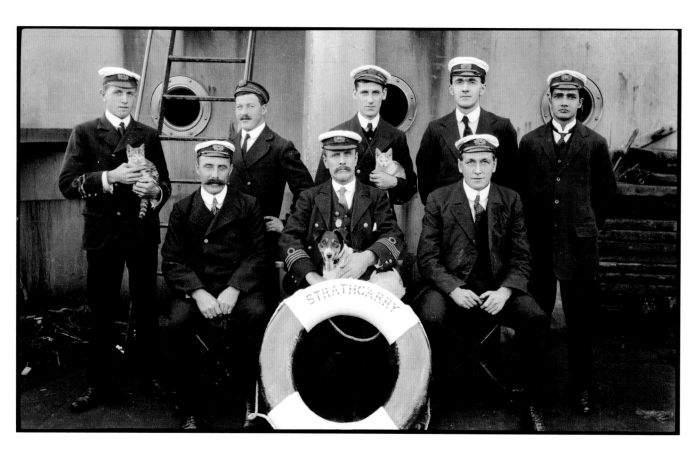

David Moore's 'soft flow of time'

David Moore was a renowned Australian photojournalist with an extraordinary 60-year career. He had a strong interest in maritime subjects, and served in the navy during World War II. In 1951 he turned down Max Dupain's offer of a junior partnership to seek a career overseas in photojournalism. He worked a passage on the *Oronsay* to London by taking photographs for the Orient Line. In London, Moore sold his first story: a magazine-style photo-essay on the cruise ship *Himalaya* in Sydney Harbour in 1950.

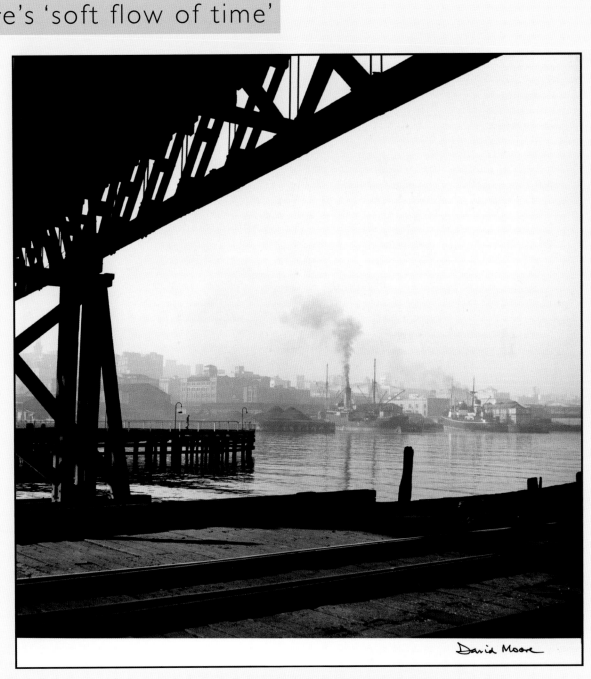

> David Moore (1927–2003) *Pyrmont Bridge Sydney II*, c1947 Silver gelatin print photograph on paper, 29.3 x 29.3 cm (image), 51 x 40.5 cm (overall) © Estate of the artist, reproduced with permission

The museum collection includes 67 of Moore's prints with a maritime theme. His images of Sydney's harbour and beaches are iconic, and range broadly in subject from industrial scenes, such as his c1947 *Dockworkers and Titan Crane*, to the harbour foreshores in *Pyrmont Bridge Sydney II* (c1947).

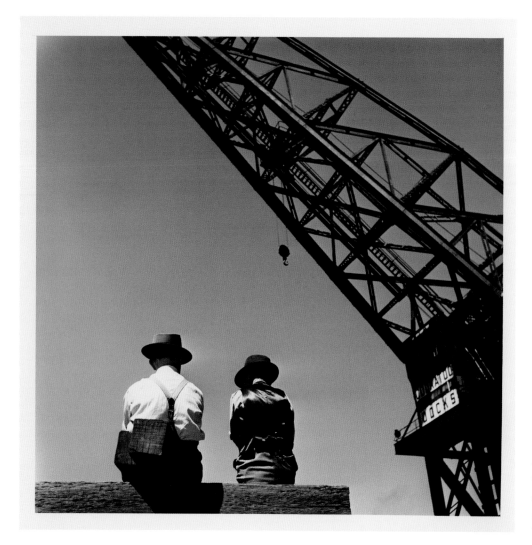

< David Moore (1927–2003) *Dockworkers and Titan Crane,* **c1947** Silver gelatin print photograph on semi-gloss fibre paper, 36 x 36.2 cm (image), 48.5 x 46 cm (overall) © Estate of the artist, reproduced with permission *Gift from David Moore*

> David Moore (1927–2003) *Painting the* Himalaya, 1950 Silver gelatin print photograph on semi-gloss fibre paper, 70.8 x 56.8 cm (image), 78 x 68 cm (overall) © Estate of the artist, reproduced with permission *Gift from David Moore*

They are outstanding works of art, as well as an important historical record.

In *Dockworkers and Titan Crane,* we see how Moore's exquisite composition turns the everyday into an artwork. Two men are dwarfed by the giant Titan floating crane, and a humble moment in their daily working lives is transformed into a scene of humanity and industry. In *Pyrmont Bridge Sydney II* (p. 185) Moore frames the haze and smoke of waterside industry in Darling Harbour with a contrasting dark underside of Pyrmont Bridge and railway tracks. Even before Moore had begun his career in photography, we see in these 1940s images the ambiguity and serenity that were to characterise his later works.

When Moore returned to Australia in 1958, he contributed picture stories to magazines such as *Walkabout,* and continued to publish in American and British magazines, joining the New York-based Black Star photo agency. Moore published more than a dozen books, and was one of the founders of the Australian Centre for Photography in Sydney. In the 1970s he developed non-commissioned works aimed at capturing what he called 'the soft flow of time', as opposed to the 'decisive moment' favoured by magazine editors. His photographs show a sensitivity for subject and place and an eye for scenes with, as he called it, 'ambiguous elements'. Such a combination of flow and uncertainty make Moore's work both a tribute to and a commentary on 20th-century modernity and place him among the greats of Australian photography.

Stephen Gapps

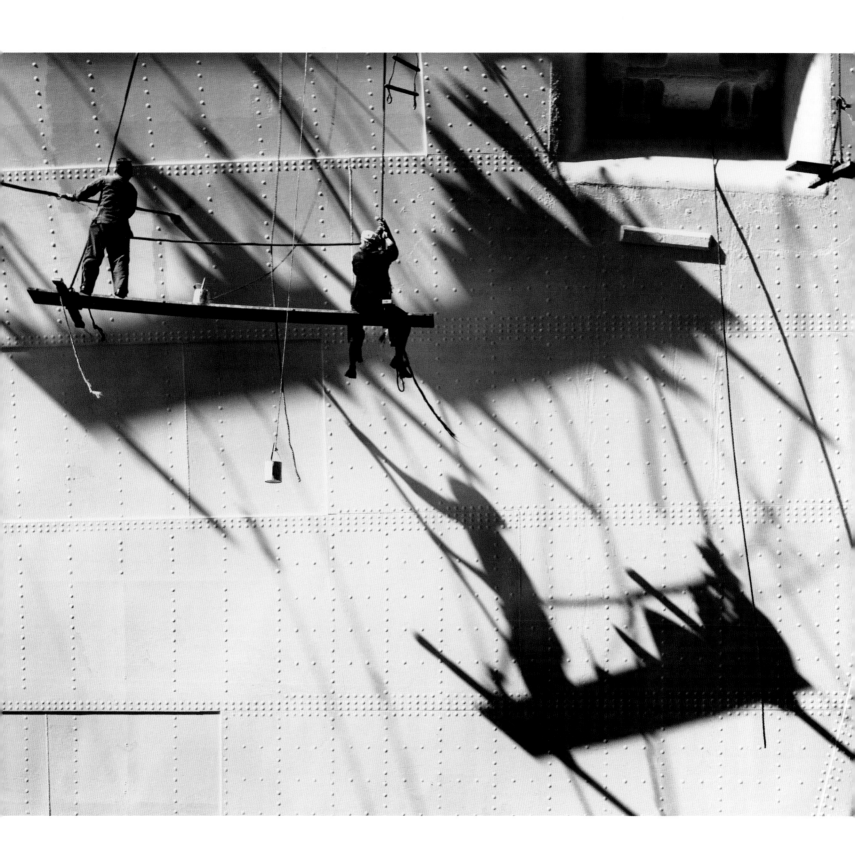

Jeff Carter and David Potts documented Australians at work and play, skilfully exploring their chosen subjects through photojournalism. Their approach reasserted the importance of 'subject over style' in the 1950s, an era in Australian commercial photography when advertising departments generally controlled the photographer's creative process.

Documentary photography

A pioneer of Australian documentary photography, David Potts contributed to international and Australian publications such as *Sports Illustrated* and *Time–Life* magazines with his evocative images of life in postwar Britain and Australia.

His powerful series documenting a shark hunt was taken over a six-day period in 1957. Potts photographed Alfred Dean (a farmer from Mildura, New South Wales) and his fishing companion Tom Cooper (owner of the

South Australian Coopers Brewery) shark hunting at Ceduna, South Australia. Ken Puckeridge – a professional fisherman and owner of the 28-foot cutter *Victory* hired for the voyage – was also on board. Puckeridge's boat was not designed for game fishing, and essentials such as the fishing chair (a converted tractor seat), the gaffs and other equipment were provided by Dean and Cooper.

Potts photographed the men preparing hooks with seal-liver bait, the 'fight' between fisher and shark, and the eventual capture and dismemberment of the shark. His realistic and spontaneous approach produced dramatic and sometimes disturbing images. Potts also interviewed the

fishermen for his project, 'Hunting the killer of the southern seas'. This was a time when sharks were seen as man-eating monsters that were hunted and prized as big-game trophies.

Jeff Carter also combined writing and photography. As editor of *Outdoors & Fishing* magazine from 1949, he taught himself photography and made his reputation recording the lives of ordinary Australians, travelling to rural and outback Australia and to the beaches of New South Wales and southern Queensland. Carter celebrated working lives often touched by harshness and poverty. In 1959–60 he travelled to Ulladulla, New South Wales, where he photographed members of the Sicilian fishing community – some were postwar migrants, others had been raised or born in Australia.

During his stay, Carter spent time with several families ashore and on their fishing trawlers, recording them long-line fishing for snapper as well as net fishing. He wrote two articles for *People* magazine, illustrated with these images ('Long-lining is tough work', 28 October 1959, and 'Australia's foreign port', 13 April 1960). In these stories he commented on the prejudice Italians faced from the wider community, tensions that were heightened when fish were scarce and the catch small. He also noted perceptions that the Italians were perceived as 'clannish' and not interested in 'assimilation'. For Carter, his images were a way to humanise the fishing community and, more generally, to champion the poor and unknown.

Penny Cuthbert

David Potts (b 1926)
<< Alfred Dean fishing for Great White Shark, 1957 Silver gelatin print 1994, 30.5 x 45.5 cm
< Self portrait with Great White Shark, 1957 Silver gelatin print 1994, 50.5 x 40.3 cm Both © David Potts, courtesy Josef Lebovic Gallery Sydney

Jeff Carter (1928–2010)
Hauling in a fishing net, Ulladulla, NSW, 1959–60 Silver gelatin print 2003, 51 x 49.5 cm Men and children hauling a net onto a beach Ulladulla, NSW, 1959–60 Silver gelatin print 2003, 51 x 49.5 cm Both © Estate of the artist, reproduced with permission *Gift from Sandra Byron Gallery*

Sharks, spears and cameras

Ron and Valerie Taylor were household names in the 1960s, 70s and 80s, with their dramatic and beautiful underwater photography featuring in movies such as *Shark hunters*, *Jaws*, *Orca*, *Blue water white death*, *Age of consent* and *Blue lagoon*.

After terrifying thousands of divers and swimmers with their unbelievable footage of sharks, the Taylors went on to become leading figures in the conservation movement, drawing world attention to the plight of the marine environment. In particular, they were instrumental in having grey nurse and great white sharks protected in Australian waters.

Ron took up skindiving in 1952 and Valerie in 1956, meeting each other at the St George Spearfishing Club in Sydney. At that time there was little awareness of marine conservation, and the couple had their first successes in national and world spearfishing competitions. But their aquatic interests soon grew to encompass scuba diving and underwater photography, and they swapped their spears for cameras. When television came to Australia in 1956, Ron saw the potential for underwater news stories, and built the first of many waterproof underwater housings that allowed them to take land cameras beneath the sea. He then sold the footage to television stations and the cinema newsreel Movietone News.

In 1962 Ron received his first award for underwater photography, and in 1963 he and Valerie made their first underwater film, *Shark hunters*, which they sold to enthusiastic networks in both Australia and the United States. They soon gained an international reputation for cutting-edge underwater photography, and many more awards followed.

The Taylors gave up competitive spearfishing in 1969 and devoted themselves full time to marine conservation, underwater photography and shark research. They often worked with marine biologists and university researchers from around the world. With the Natal Shark Board in South Africa they developed stainless steel chain-mail diving suits and electronic shark-deterrent equipment, and they were the first ever to film great white sharks underwater without a cage.

More underwater filming opportunities arose: *Jaws* (1975), *Sharks* (1975), *Orca* (1977), Peter Weir's *The last wave* (1979), *The blue lagoon* (1980), *Gallipoli* (1981), *The year of living dangerously* (1982), *In the realm of the shark* (1988), *Return to the blue lagoon* (1991), and *The island of Dr Moreau* (1996), among many others. They also filmed many of the scenes in the American feature film *Blue water white death* (1971), even playing two of the main characters. Shortly afterwards, the Taylors directed and filmed a 39-episode television series called *Barrier Reef* (1970–71) and followed this with *Taylor's inner space* (1972–73), featuring their encounters with the marine life of Australia's east coast and the western Pacific.

The Taylor Collection holds Valerie's trademark blue-rubber face mask, which featured in many of her underwater adventures, and an assortment of late-1950s to mid-1980s diving equipment. Other highlights include the first acrylic 35-mm underwater camera housing made by Ron in 1956, a Rollie Marine camera and housing used by world-famous diver Hans Hass when he visited Australia in the 1960s, and the underwater camera housing used to film *Jaws*. Chain-mail suits worn during Operation Shark Bite – illustrated here in a poster for the world-famous underwater film festival at Lucerne in Switzerland – and a banded Lycra suit worn by Valerie during scientific research into shark deterrents (based on sharks' apparent dislike of sea snakes) represent their research work.

The Taylors have been recognised for their work all over the globe. In 2003 Ron became a Member of the Order of Australia, joined by Valerie in 2010 for her conservation work, and in June 2011 they were both inducted into the Australian Cinematographers Society's Hall of Fame.

Kieran Hosty

UW-Film Festival Luzern, 1984. In 1984 the Taylors were invited guests at the Lucerne film festival for underwater productions. This poster shows the frightening image of a shark biting into Valerie's arm – saved by the stainless steel chainmail diving suit she was wearing. *Ink on paper, 102 x 90 cm Gift from Ron and Valerie Taylor*

Valerie Taylor

Internationales
Unterwasser-Film-Festival
13. + 14. Oktober 1984, Kongresshaus Luzern
Schweiz/Suisse/Switzerland

**UW-Film
Festival
Luzern**

	12. Oktober	13. Oktober	14. Oktober
Film-Festival 84	19.00–22.00	9.30–11.30	10.30–12.00
Postfach 196	(Soirée mit	14.00–16.00	14.30–17.00
CH-8029 Zürich	freiem Eintritt)	16.30–18.30	
		20.30–22.00	

**Sponsored by
Eastman Kodak Company,
Rochester and
Kodak SA, Lausanne**

Patronat Documenta Maritima

Pearling lugger and 'couta boat

The men who plied their trades in these two working craft faced hazards and hardships of very different kinds. Each vessel demonstrates its own distinctive Australian style, one that evolved to suit the needs of local environments and fisheries. Both were among the last craft to carry working sail.

Thistle represents the museum in classic-craft events on Sydney Harbour. Photo: Jenni Carter, ANMM

The Broome pearling lugger *John Louis* (pronounced 'Lewis'), built in 1957, worked in a century-old industry on the remote Kimberley coast. Here, and in Torres Strait, divers brought up lustrous, giant gold-lipped pearl shells that were used to fashion ornaments and buttons in the days before plastics. But sometimes the shell contained a rare and fabulously valuable pearl and, like a gold rush, the industry attracted its share of adventurers, gamblers, swindlers and thieves. Fleet owners could make a fortune in a season or lose it just as quickly on a market fluctuation, or when cyclones sank whole fleets of luggers.

The outback port Broome, where *John Louis* was built for pearler Louis Placania, was one of Australia's earliest multicultural communities, with Aboriginal and Torres Strait Island people, Japanese, Malays and other Southeast Asians dominating the population. They reflected the industry's development. It first used free or 'skin' divers, often Aboriginal women, to work shallow beds of pearl shell. From the 1880s, hard-hat diving equipment allowed deeper beds to be worked, from larger, more specialised craft that came to be called luggers. Until the 1960s it was believed that Europeans could not use the heavy diving gear as well as Asian and Indigenous divers. The risks were many, including sharks, the bends and drowning.

Luggers towed divers over the pearl beds, drifting under a sail set on the after mast while crew shelled the oysters on deck. A cultured-pearl industry developed in the 20th century, with live shells gathered, 'seeded' and

returned to the sea where a pearl slowly grew inside. In the 1970s *John Louis* trialled lighter, easier-to-use 'hookah' diving gear, and the lugger was modified to suit the changing industry. The foredeck was raised to provide roomier accommodation as taller European Australians worked as divers. The museum acquired the vessel in 1987 at the very end of its working life.

The seas plied more than a century ago by Victorian fisherman George Darley in the 'couta boat *Thistle* could hardly have differed more from those of the tropical Kimberleys. With only one other crewmember to manage the open, centreboard sloop, George braved the relentless south-westerly gales of cold, tempestuous Bass Strait. He sailed from Port Fairy on Victoria's 'shipwreck coast', a long, gale-swept lee shore that had earned its reputation all too well.

Hundreds of 'couta boats sailed from ports along this coast, or from Victoria's Port Phillip and Westernport bays, out into Bass Strait to hand-line for the big, needle-toothed fish called barracouta – not to be confused with tropical barracuda. Even in summer it was cold, wet work for the short-handed crews – often just a man and a boy – who kept a wary eye on the weather, ready to run for home. The half-decked 'couta boats had no cabin for shelter but their skiff-like lines and efficient rigs made them swift, handy sailers, until they were replaced by motorised fishing craft as the 20th century progressed.

George Darley used *Thistle* – thought to have been built in 1903 by a Melbourne boatbuilder called Jones – for crayfish and barracouta and later for shark, a staple of the fish-and-chip

shops. The boat changed hands several times and by the late 1960s was motorised and pulling a dredge on Port Fairy's Moyne River. In the 1970s, *Thistle* had become a houseboat fitted with a cabin.

Tim Phillips, an authority on the history and construction of 'couta boats, bought *Thistle* in 1987 and restored it for the museum, retaining most of the original timbers and returning it to the sturdy and honest workboat that it was. He avoided the yacht-style finishes given to many restored or new-built 'couta boats, which have become prized exemplars of Victoria's fine maritime heritage.

Jeffrey Mellefont

John Louis hoists its gaff ketch rig, sailing regularly from the museum. Photo: Jenni Carter, ANMM

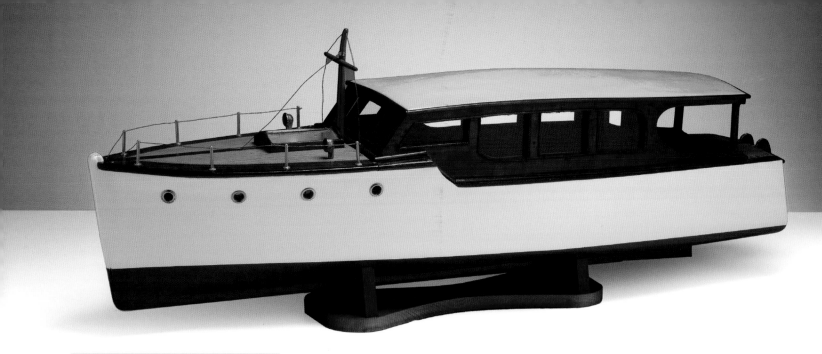

The Halvorsen boatbuilding dynasty

'If you can build a boat you can build anything.'

Lars Halvorsen

This 'can do' philosophy underpins the skills and achievements of an enterprising Norwegian–Australian family of boatbuilders and champion sailors, led by Lars Halvorsen, which made a major contribution to Australian boating during the 20th century. The Halvorsen hallmark was a vessel that was refined, elegant and balanced, where nothing seemed out of place.

The Halvorsens are famous for designing and building a large and diverse range of vessels – from stylish motor cruisers to World War II military vessels, champion racing yachts and a variety of working craft, including tug boats and fishing trawlers.

A fascinating collection held by the museum includes Halvorsen vessel plans, tools, photograph albums, scrapbooks, models and wooden patterns for casting metal vessel fittings. It documents the family's passion for boats,

their design skills and remarkable output. Today, Halvorsen boats are considered design classics and are highly sought after for restoration.

Lars Halvorsen came to Sydney in 1924. He immediately set up a boatbuilding business, and by 1934 all of his five sons – Harold, Carl, Bjarne, Magnus and Trygve – were working at the boatyard. Lars had learnt his boatbuilding skills in Norway, and then in American boatyards, and he passed his knowledge to his sons as they joined him as apprentices.

Once established in Sydney, Lars Halvorsen's boatyard soon gained a reputation for excellent workmanship and fine design, and wealthy Sydney businessmen commissioned motor launches and yachts. Lars also designed several 'missionary boats' for the Seventh-Day Adventist Church to transport missionaries and their goods in the New Hebrides (Republic of Vanuatu).

After Lars's premature death in 1936, at the age of 49, the family business continued as Lars Halvorsen Sons Pty Ltd from 1937, with eldest son Harold as principal designer and managing director, and other family members as directors. The firm was originally based in Neutral Bay, and then established additional premises at Ryde, where they continued to produce launches of all sizes. During World War II, Lars

Halvorsen Sons Pty Ltd built hundreds of vessels for military use, including Fairmile launches, crash boats and patrol boats, and focused on vessel maintenance. They also diversified into commercial fishing with Halvorsen Fisheries Pty Ltd, operating a small fleet between Eden and Sydney and fish shops at Kings Cross and Rose Bay.

After the war, the family ventured briefly into tourism with chartered tours of Sydney Harbour, and then operated a successful launch-hire business from Bobbin Head, north of Sydney. Harold Halvorsen's son, Harvey, continued the family tradition of motor launch design, initially working in California and then returning to Sydney in about 2002, where he launched a new range of powerboat designs for the Australian and international market. Harvey's son, Mark, continues to operate this business.

Beyond the boat yard, the Halvorsens distinguished themselves in competitive sailing. In the 1930s they crewed in the Sydney Amateur Sailing Club's harbour races. When sailing resumed after World War II, the Halvorsens were soon successful in ocean racing. In 1932 Lars had designed and built the yacht *Christina*, which later won the 1946 Sydney–Hobart race, while his sons Trygve and Magnus made sailing history with their three consecutive Sydney–Hobart handicap wins in *Freya* (1963–65), a record that still stands. Magnus competed in 30 Sydney–Hobarts from 1946 to 1982, developing his expertise as a navigator. Trygve and Magnus won four Trans-Tasman races between 1948 and 1961 in their yachts *Peer Gynt*, *Solveig* and *Norla*, and went on to compete in Australia's first Admiral's Cup and America's Cup Challenge series, in *Freya* and *Gretel* respectively. They also competed in the Southern Cross, Trans-Pacific and other races. Carl Halvorsen distinguished himself in the 5.5 class, winning the Australian championship in 1967, 1982 and 1991. The Halvorsens' impressive sailing record has been recognised with national and international awards.

Penny Cuthbert

< Henry Jackson (1908–1971) Amateur model of Halvorsen motor cruiser, 1930s Wood, canvas, brass, paint, 43 x 111 x 29 cm *Gift from the Estate of Laurence Henry Jackson*

ᵛ Lars Halvorsen (1887–1936) General arrangement plan of the auxiliary ketch-rigged mission boat *Lephare*, 1930 Ink on linen, 44 x 64 cm © The Halvorsen family

ᵛ Unsigned copy of general arrangement plan of the bridge-deck motor cruiser *Pollyanna*, after a 1933 design by Harold Halvorsen (1910–2000) Ink and pencil on paper with hand-colouring, 47.5 x 71 cm © The Halvorsen family *Both plans gifts from Harvey Halvorsen and Judith Lynne Vigo*

8 SPORT AND PLAY

With striking modernist illustrations and a palette of bright colours, the new Australian National Travel Association alerted the world in the 1930s to Australia's wide open landscapes, sun-drenched beaches and outdoor lifestyle.

The agency's aim was to capture attention in Europe and elsewhere and tell people in those often depressed areas about the great opportunities for immigration, investment and holidays in a young and relatively carefree nation. The campaign succeeded, but it also had another, more enduring

effect. Its imagery of sunshine, open space, good health and physical strength defined Australia and Australians for people overseas, and generally confirmed in the minds of Australians the perceptions they were forming of themselves and life in this country. And it didn't end there.

The themes of that ANTA initiative have reverberated down through the years in successive corporate and government campaigns that sought to capture an aspect of 'Australianness'. The qualities that this early campaign captured are still considered central to the Australian identity.

A focus on watersports and pastimes is one of the ways that this museum has expanded the traditional ambit of maritime history, to give even more people a sense that

they are a part of this country's water-based heritage. The museum holds a significant collection of posters that refer to Australia's beach culture and other aspects of life and the environment in coastal and river areas. It also has a far-reaching collection of objects that attest to Australia's love of the outdoor life and its prominence in aquatic sport.

Australian swimmers have won a total of 58 Olympic gold medals, easily securing their status as Australia's top athletes. There has been a similar progression in sculling and rowing, from Henry Robert (Bobby) Pearce's Olympic gold medals in 1928 and 1932, to the internationally celebrated 'Oarsome Foursome', who won three Olympic gold medals and four world titles in the 1990s. From the 1960s, our surfers have been carving their place in world competition. And in sailing, Australia has always moved well in international company – never more triumphantly than that breathtaking September in 1983 when *Australia II* snatched the 'unwinnable'

America's Cup from the Americans who had held it for 132 years.

What has driven such high levels of achievement in and on the water? Climate is clearly part of the answer. And so too, in all likelihood, is the perception held elsewhere in the world and by us in this country that Australians are strong, healthy people who enjoy their time outdoors in the sun.
Bill Richards

< Gert Sellheim (1901–1970) *Australia for Sun and Surf*, 1936. In one of the Australian National Travel Association's most famous posters, artist Gert Sellheim evokes for an international audience the exuberance and enduring allure of Australia. Colour process lithograph, 105.6 x 61.8 cm, courtesy Nik Sellheim and Josef Lebovic Gallery Sydney

v Narelle Autio (b 1969) and Trent Parke (b 1971) *Untitled #11* from *The Seventh Wave*, 2000. After travelling the globe as award-winning photojournalists, Autio and Parke wanted to explore Australia's underwater world. Here under the pier, swimmers float in water, in shadows and light, as much at home as the fish. Silver gelatin print, 109.7 x 288.1 cm © Narelle Autio and Trent Parke. Image courtesy of the artists and Stills Gallery, Sydney

Colonial boating was much more colourful than suggested by the pictures, popular on yacht club walls, of the glorious white-winged yachts of wealthy owners and sailors. In fact, it had more in common with the ramshackle antics of the Northern Territory's infamous Henley-on-Todd Regatta (held on a dry riverbed) than with races for elite craft off Cowes in the United Kingdom. From the 1830s, colonial leaders assembled whatever boats and crews they could to shape a pageant for sailors, rowers, scullers and spectators alike.

Regattas

As the fledgling colonies developed, aquatic spectacles became a focus of community celebration and an assertion of growing mercantile confidence.

The Australia Day Regatta has been held on 26 January every year since 1837. Then known as the Anniversary Day Regatta, it celebrated the establishment of the British colony in New South Wales in 1788. Picnickers at harbour vantage points watched races between amateur and professional rowers, or between working craft and elite sailors in the few large yachts, while the cream of colonial society watched from the flagship, usually a visiting naval or important merchant vessel. The *Sydney Gazette* described the first regatta in 1837 as 'entirely devoted to pleasure', setting the pattern for Australia Days to come.

< J Henderson *Picnic at Lady Macquarie's Chair, Sydney N. S. Wales in 1852*, 1870s
Hand-coloured lithograph after oil painting by unknown artist, 47.5 x 68.5 (image)

> Charles Louis Napoléon d'Albert (1809–1886) *The Regatta Waltzes*, 1855
Sheet music, 34.4 x 25.7cm

The Hobart Regatta was inaugurated one year later, under the patronage of Governor John Franklin's wife, Lady Jane. Far more than a yacht race, it was held every year, usually in early December, to commemorate the anniversary of Abel Tasman's 'discovery' of the island in 1642. It hoped to demonstrate the unity and patronage of civil and military elites, promoted whaling and other free-settler enterprises, and even aimed to reduce the colony's convict stain.

The program reveals the commercial and leisure activities at the time. Professional watermen who carried people and goods across the waters raced the crews of the many visiting naval, whaling and trading ships and ketches, in gigs, pulling boats, skiffs and sculls. The spectators mixed more freely, representing a broad cross-section of society. A public holiday was declared and free beer and food dispensed to those who took part from the fledgling convict settlement. By the 1900s, the boat races were competing with other novelty

An assortment of trophies from the 19th and 20th centuries
Gifts from the Wright Family of Roma, Queensland through Donna and Ross Fraser & Lesley and Stanley Harrison; Francis Pinel, Judy Gifford, Carol and Gordon Billett, Faye Magner, Dr David Lark, Lady Desolie Hurley, Iain and Alex Murray

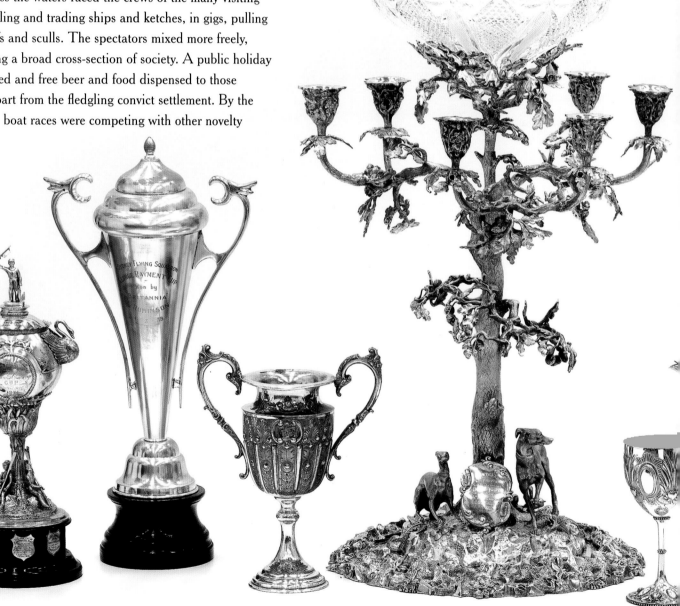

entertainments, including fancy costume parades, bearded ladies, greasy-pole fights and snake charmers.

The museum's collections feature many rare and exciting artefacts, which show these early colonial regattas as public celebrations and assertions of progress. There are also more humble artefacts showing the activities of smaller communities, where the regatta played an equally pivotal role as a sporting forum and source of community pride. Illustrated (on p. 199) are a rare piece of English piano sheet music entitled *The Regatta Waltzes*, published in Sydney with vignettes of local scenes in 1855, and (below) a variety of cups, trophies and other prizes awarded to regatta winners.

These prizes varied, and included highly crafted silver trophies, purses, amounts of money and, for the Intercolonial Sailing Carnival held from 1897 to 1899, a most idiosyncratic trophy made from the head of merino ram with silver detailing (below), offered by the John Walker Whisky company to the boat that won the event twice – the 22-footer *Effie*, owned by James McMurtrie.

Competition grew with the various colonies' development, with more boats, more races and more opportunities for the many clubs supporting aquatic sports. Rowing was especially strong in river communities, large and small.

Today, aquatic spectacles remain a focus for public celebrations on waterways around Australia – witness the annual New Year's Eve celebrations. Although no longer the feature event as it was in colonial times, the regatta remains one of many offerings in a smorgasbord of public entertainment. The former Anniversary Day Regatta is today known as the Australia Day Regatta and, evoking its spirit, local working craft feature on the day – the ubiquitous Sydney ferries race to huge public interest and enthusiasm.

Daina Fletcher

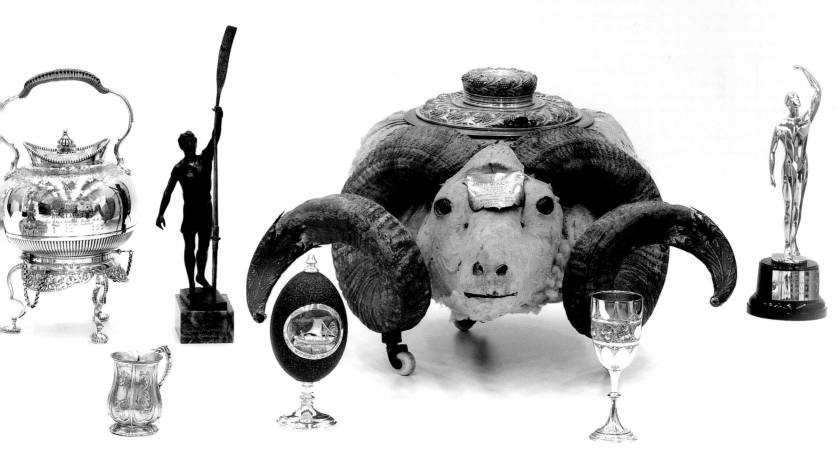

Colonial enterprise

In October 1888 a group gathered at Auckland docks to see Scottish boatbuilder Robert Logan's new 39-foot yacht loaded on board the SS *Nemesis* to sail for Melbourne, to take part in the Intercolonial Regatta to celebrate the centenary of British settlement in the colonies. *Akarana*, the Maori name for Auckland, featured a figurehead of a Maori on its bow and took with it New Zealand's honour and Logan's aspirations, with the boatbuilder and his skipper Jack Bell on board. Logan returned six months later, but it was a century before the plucky gaff cutter was back in New Zealand again.

Maori figurehead from *Akarana*, 1888, made into a domestic ornament 1890s Kauri, mahogany, paint, glass, 37.5 x 28.7 cm *Gift from Arthur and Nancye Goard*

Yacht Club's season. With a six-minute time allowance, they beat St Kilda's centre-boarders to the gold medal by 12 minutes, in light airs, without even hoisting a topsail.

But the Intercolonial Regatta yielded uneven results. On day one, 24 November, in still air, *Akarana* (by then the race favourite) beat its rivals in the 5–10 tonne class and claimed the £130 prize. On day two, in stronger winds, *Akarana* trailed the fleet behind many of the vessels it had beaten the previous day, providing one of the surprises of the regatta.

Among the small yachting fleets of the colonies every new yacht was eagerly reported, and especially so an intercolonial challenger racing under the burgee of the Auckland Yacht Club. The *Auckland Star* wished Logan well, describing the narrow, triple-skinned diagonal kauri-planked gaff-cutter as 'built on beautiful lines. She is of the deep-sinker type, and has a lead keel weighing five tons, while another one or two tons will be carried for additional ballast'.[1] The *Star* also reported that Logan hoped to sell *Akarana* for £500.

On Port Phillip Bay, Jack Bell sailed *Akarana* in trials in late October and early November, and they were then invited to compete in the gala opening of St Kilda

Logan took the yacht to Sydney for the Anniversary Day Regatta on 26 January 1889, and entered it in the second class race for yachts under 20 tonnes. *Akarana* won, despite losing three minutes after grounding off Fort Denison – earning Logan £20, three cases of Moët et Chandon champagne, and an even higher regard for *Akarana*'s performance and his own patriotism in sending a New Zealand challenger to the Australian centennial regattas.

Logan did indeed sell his yacht in Sydney, to a Royal Sydney Yacht Squadron sailor, chemist John Simpson Abraham, and *Akarana* became a feature of late-century events on Sydney Harbour. During the ensuing decades

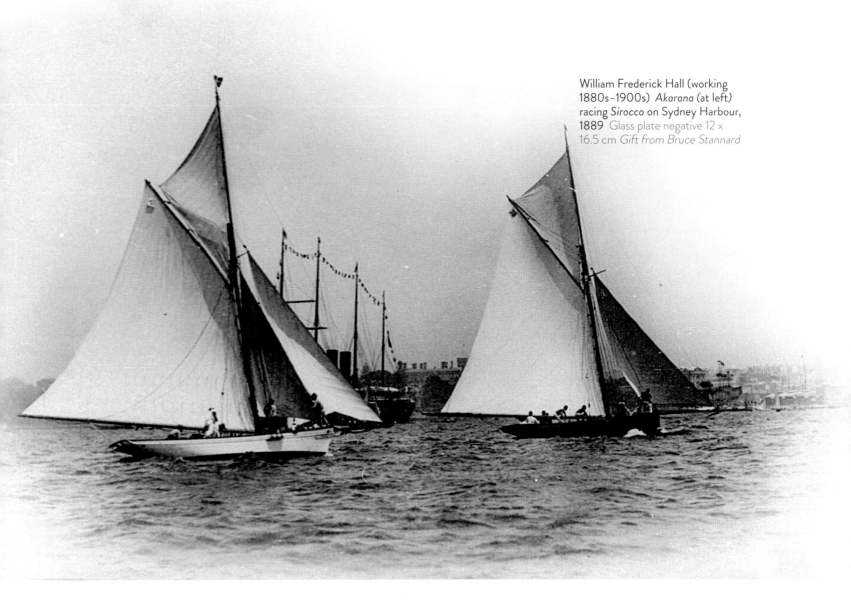

William Frederick Hall (working 1880s–1900s) *Akarana* (at left) racing *Sirocco* on Sydney Harbour, 1889 Glass plate negative 12 x 16.5 cm *Gift from Bruce Stannard*

the yacht passed through many owners, whose photographs show a life of pleasure, cruising on the harbour and Broken Bay, with parasols and picnics.

Akarana raced again in the 1940s in Sydney and, as expected for a yacht that survived two world wars and economic vagaries, underwent many modifications and permutations, including the souveniring of its Maori figurehead (subsequently located in a former owner's garage during a museum research program). Nonetheless, it was much loved.

In 1987 the New Zealand Government bought *Akarana*, intending to present it to Australia as a bicentennial gift from the government and people of New Zealand. So after 99 years, *Akarana* made its way across the Tasman to Auckland for restoration. For the bicentennial celebrations in Australia, the (then) Prime Minister of New Zealand, David Lange, presented *Akarana* to his Australian counterpart, Bob Hawke, on 20 August 1988 at the Australian National Maritime Museum site in Darling Harbour, three years before the museum's opening.

Akarana's speedy reconstruction in New Zealand allowed little time to research changes to its former configuration. The yacht was taken from the water in

1997–98 in a year-long project to return it as close as possible to its original keel design.

This work included reinstating its five-tonne lead keel, with adjustments to the spars and sails. *Akarana* now has greatly improved sailing performance, yet after 110 years it remains a fair-weather yacht. Today, the deep-keeled gaff cutter is testimony to its builder Robert Logan's adventurous spirit, and indeed to the enduring spirit of friendship and rivalry with our neighbours across the Tasman.

Daina Fletcher

> Builder's certificate for *Akarana*, October 1888 Paper, ink, 44.5 x 28.4 cm *Gift from John Beach (MBE)*

William Frederick Hall (working 1880s–1900s) *Akarana* sailing on Sydney Harbour, 1893 Glass plate negative, 16.5 x 21.5 cm *Gift from the Royal Sydney Yacht Squadron*

BUILDER'S CERTIFICATE.

Name of Vessel *Akarana*

Chasing the action on Sydney Harbour

It's a Saturday race day on Sydney Harbour in 1922, and the heavy timber skiffs are launched from working sheds dotted around the harbour foreshore. The crews assemble and hoist the huge sails to career down the harbour, eventually setting topsails and ringtails, tacking and gybing through a triangular course. They are chased by a little motorboat sporting a small flag on its bow, printed 'Hall Photo'. William Hall is there with his camera, intent on capturing the exciting antics.

William James Hall (1877–1951)
Miss Phyllis, 1930s Nitrate
negative, 12 x 16.5 cm *Transfer
from the Mitchell Library*

The Hall photographic studio played a vital role in the Sydney boating world from the 1880s, when it was established by William Frederick Hall, a fingerprint expert. His son, William James, took over the business in 1902, and went on to record the explosion of leisure craft on the harbour into the 20th century. Although neither man was a sailor, both developed a keen interest in boating, documenting the weekend sailors, their craft and their supporters on Sydney Harbour. Each Monday, Hall displayed photographs of weekend races in the window of his Hunter Street studio, advertising and selling his work to the sailors, boat owners, their family and friends. Yacht clubs, too, proudly displayed their champions on their walls.

Hall photographed all manner of boating and boats. The museum's collections number in the thousands, and the Hall studio's subjects include early craft, from rowing eights, fours and skiffs and naval cutters of the late century, to the first surf rescue boats, and the handful of glorious first-class

yachts and smaller second-class yachts of the Royal Sydney Yacht Squadron and the Royal Prince Alfred Yacht Club. Regattas also feature, with the large liner as flagship shown in a harbour crowded with vessels.

William James Hall photographed the action in a series, hoping for that magic image, hurriedly pressing the shutter as the boats raced or sailed past. Some of the images don't work, but some do. He captured the rise of motorboating as a gentlemen's sport, when engineers fired the inboard engine and goggle-clad drivers took the wheel. In one series, he did indeed capture a magic image when the exuberant crew on board the half-cabin cruiser *Miss Phyllis* heralded his arrival and that of the speedboat tied up alongside.

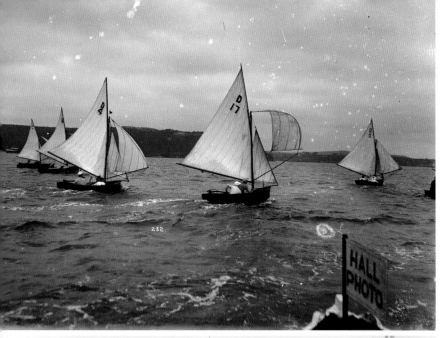

It is a very warm image, enhanced by information provided by studying other images from the same series in the collection, which show us that the two boats were motoring on the George's River, south of Sydney, and that the speedboat alongside is the *G-Whiz* and that it raced with the St George Motor Boat Club.

Similarly, the series of images of the 10-footer *Commonwealth* in the 1920s show the five crew clad in their rugby league jerseys careering down the western reaches of the harbour, with massive sail, topsail and ringtail variously set. The class echoed the larger 18-foot open boats, which the studio and especially William James Hall captured so well. They were classes that were, up to the 1930s, defined largely by hull length only.

Dramatic and colourful, they were great subjects for a photographer, but Hall also sought images of the sailors, and he was often able to get close chasing the crews in his little motorboat. Many of his images buzz with the excitement of the class. See the photograph of *Arakoon* (right) during the one day of the year when the big boats carried a woman crewmember: the Queen of the Harbour competition held to raise funds for charities. We see the crew hanging off the gunwale, backs bent down to the water. And we see the delighted female crewmember, standing out in her light sweater and beret.

Documenting the rise of the exciting open-boat racing was to become the Hall studio's signature work. As a collection, it provides a detailed record of the fortunes of these boats and their crews, from the huge 22-footers of the 1880s to the sport's boom time in the 1930s.

Daina Fletcher

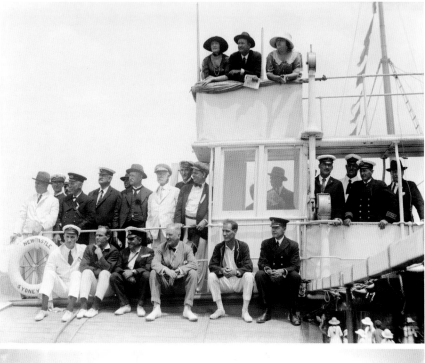

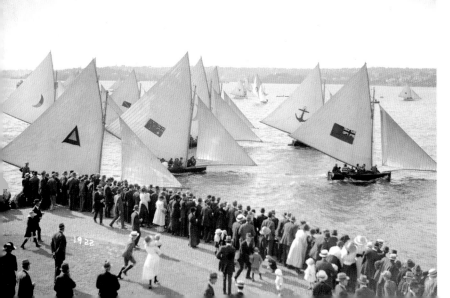

FROM TOP All photos by William James Hall (1877–1951) Hall's motor boat chasing 12-foot cadet dinghies, Sydney Harbour, 1920s; Spectators watching a sailing race aboard the ferry *Newcastle*, 1920–25; Spectators viewing the start of an 18-footer race off Clark Island, 1920s All glass plate negatives, 12 x 16.5 cm, *All: transferred from the Mitchell Library*

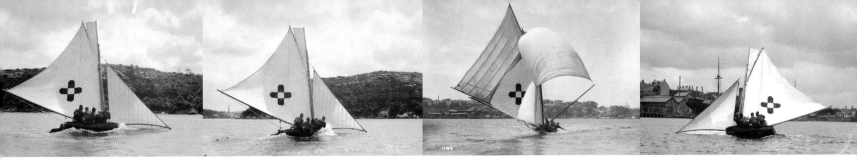

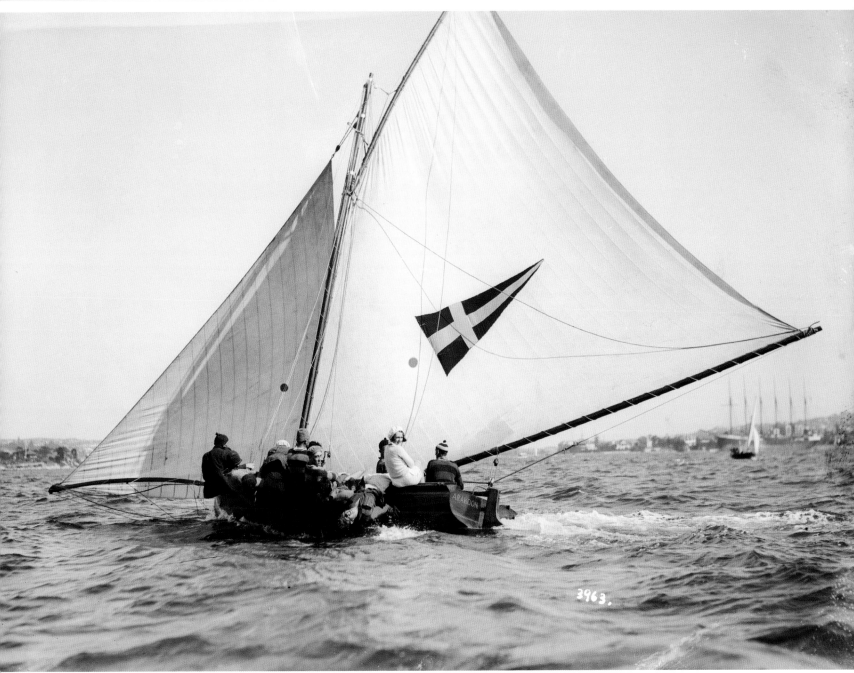

∧ William James Hall (1877–1951)
Arakoon in the *Queen of the Harbour* yacht race, 1931 Glass plate negative 12 x 16.5 cm *Gift from Bruce Stannard*

⋀ William James Hall (1877–1951) Following the 10-footer *Commonwealth* on Sydney Harbour, 1920s Four glass plate negatives, all 12 x 16.5 cm *Gift from Bruce Stannard*

Model yachting has captivated sailors and would-be sailors for ages, and the craft have become works of art in their own right, home built with obsessive and often lavish attention to detail. Their owners showed them off as though they were a new family member, then raced them hard against fellow competitors.

Model yachts

The museum has collected a number of typically Australian examples, spanning the local classes from the early 1900s through to the present internationally raced yachts. Covering hand-carved wood to hi-tech composite fibreglass construction, the collection also tracks the changes from hands-on, on-the-water involvement to onshore radio control.

In Sydney, the ponds at Centennial Park were a popular, enclosed stretch of water for model yacht sailors from the early 1900s. Congregating at one end of the pond, on the starter's orders the owners released their boats together, cheering them on as they sailed toward the opposite shore.

Around the same time, model skiffs began racing on open water, creating a new community event. The skipper and another rower, in a typical 10- or 12-foot clinker dinghy, tracked the model as it raced, coming alongside to adjust the rig or tack the boat. These dinghy teams often comprised brothers, fathers, sons, cousins and nephews, and sometimes even their girlfriends. Ferries carried spectators, crowds lined the shore, and bookmakers circulated to take advantage of Australians' desire to bet. The models often raced in large fleets, even out on the main harbour, up to the mid-1950s.

Building and sailing a skiff was done by eye and feel, based on experience handed on by each generation. Hulls took form in the evening after a day's work, and the model boatyard could be a kitchen table as easily as a shipwright's bench. Builders conjured fittings from offcuts of metal, and sails were scrounged from leftover materials. Getting the rig proportions right and the trim correct each day was an art form, but balanced correctly the unmanned craft sailed true and fast, even under spinnaker.

∧ Henry 'Waltho' Mobberley Model of two-footer *Lily*, with trophies, 1920s–1930s Cedar, brass, 63.2 x 14.5 cm Photo: Jenni Carter, ANMM *Gift from Ron Mobberley*

> FROM TOP George McGoogan (1922–2009) with *Joan* in Balmain; Max Howard prepares his model *Comet* before the race; Janice Mahoney holding the hull of Max Howard's model yacht *Comet*. All: Photographer unknown

The early model skiffs were carved from solid Queensland red cedar, a light timber used for planking the real skiffs, while later models were planked up on frames, also like the real skiffs. The large two-footer *Lily* (left) was home-made at Redfern during the Depression era. Henry 'Waltho' Mobberley carved *Lily* out of a solid block of cedar, and made the wooden spars for the two rigs it used to suit different conditions. Henry's wife, Rose, made the sails and a bag for carrying the rigs. *Lily* was a successful skiff for Mobberley, winning many trophies.

As the model skiffs faded from the harbour in the 1950s, model yachting in other classes maintained a strong following on lakes and other more sheltered waters. It was an international sport, one of the most popular classes being the American Marblehead boats. *Snoopy*, built by John Pollnitz in South Australia in 1970, is typical of boats built in this era. Because fittings were not commercially available then, Pollnitz meticulously fabricated everything, including the gears and other parts of the vane steering assembly – an example of the skill and ingenuity of the craftsman that remained on show with the new classes.

The mid-1970s saw the introduction of radio control for steering and sail trim, and then composite construction. Builders adopted on a micro scale the exotic high-strength materials, such as carbon fibre and Kevlar, which now dominate contemporary yacht building. Engineer Bob Sheddon built his international 10-rater, *Toad*, in 1997. Even though plans, boats and fittings had become freely available, Sheddon, like other dedicated model yacht builders, still designed and built the carbon fibre hull and all its fittings himself. It was a championship-winning combination in 1997 and 1998, and is a wonderful expression of Sheddon's devotion to the sport. Model yachting continues strongly in the 21st century, adopting the latest big-boat trends, such as canting keels, and shows no signs of ever declining.

David Payne

> FROM TOP *Vera* makes a good start on the first leg; *Ivy*'s skipper and crew row hard to keep up with the skiff; K Haydon tacking his skiff *Dynamic* by holding the boom tip; M Phillips reaches under *Fay* to move the keel

It's the period between the wars during the years of the Great Depression. On a typical London winter evening, you're walking past Australia House on the Strand or running through Victoria Station to catch the last train home. Your eye is drawn to the smiling suntanned beach girl splashing in the surf, to the magnetic yellow and blue geometry of surf lifesavers on parade or to the bright exotica of tropical fish in a blossoming colour field of coral. Australia beckons.

Australia for sun and surf

These posters – exhorting visitors to Australia as travellers, tourists, immigrants, investor settlers and industrialists – were produced by the Australian National Travel Association (ANTA), established in 1929 to promote Australia internationally. The ANTA employed a stable of brilliant graphic artists, many of whom were European immigrants versed in modernist design aesthetics and commercial advertising art practice (learned at Melbourne's Art Training Institute). They included Douglas Annand, Gert Sellheim, Eileen Mayo, Percy Trompf and James Northfield.

These artists designed striking lithographs of geometric form in dazzlingly bright blocks of colour, using a lexicon of symbols of wide, sun-drenched beaches and vast grazing country, dotted with the exotic eucalypt. AUSTRALIA, they cried, was a land of visceral and spatial physicality – of large sunny skies over even larger landscapes. It was a place of freedom and fun, which also embodied more familiar characteristics of stoicism and a pioneering spirit – idealised images certainly, and now mythologised – but at the time, most certainly tempting.

By 1936, with an annual budget of £20,000, the ANTA had distributed more than 200,000 posters, 87,000 photographs and 3.5 million booklets and folders, and secured 3,000 permanent poster sites in travel agents, embassies, consular offices, shipping and airline companies, and even in the windows of leading department stores. It had mailed publicity material to 200 army messes in India, and brought writers to Australia from Europe and North America. It also organised promotional events in Australia and around the world, including representation at fairs and festivals.

v Gert Sellheim (1901–1970)
Sea & Sunshine Go By Train!
1930s Colour process lithograph, 100.6 x 63 cm, Courtesy Nik Sellheim and Josef Lebovic Gallery Sydney

> Percival Trompf (1902–1964)
Tropical North Queensland, Australia, c1930 Colour lithograph, 108.3 x 74 cm, Courtesy Percy Trompf Artistic Trust and Josef Lebovic Gallery Sydney

Tropical North Queensland (April to Sept.)

Australia

PARTICULARS AT SHIPPING AND TRAVEL AGENCIES

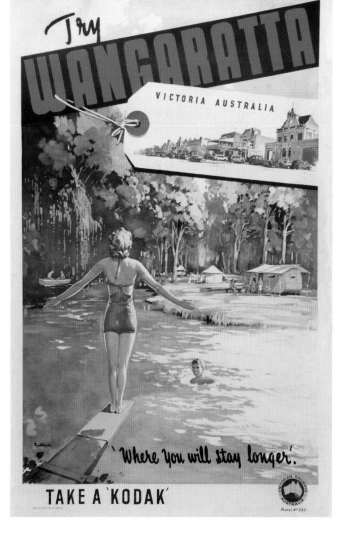

James Northfield (1887–1973)
Try Wangaratta Victoria Australia,
1949 Colour process lithograph,
109.3 x 71.1 cm © James Northfield
Heritage Art Trust, reproduced with
permission

The ANTA shaped the work of the local state tourism agencies, working with railway companies and tourist agencies to better promote local tourism and leisure sites for the national market. With that mandate, it produced the magazine *Walkabout* from 1934 to 1974, and more posters, booklets and brochures as a powerful mouthpiece for 'Australianness'.

All this catalysed a new national image – an outward-looking consciousness, based on marketing unique Australian forms and attributes.

The prominence of beach, coastal and river culture in this poster imagery is of interest to the museum. The posters promoted a national image that drew fresh emblems from liberal beach, bay and swimming cultures, a unique lifesaving culture specialised in the surf, national and international sporting success at swimming and, later, surfing and the rise of the Great Barrier Reef as an international tourist site.

After World War II, the ANTA eventually morphed into the Australian Tourist Commission, taking on a broader role of organising events as well as producing marketing material. In the 1950s, its *Walkabout* editorial declared that it would 'underline the natural attractions of Australia, its climate, its outdoors, its plenty and its opportunities for people to settle in a more or less British atmosphere and way of life'. This was the time of then Immigration Minister Ben Chifley's 'populate or perish' maxim.

Daina Fletcher

Since the late 19th century, the swimsuit has courted controversy, becoming synonymous with sex and sexuality – a modern-day scandal suit. It has pushed the boundaries of what is acceptable for men, women and children to wear in public. Popularised by movie sirens, aquatic stars, bathing beauties and athletes alike, the swimsuit – whether for fashion or sport – was the garment that framed and revealed the body to perfection.

Evolution of the swimsuit

The museum has an extensive collection of swimwear and accessories from the 19th to the 21st centuries, an archive of original swimwear designs and samples, and patents, catalogues, swatch books and advertising brochures focusing on swimwear fashion from the 1920s to the 40s.

Women's swimwear has developed from the bulky bathing dresses of the 1890s and unisex swimsuits of the 1920s to the revealing styles of the 1970s and 80s, designed to emphasise a lean, fit, sculpted body, and paving the way for the luxury ranges of the 1990s. From the mid-20th century, gravity-defying designs were made possible by innovations in textile technology. Into the 21st century, the swimsuit continues to embody fashion and function, whether as a specialised racing suit or a catwalk statement.

Australian swimmers and designers have taken a leading role in the development of the modern swimsuit. Annette Kellerman was pivotal in changing the style of swimsuit worn by women in the early 1900s. As a professional swimmer and vaudeville and film star, she promoted active glamour and physical fitness for women, and in 1907 dared to wear a man's one-piece unitard swimsuit with her legs uncovered in public. The ensuing publicity saw a shift in public opinion, and cumbersome bathing dresses were replaced by this style of modern swimsuit that allowed greater freedom of movement in the water. Kellerman also designed and promoted a range of women's swimwear made by Asbury Mills in the United States.

In 1929 the MacRae Knitting Mills of Sydney diversified into swimwear and launched their new line under the trade name 'Speedo'. The now-famous brand began with one-piece athletic swimsuits for men and women in a range of solid-coloured fabrics for competitive and recreational swimming. Speedo has supplied costumes for Australian Olympic swimming squads since 1936 and also supplied swimsuits and accessories to Australian

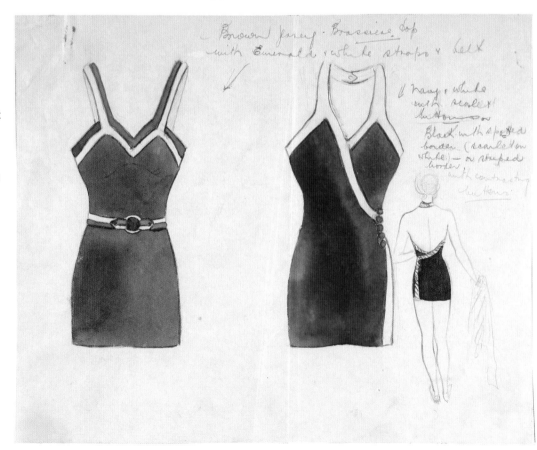

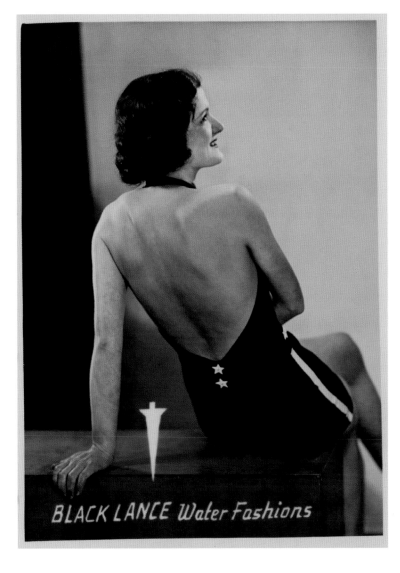

Commonwealth Games teams. Its controversial LZ Racer Fastskin debuted in competition at the 2008 Beijing Olympic Games. The suit fitted the body so tightly it could take up to 15 minutes to put on. But when it was found that 94 per cent of swimmers who won gold medals at the Beijing Games had competed in the LZ Racer, questions were raised about its performance-enhancing qualities. It has since been banned from competition.

A less well-known Australian brand, Black Lance, operated in Melbourne in the 1930s. It offered stylish swimwear ranges for men and women, inspired by the latest fashions from Europe and the United States. The brand's slogan – 'as modern as the moment after midnight' – typified the idea of the modern swimsuit as a fashion statement, and appeared in newspaper and magazine advertisements. Peter O'Sullivan, head designer, was the first Australian to successfully design and manufacture swimwear for export to the United States. For women, he designed classic maillots with elegant lines, plunging backs and cross straps. And for men, he designed a swimsuit with a detachable top that could be unbuttoned to create swimming trunks, and reattached when required for modesty – similar to the Jantzen 'Topper' with its detachable zipped top, introduced in 1932. O'Sullivan's later design also allowed the wearer to go bare-chested, and men could stop rolling down the tops of their one-piece swimsuits to achieve an even tan.

Penny Cuthbert

< Peter O'Sullivan (1904–1977) Hand-coloured design for women's swimwear, 1930s
Graphite pencil, watercolour paints, 20.5 x 25.5 cm © Estate of the artist, reproduced with permission *Gift from Dale O'Sullivan*

∧ Catalogue photograph for Black Lance Water Fashions, 1930s Silver gelatin print, 21 x 17.5 cm *Gift from Dale O'Sullivan*

Ashbury Mills (USA) Manufacturer's label from Annette Kellermann brand swimsuit, 1910–20s

Jantzen (England) Men's Topper swimsuit with detachable top, 1930s
Wool, 61 x 40 cm

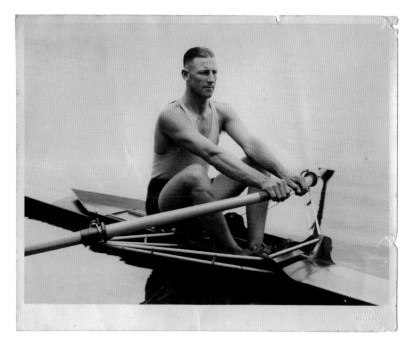

A single rowing scull formerly owned and used by Pearce is now a highlight of the museum's rowing collection. One of four designed and built by A & H Green of Abbotsford, Sydney, and known to have been used by Pearce, it was built in about 1930, and is a typical single racing scull of the period, with a varnished wooden double-ended hull, canvas deck and fixed fin under the hull for directional control. A wooden sliding seat runs on brass wheels and wooden tracks. The wooden foot stretchers are fitted with leather uppers, laces in one side and brass heel cups.

Henry Hauenstein (1881–1940) was a member of Leichhardt Rowing Club and the first eight-oared representative to row in state crews. He was selected for the Australian Men's Eight, who memorably competed at the Royal Henley

Oarsome champions

Australians have claimed world championships in sculling and rowing since the 1880s, when rowing was one of the most popular sports in Britain and its colonies. Olympic successes followed, and rowers have become household names. During the Olympic single sculls final in 1928, Australian rower Bobby Pearce (above) allegedly slowed down for a brood of ducklings blocking his lane – a gesture that endeared him to the children of Amsterdam and showed the world his grace under pressure.

Henry Robert 'Bobby' Pearce went on to win Australia's first rowing Olympic gold medal at the 1928 Amsterdam Olympic Games in a world record time. Born and raised in Sydney, Pearce is regarded as the greatest sculler, amateur or professional, before 1939. He is the only sculler to have won the single sculls event at the Empire Games, the Diamond Sculls at Royal Henley Regatta and the Olympic Games. In 1932 he also became the first Australian to win successive gold medals in the same event, after his victory at the Los Angeles Olympics.

Regatta in July 1912, beating the British Olympic team, 'Leander', in the Grand Challenge Cup before the king and queen and a crowd of 150,000. The popular Australian rowers were described in the British press as 'well-tanned by the sun and fit as the proverbial fiddle'.

Only a few weeks after their Henley triumph, the Australians lost to Leander in a much anticipated rematch in the final of the Men's Eights at the Stockholm Olympic Games, with Hauenstein rowing as (5). Both teams had substituted crew members after Henley, a tactic some claimed cost the Australians the Olympic final. While missing out on Olympic medals, Hauenstein and his fellow crew received Olympic merit diplomas to acknowledge their efforts in the final.

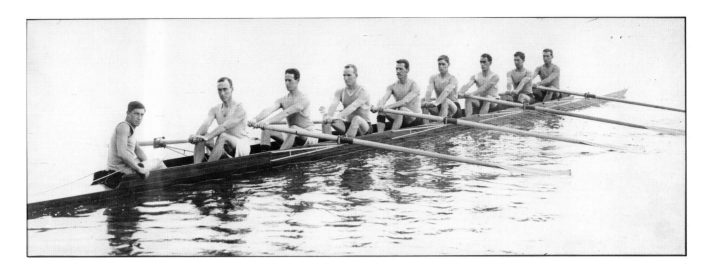

While Australian men have been competing in Olympic rowing since 1912, it took until 1976 for women to be invited to compete in Olympic competition, and another four years before Australia sent a women's rowing team to the Olympic Games. In 1996 Kate Slatter and Megan Still won Australia's first gold medals in women's rowing.

The Australian rowing crew nicknamed the Oarsome Foursome™ won their first gold medal at the 1992 Barcelona Olympics in the ultra-lightweight rowing shell *Australian Olympic Committee*, now in the National Maritime Collection. Made in Germany by Empacher in 1991, it was crewed by James Tomkins (stroke), Nick Green (3), Mike McKay

(2) and Andrew Cooper (bow). These four rowers symbolised Australia's domination of the sport in the early 1990s, and were also a part of a growing trend to market elite athletes as high-profile commercial brands in their own right.

Penny Cuthbert

<< Milton Kent Studio Photograph of rower Bobby Pearce seated in a single scull, 1920s–1930s Silver gelatin print, 20 x 25 cm *Gift from Christine Stewart*

∧ William James Hall (1877– 1951) Photograph of Coxed Men's Eight training with Henry Hauenstein rowing as (5), 1910–11 Silver gelatin print, 43.4 x 82 cm

∧ Single rowing scull formerly owned and used by Henry Robert 'Bobby' Pearce, c 1930 Rowing scull, 780 x 26 cm (length x breadth)

> Olle Hjortzberg, designer (1872–1959) Olympic Merit diploma awarded to Henry Hauenstein for representing Australasia in rowing at the Stockholm Olympic Games, 1912 Applied gold, ink, paper, 46.8 x 29.3 cm (image), 71.2 x 48.4 x 2.4 cm (overall)

The Sydney Harbour 18-foot skiffs

No quarter is given from the moment the gun goes. Trim, speed and tactics are constantly monitored, as the boat powers toward the rounding mark. Then it's helter skelter under spinnaker, driving downwind, playing the wind angles and always on the edge of control.

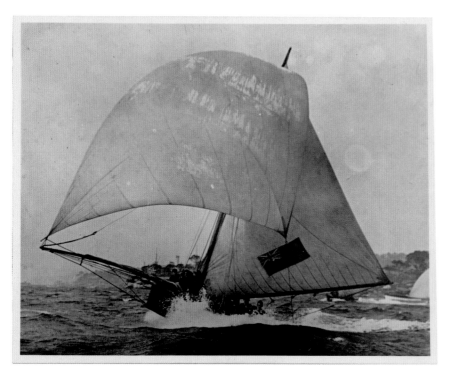

< Lee Presdee Untitled (*Britannia* racing downwind on Sydney Harbour), 1930s–1940s Silver gelatin photograph on fibre-based paper, 15.8 x 20 cm *Gift from Peter Knight*

Bruce Farr, designer *KB* – plan of mold and shell (hull) construction (left) and intermediate rig sail plan (right) by Bruce Farr, 1972 Paper, ink © B. K. FARR, reproduced with permission *Gift from David Porter*

The Sydney Harbour 18-foot skiff class has always featured spectacular racing, clouds of sail and athletic crew work. The internationally recognised class became a major weekend spectator sport, but intrigue, grandstanding and creative development all steered its destiny. Appropriately the museum's collection features examples of these icons of Australian sailing.

Britannia, from 1919, is straight from the class origins. It is the working man's open boat: built on tradition, crewed by Balmain brethren wearing the Balmain Rugby League Club's colours, and sailed with no limits. The varnished cedar, seam-batten planked hull was the work of a craftsman, with the builder's art shaping the hull. Skipper 'Wee Georgie' Robinson was a shipwright with an eye for the flow of the water and feel of the boat as he hand-carved his model. Small in stature, Wee Georgie worked on Cockatoo Island, sailed in summer and played football in winter. *Britannia* raced for more than 20 years, winning many major championship events on the harbour. Between the wars, builders dared to break with tradition, building narrower boats with fewer crew, causing a major split in the class. *Britannia* retired a champion after World War II, and

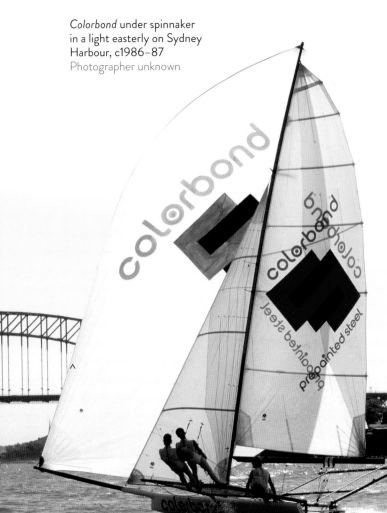

Colorbond under spinnaker
in a light easterly on Sydney
Harbour, c1986–87
Photographer unknown

having upheld the class's traditions, it became the club starting boat, fitted with an engine and small cabin.

The revolutionary *Taipan*, from 1959 (see also pp. 226–27), brought the class into the world of high performance, and *KB* was a direct development from *Taipan*'s concept. Advertising a popular brew of the time, *KB* reflects the class in the 1970s, when sponsorship became entrenched. Its yellow hull matched its bright-yellow spinnakers and the *KB* sail logo. This was also a time of refined design development, and *KB*'s New Zealand designer, Bruce Farr, was at the forefront. Farr was a champion sailor and self-taught designer whose precisely drawn plans carefully created *KB*'s shape and engineered its plywood structure. Each year Farr made gradual improvements, often customising features or proportions to suit the crew. Dave Porter, another class legend, skippered *KB* as it raced at the head of the Sydney fleet. *KB*'s hull also featured small extensions of the deck planking beyond the gunwale, increasing beam and making the crew's weight on their trapezes much more effective. This was soon a common feature on all 18-foot skiffs.

Colorbond turned heads in the mid-1980s, with its minimalist styling and high-tech construction. But it also mirrors a decade when the prime features of the 1970s – beam and sponsorship – grew way out of proportion. In the late 1970s, aluminium racks extending well beyond the hull pushed the crew further away from the boat, and the skiffs soon became wider than their length, with a massive increase in stability. This allowed huge rigs, with asymmetric spinnakers and unrivalled speed, all at a huge cost. The boats that dominated the 1980s were backed by budgets from generous sponsors. *Colorbond* was sponsored by BHP, but designed and built in the US with the latest materials and methods, then shipped to Australia. There was even a paid hand as support crew to maintain the boat. The bubble burst as the 80s drew to a close, and the class adopted restricted, manageable proportions on limited budgets, leading to new growth in the 1990s and a strong class racing in the 2000s.

David Payne

Speedboats

The public embraced speedboats when the first examples appeared on the major harbours in the first decade of the 1900s. Skimming the waves with a deep, addictive drone as the slower motor launches putt-putted along in their wake, speedboats developed into a significant form of recreational boat during the 1920s. They took hold in great numbers during the booming 1950s, due to a combination of low-cost construction, outboard motors and durable, attractive craft. The museum collection covers the early speedboating days of fun and leisure and the craft's evolution into the power and class of the popular ski boats.

⩓ *Ski-Bye* turned heads when towed by the O'Neil family's imported black Packard, c1950s Photo reproduced courtesy Garry O'Neil

⌃ Belmont Dorsett Caribbean Fifteen-foot skiboat *Matilda*, 1961 Fibreglass, 450 x 183 cm (length x width)

> A G Rymill at the wheel of Griffith Cup winner *Tortoise*, 1926 Cover, *The Australian Motor Boat & Yachting Monthly*, May 1, 1926, 30 x 21 cm

Mystery is straight from the classic Australian do-it-yourself school, and was made in the Depression-era 1930s. Builder Jim Laing knew what he wanted: one of those sleek American-style craft he'd seen in the magazines.

In that period of desperation, Laing could only aspire to owning such a luxury item if he scrounged the materials and used his own building know-how. Planked in New Zealand kauri, *Mystery*'s simple shape and construction lack the finer detail and class of the original types, but the craft worked well and the Laing family went boating with the Port Hacking Rowing and Motor Boat Club, south of Sydney.

In the 1950s, as Australia left the dark postwar days, successful businessman Les O'Neil wanted a top-of-the-line speedboat as a ski boat. He could easily afford to commission it from craftsman Harry Hammond, who

maintained the highest standards of workmanship with his small firm at Brookvale, Sydney. Hammond only made boats to order, giving each his personal attention throughout its construction.

O'Neil's boat, *Ski-Bye*, is a classic Australian clinker-style displacement hull speedboat. The type had its origins in craft first built just before World War II. After the war, they developed quickly as race boats, with production-line assembly (at yards like Lewis Bros) making the craft available to the public. Meanwhile, Hammond Craft could specialise in producing top-quality custom designs one at a time, with a steady stream of orders. Their long overhanging stem, tumblehome stern and lines accentuated by the clinker plank laps made them attractive and unique. Built in local timbers, boats such as *Ski-Bye* matched the more expensive European and American craft for style and quality.

Production craft finally dominated the market when fibreglass construction was introduced in the early 1960s. The outboard-powered, fibreglass ski boat *Matilda* represents the beginning of the high-volume mass production of identical craft using precision tooling specific to individual models. Its stylish, low-maintenance hull was sold fully fitted out and available in a range of bright colours. This combination of features made recreational boating more affordable, practical and desirable for the public. *Australian Water Sportsman* published a boat test in April 1961 commenting, '… quick onto the plane, soft entry through a choppy sea and nimble handling had us convinced in a very short time that HERE was an acquisition to the runabout market'.

With a powerful outboard motor, speedboats such as *Matilda* made water-skiing accessible for the public, and it became a favourite pastime on rivers, lakes and enclosed coastal waters around the country. *Matilda*'s owners kept it on a trailer with easy access to Botany Bay in New South Wales, and the boat remained with the same family for more than 25 years.

David Payne

MAY 1. 1926. Registered at the General Post Office, Sydney, for transmission by post as a Newspaper

The Australian
MOTOR BOAT & YACHTING
Monthly

MAY 1. 1926.
PRICE 1/-

A blond, muscular, brave and bronzed man is the image of the lifesaver that dominated the public imagination in Australia between the world wars. It reflected the military origins of surf lifesaving and its codes of self-discipline and sacrifice. This ideal was reinforced by a volunteer rescue service, the military precision of rescue drills, the pageantry of march-past parades and the tough competition of surf carnivals. March-past costumes, surf-lifesaving club banners, medals, carnival programs, surfboats and rescue and resuscitation equipment are all part of the National Maritime Collection.

∨ Yamba Surf Life Saving reel, 1931–32 Metal, nylon, paint, wood, canvas, 82 x 64.9 x 148.5 cm (overall) *Gift from Yamba Surf Life Saving Club*

∧ Members of the Neptune Royal Life Saving Club, Gold Coast, Queensland, 1928. Photographer unknown. Reproduced courtesy Phyllis Wells, Neptune Royal Life Saving Club

Australians took to the surf in increasing numbers from the early 1900s, when swimming became more popular and daylight bathing was liberalised. But the often dangerous surf conditions caused an increase in drownings and the need for safety in the surf.

The still-water rescue and resuscitation techniques developed by the Royal Life Saving Society of Australia in the early 1900s were adapted to surf conditions by newly formed surf-bathing clubs. In 1907, the Surf Bathers Association of New South Wales was formed to regulate safety on the beaches and in the surf. By 1922 a National Association of Surf Clubs was formed, with Victoria joining in 1947 and South Australia in 1956.

By the 1930s, the lifesaver featured on posters commissioned by the Australian National Travel Association promoting Australia as a desirable travel destination. Part of the challenge at this time was a shift in attitude towards the participation of women in lifesaving. The Royal Life Saving Society in Queensland and other states welcomed women's involvement in carnivals, march-pasts, learned and applied resuscitation and, where needed, rescues – but not officially, as patrols and rescues on surf beaches were done by men.

As the surf-lifesaving movement gained jurisdiction over surf beaches, women became marginalised. During World War II, some clubs remained open only because women kept them going, but in the postwar years the gender bias returned. The Neptune Ladies Life Saving Club, formed in 1928, was affiliated with the Royal Life Saving Society. Queensland's first women's lifesaving club was part of a strategy to attract more women into the Royal Life Saving Society.

< Manly Surf Life-Saving Club commemorative plaque, 1914. The watercolour painting shows Fairy Bower beach, Manly. The inscription reads: 'In humble appreciation of a brave action in saving Mrs White from drowning in heavy surf at Manly 9th September 1914 from Arthur N White Manly 29th September 1914 to Mr Tom Gunning Manly.' Metal, watercolour on paper, wood, 16.5 x 13 x 2.5 cm *Gift from Surf Life Saving Association of Australia*

> Gert Sellheim (1901–1970), *Australia Surf Club*, c1936 Poster, colour lithograph, 102.2 x 63 cm, Courtesy Nik Sellheim and Josef Lebovic Gallery Sydney

Between the 1920s and 50s surf carnivals became an important part of surf lifesaving and Australian beach culture. They opened with a ceremonial march-past parade of competing teams wearing swimsuits in club colours and carrying club pennants and surf reels. Carnival events included surf races, alarm reel (belt race), surf relay (surf teams), rescue and resuscitation, as well as novelty events.

The surf reel has been a key element of surf rescue and surf carnivals for more than 70 years. Originally called an alarm reel, it was invented by John Bond, Lyster Orsmby and Percy Flynn of the Bondi Surf Bathers Life Saving Club and made by Olding and Parker, coach builders in Paddington, Sydney. It was first used on Bondi Beach on 23 March 1907. This innovative device allowed a lifesaver, known as a 'beltman', to reach a swimmer in distress; lifesavers on the beach then pulled them back to safety. In 1911 the Royal Life Saving Society adopted the surf reel for use by beach clubs.

While the design of surf reels remained consistent, by the late 1950s timber components were being replaced with metal to make the reels lighter and more durable. Beltmen originally wore cork belts, but the cork's buoyancy was a hindrance when swimming through breaking surf. By 1945 cork belts were replaced by a flat canvas belt, but a major safety drawback remained: how to quickly remove the belt underwater if a line was snagged. After several lifesavers drowned, pin release mechanisms, known as Ross safety belts, were developed and became compulsory in the 1950s.

The surf reel, line and belt equipment was regarded as too heavy for women to use in surf rescue, and they were prohibited from officially joining surf patrols until 1980, when inflatable rescue boats (IRBs) replaced the traditional surfboats for patrol work and the reel, line and belt were gradually phased out, vanishing by 1994. Today surf reels are still an important symbol for surf-lifesaving clubs.

Penny Cuthbert

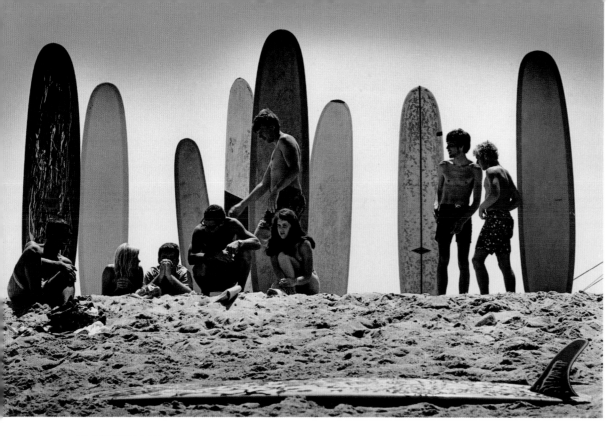

Surfing

Surfing is a transformative and immersive experience,
moving at speed on a breaking wave where rider, board and
wave are in a state of balance and harmony. It originated in
pre-colonial Hawaii as *he'e nalu* (wave sliding) and then
spread across the Pacific to Australia and California in the
early 20th century. Today, for many, surfing is an integral
part of going to the beach.

The thrill, energy and appeal of surfing reached a wider
public through film, music, multimedia, art, language,
fashion and writing. This has helped surfing transcend
being labelled simply as a sport, art, lifestyle or industry.
It encompasses all these facets in what is now a vibrant
global culture.

In the late 19th century, 'surfing' referred to
bodysurfing and swimming in the surf. Bodysurfing
enabled swimmers to move past the threshold of the
breakers and is believed to have been introduced to

Australia by Tommy Tanna, a Pacific islander who taught the locals at Manly in the 1890s. From the 1920s, bodysurfers used handboards to hold a wave longer and to keep their head up throughout the 'shoot'.

Stand-up board riding was popularised in Australia by visiting Hawaiian Olympic swimmer Duke Kahanamoku, who gave demonstrations on a heavy *alaia* timber board at Freshwater Beach and Cronulla, Sydney, over the summer of 1914–15. Before the 20th century, thin, round-nosed and square tailed *alaia* surfboards were used by commoners and royalty in Hawaii. With developments in design and construction methods throughout the 20th century, surfboards became shorter, lighter and easier to turn across the face of a wave.

In recent years Australian artists have drawn on the popularity of surfing to explore emerging tensions, bringing into question the ideal of the beach as a democratic space and a site of innocent fun and pleasure. James Dodd and Phillip George have decorated surfboards to examine the stereotypes and notions of identity associated with the Australian beach. While Dodd's surfboard, with its tattoo-like decoration, references the 'Bra Boys' brotherhood and their aggressive brand of Maroubra localism, George's *Eden* surfboard is a response to the Cronulla race riots of December 2005. These events sparked a backlash against Muslims at Cronulla Beach. By combining the familiar surfboard with Muslim iconography George crosses a border between the familiar and unfamiliar, the local and the foreign, and between the secular and the fear of Islam.

Penny Cuthbert

Each July in Australia's tropical northern capital, Darwin, all manner of whimsical and ingenious craft made of brightly coloured drink cans race to raise money for charity. They provide fun for the local population and an outrageous spectacle for visitors. The Beer Can Regatta is an event that has flirted with Darwin's hard-drinking, larrikin reputation. It's emblematic of both the frontier life of Australia's north and the generous spirit of its community.

The Beer Can Regatta

This beer-can sailing boat (right), or 'tinny', was designed and built by Beer Can Regatta founder and long-time Darwin resident, Lutz Frankenfeld. Thirsty members of Dinah Beach Yacht Club supplied more than 2,000 cans to the designer's specifications: Victoria Bitter and XXXX Bitter, to dress the boat in Australia's sporting colours of green and gold. Following the regatta's 'canstruction' rules, the empty cans were washed, taped together end-to-end to cover the ring-pull holes, and then fixed to a specially designed aluminium frame.

The boat, more than four metres long, has spars and oars of bamboo and features a papier-mâché figurehead of a lion to pay homage to the service club that sponsors the regatta. With its bow in the style of a Viking longboat, a stern alleged to be 'Greek galleon-looking' and a distinctly South-East Asian lateen rig, Frankenfeld says the boat is as multicultural as the community in Australia's Northern Territory.

Lutz Frankenfeld established the regatta in a spirit of fun in June 1974, 'to put Darwin on the tourist map' and to help clean up the cans that littered the city. The event came into its own and captivated the local population's spirit the following year, after Cyclone Tracy had devastated Darwin

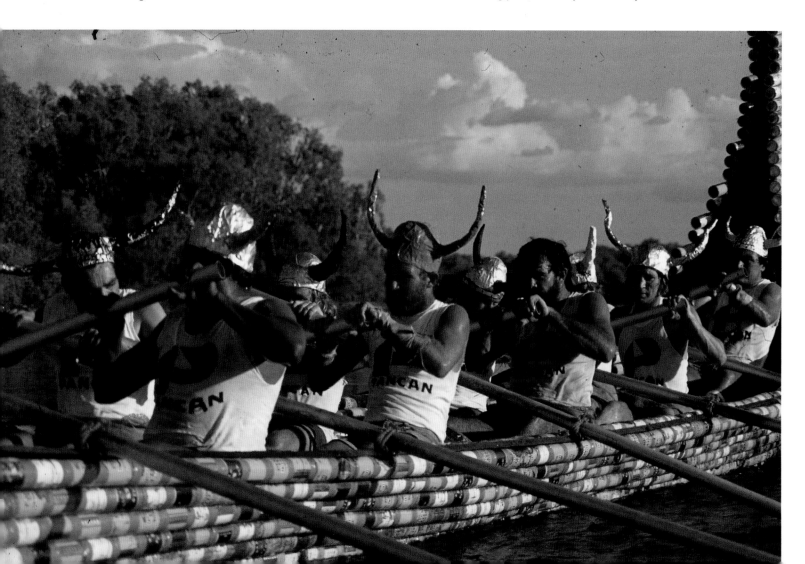

on Christmas Eve 1974. The huge influx of construction workers and engineers rebuilding Darwin drank a lot of beer in the tropical climate. The 1975 Beer Can Regatta recycled the cans, raised people's spirits and raised money for local charities as well.

To Darwin's surprise, the knockabout event attracted worldwide attention as it grew in the 1970s and 80s. It became pivotal in the campaign to attract tourists back to Darwin. In its early years the event would attract 30,000 people, when Darwin's population was not that much larger. All the schools were involved, and there were dozens of boats competing.

Frankenfeld handed over event organisation to the Darwin Lions Club in 1977. The event is promoted and sponsored by local business and community groups, from Apex to the armed forces, and from schools to supermarkets. All vessels are made and raced according to strict rules.

In 1980 the Beer Can Regatta attracted 66 boats of all shapes and sizes, from across Australia and other parts of the world. In the 1990s the event was recast as a broader beach festival, with a brief name change to 'On the Beach' when civic leaders were keen to downplay Darwin's image as a haven for hard drinkers.

Renamed the Lions Club Beer Can Regatta, today the event remains a major Northern Territory tourist attraction, with crowds gathering to cheer the most outlandish aluminium-can boats and the antics of their crews armed with flour and water cannon. The boats themselves – although much reduced in number from the glory days of the 1980s – remain a constant. They embody a spirit of fun and sense of community.

Daina Fletcher

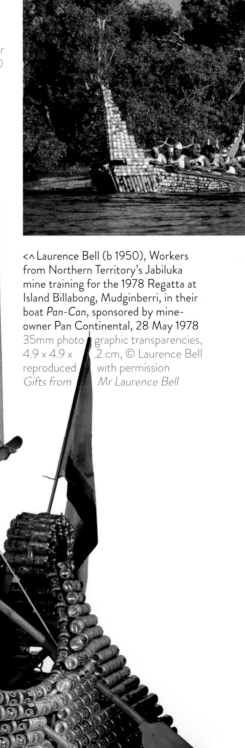

∨ Lutz Frankenfeld, *Beer Can Boat*, 2000 Cans, aluminium, wire netting mesh, bamboo, calico, plastic straps, tape, papier mâché, 320 x 407 x 330 cm (height x length x breadth, sails hoisted, paddles out)

<∧ Laurence Bell (b 1950), Workers from Northern Territory's Jabiluka mine training for the 1978 Regatta at Island Billabong, Mudginberri, in their boat *Pan-Can*, sponsored by mine-owner Pan Continental, 28 May 1978 35mm photographic transparencies, 4.9 x 4.9 x .2 cm, © Laurence Bell reproduced with permission *Gifts from Mr Laurence Bell*

Three-all and the final chance for victory and history, but it all seemed lost with two legs to go for *Australia II*, trailing *Liberty* in the final match for the 1983 America's Cup. Yet they came from behind, sailing under *Liberty* to go ahead at the last mark, then holding them off in a furious battle to the finish – it was the yacht race of the century.

Australia II test tank model

The *Australia II* test tank model embodies the story behind the breakthrough hull and keel design that helped Australia win the America's Cup. But the drama surrounding that famous win had begun much earlier, when the radical International 12-metre *Australia II* began demolishing its rival challengers in the lead-up series, and the keel, then carefully hidden from view, became known as the yacht's secret weapon.

Alarmed by this apparently unbeatable yacht from Down Under, the American defenders sought to have it banned and tried to discredit its famous designer, Ben Lexcen. They failed, and *Australia II* went on to defeat the defender *Liberty*, 4 to 3, in an outstanding series that could have been scripted for Hollywood. The theatre continued after the finish, with a dramatic unveiling of the hull and keel under lights in Newport Harbour, orchestrated by flamboyant syndicate head, millionaire Perth entrepreneur and yachtsman Alan Bond.

This same hull and keel are captured at one third of their size in the striking gold-painted test tank model in the museum collection. This was the last model tested in Holland by Lexcen and the technicians at the Delft facility he used. Smooth on the outside but roughly stepped on

its interior, the shape is eye-catching and enhanced by a grid of black reference lines. The knuckle at the bow and the truncated, flat stern are two design features that exploit aspects of the International 12-Metre class rule. However, the biggest exploitation was the upside-down keel with wings, a piece of lateral thinking that spooked its competitors and was hidden from view until the series ended.

Out of the water, the model appears to sit poised and ready to spring off that famous keel. It is both elegant and aggressive, and testament to Lexcen's rigorous design program of models, along with his well-documented, volatile history of wildly different ideas.

Ben Lexcen's famous design remains controversial. Dutch technicians and naval architects who oversaw the testing claimed they played the major role in proposing, designing and testing the keel configurations, and that Lexcen had little input into the process. But Lexcen's friends and supporters pointed out that the endplates and other radical features on Lexcen's

< The Netherlands Ship Model Basin. The hull of the one-third scale test tank model of *Australia II*, 1981 Wood, paint, 124 x 665 x 128 cm (height x length x width) *Gift from America's Cup Defence 1987 Limited*

1959 18-foot skiff *Taipan* (see also p. 217) proved that he had begun looking at keel extensions decades before *Australia II*.

Taipan encapsulates the story of Ben Lexcen's career. Lexcen designed and built it in 1959, and the radical shape of its plywood hull perfectly captures Lexcen's ability and willingness to experiment with new and original ideas. *Taipan*'s whole concept was a revolution for the class, and Lexcen also used the boat to continue his experiments with endplates on the rudder and centreboard.

His impatience was legendary as he ploughed ahead with his latest idea, having abandoned an earlier one, and *Taipan*'s crew ended up helping to finish the boat. Once sailing, it dominated many races, but suffered gear failures at critical times. Above all, it upset the class establishment who tried to have it banned, but ultimately *Taipan* became the prototype for a new high-performance direction to the 18-foot skiff class, which it still follows.

Much of this story is repeated elsewhere in Lexcen's other designs, which lead directly to the winged keel of his victorious 12-metre design, *Australia II*. Lexcen was a larger-than-life larrikin, a champion sailor, sailmaker and designer, who followed that quintessentially Australian story of the boy from the bush who made it to the top of his profession, learning from the school of hard knocks.

David Payne

ᵛ *Australia II* leads *Liberty*, race 3, under spinnakers, 1983 35 mm photographic slide. Photographer unknown. *Gift from Louis D'Alpuget*

> Ben Lexcen skippering *Taipan* on a test sail on the Brisbane River, 1959 Photographer unknown, picture supplied by Tom Cuneo

At every Dragon Boat Festival, Taoist priests conduct an age-old ceremony, chanting, offering food and wine and burning candles, incense and paper money to ward off evil, bless the boats and bring good luck. Then the priest and prominent community members 'dot the eyes', painting the eyes of the dragon in red, bringing the dragon to life. On the boat, there is much drum beating and splashing at the start of the ceremony to scare the fish away, and the race begins.

< > Dragon boat figurehead and tail, 1999 Wood, paint, fibre, plastic, metal, (figurehead) 57 x 15 x 112 cm, (tail) 20 x 10 x 122 cm (height x width x length) Carved in Hunan Province, China *Gift from Carlos Ung*

Dragons and drumbeats

Although dragon boat racing is thousands of years old, today it is one of the fastest-growing team sports in the world, particularly in Australia, where it presents a unique blend of cultural traditions: Chinese boats, cultural rituals and teams, and competitive rowing and surf-lifesaving traditions.

Dragon boats are long (nearly 12 metres) and narrow (just over one metre wide), like a dragon, with a dragon figurehead at the bow, a tail at the stern, and paddles that symbolise the dragon's claws. The crews of 20–22 paddlers sit in pairs, keeping time to the beat of the drummer at the bow of the boat as they race distances of 200 and 500 metres.

The museum's timber drum, dragon head and tail form part of a collection focusing on the development of this sport in Australia. They were carved in China's Hunan province in 1999, for Australia, as part of the cultural program to take dragon boating to the world. These magnificent and sometimes startling pieces were donated by dragon boat official Carlos Ung. Today the dragon heads and tails, like the boats, are made of fibreglass.

The collection also includes a decorative parasol and commemorative souvenirs from Chinese community leader Raymond Leung, relating to the annual Darling Harbour Dragon Boat Festival; and clothing, medallions, souvenirs and programs from paddlers themselves. There is also a brightly coloured dragon boat model made by Rocky Wong, who was a painter and art tutor in China before he came to

Rocky Wong (working 1990s– 2000s) Dragon Boat model 2001 Fibreglass, wood, paint 10 x 69.5 x 15 cm (height x length x width, paddles out)

Australia in 1979. He has been part of Australian–Chinese dragon boat racing since, helping with race organisation and making decorations for the boats.

Dragons have been a potent symbol in Chinese culture for thousands of years – people believed they lived in rivers and lakes and controlled rains and crops. They were mostly protective, yet when angered created havoc with floods and drought. Chinese communities honoured dragons with festivals and sacrifices. They built boats in the dragon's image and held races in the belief this would bring prosperity and good crops.

Many people locate the origins of the Dragon Boat Festival to 287 BC when, according to legend, the political advisor to the King of Chu, poet Qu Yuan (340–278BC), drowned in the Miluo River in Southern China.

The most powerful kingdoms at the time were Chu and Qin. Qu Yuan was exiled for giving allegedly treacherous advice when, suspecting foul play, he advised against signing a peace treaty with the State of Qin. His advice was not taken, the treaty was signed and eventually proved to be a trap – the State of Chu was conquered by the Qin army.

In shame and despair at official corruption, Qu Yuan threw himself into the river. It was the fifth day of the fifth lunar month in the lunar calendar. Hearing of his apparent suicide, villagers raced out in their dragon boats, beating drums and splashing furiously with their paddles to stop the river dragon and fish eating his body. They threw rice into the water both to feed Qu Yuan's spirit and as an offering to the river dragon. In Asia, the festival has been held every year on that day since, to commemorate Qu Yuan's death.

Dragon boat racing has grown in Australia since 1980, when a Western Australian surf-lifesaving team competed

in the Penang Dragon Boat Festival in Malaysia. In 1991, Australia was a founding member of the International Dragon Boat Federation, and an Australian team took part in the First World Championships held in Yueyang, China, in 1995.

Daina Fletcher

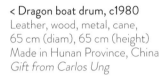

< Dragon boat drum, c1980
Leather, wood, metal, cane,
65 cm (diam), 65 cm (height)
Made in Hunan Province, China
Gift from Carlos Ung

v Rocky Wong (working 1990s–2000s) *Asking the Heavens – Portrait of Qu Yuan*, 2001
Watercolour on paper, 42.5 x 30.5 cm © Rocky Wong

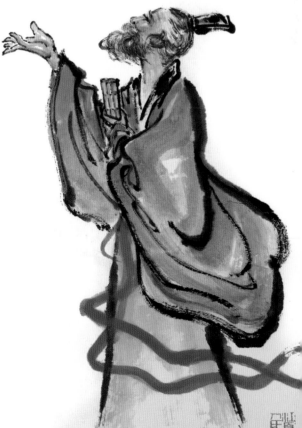

9 ADVENTURERS

Crossing the wilds of the world's oceans alone is dangerous, perilous and, some would say, madness. What pushes people to sail, row or even swim across great expanses of water, for days or months on end? Why do they do it? How do they get through it and why do we find them inspiring? Some have become household names and national heroes. Others have slipped in below the public radar, their extraordinary achievements unrecognised for years, or known only in specialist circles.

In the early 20th century, two of the nation's most acclaimed female swimming sensations were Annette Kellerman and Beatrice Kerr – both achieved international fame which, in Kellerman's case, led to stardom in vaudeville and on the silver screen. They played a role, too, in promoting a different identity for women and in changing attitudes towards women's bodies and dress in the public arena.

Blackmores First Lady was the vehicle for solo sailor Kay Cottee's record-breaking circumnavigation of the world in 1987–88. She was the first woman to sail around the world singlehanded, non-stop and unassisted, one of a long line of world sailors pushing their limits. Another yacht in the collection, the 1930s gaff ketch *Kathleen Gillett* – a pioneer of Australia's blue-water classic, the Sydney–Hobart yacht race – tells another story of adventure, determination and love.

The sport of kayaking has thrown up heroes too. The museum collection includes the kayaks and other materials from two Australian attempts to be the first to paddle across the Tasman from west to east: in 2007, lone kayaker Andrew McAuley lost his life within sight of Milford Sound, New Zealand, after braving horrific conditions over 30 days; James Castrission and Justin Jones made landfall on

New Zealand's North Island the following year after 62 days at sea in their special two-man craft. But undoubtedly the most extraordinary of all our kayak adventurers was German-born Oskar Speck, who paddled from Germany to Australia in the 1930s. It took him seven years!

The quest for speed on and in the water has also propelled Australians to world prominence. In 1950, Keith Barry and Ernie and Enid Nunn were at the centre of a fierce hydroplane competition to claim the first world water speed record for Australia. Barry won the day with a speed of 115.66 km/h. A star attraction at the museum, however, is the fastest boat in the world – Ken Warby's great jet-propelled hydroplane *Spirit of Australia*. Warby, an extraordinary do-it-yourself engineer, drove *Spirit* to a new world water speed record of 511.11 km/h in 1978, setting a mark that has never been matched.

At the heart of the museum's collection are the stories of people who made Australia's maritime history. This final chapter presents a selection of some of the more recent and remarkable characters of this ongoing narrative.

Bill Richards

Two twentieth-century Australian adventurers

< Beatrice Kerr – acclaimed Australian aquatic performer who took early 20th-century England by storm – ready on the diving board, 1906. Photograph on board, 20.7 x 15.2 cm (image) *Gift from the Williams family, descendants of Beatrice Kerr Donated through the Australian Government's Cultural Gifts*

> Harold Nossiter on deck during his voyage around the world 1935–37 – the retiree sailed with sons Harold Junior and Richard to become the first Australians to circumnavigate the globe. Nitrate negative, 9.4 x 6 cm Photo: Richard (Dick) Nossiter, reproduced courtesy the photographer *Gift from RSL Veterans Retirement Village*

Beatrice Kerr, champion lady swimmer and diver of Australia

It's a chilly autumn day in September 1906 at Blackpool's North Pier in England. The pier is crowded with spectators, who watch eagerly as 17-year-old Australian swimmer Beatrice Kerr perches on a wooden plank in her clingy woollen swimsuit. She dives gracefully into the water as the band plays. She continues her routine: the running-buck dive, the back-front dive, the wooden soldier, the spinning top and the stand-sit-stand dive. She then somersaults into the briny below as the crowd applauds.

From 1906 to 1911, Beatrice Kerr toured England performing in vaudeville-style aquatic events, demonstrating her prowess to a public largely inexperienced in ocean swimming. Proudly promoting her Australianness, photographs show her wearing either a swimsuit adorned with an embroidered kangaroo, or a silver-spangled fish-scale suit presented by the silver-mining community of Broken Hill, where she had toured earlier.

Living out of a suitcase in England, Kerr performed at swimming carnivals for local communities, the police and fire brigades and at various gala carnivals and events. She kept her suitcase and all her papers – handbills, posters, employment contracts, letters, photographs, advertisements and reviews from her hectic schedule – after arriving in London in July 1906. This collection is now in the National Maritime Collection.

The press variously described her as the 'Australian Lady champion of fast swimming and ornamental diving and swimming' and 'the plucky young lady whose graceful disportations in the briny never fail to attract attention'.

In the early 20th century, swimming became hugely popular in England, and even more so in temperate Australia,

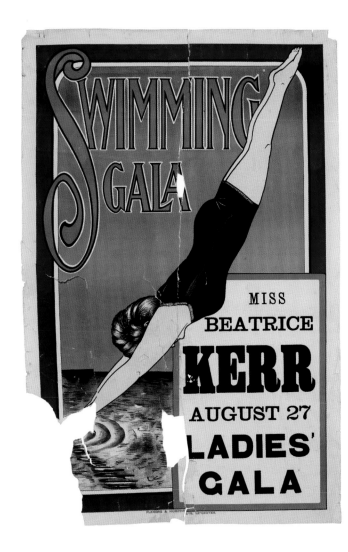

and the lifesaving and learn-to-swim movements were growing. Young swimmers could earn money showing how it was done.

Kerr was a schoolgirl champion from Victoria, who had won 44 prizes – including bangles, hairbrushes, opera glasses and cruet sets – in 50-yard, 100-yard and half-mile races. Following the lead of older Sydney swimmer Annette Kellerman, she toured Australia in 1905, after Kellerman left for England, and performed in the swimming baths of the distant mining communities of Broken Hill, and Kalgoorlie in Western Australia. In Adelaide she introduced the sensational Monte Cristo Fire Bag trick. Sewn into a hessian sack, she was doused with petrol, set alight and dropped into the water, where she freed herself, to great applause.

The collection records her crossing paths with Kellerman, who was attracting media attention swimming in the UK. The Australian press ordained Kerr as worthy to assume Kellerman's mantle and, when in London, she challenged Kellerman to a swimming race a number of times. The canny Kellerman never accepted.

The archive also yields autographs, photographs and letters showing the camaraderie of the expatriate sporting community in Europe. Some of the swimmers went on to win gold and silver medals at the 1912 Stockholm Olympic Games, the first Olympic Games in which women were allowed to compete. Beatrice did not campaign for the 1912 Games. In late 1911, she made her way back to Australia to marry and start a family.

All early Australian female swimmers contributed to raising swimming's profile and popularity. As TW Sheffield, Canadian swimming and lifesaving instructor, wrote in his 1909 book, *Swimming*: 'Miss Beatrice Kerr is the best and most experienced lady diver in the world ... closely followed by Miss Annette Kellerman, who is one of the neatest trick swimmers and divers ... no doubt keen interest taken by the public ... has led ladies to take up the art more vigorously'.[1]

Daina Fletcher

< Beatrice Kerr diving at performances in the UK, 1906–11 Black and white photograph, 20.3 x 17.7 cm *All works donated by the Williams family, descendants of Beatrice Kerr Donated through the Australian Government's Cultural Gifts Program*

∧ Swimming Gala poster featuring Beatrice Kerr, c1906 Paper, 87.6 x 56.8 cm

< Beatrice Kerr in the silver-scaled suit presented to her from the mining community of Broken Hill, NSW, with a collection of her swimming trophies, c1905 Photograph on board, 19.1 x 13.3 cm (image), 25 x 18.9 cm (overall);

∨ Poster for the Olympia Theatre's *Treasure Ship in Fairy Seas*, 1908 Paper, 88.8 x 56.7 cm

Annette Kellerman was larger than life. When MGM made *Million dollar mermaid* in 1952 as a vehicle for its glamorous aquatic star Esther Williams, its spectacular swimming scenes choreographed by Busby Berkeley brought Kellerman's story to the big screen with all the drama and vivaciousness of her exotic and energetic life.

A modern take on the Million Dollar Mermaid

Sydney artist Wendy Sharpe's figurative, lush, expressionistic style is an equally fitting medium to portray the Kellerman story. The Sharpe paintings are a spectacular series of vibrant, large-scale murals commissioned for the high walls of Sydney's Cook+Phillip Park pool, opened in 1999; and the museum has in its collection a selection of Sharpe's studies for the murals, along with three scroll studies from 1997 and 1998. The drama of Kellerman's life is well suited to Sharpe's expressive, painterly and, at times, erotic style. She worked on the murals for two years, researching Kellerman's life to select the events depicted.

The murals appear as freeze frames of high points of Kellerman's life. The first features Kellerman as a young

∧ Wendy Sharpe (b 1960) Detail from scroll for the study of *The Life of Annette Kellermann in Eight Episodes*, 1998 Oil on card, 38.5 x 257 cm © Wendy Sharpe, reproduced courtesy of the artist

∨ Wendy Sharpe's *The Life of Annette Kellermann in Eight Episodes* mural, at Sydney's Cook + Phillip Park pool, 1999

> Studio portrait Annette Kellerman, c1910 Postcard, 8.8 x 13.7 cm

swimmer, in three states: the NSW teenage swimming champion receives trophies, with Kellerman as a child in calipers at left, and as an elegant young adult Kellerman on the diving board at right. Sharpe then presents Kellerman's spectacular rise to international stardom in chronological sequence.

Born in 1886, Kellerman had a sensational career as an aquatic entertainer in vaudeville and film in the first two decades of the 20th century. After conducting popular swimming and diving demonstrations, with fish, in the Melbourne Aquarium, she embraced the theatrical side of the sport and left for England in 1905 to help her cash-strapped family financially. Her Australianness was part of her mystique – she would call out a loud 'Cooee' before diving into the pool during her early swimming demonstrations at London's Hippodrome, and was variously promoted as 'Australia's Mermaid', 'Neptune's daughter' and 'the Perfect Woman'.

Kellerman swam marathons along the soupy Thames and parts of the English coastline. There were three unsuccessful but highly publicised attempts to swim the English Channel, and challenge swims on the Seine and Danube, against both male and female swimmers.

She then moved to vaudeville in America, where her acts combined swimming, theatre, ballet and, increasingly, titillating striptease. Kellerman pushed the boundaries performing in her figure-hugging one-piece suit. At the time, this style of suit was nothing new in Australia, but in America it created a sensation. It was an era of gender segregation, with firm ideas about morality, decency, fashion, femininity and women's sport, when appearing in a clingy woollen swimsuit was considered extremely risqué, even pornographic. Kellerman quickly moved into film, becoming, in the 1920s, one of America's highest-paid silent movie stars. She regarded her championing of less restrictive women's swimwear and physical fitness as her greatest achievement. Wendy Sharpe has celebrated this, in the filmic freeze frames of Kellerman's life in this unusual mural commission for a public swimming pool.

Daina Fletcher

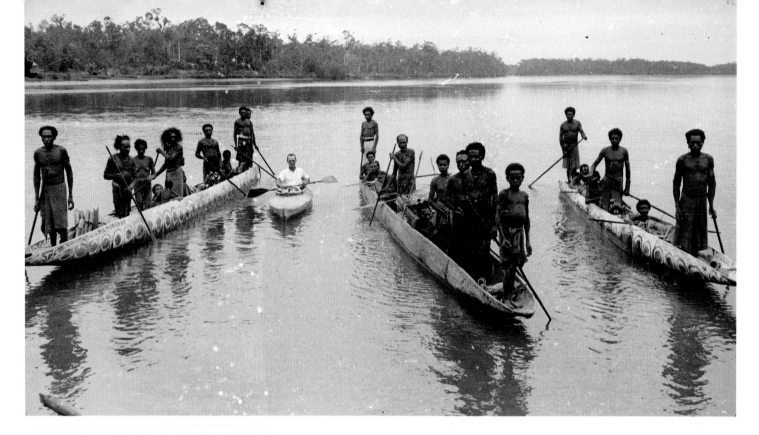

50,000 kilometres by kayak

When German adventurer Oskar Speck arrived by kayak on Thursday Island in September 1939, it was the end of a remarkable 50,000-kilometre voyage from Germany to Australia that took an unprecedented seven years and four months.

Oskar Speck's story can be pieced together from a rich collection, donated to the museum from several sources. It includes letters, diaries, photographs, passports, news clippings, rare media interviews and 16mm film, fittings from his kayak and other personal effects. What emerges is a picture of a complex and enigmatic man whose voyage to Australia through a colonial world epitomised an age of wanderlust.

Canoeing and kayaking were popular summer pastimes in Europe in the 1920s and 1930s, and Oskar Speck, born in Hamburg in 1907, was a keen and competitive young kayaker. In 1932, during the Depression, he found himself unemployed along with millions of other Germans. 'The times in Germany were very catastrophic ... all I wanted was to get out of Germany for a while,'

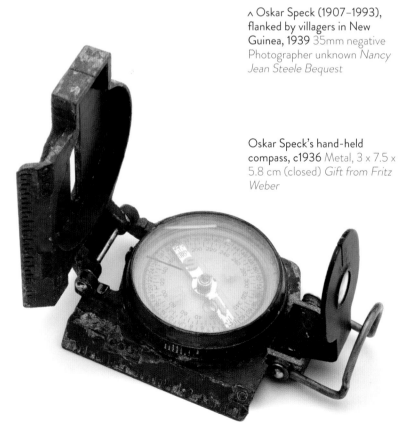

∧ Oskar Speck (1907–1993), flanked by villagers in New Guinea, 1939 35mm negative Photographer unknown *Nancy Jean Steele Bequest*

Oskar Speck's hand-held compass, c1936 Metal, 3 x 7.5 x 5.8 cm (closed) *Gift from Fritz Weber*

Speck said.[2] 'I had no idea that I would eventually end up in Australia.'

Speck converted his 5.49-metre collapsible kayak, *Sunnschien* (*Sunshine*) – designed for two paddlers – into a solo craft with room for luggage and voyage provisions. His odyssey began on 13 May 1932 along the Danube. Finding these still waters too tame, he tested his skills on the rapids of the Varda River in Macedonia, damaging his kayak. After repairs he continued towards the Mediterranean. His original kayak was to be replaced by several others supplied by his main sponsor, the Pionier Faltbootwerft, in Bad Tolz, Germany. They encouraged him to continue to Australia, seeing his adventure as a way to promote their kayaks.

To cross the open sea of the Mediterranean to Cyprus and then Turkey, Speck had to master sailing and paddling between the Greek islands. 'You must be constantly active … constantly steering to bring the boat's bow to the right position to meet every single wave,' he explained.[3] Speck's vulnerability was highlighted by the fact that he could not swim and tied himself into his kayak.

In the Near East, instead of taking the Suez Canal, Speck paddled down the Euphrates River, coming under rifle fire, before arriving at the head of the Persian Gulf. Here he contracted malaria, which would recur throughout the voyage. Undaunted, Speck continued around the shores of India to the Bay of Bengal, meeting governors and maharajas along the way and giving occasional public lectures to raise money.

Following the coastlines of Thailand and the Malaya peninsula, Speck reached Singapore and made his way through the Dutch East Indies (Indonesia), acquiring a 16-mm cine-camera in Java. The surviving

footage taken in 1938–39 captures the cultural diversity of people living beyond the Java Sea through to New Guinea, and a coastal way of life that has since changed dramatically.

Speck survived other severe bout of malaria, which hospitalised him in the Dutch East Indies, and an attack by 20 armed villagers in the Moluccas, who bound and beat him.

Crossing to Dutch New Guinea, he paddled right around its extensive coastline, filming Melanesian communities along the way, until he reached Australian-administered Papua New Guinea. At Samarai Island he stayed with an Australian family who operated the local coastal radio station. They remember listening with him to a radio broadcast of Adolf Hitler.

In Daru (New Guinea) Speck learned that Australia was at war with Germany. Police officials sportingly allowed him to continue into Australian waters to Thursday Island so that he could realise his dream of reaching Australia. His surprising arrival in wartime raised questions about his activities in the region, why and for whom he was making a film and whether he was acting as a German agent. Speck was arrested as an enemy alien and transferred to internment camps on the Australian mainland, where he remained for the rest of the war – except for a brief period when he escaped!

Freed at the war's end, Speck remained in Australia. Days after his release, he was in Lightning Ridge, New South Wales, mining opal. He later established a successful opal-cutting business, retiring to Killcare Heights on the NSW Central Coast in the 1970s.

Penny Cuthbert

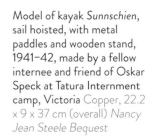

Model of kayak *Sunnschien*, sail hoisted, with metal paddles and wooden stand, 1941–42, made by a fellow internee and friend of Oskar Speck at Tatura Internment camp, Victoria Copper, 22.2 x 9 x 37 cm (overall) *Nancy Jean Steele Bequest*

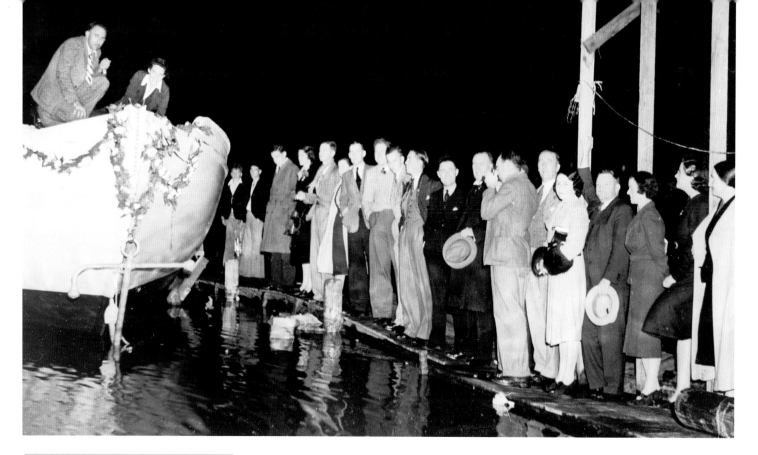

Kathleen Gillett

In 1933, newlyweds Jack and Kathleen Earl, both keen sailors, shared a dream of sailing around the world, and set about commissioning the boat that would take them there. They approached Sydney boatbuilder Charles Larson with a fishing-boat design by Norwegian naval architect Colin Archer, renowned for his seaworthy designs. But Larson pulled a different Archer plan out of his drawer – for a ketch thought to be a redningskoite, or pilot boat – and offered to build that one instead, because it was better suited to a world voyage.

Jack Earl later recalled that during those Depression years, he 'had no sugar', so Larson, glad of the work, slowly built the 45-foot huon pine hull as the couple scraped funds together. Fourteen years passed before the sturdy ketch finally sailed out of Sydney Heads for the circumnavigation – but without Kathleen Earl.

Six years after they first visited Larson, on the eve of World War II, the boat was launched, christened with Kathleen's maiden name – *Kathleen Gillett*. Kathleen and Jack lived aboard their ketch in Rushcutters Bay and later Mosman Bay as they slowly fitted it out. The Earls had two children, Michael and Maris, and they all lived on board. During the war, Jack was required to use *Kathleen Gillett* for

coastal surveillance as part of the small fleet of requisitioned private yachts. In 1945, after the war's end, Earl raced friends to Hobart, competing against visiting English sailor Captain John Illingworth, in the first running of the Sydney to Hobart yacht race. All the while, he harboured his ambitions to sail the world.

Finally, on 7 June 1947, *Kathleen Gillett* left Sydney, with Jack at the helm and four paying crew. The couple had made the difficult decision that Kathleen and their children would stay behind, because sailing as a family would have been too disruptive to the children's schooling and too costly. So the family caught the train for three days north to join the boat for the leg along Queensland's north

Kathleen with Michael and
Maris – Jack's family on board
after the voyage, c1949 Photo:
Jack Earl, courtesy the Jack Earl
Trust. All photos reproduced with
permission

World map tracing the journey of
Kathleen Gillett from 7 June 1947
to 8 December 1948 Paper, 101.8
x 47.8 cm *Gift from Lyall Morris*

In Kingston, Jamaica, the crew swapped
stories with Hollywood movie star Errol
Flynn (centre), 1948 Photo: Jack Earl,
courtesy the Jack Earl Trust

coast. Earl and his crew were away for exactly 18 months, sailing back through the Heads on 7 December 1948, after covering 26,000 nautical miles.

The voyage was followed by an appreciative audience reading monthly despatches by first mate Mick Morris, illustrated by Earl (a newspaper illustrator), in *Seacraft* magazine. Crewmember Will Sinclair also sent photos, but the wonderful images by Earl and the extraordinary illustrated log he sent back, at first quietly to Kathleen, became eagerly anticipated by his broader circle. And, with Earl's many contacts in the press publishing his lively illustrations of the crew's exotic encounters in foreign ports, the journey became the real-life incarnation of the swashbuckling adventures of the characters they met on the way, including Australian actor Errol Flynn, who shared a drink with the crew in Kingston, Jamaica.

Jack earned money during the voyage painting commissions in ports of call – the voyage publicity gave him broader recognition, and at voyage end he was able to attract commissions as a marine artist.

In the 1950s, *Kathleen Gillett* was sold to owners in the north, and for a time was worked around Papua and the Solomon Islands crocodile hunting.

In 1987 the ketch, damaged in a tropical cyclone, was located in Guam and purchased by the Norwegian government for presentation to the museum as Norway's official gift to Australia for the bicentennial in 1988. Halvorsen Ltd – renowned Sydney boatbuilders of Norwegian background (see pp. 194–95) – were approached to restore *Kathleen Gillett*, with advice about its original configuration and fit-out from the then 83-year-old Jack Earl. At its relaunch, he proudly took the helm again, nearly 50 years and many adventures after it first went in the water.

Daina Fletcher

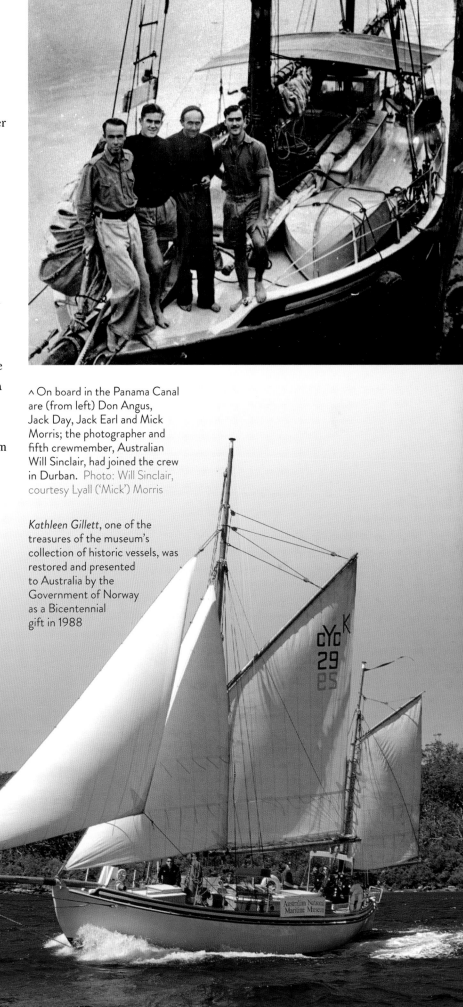

∧ On board in the Panama Canal are (from left) Don Angus, Jack Day, Jack Earl and Mick Morris; the photographer and fifth crewmember, Australian Will Sinclair, had joined the crew in Durban. Photo: Will Sinclair, courtesy Lyall ('Mick') Morris

Kathleen Gillett, one of the treasures of the museum's collection of historic vessels, was restored and presented to Australia by the Government of Norway as a Bicentennial gift in 1988

The race to the record

At dawn on Saturday 14 January 1950, two rival teams revved their hydroplane engines on the quiet waters of Kogarah Bay, on the Georges River in southern Sydney, in front of hundreds of spectators and supporters. It was a morning of intense rivalry between two speedboat drivers in a race to claim the first world water speed record for Australia.

The record in the 91-cubic-inch engine class (the smallest class of engine) was eagerly sought by two speedboating families: those of Keith Barry and Ernie Nunn. Barry – an engineer, designer, builder, driver, and president of the Australian Power Boat Association – had built his lightweight hydroplane, *Firefly II*, in less than two weeks, after hearing that rival Ernie Nunn, also a designer, builder and speedboat driver, had mounted a challenge for the record, then held by American Jack Cooper.

Nunn's boat *Do* was to be driven by his niece Enid Nunn – one of a small number of women in the sport – because she was lighter.

Keith Barry, a veteran of the sport, had raced boats from the early 1930s. He built his first boat, *Spitfire*, in 1938, to the then reasonably new three-point hydroplane design: this type planed at high speed with only three points on the boat touching the water – the aft ends of the two sponson hulls on either side of the main hull, with the third point at the stern often being the propeller. Barry borrowed the superlight spruce and fabric construction from the aircraft industry, along with the names he bestowed on his boats.

Spitfire, with its tiny 'Barry special' 61-cubic-inch, two-cylinder motorcycle engine, held the Australian mile record for nine years, reaching a peak speed of 45.535 mph (73.281 km/h).

Barry built his second hydroplane, *Firefly*, in 1947, fitting it with a 135-cubic-inch surplus jeep engine, and was never defeated in three years of racing against more than 100 boats over various events. He also beat Ernie Nunn to the Lawson Shield.

But, by the end of the 1940s, larger engines and newer boats were entering the competition and Barry decided to rise to the challenge. His friend Bill McLachlan, a racing-car driver, offered Barry a 1936 MG TA engine from a smashed car, which Barry set about stripping and rebuilding. Once he fitted it to *Firefly*, he easily beat his record in *Spitfire* at 57 mph (91.732 km/h).

Then Enid Nunn raced to 60 mph (96.560 km/h) to take the Australian record, which spurred her uncle Ernie to apply for the 91-cubic-inch record, set at 64.689 mph (104.106 km/h) in California in 1941.

∧ Life jacket and safety helmet worn by Keith Barry during his racing career on the motor cycle speedway and then in speedboats, 1920s–50s *Gift from Keith Barry*

< Keith Barry on an earlier run on *Firefly*, c1947–48

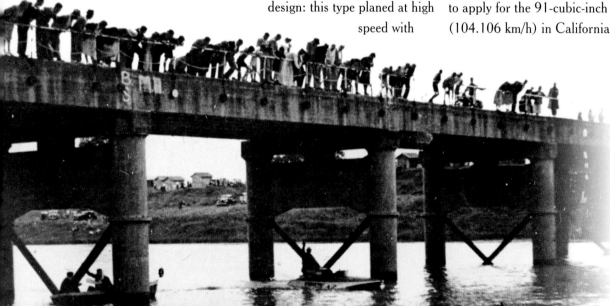

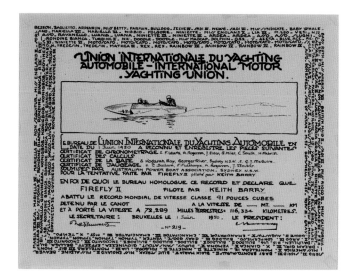

So the stage was set for a showdown.

Barry and friends, including waterski champion Jack Murray, worked night and day for 11 days to build the little hydroplane from plans drawn at Barry's kitchen table. They installed the same 91-cubic-inch engine and then trialled the 3.79-metre boat on the 12th day, secretly reaching an average speed of 70 mph (112.654 km/h) – over two one-mile runs – beating the record speed. The *Firefly II* team felt quietly confident.

At daybreak on 14 January, both teams assembled in front of the huge crowd. At 4.30 am, Enid raced *Do* to an average speed of 66.5 mph (106.07 km/h), becoming the first Australian to break a world record on the water. Success was fleeting. Forty minutes later, Barry lined up and took his new hydroplane to 72.289 mph (115.66 km/h).

Since both records were broken minutes apart, the Union International du Yachting Automobile awarded the world record to Keith Barry in his heroic, purpose-built hydroplane *Firefly II*. Barry also smashed six NSW and Australian records, including rival Ernie Nunn's 71.289 mph (114.73 km/h) record speed in the larger engine class – the 255-cubic-inch engine capacity.

Eleven months later *Firefly II* extended the record to 78.006 mph (125.54kph), with the lighter Bill McLachlan at the wheel.

Daina Fletcher

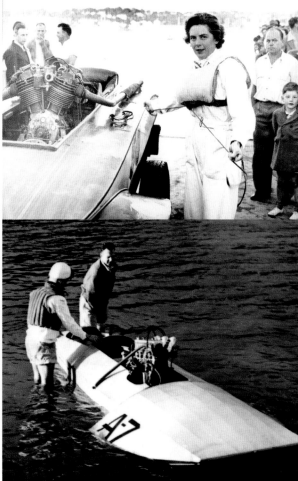

The world's fastest boat

It was 1977, and strapped into the aircraft-style cockpit by his assistants each time he set off, Ken Warby used a classic phrase to describe the instinctive piloting needed for his three-point, jet-powered hydroplane, *Spirit of Australia*: 'You don't drive the boat, you wear it.' [4]

In many ways it was a boat Warby had worn from its inception. He had single-handedly designed, built and driven *Spirit of Australia*, with a combination of intuitive genius and logical progression. On the water, his life was on the line.

For more than 30 years, Australia and Ken Warby have owned the title of 'the fastest man on the water'. The wooden-hulled *Spirit of Australia* first broke the record on 20 November 1977 with a speed of 464.44 km/h, and then set a record of 511.11 km/h on 8 October 1978 at Blowering Dam, NSW. That record has never been broken.

Warby designed and built the 8.22-metre craft himself at his Sydney home, and then tested and improved it in a series of gradual steps. His friends and volunteers were his support staff, and his program self-devised, with a day-by-day, learn-from-experience approach. Unlike modern sportspeople with a team of handlers, no one ever checked his diet, his training regime or even his mental state – in fact, as his neighbours watched Warby building the boat in his backyard, they thought he was nuts. His shoestring budget dictated the slow rate of progress, but when he established his credentials with his first world record in 1977, a major sponsor came on board with significant support.

The story is full of fascinating anecdotes. The three air-force surplus jet engines Warby began with cost him just $265 in total. When one was damaged, he fitted the $65 one he had put aside for spares, and then set a world record. He set the final record with a fourth engine, procured by swapping one of his dud engines with a working model used by trainees at the Wagga Wagga RAAF base.

He had also sought technical advice from professional colleagues Professor Tom Fink and (now) Emeritus Professor Lawry Doctors at the University of New South Wales. Testing a model of *Spirit of Australia* in their wind tunnel, they were astonished at the amount that Warby clearly knew by intuition. There was nothing high-tech about Warby's wooden boat, and he set the record on a dam open to the public for boating and fishing.

Warby's record attempt had every chance of ending in disaster. The road had already been travelled by many, and was marked with fatal accidents. Warby was cautious. He did not know the answers for many of the problems he expected to meet along the way, so he followed a path of learning as he progressed. He started with a shape based on his knowledge of hull design, then built the basic hull in the wooden materials that he understood, testing it at partially complete stages and modifying as necessary, and then went on gradually to explore the problem areas and search for the solutions.

How fast is 500 km/h? That's one kilometre every seven seconds and, while *Spirit of Australia* travels on a straight line all the way, delicately balanced on the tips of its sponsons, fins, rudder and planing shoe, it has an unnerving, casual motion, rocking from side to side. Warby called this 'sponson walking': what it feels like to 'wear a boat' releasing air pressure as it travels at over 100 metres per second.

David Payne

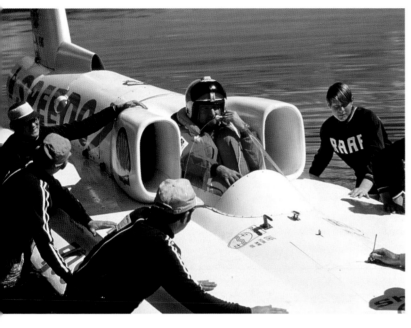

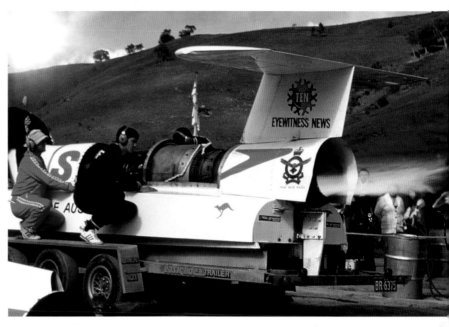

< Viewed from the bow, *Spirit of Australia* shows off its sleek aerodynamic lines 822 x 237 cm (length x width) *Purchased with the assistance of the Speedo Group Ltd*

∧ Ken Warby, in *Spirit of Australia*, takes to the water assisted by Warby's shore crew, 1978. Photo: Michael Jensen © the photographer, reproduced with permission

∧ Ken Warby and RAAF technicians testing *Spirit of Australia*'s engine on the shore of Blowering Dam, 1978 Photo: Michael Jensen © the photographer, reproduced with permission

∨ Wearing the boat ... Ken Warby and *Spirit of Australia* at full speed on Blowering Dam, 1978. Photographer unknown. All 1978 photographs National Archives of Australia

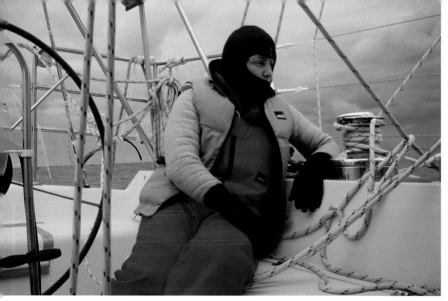

Kay Cottee had been sailing across the Pacific for six weeks, after leaving Sydney in her largely self-built 37-foot (11.28-metre) yacht – *Blackmores First Lady* – aiming to be the first woman to sail around the world non-stop, by way of both hemispheres, unassisted and alone. Yet with the Horn ahead of her, things nearly went terribly wrong. In heavy weather the yacht was knocked flat and the boom cracked when the self-steering failed and the boat did a radical gybe.

Kay Cottee's great adventure

Cottee had spent years preparing for her voyage in a methodical and workmanlike manner. She ran a small yacht-charter business, and slowly built the skills necessary for the voyage. She had purchased a Cavalier 37 production hull and customised it, reinforcing it with extra bulkheads, reconfiguring storage, and rigging it for single-handed sailing with all lines leading to the cockpit. But would her little boat get her past every sailor's spectre: Cape Horn?

At sea on her own, in a time before email and instant messaging, Cottee spent much of the voyage exhausted in the southern latitudes, often surviving on two hours' sleep, on watch for weather, icebergs, vessels and, later, pirates; fearful of collisions, getting holed and sinking. Her yacht was pitchpoled, capsized in the thunderous southern seas, then becalmed in the tropics. Cottee was thrown overboard and violently back on board, tethered to her yacht in her

harness; she was sunburnt and severely sleep deprived; yet after six months she did claim her record, sailing *Blackmores First Lady* into Sydney Harbour on 5 June 1988 to a massive public welcome.

The success of the voyage sprang from Cottee's courage, determination and preparation. The museum acquired *Blackmores First Lady* in 2001 and refitted it with an interactive and experiential installation of Cottee's personal effects, allowing visitors to experience firsthand something of the daily challenges and loneliness of the long-distance sailor.

We're transported to a period eight weeks into the six-month voyage, from late January to early February 1988. Kay had sailed around the towering black cliffs of Cape Horn on 20 January, celebrated her birthday on 25 January, and was sailing north into the Atlantic to cross the equator.

While most solo sailors would have every area squared away when not in use, the museum has suspended this convention to show how Cottee used each area of the yacht. You can see the navigation station,

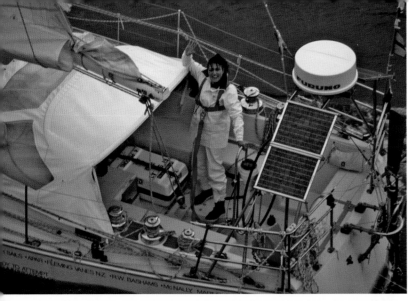

L–R: Approaching Cape Horn, 19 January 1988 Photo: Kay Cottee © the photographer. Kay's nest with first mate Teddy, a clear bunk for sleeping in 20-minute to two-hour shifts, with instruments above to keep an eye on the time, the weather and who else was out there.

Seeing people for the first time in 144 days, Kay, tethered to her cockpit, waves to a helicopter film crew off Tasmania's South-East Cape, 27 May 1988. Photo: News Limited

⌄ Blackmores First Lady, now in its home in the museum

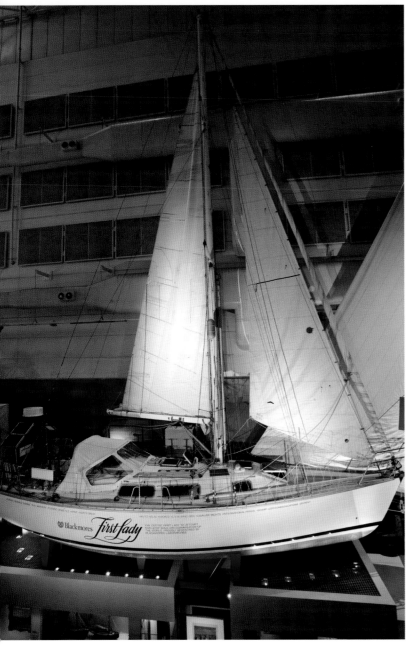

the head or bathroom, the cabin with books, tapes and birthday presents, the galley with gimballed stove, pots and pans for preparing dried or canned food inscribed with messages from family, her daily water ration, gloves drying on the stove, and the work bench and sail locker. It seems as if Kay's presence is in each area, cooking, plotting her course, reading, listening to audiobooks or doing repairs. Down below, it is as if she had just stepped out on deck to wash her clothes. Kay's first mate, a huge teddy, sits on the forward bunk.

The interior reveals the nest-like space Cottee inhabited for six months, and the volume and scope of material needed for a solo voyage. Added to this are the ocean sound effects and the slight crookedness of the cabin, produced by the angle of the yacht in its support cradle. All combine to evoke something of the extraordinary world of a self-reliant sailor alone at sea.

So how did Kay Cottee tackle Cape Horn and deal with the cracked boom in the treacherous Southern Ocean? The work bench amidships shows a section of the spinnaker pole she fashioned in the vice to strengthen the boom just before rounding the Horn, exhausted and elated, during a break in the weather. She celebrated by applying lipstick and perfume her mother had given her for the event, then sitting down to crab and mayonnaise and a glass of Grange Hermitage. The boom repair is still on the yacht in the museum today.

Daina Fletcher

Across the Tasman

On 10 February 2007, Andrew McAuley's upturned kayak was found within sight of Milford Sound, on New Zealand's South Island, 30 days after he left Tasmania aiming to be the first to kayak the 1,666.8 km from Australia to New Zealand. On 9 February the New Zealand Coast Guard had received a garbled message from McAuley: 'My kayak is sinking' and 'I've lost … oh no'. After a three-day air and sea search, Andrew McAuley was presumed drowned.

The museum's collection includes McAuley's kayak and many of the provisions and equipment found in it. These items, together with the kayak and select material from two kayakers who made a similar journey less than a year later, tell of two very different attempts to cross the Tasman.

Andrew McAuley was a very experienced sea kayaker who had completed solo crossings of Bass Strait and the Gulf of Carpentaria. Crossing from Australia to New Zealand below the 40th parallel, where the ocean is particularly brutal, was an extreme choice and evidence that, to McAuley, pushing his physiological and psychological bound-aries was perhaps as important as the crossing itself. McAuley chose a 6.4-metre custom-ised production kayak, the smallest boat he could get away with. In it he sat below the waterline, with his eyeline less than a metre above it – and that was in calm seas.

McAuley had packed 36 days' worth of food and 136 litres of fresh water, and had glued a small photo of his three-year-old son Finlay to the kayak's cockpit. Throughout his voyage, McAuley maintained daily SMS contact with weather forecaster Jonathan Bogais, who passed McAuley's brief messages to his wife and ground crew.

He endured several capsizes, yet averaged 55.56 km a day. However, three quarters of the way across, he was hit by a force 10 storm similar to that which tore apart the 1998 Sydney to Hobart fleet. He locked himself under the cockpit canopy for 28 hours. Winds gusting up to 70 knots whipped up monstrous 10- to 12-metre waves. McAuley's kayak would have been airborne and weightless every 15 seconds as it was tossed off each wave's peak like a javelin. Several equipment failures compromised communications and, even more dangerously, made him unable to use his cockpit canopy safely.

Later that year, on 13 November, James Castrission and Justin Jones left Forster, New South Wales, on the same quest to cross the Tasman Sea, but as a pair. After paddling for 62 days and 3,318 km, they arrived at Ngamotu Beach on New Zealand's North Island on 13 January 2008. They achieved both the world first of successfully kayaking west to east, and also the world record for the longest trans-oceanic kayaking expedition undertaken by two expeditioners. In 2008 Castrission and Jones were awarded the Australian Geographic Young Adventurer of the Year Award.

McAuley, Castrission and Jones had met many times in 2006 and spoke of their separate quests to be the first to kayak across the Tasman. Each expedition was uncomfortably aware of the other, with McAuley in particular pushing to set off first.

Paul Hewitson, Mirage Sea Kayaks, builder, Andrew McAuley's Trans-Tasman quest sea kayak, with the cockpit canopy 'Caspar', 2006 Fibreglass and Kevlar, 640 x 62 cm (length x breadth) Gift from Paul Hewitson

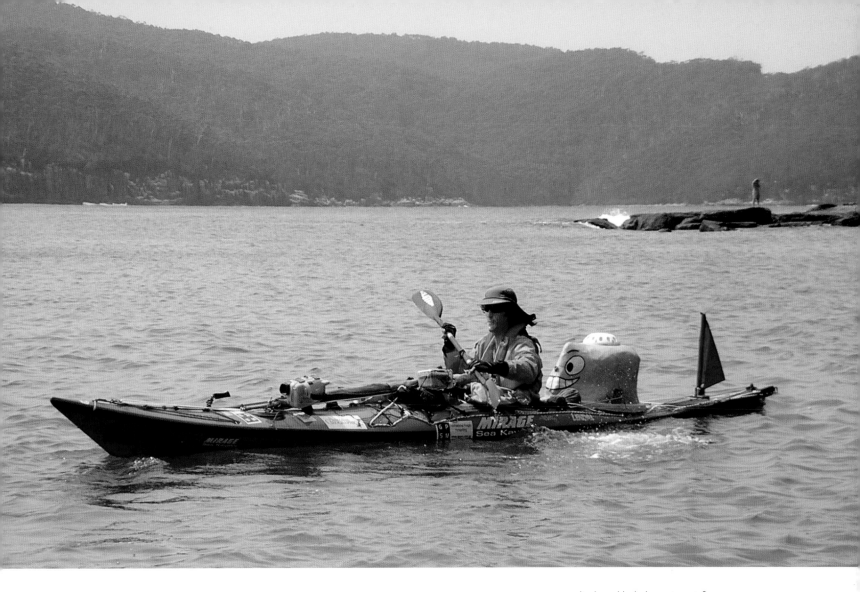

Andrew McAuley sets out for
New Zealand from Fortescue Bay,
Tasmania, 11 January 2007
Vicki McAuley Collection ©
Vicki McAuley, reproduced with
permission

< Andrew McAuley during his
Trans-Tasman crossing, 2007
Vicki McAuley Collection ©
Vicki McAuley, reproduced with
permission

<< Andrew McAuley and James Castrission and Justin Jones used their iridium satellite phones to stay in touch with their shore crew – McAuley only with brief daily SMS messages, while the pair spoke regularly to the media. Plastic, 15.3 x 6.1 x 5.8 cm (antenna down). *Donated through the Australian Government's Cultural Gifts Program by James Castrission and Justin Jones of Crossing the Ditch*

∧ Panasonic Toughbook, used to broadcast and track the voyage on the web by Justin Jones and James Castrission, who posted photographs and updates during their Trans-Tasman crossing, c2006 Laptop, plastic, metal, 5.2 x 27.1 x 21.6 cm *Donated through the Australian Government's Cultural Gifts Program by James Castrission and Justin Jones of Crossing the Ditch*

The pair chose a more northerly route across the Tasman, selecting safe and protected harbours as their departure and arrival points. Their purpose-built nine-metre kayak featured a sleeping cabin. Castrission and Jones's voyage was broadcast live on the web, with daily updates and regular radio interviews. They were farewelled and greeted by television cameras and thousands of supporters.

This contrasts starkly with McAuley's bare-bones and purist approach. Almost 20 years older than Castrission and Jones, he was determined to keep his solo crossing as close to an 'ordinary' kayaking adventure as possible. According to McAuley's wife, Vicki, although he drowned, the fact that he made it to within sight of land indicates that

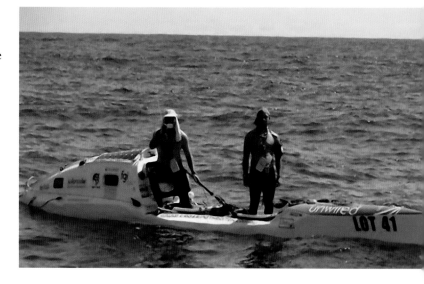

James Castrission (front) and Justin Jones facing the ocean and the challenge of Crossing the Ditch
Photo: Justin Jones and James Castrission, © James Castrission and Justin Jones of Crossing the Ditch, reproduced with permission

< Justin Jones (left) and James Castrission in *Lot 41* during their Trans-Tasman crossing, 2007–08.
Photo: Graeme Templeton © the photographer, reproduced with permission

this quest was realistic for him. The coroner reported that: 'The journey itself, up to the point of disaster so close to destination, was a remarkable achievement and testament to Andrew McAuley's planning, skill, fortitude and above all mental strength.'[5]

Andrew McAuley was posthumously awarded the Australian Geographic Society's Lifetime of Adventure Award in 2007 – the highest honour to recognise those special Australians who have not only lived an adventurous life, but have also put something back into Australia and inspired other Australians.

Daina Fletcher and Megan Treharne

Notes

1 FIRST MARINERS

1 Marrnyula Munungurr quote from *Saltwater – Yirrkala Bark Paintings of Sea Country – Recognising Indigenous Sea Rights*, by Buku-Larrngay Mulka Centre, 1999, Jennifer Isaacs Publishing.

2 John Wilson Wuribudiwi, text, viewed 5 December 2011, <http://www.tiwiart.com/artists/item/12>.

3 Pedro Wonaeamirri 2008, 'Pedro Wonaeamirri', text, viewed 5 December 2011, <http://www.tiwiart.com/artists/item/12>.

4 Lola Greeno 2002, 'Shell necklace maker Lola Greeno', text, viewed 5 December 2011, <http://hosting.collectionsaustralia.net/foundmade/shellmakersf723.html?ID=10>.

5 Ken Thaiday Snr 2004, 'Paradise now? Contemporary art from the Pacific', text, viewed 5 December 2011, <http://sites.asiasociety.org/arts/paradise_now/thaiday.html>.

2 EXPLORERS AND SETTLERS

1 Australian Netherlands Committee on Old Dutch Shipwrecks.

2 'Furneaux's narrative', Appendix IV, *Extracts from Officers' Records in the Journals of Captain James Cook on his Voyages of Discovery: the Voyage of the Resolution and Adventure 1772–1775*, edited by JC Beaglehole, The Boydell Press in association with Horden House, Sydney, NSW, 1969, pp. 743–44.

3 Royal Society of London, 15 February 1768.

4 *A Voyage Round the World Performed by Order of His Most Christian Majesty in the Years 1766, 1767, 1768 and 1769* by Lewis de Bougainville. Translated from the French by John Reinhold Forster, Nourse and Davies, London, 1772, p. 229.

3 MIGRANTS AND REFUGEES

1 Arthur Lederer, letter to Lady Max Muller, 14 February 1939.

2 Walter Lederer, interviewed by Sue Effenberger, 1992, sound recording, Vaughan Evans Library, Australian National Maritime Museum.

3 Anne Zahalka and Sue Saxon, artists' statement, *Isle of refuge*, Ivan Dougherty Gallery, 2003.

4 ibid.

5 ibid.

6 Sue Saxon 2003, 'Displaced persons', Sue Saxon – text, viewed 8 December 2011, <http://suesaxon.com/pages/text.html#displacedpersons>.

7 Eugene Seiz, letter to Department of Immigration, 13 July 1957.

8 Natalie Seiz, interviewed by Lindl Lawton, 2007, sound recording, Vaughan Evans Library, Australian National Maritime Museum.

9 Lois Carrington, interviewed by Lindl Lawton, 2006, sound recording, Vaughan Evans Library, Australian National Maritime Museum.

10 Lois Carrington, *A Real Situation: The story of adult migrant education in Australia 1947 to 1970*, Lois Carrington, Canberra, 1997, p. v.

11 Lois Carrington, interviewed by Lindl Lawton, 2006, op. cit.

12 ibid.

13 Gina Sinozich, interviewed by Lindl Lawton, 2005, sound recording, Vaughan Evans Library, Australian National Maritime Museum.

14 Tuyet Tran, interviewed by Lindl Lawton, 2005, video recording, Australian National Maritime Museum.

15 Mo Lu, interviewed by Lindl Lawton, 2005, video recording, Australian National Maritime Museum.

16 Thi Nguyen, artist statement, ARTEXPRESS, Art Gallery of New South Wales, 1995.

17 Claire Bailey, artist statement, *Third eye, fourth hand*, Heathcote Museum and Gallery, 2006.

18 Steve Creedy, 'Scourge of the smuggler', *The Australian*, 12 October 1999.

19 J Allen, 'Revealed: The plot to get 69 Chinese illegals ashore', *Illawarra Mercury*, 19 May 1999.

20 Kerry O'Brien, '*Tampa* captain gives his side of the drama', *The 7.30 report*, 6 September 2001.

21 Steffensen, '*Tampa*'s captain finally back home in Norway', *Norway today*, 20 November 2001.

22 Glenn Morgan, artist statement, *Glenn Morgan – new work 08*, Ray Hughes Gallery, 2008.

23 Marg Hutton 2003, 'Survivors speak: Ahmed Hussein', SIEVX.com, viewed 8 December 2011, <http://www.sievx.com/archives/2003_07-08/20030705.shtml>.

24 Faris Kadhem, interviewed by Lindl Lawton, 2006, sound recording, Vaughan Evans Library, Australian National Maritime Museum.

6 LINKED BY THE SEA

1 *Narrative of the United States Exploring Expedition during the Years 1838, 1839, 1840, 1841, 1842* by Charles Wilkes, USN Commander of the expedition, member of the American Philosophical Society, Lea & Blanchard, Philadelphia, 1845.

2 Samuel Eliot Morison, *The Maritime History of Massachusetts, 1783–1860*, Houghton Mifflin Company, 1921.

3 *The Queenslander*, 18 March 1882.

4 Christie's Melbourne, Sale 121 catalogue, lot 835.

5 *Barrier Miner*, 26 April 1946, p. 1.

6 Personal communication, 'Operation war bride' interview, 1994.

7 INDUSTRY AND ENVIRONMENT

1 HW Downes, *Log Book of the Barque Terror, Whaler. Henry William Downes Master. South Seas, 1846–47*, unpaginated.

2 ibid.

8 SPORT AND PLAY

1 *The Auckland Star*, 22 August 1888.

9 ADVENTURERS

1 TW Sheffield, *Swimming*, Hamilton, Ontario, 1909.

2 Interview with journalist Margot Cuthill for SBS, 1987.

3 Interview with Duncan Thompson for *Australasian Post*, published 6 December 1956.

4 Ken Warby, interviewed by David Payne and Daina Fletcher, 1997, sound recording, Vaughan Evans Library, Australian National Maritime Museum.

5 In the Coroner's Court of Invercargill, In the matter of an inquest into the death of Andrew Peter McAuley, Finding of Coroner TL Savage, 8 February 2008.

About the contributors

PENNY CUTHBERT
Penny is Curator of Sport and Leisure History at the Australian National Maritime Museum. She has a BA DipMusStud from the University of Sydney and has worked in museums since 1988.

DR NIGEL ERSKINE
Nigel is Curator of Exploration and European Settlement at the Australian National Maritime Museum. Before joining the museum, he was Director of the Norfolk Island Museum. Nigel's areas of expertise include exploration of the Pacific, and in 1998 he led the Pitcairn Project, an archaeological investigation of the mutineer settlement at Pitcairn Island. He has published widely on the maritime history of Australia.

DAINA FLETCHER
Daina has been a Senior Curator at the Australian National Maritime Museum since 1992, having developed collections and exhibitions on sport, leisure, travel and tourism for the museum's opening. Daina studied art history and museology at Sydney University – BA (Hons) Fine Arts – and is a past president of the Australian Maritime Museums Council. She has worked on many programs about community and national histories and is on the steering committee and national Council for the Australian Register of Historic Vessels.

ANDREW FROLOWS, PHOTOGRAPHER
Andrew is the Manager of the museum's Photographic Services, and took most of the photographs in this book. He was previously at Sydney's Powerhouse Museum, where his work appeared in a number of books, including *Treasures of the Powerhouse Museum* (1994).

DR STEPHEN GAPPS
Stephen has been Curator of Environment, Industry and Shipping at the Australian National Maritime Museum since February 2010. Prior to this he worked as an academic and consultant historian and in 2003 completed a PhD thesis at the University of Technology, Sydney on the history of historical reenactments. In 2011 Stephen won the NSW Premier's History Prize for Community and Regional History with his book *Cabrogal to Fairfield City: A history of a multicultural community*.

KIERAN HOSTY
Kieran has been Curator of Maritime Archaeology, Ship Technology and 19th-century Immigration since he joined the museum in 1994. Formerly the Commonwealth Shipwrecks Officer in Victoria, he is a member of the NSW Maritime Archaeology Advisory Panel. Kieran completed his BA at the Western Australian Institute of Technology and his Diploma in Maritime Archaeology at Curtin University.

PAUL HUNDLEY
Paul is the Senior Curator of the USA Gallery at the museum, a position he has held since 1994. He is a member of the USA Gallery Consultative Committee and a representative on the Council of American Maritime Museums. Paul holds a BA in Anthropology and an MA in Maritime Archaeology from Texas A&M University.

VERONICA KOOYMAN
Veronica worked at the Australian National Maritime Museum between November 2009 and September 2011 as Welcome Wall Manager and then in the Curatorial section. She completed a BA (History Honours) in 2006 and a Masters of Museum Studies in 2008, both at the University of Sydney.

LINDL LAWTON
Lindl is currently Senior Curator at the South Australian Maritime Museum. She was Curator of Post-Federation Immigration at the Australian National Maritime Museum from 2004 to 2008. Prior to this Lindl worked as a consultant historian for several national institutions and on heritage projects in Northern Queensland. She holds a Masters of Public History from Monash University.

JEFFREY MELLEFONT
Formerly a wharfie, tuna-fisherman and professional yacht captain, Jeffrey has worked for the Australian National Maritime Museum since 1987 as a consultant, Public Affairs and Publications Manager, and edits its journal *Signals*. He has researched and published extensively on traditional Asian maritime communities, and leads museum tours to the region.

PATRICIA MILES
Patricia was part of the original curatorial team, joining the museum in 1987. She worked at the museum for 22 years, initially on naval history, and from 2001 as Curator of Commerce. She has a BA in History from the University of New England.

LEONIE OAKES
Leonie worked in the Registration section of the museum before becoming Assistant Curator of the Commerce collection in 1989. She was Curator of the Indigenous collection 1992–2000, and left the museum in 2001 to work as a consultant curator. She worked with the Torres Strait Island Commission on their Cultural Centre.

KIMBERLY O'SULLIVAN
Kimberly was Curator, Post-Federation Immigration from 2003 to 2005. She is an archivist and a historian, and since 2006 has been working in this role for Waverley Council, Sydney.

DAVID PAYNE
David has been a consultant to the Australian National Maritime Museum from 1988 until taking a curatorial position at the museum in late 2004, managing the Australian Register of Historic Vessels. He graduated with a BA (Industrial Design) in 1980 from the Sydney College of the Arts, and has worked as a yacht designer and consultant since 1983.

BILL RICHARDS
Bill gained a BA, Dip J, Dip Pub Admin at the University of Queensland, and trained in journalism on *The Courier-Mail*, Brisbane. He worked for several years on *The Sun*, a national daily in London, before moving to Sydney to become Marketing, PR and Publishing Manager of the National Trust. More recently he has been Media and External Relations Manager at the Australian National Maritime Museum. Publications include *The National Trust in New South Wales* and *Food at sea – eating and drinking with sailors 1500–2000*.

LINDSEY SHAW

Lindsey is a Senior Curator at the Australian National Maritime Museum and has worked in the Curatorial section since 1986; she is a committee member of the Naval Historical Society of Australia and a member of the Board of Directors of the Historic Naval Ships Association. Lindsey completed her BA and Diploma in Museum Studies at the University of Sydney.

KEVIN SUMPTION

Kevin first joined the ANMM in 1992 and through to 1995 held curatorial positions including Curator USA Gallery and Curator Immigration. Afterwards he moved to Sydney's Powerhouse Museum and after working as a Curator of Information Technology, he joined the Powerhouse Museum executive team with responsibilities including permanent gallery development, digital outreach and strategic planning. In 2008 he moved to London as the new Director of Exhibitions and Programming for the Royal Observatory and National Maritime Museum Greenwich. Kevin returned to Sydney in early 2012 to become the third Director of the Australian National Maritime Museum.

KIM TAO

Kim has been Curator of Post-Federation Immigration since 2009. She has a BA in Classical Archaeology, Anthropology and Sociology, and an MA in Museum Studies, both from the University of Sydney, and in 2008 was awarded a Churchill Fellowship to study community engagement in museums in the UK, Canada and USA.

MEGAN TREHARNE

Megan has been involved in several projects for the Australian National Maritime Museum since graduating from the University of Sydney with a BA (Fine Arts) in 1993. Awarded a Masters in Art Administration from the College of Fine Arts (UNSW) in 1998, she has worked as a curator in both galleries and museums for almost 20 years.

HELEN TREPA

Helen was Assistant Curator of 20th-century Immigration and Passenger Travel from 1999 to 2004. She is now Collection Coordinator at the Performing Arts Collection, Adelaide Festival Centre.

MARY-LOUISE WILLIAMS

Mary-Louise joined the museum as Senior Curator in 1988. She worked with museum staff and consultants to develop original exhibitions and programs. Two years later she became Assistant Director, Collections and Exhibitions Branch. She was appointed Director in November 2000 and, after 12 years as CEO and 24 years with the museum, retired in February 2012. She has played a leading role in the development of the museum's vision, its exhibitions, collections and programs virtually from its inception.

Acknowledgements

This book is the result of the combined talents, generosity and efforts of many people. The Australian National Maritime Museum (ANMM) thanks those who have contributed their time and expertise to *100 stories from the Australian National Maritime Museum*, including the following individuals and organisations.

Firstly and above all, we acknowledge the artists and makers of the works in these pages; the people, and their families, whose stories we have told here; and the writers and photographers who have now brought these stories to a new readership.

We have been greatly assisted by the following artists and makers, their representatives and associated art centres, agents and galleries; other copyright holders; a number of individuals mentioned in these pages, and their families and representatives; and others who have shared their knowledge. In order of appearance in the book, they include: Roger Scott and Josef Lebovic, Josef Lebovic Gallery Sydney; Adam Cullen and Michael Reid; Laurie Marburduk and the family of John Bulun Bulun, Claire Summers and Mark Hutchings (Bawinanga Aboriginal Corporation), Maningrida Arts and Culture; Aboriginal and Torres Strait Islander watercraft makers Don Miller, Jemima Miller, David Isaacs, Arthur King, Roy Wiggan, Annie Karrakayn, Ida Ninganga, Isaac Walayungkuma and the family of Ngarrawurn Murdumurdunathi; Nuwandjali Marawili, Marrnyula Munungurr and Will Stubbs, Buku-Larrnggay Mulka Centre; John Wilson Wuribudiwi, John Martin Tipungwuti, Leon Puruntatameri, Pedro Woneaemirri, Patrick Freddy Puruntatameri and Cher Breeze, Jilamara Arts and Crafts Association; Lola Greeno and Rex Greeno; Susan Jenkins and Steve Fox; the family of Arthur Koo'ekka Pambegan Jr and Guy Allain, Wik & Kugu Arts and Crafts Centre; Ken Thaiday Snr and

Michael Kershaw, the Australian Art Print Network; Michel and Jayne Tuffery, Tuffery Art Management Ltd; Billy Missi and Beverley Mitchell, KickArts Contemporary Arts Ltd; Emily Beech, Natural History Museum (London); Mrs Jean Lederer; Sue Saxon and Anne Zahalka; Natalie Seiz; Mim and Ed Carrington; Gina Sinozich; the Lu family; Michael Jensen; Claire Bailey; Glenn Morgan and Place Gallery, Melbourne; Ann Adams, Hugh Krijnen and Hugh Lander, Sydney Heritage Fleet; Beatrice Yell; Tamsin Lloyd and the Maritime Union of Australia; Robert McCrae; Peter Nicholson; the Navy Imagery Unit; Luca Babini and Kevin Williams (Myoo Media); Lisa Moore; Sandra Byron; David Potts; Ron and Valerie Taylor; Harvey Halvorsen; Nik Sellheim; Narelle Autio, Trent Parke and Stills Gallery, Sydney; Percy Trompf Artistic Trust; Mrs Brenda Northfield, James Northfield Heritage Art Trust; Dale O'Sullivan; Bruce Farr; Gary O'Neil; Phillip George; James Dodd; Laurence Bell; the Nossiter family; Wendy Sharpe; Ben Hawke, on behalf of the Jack Earl Trust and Lyall Morris; the Barry-Cotter family; Ken Warby; Kay Cottee; Vicki McAuley; Paul Hewitson; and James Castrission, Justin Jones and Graeme Templeton. Belinda Layton (Viscopy), ADAGP Paris, Amanda McKittrick and Siân Folley, Sotheby's Paris assisted with copyright matters. And we acknowledge Diane Moon, Merinda Campbell and Jenni Carter – photographers who have worked for the ANMM, and whose work appears in the preceding pages.

We also sincerely thank those donors who have contributed to the museum's collection through their generous gifts.

For invaluable input we thank New South Publishing, and the team who gave us continuing support and advice: Elspeth Menzies (publisher), Emma Driver and Heather Cam

(managing editors) and Diane Quick (design manager) – Di brought immense creative insight to a challenging and complex project. We also acknowledge the work of Martin Ford and Genevieve O'Callaghan, who undertook edits when the project was in its formative stages, and our copy editor Janine Flew, indexer Mary Coe, and proofreader Stephen Roche, who brought their expertise to the text at vital points in the production process.

Through their dedicated work at the Australian National Maritime Museum, past and present staff members have contributed to this book in many significant ways. We would particularly like to thank the staff of the following areas: Photographic Services, Registration, the Vaughan Evans Library, Curatorial, Conservation, the Preparators, Information Services, the External Relations Unit, Publications, Retail and Merchandise and Reception. Theresa Willsteed, the book's editor and project manager, managed both the detail and bigger picture of this ambitious project, and worked with the many people – both within and outside the museum – involved in bringing *100 stories* to our readers. The ANMM Council supported the book's production and an ANMM executive committee – Michael Crayford, Daina Fletcher, Paul Hundley, Matt Lee, Jeffrey Mellefont (who instigated the project), Vicki Northey, Lindsey Shaw, the museum's immediate past director Mary-Louise Williams, and present director Kevin Sumption – advised at important junctures. Mary-Louise championed the project. This book is a tribute to both Mary-Louise and Kevin's belief in sharing with as many people as possible the incredible stories of the objects – from a delicate bracelet made of marineer and cockle shells, to the 119-metre naval destroyer HMAS *Vampire* – at the heart of the Australian National Maritime Collection.

Index